The publisher gratefully acknowledges the generous contributions to this book provided by The Russell Family Foundation and the Blakemore Foundation.

modern chinese artists

MODERN CHINESE ARTISTS
a biographical dictionary

michael sullivan

UNIVERSITY OF CALIFORNIA PRESS
berkeley los angeles london

University of California Press, one of the most distinguished university presses in the United States, enriches lives around the world by advancing scholarship in the humanities, social sciences, and natural sciences. Its activities are supported by the UC Press Foundation and by philanthropic contributions from individuals and institutions. For more information, visit www.ucpress.edu.

University of California Press
Berkeley and Los Angeles, California

University of California Press, Ltd.
London, England

Library of Congress Cataloging-in-Publication Data

Sullivan, Michael, 1916–.
 Modern Chinese artists : a biographical dictionary / Michael Sullivan.
 p. cm.
 Includes bibliographical references and index.
 ISBN-13: 978-0-520-24449-8 (cloth : alk. paper), ISBN-10: 0-520-24449-4 (cloth : alk. paper)
 1. Artists—China—Biography—Dictionaries. 2. Art, Chinese—20th century—Dictionaries. 3. Art, Chinese—21st century—Dictionaries.
I. Title.

 N7348.S85 2006
 700/.92/2 B—dc22 2006011263

Manufactured in the United States of America

15 14 13 12 11 10 09 08 07 06
10 9 8 7 6 5 4 3 2 1

The paper used in this publication meets the minimum requirements of ANSI/NISO Z39.48-1992 (R 1997) (*Permanence of Paper*).

to all our artist friends over the years

contents

preface

In the mid twentieth century, Western interest in modern Chinese art was minimal. Few museums or private collectors had ventured into this uncharted territory, one reason being that Westerners tended to dismiss modern Chinese art as either the tail end of a dying tradition or as feeble attempts to copy Western art. Although a number of Chinese artists who later became famous studied Western drawing, painting, and sculpture in the West, particularly in Paris, the works presented in exhibitions, such as those brought to Europe by Xu Beihong and Liu Haisu in the mid 1930s, and shown by Alan Priest at the Metropolitan Museum, New York, in 1948, were exclusively safe traditional painting, *guohua*, easily recognized as Chinese. But few even of such works as these were accessible for purchase to museums and collectors. In the meantime, Wang Yiqiang had in 1947 published a useful reference work for Chinese readers, *Zhonghua Minguo sanshiliunian meishu nianjian* (Art yearbook for the thirty-sixth year of the Republic of China).

After 1950 this general attitude to modern Chinese art began to change. Although the import into the United States of anything originating in Communist China was forbidden, works by living *guohua* masters were coming to Europe, either bought in China by, for instance, Vadime Elisséeff of the Musée Cernuschi in Paris and Arno Schüller in Prague, or, in Switzerland, Charles Drenowatz and Dr. Franco Vannotti–the latter acquiring most of his collection by exchange of Western art books with the Chinese cultural authorities. In the meantime modern *guohua* was appearing in the Hong

Kong auction houses in ever increasing quantities, much of it expropriated from the artists and sold by Chinese official bodies (often without the artists' permission or knowledge) for much-needed foreign exchange. Li Keran, for example, was dismayed when some of his landscapes, which he had lent to the Rongbaozhai art publishing house for reproduction, turned up in the sale rooms in Hong Kong. Mrs. Shen's Gallery opposite the British Museum in London was for many years the chief commercial outlet in Europe for works that had been legally exported from the People's Republic.

In 1972 the United States government lifted the embargo on the import of Chinese goods, while in 1979 in China the cultural thaw, which slowly developed after the death of Mao Zedong in 1976, began to stimulate the free flow of art from China that has since expanded into a flood. In Europe and America museums began seriously to collect modern Chinese art; auction houses mounted frequent specialized sales; commercial galleries devoted to the contemporary movements sprang up; and the number of private collectors steadily increased. At the same time twentieth-century Chinese art became, almost for the first time, the subject of serious scholarly study. Today courses and seminars on the subject are offered in leading universities in Europe and the United States, and an increasing number of doctoral theses are devoted to aspects of this fascinating and hitherto almost unexplored subject.

Meantime, in China, the social and economic revolution that gathered pace in the last two decades of the twentieth century has had a profound effect on the art world. While some artists still gain their living chiefly by teaching, more and more are independent, deriving their living partly from ever increasing foreign sales, partly from a domestic market that is the product of the new commercialism of the cities and the emergence of a new moneyed class. Yet ambitious Chinese artists still count on foreign recognition, secured by exhibitions in the West and showing in such events as the São Paulo and Venice Biennales–with which the Shanghai Biennale and the new international exhibitions in other Chinese major cities are now competing.

The effect of these economic and social changes has been a vast increase in the production of works of art and of the number of practicing Chinese artists whose work is becoming known in the West. When the Western study of modern Chinese art was in its infancy, I included in my book *Chinese Art*

in the Twentieth Century (1959), a biographical index listing 261 artists, for which much of the information had been given to me by my painter friend Pang Xunqin in Chengdu during World War II and in subsequent correspondence between us after I left China in 1946. Lin Jiantong's *Dangdai Zhongguo huaren minglu* (Biographies of present-day Chinese artists) appeared in 1971. The next book on this subject was Tsuruta Takeyoshi's *Kindai Chūgoku kaiga* (Modern Chinese painting) (Tokyo, 1974); Tsuruta also published the brief biographical notes he had accumulated in the art journal *Bijutsu Kenkyū* (Fine Art Research) between 1974 and 1978. The artists included were almost exclusively conservative practitioners of *guohua*. Ten years later the University of California Press published Ellen Laing's *The Winking Owl: Art in the People's Republic of China,* covering the period up to the arrest of the Gang of Four in September 1976 and including "Brief Biographical Notices" of 168 artists. In 1984 Laing's much more substantial *Index to Reproductions of Paintings by Twentieth-Century Chinese Artists* contained thousands of listings of works reproduced in periodicals, along with somewhat skeletal biographical information. Other works that contain useful biographies are included in the Bibliography at the back of this book.

My own book *Art and Artists of Twentieth-Century China* (1996) included a biographical index with more than eight hundred entries, but, as I am well aware, it contains a number of errors and omissions and is by no means definitive. I am therefore particularly grateful to the University of California Press for giving me this opportunity to produce a more substantial work, which I hope will provide a useful reference source for Western scholars and students of modern Chinese art, collectors, museums, libraries, dealers, and auction houses.

The artists chosen for inclusion (among the many thousands listed, for example, in such Chinese works as *Zhongguo meishu nianjian* [Beijing, 1988]) are those who attained some reputation in China in the twentieth century and opening years of the twenty-first, even though born in the nineteenth, and those whose works are likely to appear in collections, exhibitions, and auctions abroad. Only artists who grew up, or were trained, in China are included, even if they subsequently went abroad to work during, for instance, the diaspora of the 1980s and '90s. Inevitably, the choice of whom to include,

whom to leave out, is to some degree subjective, and I take full responsibility for it. The term *yishu*, fine art, embraces both painting and calligraphy—indeed in Chinese eyes calligraphy is the mistress of the arts. The number of accomplished calligraphers, from Mao Zedong down, in modern China is huge; but I have excluded them unless they were also known as painters, for otherwise this book would be of unmanageable size.

Compiling the entries was a challenge. Biographical information is uneven and sometimes conflicting. Sources cite three different dates, for example, for the birth of Chen Zhifu (1895, 1896, 1898), while artists have sometimes intentionally fiddled with their date of birth, the most celebrated case being that of Qi Baishi, who added two years to his age on the advice of a fortune-teller. Moreover, even when an artist born, say, in 1904 has not been heard of for decades, that is no proof that he or she is deceased. Chinese artists often live to a great age. Zhu Qizhan was still serenely painting until shortly before his death at the age of 104. The calligrapher Yang Chaoshen wrote an inscription for me in Singapore at the age of 118. He died four years later. I hope that users of this dictionary will pass on to me any information of this sort, or corrections and additions, that may be included in subsequent editions.

Although I have been adding to this dictionary from time to time for half a century, it would be far less comprehensive and accurate without the help of a number of young friends who have made their contributions to it over the years, beginning with Dr. Mayching Kao, who completed what was probably the first Western doctoral thesis on modern Chinese art at Stanford University in 1972. She was followed at Oxford University by Dr. Xiu Huajing Maske, whose thesis in the same area earned her a D.Phil. in 2000. Since my retirement, several post-graduate students at Oxford have contributed in a number of ways, with research, typing, and editorial work, the insertion of Chinese characters, checking entries, and putting the work on disk. I should like particularly to mention Professor Li-ling Hsiao of the University of North Carolina; Dr. Hsiao-ting Lin, Research Scholar at the Hoover Institution, Stanford University; Hiromi Kinoshita, Fuyubi Nakamura, Josh Yiu, Ruth Hung, Wang Hsien-chun, and He Weimin at Oxford University; and Dr. James Lin at the Fitzwilliam Museum, Cambridge. Working with

them on this and other projects during our weekly sessions at Northmoor Road has been, and continues to be, one of the great pleasures of our life at Oxford. For helpful corrections and additions, I should also like to express my gratitude to Dr. Joshua Jiang in Birmingham; Dr. Maxwell Hearn at the Metropolitan Museum of Art, New York; Professors Pang Tao, Chen Ruilin, Shui Tianzhong, Lang Shaojun, Chen Weihe, and Meg Maggio and Robert Bernell in Beijing; Professor Cao Yiqiang in Hangzhou; Dr. Britta Erickson at Stanford; Dr. Zheng Tiansheng in Vancouver; Professor Jason Kuo at the University of Maryland; Professor Jerome Silbergeld at Princeton; Claire Roberts in Sydney; Professor Wan Qingli in Hong Kong; Claire Hsü and her colleagues in the Asia Art Archive, Hong Kong; Johnson Zhangan Jeff Leung at Hanart T Z Gallery, Hong Kong, and especially Professor Hong Zaixin at the University of Puget Sound for the great care with which he went through the manuscript and for long and illuminating discussions with him.

As always, I am happy to record my appreciation of the work done at the University of California Press by all those involved in the production of this book, especially my lynx-eyed cheerful copyeditor Amy Klatzkin, as well as Deborah Kirshman, Sue Heinemann, Sigi Nacson, and the designer Jessica Grunwald.

I should also like to express my heartfelt gratitude to George Russell, who, once again, contributed in a very practical way to my work, and in particular to the Master and Fellows of St. Catherine's College, Oxford, who have given me not only a home, but also much generous support and encouragement during the time of my Fellowship and after.

Not least do I wish to thank all our Chinese artist friends who, over a period of sixty years, have given us not only information and catalogues of their exhibitions, but even works of art for the collection that my late wife Khoan and I built up over the years. Without them, indeed, this work could never have been contemplated.

abbreviations

AFA	Academy of Fine Art(s) (*any*)
CAA	Chinese Artists Association 中國美術家協會
CAAC	Central Academy of Arts and Crafts (Beijing) 中央工藝美術學院
CAFA	Central Academy of Fine Art (Beijing) 中央美術學院
CCP	Chinese Communist Party 中國共產黨
KMT	Kuomintang (Nationalist Party) 國民黨
LXALA	Lu Xun Academy of Literature and Arts (Yan'an) 魯迅藝術文學院
LXAFA	Lu Xun Academy of Fine Arts (Shenyang) 魯迅藝術學院
NAA	National Academy of Art 國立美術學校
NCU	National Central University 國立中央大學
NTNU	National Taiwan Normal University (Taipei) 國立台灣師範大學
PLA	People's Liberation Army 解放軍. Originally named Red Army 紅軍.
PRC	People's Republic of China
ROC	Republic of China
WWII	World War II
ZAFA	Zhejiang Academy of Fine Art (Hangzhou) 浙江美術學院

name changes of principal art academies

The major art academies have changed their names, in some cases a number of times, over the years. To avoid apparent inconsistencies in the entries—when, for example, an artist graduated from the National Hangzhou Art School and subsequently taught in the National Fine Art Academy, which is the same institution—one name is used throughout. An exception to this rule is abbreviated names (see Abbreviations on p. xv and the listings below). An institution is sometimes called in its official title a *zhuanmen* (or *zhuanke*) *meishu xuexiao*, literally "specialized art school." In translation, the word *specialized* is omitted.

Beijing Academy (NAA Beijing, CAFA)

1918	Guoli Beijing Meishu Xuexiao 國立北京美術學校 (NAA Beijing)
1923	Beijing Meishu Zhuanmen Xuexiao 北京美術專門學校 (National Beijing Fine Art School)
1925	Meishu Zhuanmen Xuexiao 美術專門學校 (Fine Art School)
1927	Guoli Beiping Daxue Meishu Zhuanmen Bu 國立北平大學美術專門部 (National Beiping University, Fine Art Division)
1928	Beiping Daxue Yishu Xueyuan 北平大學藝術學院 (Beiping University Art Academy)
1934	Beiping Yishu Zhuanke Xuexiao 北平藝術專科學校 (Beiping Art School)
1937–45	Merged with Hangzhou Academy and renamed Guoli Yishu Zhuanke Xuexiao 國立藝術專科學校 (National Art School)
1946	Guoli Beiping Yishu Zhuanke Xuexiao 國立北平藝術專科學校 (National Beiping Art School). In 1949 it incorporated the Huabei Daxue Disan Bu Meishuke 華北大學第三部美術科 (Huabei University, Third Division, Fine Art Department)
1950–	Zhongyang Meishu Xueyuan 中央美術學院 (CAFA)

Beijing Minorities Art Institute

1959 Zhongyang Minzu Xueyuan Yishuxi Meishu Zhuanye 中央民族學院藝術系美術專業 (Central Minorities Institute, Art Department, Fine Art Section)

1983– Zhongyang Minzu Xueyuan Meishuxi 中央民族學院美術系 (Central Minorities Institute, Fine Art Department)

Central Academy of Arts and Crafts (CAAC)

1956 Zhongyang Gongyi Meishu Xueyuan 中央工藝美術學院

1999 Qinghua Daxue Meishu Xueyuan 清華大學美術學院 (Tsinghua University, Academy of Arts and Design)

Guangzhou Academy

1916–38 Chunshui Huayuan 春睡畫院 (Chunshui Painting Academy)
Reestablished 1947–49 as Sili Nanzhong Meishuyuan 私立南中美術院 (Nanzhong Private Academy of Fine Art)
Replaced in 1959 by Guangzhou Meishu Xuexiao 廣州美術學校 (Guangzhou Art School)

Hangzhou Academy (ZAFA)

1928–30 Guoli Xihu Yishuyuan 國立西湖藝術院 (National West Lake Academy of Art)

1930–38 Guoli Hangzhou Yishu Zhuanke Xuexiao 國立杭州藝術專科學校 (National Hangzhou Art School). *See also* Beijing Academy

1938 Merged with Beiping Yishu Zhuanke Xuexiao 北平藝術專科學校 to become Guoli Yishu Zhuanke Xuexiao 國立藝術專科學校 (National Art School)

1946 Separated again; Hangzhou school kept the name

1950 Became Huadong (East China) branch of the Zhongyang Meishu Xueyuan 中央美術學院華東分院 (Central Art Academy)

1958 Zhejiang Meishu Xueyuan 浙江美術學院 (ZAFA)

1993 Zhongguo Meishu Xueyuan 中國美術學院 (China Academy of Art)

Nanjing Academy

1952 Shanghai Academy, Suzhou Academy, and the Shandong Daxue Yishuxi 山東大學藝術系 (Shandong University, Department of Art) amalgamated to form the Huadong Yishu Zhuanke Xuexiao 華東藝術專科學校 (East China Art School)

1958–59 Moved to Nanjing and renamed Nanjing Yishu Xueyuan 南京藝術學
院 (Nanjing Art Academy)

National Normal University, Department of Fine Arts

1906–11 Liangjiang Shifan Tuhua Shougongke 兩江師範圖畫手工科 (Zhejiang-
Jiangsu Normal School, Painting and Handicraft Division)

1916 Nanjing Gaodeng Shifan Tuhua Shougongke 南京高等師範圖畫手
工科 (National Zhejiang-Jiangsu High Normal School, Painting and
Handicraft Division)

1918 Nanjing Gaodeng Shifan Gongyi Zhuanxiuke 南京高等師範工藝專
修科 (Nanjing High Normal School, Craft Specialized Division)

1923 Nanjing High Normal School merged with Dongnan Daxue 東南大學
(Southeastern University)

Shanghai Academy (Shanghai Meizhuan)

1912–20 Shanghai Meishuyuan 上海美術院 (Shanghai Academy of Fine Art),
also called Shanghai Tuhua Meishuyuan 上海圖畫美術院 (Shanghai
Painting Academy of Fine Art). This famous art school, headed by Liu
Haisu, is often referred to as the Shanghai Meizhuan.

1920 Shanghai Meishu Xuexiao 上海美術學校 (Shanghai Fine Art School)

1930 Shanghai Meishu Zhuanke Xuexiao 上海美術專科學校 (Shanghai Fine
Art School)

1952– Merged with *Suzhou Academy* and Shandong Daxue Yishuxi 山東大學藝
術系 (Shandong University, Department of Art). *See* Nanjing Academy

Suzhou Academy

1922 Suzhou Meishu Zhuanke Xuexiao 蘇州美術專科學校 (Suzhou Fine
Art School)

1937 Moved to Shanghai

1945 Moved back to Suzhou but kept the Shanghai branch

1952 Amalgamated with Shanghai Academy (*see above*) and Shandong Daxue
Yishuxi 山東大學藝術系 (Shandong University, Department of Art).
See also Nanjing Academy

1924 Craft Division became Jiangsu Shengli Yishu Zhuanke Xuexiao 江蘇省
立藝術專科學校 (Jiangsu Provincial Art School)

1927 Merged with Disi Zhongshan Daxue Jiaoyu Xueyuan 第四中山大學
教育學院 (Zhongshan Fourth University, Education Academy) and
renamed Yishu Jiaoyu Zhuanxiuke 藝術教育專修科 (Art Education
Division)

1928 Incorporated into Guoli Zhongyang Daxue 國立中央大學 (National Central University)

1938 Zhongyang Daxue Shifan Xueyuan Yishu Zhuanxiuke 中央大學師範學院藝術專修科 (National Central Normal University, Art Division)

1949 University changed its name to Nanjing Daxue 南京大學 (Nanjing University)

1952 Art Department constituted the Departments of Fine Art and Music of Nanjing Shifan Xueyuan 南京師範學院 (Nanjing Normal School)

1984 Nanjing Shifan Daxue Meishuxi 南京師範大學美術系 (Nanjing Normal University, Department of Fine Arts)

1999 Nanjing Shifan Daxue Meishu Xueyuan 南京師範大學美術學院 (Nanjing Normal University, Academy of Arts)

Tianjin Academy

1906 Beiyang Nüshifan Xuetang 北洋女師範學堂 (Beiyang Women's Normal School); Fine Art subject established in 1926

1929 Hebei Sheng Nüshifan Xueyuan 河北省女師範學院 (Hebei Provincial Women's Normal Academy)

1949 Hebei Shifan Xueyuan Yishuxi 河北師範學院藝術系 (Hebei Normal Art Academy, Department of Arts); men admitted

1958 Departments of Music and Fine Art formed Hebei Yishu Shifan Xueyuan 河北藝術師範學院 (Hebei Normal Academy of Fine Art)

1959 Fine Art branch developed into Hebei Meishu Xueyuan 河北美術學院 (Hebei Academy of Fine Art)

1962 Reincorporated the Department of Music; renamed Hebei Yishu Shifan Xueyuan 河北藝術師範學院

1970 Tianjin Wuqi Yishu Xuexiao 天津五七藝術學校 (Tianjin Five-Seven Art School)

1973 Tianjin Yishu Xueyuan 天津藝術學院 (Tianjin Academy of Fine Art)

1980 Tianjin Meishu Xueyuan 天津美術學院 (Tianjin Academy of Fine Art)

biographical dictionary

Note: In parentheses, alternative names are identified as "original name," *zi* (字 style name), or *hao* (號 literary name), as applicable. Alternative romanizations and English names appear without comment. "Native of" distinguishes ancestral place (*jiaxiang* 家鄉) from birthplace. Within each main entry, names in bold type identify artists whose biographies appear elsewhere in this dictionary.

A Ge 阿鴿 (b. 1948, Liangshan, Sichuan province, of Yi nationality). Print artist. Wife of **Xu Kuang**. At age 12 began studying at Sichuan AFA. After graduation worked at CAA, Sichuan branch. Known for depicting life of her people and her hometown. Won international prize in Norway. Grade 1 National Artist.

A Xian 阿仙 (original name Liu Jixian 劉繼先, b. 1960, Beijing). Painter, self-taught. 1980 became professional artist. Member of avant-garde movement. 1989 visited Tasmania as artist in residence, Tasmanian School of Art, University of Tasmania. 1990 returned to Australia to settle in Sydney. 1998 began to work in porcelain. 1999 spent nine months in Jingdezhen, since then he has also worked in cloisonné, carved lacquer, inlaid bone, and, from 1998, porcelain. Many solo exhibitions. 2001 won inaugural National Sculpture Prize, National Gallery of Australia, Canberra.

A Yang. See **Yang Jiachang**

Ai Qing 艾青 (original name Jiang Haicheng 蔣海澄, 1910–96, b. Jinhua, Zhejiang province). Painter and well-known poet. Son of landowner. Father of **Ai Xuan** and **Ai Weiwei**. At school studied under Zhang Shanqi, who had studied under **Wu Changshuo**. At 18 entered Hangzhou Academy. Studied oil painting under **Wang Yuezhi**, *guohua* under **Pan Tianshou**, watercolor under **Sun Fuxi**. Told **Qi Huang** that **Lin Fengmian** had shown him an album of Qi when he was 18. In second year went to Paris, studying and paint-

ing for three years; began to write poetry. 1932 returned to China, with 20 young friends formed Chundi Huahui 春地畫會. Exhibition attended by Lu Xun, whom he showed around. 1932–35 imprisoned by KMT. During WWII became involved in literary controversy in Chongqing, Guilin, Yan'an. After 1950 worked in army cultural section.

Ai Weiwei 艾未未 (b. 1957). Avant-garde artist. Son of revolutionary poet **Ai Qing**, brother of **Ai Xuan**. Began as an amateur self-taught artist. 1978–81 worked in Beijing Film Institute on painting and cartoon design, and member of the Stars. 1981 emigrated to New York, where he studied art at the Parsons School of Design and Art Students League. Since then he has held many exhibitions and participated in group shows in US and elsewhere. 2000 exhibited at the Venice Biennale. Noted for his satires on Mao Zedong. Lives and works in Beijing.

Ai Xuan 艾軒 (b. 1947, Jinhua, Zhejiang province). Oil painter. Son of poet **Ai Qing**, brother of **Ai Weiwei**. 1969–73 served on military farm in Tibet. After 1973 stationed in Chengdu as artist, but unable to devote himself entirely to painting. 1987–88 visited US, where he met his idol, Andrew Wyeth. Specializes in Tibetan and borderland subjects.

Ai Zhongxin 艾中信 (*hao* Songye 宋葉, b. 1915, Jiangsu province, native of Shanghai). Oil painter. 1936 studied under **Xu Beihong, Wu Zuoren,** and **Lü Sibai** in Art Dept. of NCU Nanjing. 1937 attended Chinese Art Exhibition in Moscow. 1946 associate professor at NAA Beijing. After 1949 head of Oil Painting Dept. of CAFA, where in the early 1950s he attended Konstantin Maksimov's painting class. His work was much influenced by Soviet socialist realism.

An He 安和 (b. 1927, Beijing). *Guohua* painter. From 1944 she studied for seventeen years with **Pu Ru**. 1949 moved to Taiwan. 1977 settled with her family in Atlanta, Georgia. Highly accomplished conservative painter, chiefly of flowers and landscapes.

An Ho. See **An He**

Ang Kiukok. See **Hong Jiuguo**

Au Ho-nien. See **Ou Haonian**

Bai Jingzhou 白敬周 (b. 1947, Lanzhou, Gansu province). Oil painter, best known for his serial picture stories. After 1976 took postgraduate courses in Graphic Arts Dept. of CAFA, then joined faculty. 1982 enrolled on Chinese government scholarship in MFA program at Southern Illinois University, Carbondale. 1985 settled in New York.

Bai Tianxue 白天學 (n.d., Huxian, Shaanxi province). Huxian peasant painter. Active in 1960s and '70s.

Bai Xueshi 白雪石 (b. 1915, Beijing). *Guohua* painter. Began painting on his own. Later studied with Liang Shuping. After 1949 traveled widely in China, then taught in Beijing Fine Art Normal College. 1964 taught basic painting in Ceramics Dept. of CAAC. Decorated Beijing Hotel. 1982 associate professor of CAAC. Media include oil painting, woodblock printing, and sculpture.

Bao Ailun 鮑藹倫 (Ellen Pau, b. 1961, Hong Kong). Video artist. 1985 graduated from Hong Kong Polytechnic with diploma in diagnostic radiography, after which she turned to video art. Has participated in many art events in Hong Kong and abroad.

Bao Jia 鮑加 (b. 1933, Shexian, Anhui province). Painter. 1961–63 studied history painting under **Luo Gongliu** in CAFA. Professor in Anhui AFA, Hefei. Realistic oils and decorative panels in *guohua* technique, including panorama of Huangshan in Hefei bus station (1982).

Bao Peili 包陪麗 (Cissy Pao, b. 1950, Hong Kong). Mixed-media artist. From 1967 studied and worked in US. 1972 BFA, 1975 MFA, Washington University, St. Louis. She has had many solo exhibitions in Hong Kong and US, chiefly California.

Bao Shaoyou 鮑少游 (Pau Shiu-yau, *zi* Yaochang 堯常, 1892–1985, native of Zhongshan, Guangdong province). Conservative *guohua* painter, chiefly of birds and flowers, figures in garden settings, etc. 1915 graduated from West Kyoto AFA, Japan. 1918 lecturer in NAA Beijing. Active in Shanghai, Guangzhou, and (from 1928) Hong Kong, where she founded Lai Ching Art Institute.

Bi Zirong 畢子融 (Aser But, b. 1949, Macao). 1973 graduated in art education, Grantham College of Education, Hong Kong. 1977 had further training at University College, London. MA 1983 Parsons School of Design, New York. He returned to Hong Kong as independent artist and senior lecturer in Swire School of Design, Hong Kong Polytechnic. 1979 received Urban Council Fine Arts Award. 1987 elected chairman of the Visual Arts Society.

But, Aser. See **Bi Zirong**

Cai Chufu 蔡楚夫 (Choi Chor-foo, b. 1942, Wuzhaoxian, Guangxi province). Photorealist painter. 1959–63 studied in Guangzhou Academy. Early 1970s settled in Hong Kong, where he studied with **Yang Shanshen** and **Ding Yanyong**.

Cai Dizhi 蔡迪支 (b. 1918, native of Shudexian, Guangdong province). *Guohua* painter and wood engraver. During WWII engaged in anti-Japanese propaganda activities in southwest China. 1939 joined China Woodcut Research Society. Influenced by **Li Hua.** 1944 went to Guilin, where he recorded Chinese retreat during Japanese Ichigō offensive. 1947 joined Renjian Huahui in Hong Kong. 1959 in charge of organizing Guangzhou Painting Academy, of which he became vice-president.

Cai Guoqiang 蔡國強 (b. 1957, Quanzhou, Fujian province). Painter, performance and installation artist. 1985 graduated from Shanghai Drama Institute, then went to Tokyo for ten years. 1995 moved to New York. Noted for his projects involving gunpowder, e.g., *Project to Extend the Great Wall by 10,000 Meters* and *The Century with the Mushroom Cloud* (1996). 1999, for Venice Biennale, he and assistants from China recreated *The Rent Collection Courtyard* in perishable form, for which he was awarded Leone d'Oro award. June 2002 created *Transient Rainbow* "explosion event" over East River, New York. January 2003 presented less successful *Ye Gong Hao Lang* "explosion project" for Tate Modern, London. September 2003 *Light Cycle: Explosion Project for Central Park,* New York. Subject of major exhibition catalog for Fondation Cartier pour l'Art Contemporain, *Cai Guo-Qiang* (London, 2000). See also Dana Friis-Hansen, Octavio Zaya, and Serizawa Takashi, *Cai Guo-Qiang* (London, 2004).

Cai Jin 蔡錦 (b. 1965, native of Tunxi, Anhui province). Oil painter. 1986 graduated from Fine Art Dept. of Anhui University. 1991 held solo exhibition in CAFA gallery, received MA. Avant-garde artist influenced by surrealism. Also makes sensitive drawings of plants in pencil. Her paintings of the banana on a variety of surfaces widely acclaimed. Lives and works in New York and Tianjin.

Cai Liang 蔡亮 (1932–95, b. Xiamen, Fujian province). Oil painter. Graduated from CAFA, where in 1964–65 he studied history painting under **Luo Gongliu.** After political difficulties, engaged by Xi'an branch of CAA. Later became professor in Oil Painting Dept. of ZAFA.

Cai Renzi 蔡仞姿 (Choi Yau-chi, b. 1949, Hong Kong). Performance, mixed-media, and environmental artist. BFA 1976, MFA 1977, School of the Art Institute of Chicago. 1979–93 she taught at Hong Kong Polytechnic. 1993–97 lived in Toronto, returning to Hong Kong to establish Art Space. 1999 resumed teaching at Hong Kong Technical College. Has held solo exhibitions in Hong Kong, New York, Germany, and Canada.

Cai Ruohong 蔡若虹 (1910–2002, native of Jiujiang, Jiangxi province). Cartoonist and CCP activist. Graduated from Oil Painting Dept. of Shanghai Meizhuan. 1930–31 member of League of Left-wing Artists, Shanghai. 1938–39 went to Yan'an, taught in LXALA. 1949 edited pictorial page for *People's Daily*. Elected member of standing committee of CAA. Later appointed vice-chairman of CAA. An oppressive ideological influence on art and artists.

Cai Shuilin 蔡水林 (Tsay Shoe-lin, b. 1932, Taiwan). Sculptor. Active in Taipei.

Cai Tianding 蔡天定 (Chuah Thean Teng, b. 1914, Xiamen, Fujian province). Batik designer, wood engraver, and decorative artist. Studied in Xiamen AFA. 1932 settled in Penang, Malaysia. Notable for developing batik technique as method of creating paintings.

Cai Weilian 蔡威廉 (1904–39, native of Shaoxing, Zhejiang province). Oil painter. Favorite child of liberal educator Cai Yuanpei. Wife of **Lin Wenzheng**. Studied oil painting in Belgium and Lyon, France. 1928 professor in Hangzhou Academy. 1938 lived in Kunming. Noted for her portraits in oils. Died in Kunming after childbirth.

Cai Wenying 蔡文穎 (Ts'ai Wen-ying, b. 1928, Xiamen, Fujian province). Studied engineering in Shanghai. 1953 graduated in engineering from the University of Michigan. While pursuing his professional career he studied at the Art Students League in New York. From 1963 devoted himself entirely to art, creating the "Cybernetic Sculpture" for which he is best known. Winner of many commissions and awards worldwide, including the 1997 Suntory Prize, which he refused. 1997 held his first "homecoming" exhibition in Beijing.

Cai Xiaoli 蔡小麗 (b. 1956, Xi'an, Shaanxi province). Artist. 1982 graduated from CAFA. Continued to teach *guohua* there till 1988, when she became independent professional artist. Decorative flower and landscape painter in *gongbi* style. Lives and works in London and Beijing with her husband, **Wang Jia'nan**. (*Photo on p. 25.*)

Cai Yi 蔡儀 (1906–93, native of Yuxian, Hunan province). *Guohua* painter. Active in Beijing. After Liberation joined staff of CAFA as instructor. Author of several books on art and aesthetics.

Cai Yintang 蔡蔭堂 (Tsai Intang, b. 1909, Taiwan). Oil painter. Studied in Japan and from 1932 in Taipei under **Li Shiqiao**. Prominent in conservative oil-painting circles in Taiwan until he settled in US in 1977. Lives in San Francisco.

Cai Zhenhua 蔡振華 (b. 1912, Deqing, Zhejiang province). After seeing new American illustration techniques of the 1920s, he developed a special fondness for drawing and caricature. 1929 accepted by Hangzhou Academy, where he won a prize for his pattern designs. After graduation moved to Shanghai, working as graphic designer for numerous publishers, including Hongyue Advertising and Publishing Co., Xinyue Advertising and Publishing Co., and Commercial Press. 1952 staff artist in Shanghai People's Art Press. From 1949 began to accept private commissions for design projects, including collaborative bas-relief sculpture for Chinese-Soviet Friendship Hall in Shanghai and interior designs for Shanghai room in Great Hall of the People, Beijing.

Cao Dali 曹達立 (b. 1934, Beijing). Oil painter. As a child, went with his family to Indonesia, where he studied at National Art School. 1956 returned to China. 1961 graduated from Oil Painting Dept. of CAFA, where he studied under **Wu Zuoren**. 1982 held solo exhibition of oil paintings in Beijing. Member of Beijing Academy of Painting and friend of **Yang Yanping**, with whom he collaborated for several years.

Cao Jie 曹潔 (b. 1931, Suzhou, Jiangsu province). Book designer. 1949 graduated from Suzhou Fine Art Professional School, majoring in Chinese painting. After attending postgraduate course in book design at Central Institute of Art and Design, Beijing, she became art director at People's Fine Art Publishing House. Her book designs have received international recognition, including medals from International Book Fair in Leipzig, 1959 and 1989.

Cao Jigang 曹吉岡 (b. 1955, Beijing). Oil painter. 1984 graduated from Oil Painting Dept. of CAFA. Became lecturer in Stage Design Dept. of Chinese Traditional Opera Academy. Specializes in mountain landscapes.

Cao Li 曹力 (b. 1954, Guiyang, Guizhou province). Oil painter. 1982 graduated from CAFA, became lecturer in Wall Painting Dept. 1992 visiting artist in Madrid. Earlier work influenced by Franz Marc, later by surrealism.

Cao Liwei 曹立偉 (b. 1956, Liaoning province). Oil painter. 1978–82 studied in CAFA, winning first prize on graduation; later became lecturer there. Travels frequently in Qinghai and Gansu provinces, which provide material for his landscapes.

Cao Wen 曹汶 (b. 1926, Anqiu, Shandong province). Painter. Fellow art student with **Huang Zhou** in Xi'an during WWII, then worked in Chongqing. 1947 joined CCP in Nanjing. Thereafter active chiefly in Nanjing. Paints landscapes in *guohua* technique.

Cao Xinlin 曹新林 (b. 1940, Wangcheng, Hunan province). Oil painter. 1964 gradu-

ated from Oil Painting Dept. of Guangzhou Academy. Settled in Henan, where he became president of Henan Provincial Painting and Calligraphy Society. Silver Prize in Sixth National Art Exhibition. Paints chiefly figure subjects and portraits.

Cao Ya 曹牙 (Tsao Ya, b. 1956, Taiwan). Sculptor. Graduated from National Taiwan Academy of Arts.

Cao Yong 曹涌 (b. 1954, Lanzhou, Gansu province). Painter. 1980 graduated from Tianshui Teachers Training College, Gansu. Member of New Floating World Group. Satirical semisurrealist work featured in Inside Out: New Chinese Art (San Francisco and New York, 1998).

Chai Xiaogang 柴小剛 (b. 1962, Jiangsu province). Painter. 1985 graduate of Fine Art Dept., Nanjing Academy. Became art administrator of Lianyungang Municipal People's Art Museum. expressionist-surrealist and member of avant-garde movement.

Chan Chung Shu. See Chen Zhongshu

Chan, Gaylord. See Chen Yusheng

Chan Hoi Ying. See Chen Haiying

Chan Kwan Lap, Eddy. See Chen Junli

Chan, Luis. See Chen Fushan

Chan Ping Tim. See Chen Bingtian

Chan Sheng-yao. See Zhan Shengyao

Chan Shing Kau. See Chen Chengqiu

Chan, Stephen. See Zhan Shengyao

Chan Yuk Keung. See Chen Yuqiang

Chang, Arnold. See Zhang Hong

Chang Chien-ying. See Zhang Jingying

Chang, Constance. See Zhang Shangpu

Chang Dai Chien. See Zhang Daqian

Ch'ang Hsi-ya. See **Zhang Xiyai**

Chang Jin 常進 (b. 1951, Nanjing). *Guohua* painter. 1981 graduated from Jiangsu Chinese Painting Academy, where he became dean. Landscapes exhibited in Shanghai Biennale 1998.

Chang, Margaret. See **Hong Xian**

Chang Qing 常青 (b. 1965, Chengdu, Sichuan province). Oil painter. 1984 graduated from middle school attached to China Art College. 1989 graduated from CAAC, where he now teaches. Hyperrealist, especially portraits and interiors.

Chang Renxia 常任俠 (1904–96, Yingshang, Anhui province). *Guohua* painter and poet. Before WWII in Shanghai and NCU Nanjing. 1935–36 in Japan. 1937 went to Changsha with the writer Tian Han. 1939 to Chongqing, where he taught in NAA and was associated with Zhou Enlai. 1945–49 taught in Calcutta University, India. After 1949 on staff of CAFA, where he lectured on Indian and Buddhist art. Director of CAFA library. Author of many books on Asian art. (*Photo on p. 25.*)

Chang Sha'na 常沙娜 (b. 1931, Hangzhou, Zhejiang province). Painter and design artist. Daughter of **Chang Shuhong**. 1944–48 with her father at Dunhuang. 1948–51 earned MFA at Museum of Fine Art, Boston. After returning to China, taught in Architecture Dept. of Qinghua University. 1982 moved to CAAC as vice-director, succeeding **Pang Xunqin** as director on his death in 1983.

Chang Shuhong 常書鴻 (1904–94, b. Hangzhou, Zhejiang province). Oil painter. From 1926 trained in Lyon and Paris. Successively won silver and gold medals in Paris Salon. 1936 returned to China as head of Western Art Dept., NAA Beijing. 1943–82 director of National Dunhuang Research Institute. 1957 and 1958 his copies of Dunhuang wall paintings were shown, to great acclaim, in New Delhi and Tokyo. 1966 Red Guards destroyed 33 years' work, including copies and sketches of murals, records, photographs, and documents. 1979 visited Japan. On retirement from his Dunhuang post, he became adviser to National Cultural Relics Bureau and director of Dunhuang Cultural Relics Institute. 1986 visited France; saw in Lyon the pictures he had painted there in 1934. (*Photo on p. 25.*)

Chang Yu 常玉 (Sanyu or San Yu, 1901–66, Nanchong, Sichuan province). Oil painter. Studied painting at home and briefly in Japan. 1921 went to Paris, where he worked chiefly in Académie de la Grande Chaumière. 1930s invented ping-tennis. 1936 went to Berlin Olympics to promote it. 1932 invited by his friend **Pang Xunqin** to join Storm Society as corresponding member. Had some success as artist in Europe in

1930s, but during and after World War II could find no buyers for his work. 1948, to promote ping-tennis, paid fruitless visit to New York, where he became friends with the photographer Robert Frank. Returned to France, became destitute, and is thought to have committed suicide in Paris. (*Photo on p. 25.*)

Chang Yung Ho. See **Zhang Yonghe**

Chao Chun-hsiang. See **Zhao Chunxiang**

Chao Ge 朝戈 (b. 1957, Hohhot, Inner Mongolia, of Mongolian nationality). Oil painter. 1982 graduated from Oil Painting Dept. of CAFA, where he became associate professor and deputy dean. Exhibitions include 1997 Venice Biennale and 1999 International Biennial Festival, Paris.

Chao Hai Tien. See **Zhao Haitian**

Chao Lam. See **Zou Lin**

Chao Mei 晁楣 (b. 1931, Heze, Shandong province). Print artist pioneer and most important of Heilongjiang printmakers. As a teenager served in PLA Culture Troupe. Later was art cadre in Harbin Military Engineering College. Has been director of Heilongjiang Provincial Arts Gallery and held other official positions. 1992 gallery in his name founded in Heze.

Chen Baiyi 陳白一 (original name Chen Tiao 陳調, b. 1926, Shaoyang, Hunan province). Painter. Educated in Hunan, where he taught for some years. After Liberation did serials and New Year pictures.

Chen Banding. See **Chen Nian**

Chen Baochen 陳寶琛 (*zi* Boqian 伯潛, *hao* Juyin 橘隱, 1848–1935, Minhou, Fujian province). Calligrapher and orthodox *guohua* painter and calligrapher. In 1880s commissioner for education in Jiangxi province. Later tutor to last emperor, Pu Yi. Established Fujian Normal School and Dongwen School.

Chen Baoyi 陳抱一 (1893–1945, b. Shanghai, native of Xinhui, Guangdong province). Oil painter. Prominent figure in Western art circles in Shanghai before WWII. 1905–10 in Europe with his parents. 1912 fellow student with **Liu Haisu** in **Zhou Xiang**'s scenery painting school. 1913 to Japan. Joined Kawabata Art Institute and then Hakubakai (White Horse Oil Painting Society). 1914–15 back in Shanghai, taught in Shanghai Meizhuan. 1916–21 studied in Japan again under Fujishima Takeji. 1921 returned to Shanghai, opened own art studio. Organizer of Dawn Art Association (Zhenguang

Meishuhui) with **Zhang Yuguang** and others. 1922 taught Western art in Shanghai Mei-zhuan and other schools. 1930–32 dean of Western Painting Dept. of Shanghai Fine Art School, destroyed by the Japanese in 1932. 1936 with **Hu Gentian** and **Guan Liang** organized Silent Art Association (Moshe). Stayed chiefly in Shanghai during WWII. 1943 painted portrait of **Li Shutong**, unfinished at time of his death.

Chen Bingtian 陳炳添 (Chan Ping Tim, b. 1937, Hong Kong). Sculptor and ceramicist. 1988–94 head of Art and Design Dept., Northcote College of Education, Hong Kong. Has exhibited his figures in motion in solo exhibitions since his retirement.

Chen Boxi 陳伯希 (b. 1922, Shandong province). Oil painter. 1936 joined Revolution. 1939 entered LXALA in Yan'an. 1942 joined Eighth Route Army. From 1949 worked for PLA in Lanzhou, Gansu province.

Chen Cheng-po. See **Chen Zhengbo**

Chen Chengqiu 陳成球 (Chen Shing Kau, b. 1952, Hong Kong). Painter. 1978, after studying under **Liu Guosung**, he completed diploma course, Extramural Studies Dept., Chinese University of Hong Kong. Specializes in landscape painting in Chinese ink.

Ch'en Ch'i-k'uan. See **Chen Qikuan**

Ch'en Chih-fu. See **Chen Zhifo**

Ch'en Ching-Jung. See **Chen Jingrong**

Ch'en Chong Swee. See **Chen Zhongrui**

Chen Danqing 陳丹青 (b. 1953, Shanghai, native of Guangdong province). Oil painter. Sent to rural Jiangxi at sixteen when his father was branded a Rightist; stayed in countryside till 1973. Spent three years decorating coffins. 1974 joined his artist wife, Huang Suning, in Tibet. 1978 admitted to CAFA. Early 1980s painted life of Tibet. 1982 went to US, studying at Art Students League. On his return became professor of fine art, Qinghua University. Younger member of the Contemporaries (Oil Painting Research Association).

Chen Dayu 陳大羽 (b. 1912, Chaoyang, Guangdong province). *Guohua* painter. Studied under **Qi Baishi**, later worked in Shanghai. 1949 became professor in Nanjing Academy. An admirer of Matisse and Cézanne, later an abstract expressionist, he inspired a generation of modern painters in Shanghai.

Chen Dehong 陳德弘 (b. 1936, Kunming, Yunnan province). Painter and sculptor. 1960 graduated in sculpture from CAFA. 1982 went to study in Paris, where he settled. Has exhibited widely in Europe and US.

Chen Dewang 陳德旺 (1910–84, b. Taipei). Oil painter. Studied under Ishikawa Kin' ichirō in Taipei. After further study in Japan returned to Taiwan, where he became active in the group Mouve.

Chen Dongting 陳洞庭 (1929–87, Guangdong province). *Guohua* painter. Specialized in figures and landscape. Member of the Guangzhou Painting Academy.

Chen Fangming 陳芳明 (b. 1964, Taiwan). Sculptor. Graduated from Arts and Crafts Dept., Fuxing Trade School, Taipei.

Chen Fushan 陳福善 (Luis Chan; 1905–95, Panama; native of Panyu, Guangdong province). Painter in a variety of media and styles. 1910 settled in Hong Kong. 1927 studied art by correspondence with Press Art School, London. 1953 formed Hong Kong Contemporary Artists Guild. Honorary adviser to, and deputy chairman of, Hong Kong Art Club, which he had joined in 1924. From 1961 honorary adviser to City Museum and Art Gallery. Work frequently exhibited in Hong Kong; major retrospectives in Hong Kong (1984 and 1985) and Singapore (1987). Early style was conventional, but after a period of uncertainty in the 1960s, when it was considered old-fashioned, he developed a new style under the stimulus of various trends in contemporary Western art. 1984 solo exhibition Luis Chan: Fifty Years of an Artistic Career, Hong Kong Museum of Art.

Chen Haiyan 陳海燕 (b. 1955, Fushan, Liaoning province). Wood engraver and etcher. 1984 graduated in printmaking from Zhejiang AFA, Hangzhou, after which she began her "dream works" inspired by Buddhism, Daoism, and Western thought. Settled in Australia.

Chen Haiying 陳海鷹 (Chan Hoi Ying, b. 1918, Hong Kong). Painter. 1952 founded Hong Kong AFAs. Retrospective exhibition in Taipei, 1993. Specializes in portraits.

Chen He 陳鶴 (1909–?, Putianxian, Fujian province). *Guohua* painter. 1935 graduated from Shanghai Meizhuan, where he studied under **Pan Tianshou.** 1938 visited Malaya; returned to teach in Fujian.

Chen Hengke 陳衡恪 (*zi* Shizeng 師曾, *hao* Huaitang 槐堂, Xiudaoren 朽道人, 1876– 1924, b. Xiushui, Jiangxi province). *Guohua* painter and critic. Studied in Tokyo Higher Normal College. Settled in Beijing; taught in Beijing Women's College

of Art and Higher Normal College. 1919 organized the Chinese Painting Research Society, which attracted many *guohua* painters. Patron of **Qi Baishi**, admired by **Wu Changshuo**. Close friend of Lu Xun. Wrote many books on painting. Advocate of the revitalization of *wenrenhua*. Translated into Chinese Omura Seigai's thesis on literati painting. Mentor of Beijing art circle in early years of the Republic, where he had a liberating influence on *guohua* painters.

Chen Heting 陳鶴亭 (b. 1924, Dongqingxian, Zhejiang province). Sculptor. Before 1949 she made figures for Buddhist temples. 1954 became teacher in Hangzhou Academy. 1973 visited Africa. Professor in ZAFA.

Ch'en Hsing-wan. See **Chen Xingwan**

Chen Huiqiao 陳慧 (Chen Hui-ch'iao; b. 1964, Tianshui, Taiwan). Painter and installation artist. Trained in Yu-te Fine Art High School and studied in Paris.

Chen Jialing 陳家泠 (b. 1937, Hangzhou). *Guohua* painter. Studied under **Pan Tianshou** and **Lu Yanshao** at ZAFA, graduated 1963. 1987 teaching painting in Art Dept. of Shanghai University. Taught **Qiu Deshu** and later joined Qiu's Cao Cao Society.

Chen Jianzhong 陳建中 (Chan Kin-chung, b. 1939, Guangzhou). Photorealist painter. 1962–69 studied in Guangdong Provincial Art Academy. 1962 moved to Hong Kong. 1969 settled in Paris.

Chen Jiarong 陳家榮 (b. 1940, Yunlin, Taiwan). Oil painter. Studied medicine in Taipei and US until 1973, when he became a professional painter.

Chen Jieren 陳界仁 (b. 1960, Taoyuan, Taiwan). Performance artist and creator of large computer-altered photographic images, including many figures. Works in Taipei.

Chen Jin 陳進 (Ch'en Chin, 1907–98, b. Xinzhu, Taiwan). Tempera and *guohua* painter chiefly in Japanese *nihonga* style. Studied painting first in Taipei and Kao-hsiung. 1925–45 studied and worked in Tokyo. 1927 her work shown in the first Taiwan Fine Arts Exhibition. 1945 returned to Taipei where, after long neglect, her Japanese style eventually became popular again. See Huang Kuang-nan 黃光南, *Chen Jin hua pu* 陳進畫譜 [The art of Chen Jin], (Taipei, 1996).

Chen Jinfang 陳錦芳 (b. 1936, Tainan, Taiwan). Oil painter and printmaker. Studied in Paris on French government scholarship. On returning to Taiwan became active in painting, writing, and organizing of cultural associations. Has held many exhibitions in US and Europe.

Chen Jinghui 陳敬輝 (b. 1931, Jiayi, Taiwan). Oil painter. Trained in NTNU, where he became a teacher.

Chen Jingrong 陳景容 (b. 1934, Nantou, Taiwan). Oil and watercolor painter and printmaker. Studied art in NTNU and in Tokyo. MA 1967, Graduate School of Mural Painting, Tokyo National University of Fine Art and Music. Later studied copperplate printing. 1967 returned to teaching career in Taiwan. From early 1980s traveled and painted in France and Italy.

Chen Junde 陳鈞德 (b. 1937, Zhenhai, Zhejiang province). Oil painter. 1961 graduated from Stagecraft Dept., Shanghai Drama College, where he became professor. President of Shanghai Oil Painting Society. 1997 visited and painted in Australia and Hong Kong.

Chen Junli 陳君立 (Eddy Chan Kwan Lap, b. China, 1947). Painter. BA in Fine Arts, Concordia University, Canada. Lived for some time in Montreal. Paints landscapes inspired by Canadian scenery.

Chen Juxian 陳菊仙 (b. 1937, Zhejiang province). Known primarily for *nianhua* (New Year paintings). She created many government propaganda posters during the 1960s.

Chen Kezhi 陳可之 (b. 1961, Sichuan province). Oil painter. 1982 graduated from Oil Painting Dept., Sichuan AFA, Chongqing.

Chen Laixing 陳來興 (b. 1949, Zhanghua, Taiwan). Painter. 1972 graduated from Taiwan Academy of Art. 1980s developed into an expressionist and satirical commentator on politics and society of Taiwan.

Chen Liying. See **Zhang Liying**

Chen Mingshan 陳明善 (b. 1933, Sichuan province). Oil and watercolor painter. 1948 moved to Taiwan. Lives and works in Taichung.

Chen Naiqiu 陳乃秋 (b. 1935). Painter, critic, essayist, and story writer. Studied art in Shanghai and in Nanjing Normal University.

Chen Nian 陳年 (*zi* Jingshan 靜山, *hao* Banding 半丁, 1876–1970, native of Shaoxing, Zhejiang province). *Guohua* painter and connoisseur, self-taught, influenced by Ren Bonian (1840–95), taught by **Wu Changshuo**. Taught in NAA Beijing; later deputy principal of NAA. Member of Beijing Academy of Painting. Noted especially for his flower paintings.

Chen Ning'er 陳寧爾 (b. 1942, Hangzhou). Realist oil painter. 1966 graduated from Oil Painting Dept. of ZAFA. 1987 moved to US. MFA 1989, Pratt Institute, New York.

Chen Peiqiu 陳佩秋 (1922–97, b. Nanyang, Henan province). Painter. Moved with her family to Yunnan while still a child. 1941 entered Southwest Union University, Kunming, to study engineering. 1944 graduated from National Academy, Chongqing, then studied *guohua* in ZAFA; graduated 1950. Later became interested in impressionism and postimpressionism. Specializes in landscapes, birds and flowers in decorative style. Exhibited in Shanghai Biennale 2000. Married to **Xie Zhiliu**. Council member of Xiling Seal-carving Society. See Zhu Kongfen 朱孔芬, ed., *Chen Peiqiu huaji* 陳佩秋畫集 [Collected paintings of Chen Peiqiu] (Shanghai, 2000).

Chen Ping 陳平 (b. 1960, Beijing). Painter. 1984 graduated from Chinese Painting Dept. of CAFA. 1997 became a professional artist in Beijing Chinese Painting Academy. Fantasy landscapes exhibited in Shanghai Biennale 2000.

Chen Qiang 陳強 (b. 1957, Shanghai, native of Liaoning province). Printmaker. 1985 graduated from CAFA; later became a teacher there. Noted for powerful prints and mezzotints of borderland subjects.

Chen Qikuan 陳其寬 (Ch'en Ch'i-k'uan, b. 1921, Beijing). Architect and painter. BS 1944 in architecture, National Central University, Chongqing. MA 1949 in architecture, University of Illinois. 1952–54 instructor at Massachusetts Institute of Technology. Moved to Taipei, where he collaborated with I. M. Pei on designs for Tunghai University. 1960 dean of Architecture Dept., Tunghai University; 1980 dean of Engineering Dept. Has exhibited widely in the US, Europe, and East Asia since 1954. Imaginative and meticulous painter of landscapes, townscapes, monkeys, and other subjects. See Ho Kung-shang 何恭上, ed., *Chen Chi Kwan Paintings, 1940–1980* (Taipei, 1981), and *Han mo* 翰墨, no. 20 (1991.9).

Chen Qiucao 陳秋草 (1906–88, b. Shanghai, native of Ningbo, Zhejiang province). *Guohua* painter. Studied in Shanghai Meizhuan. 1928 founding member and financial supporter of White Goose Painting Research Society with **Pan Sitong** and others. Designed covers for *Shanghai Manhua* (Shanghai sketch). Practiced and taught both *guohua* and Western-style painting. Among his students were **Jiang Feng** and Xiao Hong. After 1949 chiefly in Shanghai, where in 1955 he became director of the Shanghai Museum. Council member of CAA. Member of Shanghai Chinese Painting Academy. Painted chiefly birds and flowers, insects, figures.

Chen Ren 陳仁 (b. 1963, Fujian province). Painter. 1985 graduated from CAFA. Member of New Space Group. 1992 working in Fujian Art Gallery, Fuzhou.

Chen, Robert Cheng-hsiung. See Chen Zhengxiong

Chen Ruikang 陳瑞康 (b. 1935, Saigon, Vietnam, native of Guangdong province). *Guohua* painter. 1959 graduated from Fine Arts Dept. of NTNU. Taught for nine years in Taiwan and Malaysia before settling in 1972 in New York.

Chen Shaomei 陳少梅 (*zi* Yunzhang 雲彰, *hao* Shenghu 昇湖, 1909–54, b. Hengshan, Hunan province). *Guohua* painter, especially of flowers and human figures, in the tradition of Ma Yuan and Tang Yin. In his early years, pupil of **Jin Cheng** in Beijing. Member of Hu She Painting Society, established in 1926. Also studied briefly in Belgium. Active as professional artist, teacher, and painting restorer in Tianjin, where he remained during WWII. From 1947 divided his time between Tianjin and Beijing. After Liberation attempted to make his work more realistic. See Fan Zeng 范曾, ed., *Chen Shaomei* 陳少梅 (Beijing, 2001); *Han mo* 翰墨, nos. A17–20 (1996.1991–96).

Chen Shaoxiong 陳劭雄 (b. 1962, Shantou, Guangdong province). Installation artist. 1984 graduated from Print Dept., Guangzhou Academy, then taught at Guangdong Arts Normal School. Member of Southern Artists Salon, Big Tail Elephant Group. Exhibited at Inside Out: New Chinese Art (San Francisco and New York, 1998); Venice Biennale (2003).

Chen Shiming 陳世明 (b. 1948, Changhua, Taiwan). Modernist. 1970 graduated from Taiwan National Academy of Arts. 1976 graduated from Escuela Superior de Bellas Artes de San Fernando, Madrid. 1977 in US. 1981 started teaching at National Taiwan Academy of Arts; founding member of Taipei Art Club.

Chen Shing Kau. See Chen Chengqiu

Chen Shiwen 陳士文 (*zi* Qixian 器先, Tongyu 仝于, 1908–84, Zhejiang province). Oil painter. 1928, while studying at Hangzhou Academy, he was sent to France by the liberal educator Cai Yuanpei; studied in Lyon. 1937 returned to China, became professor in Shanghai Academy. During WWII with Southwest Union University in Kunming. From 1950 lived and worked in Hong Kong. 1970 began teaching in Art Dept. of New Asia College.

Chen Shizeng 陳師曾 (1876–1923). *Guohua* painter and writer. Lived in Shanghai. 1922 met the Japanese art historian Omura Seigai 大村西崖 (1868–1927) in Shanghai. Together they published an influential book on the revival of *guohua* painting. (*Photo on p. 25.*)

Ch'en Shun-chu. See Chen Shunzhu

Chen Shunzhu 陳順築 (Ch'en Shun-chu, b. 1963, P'eng-hu, Taiwan). Painter and installation artist. BA 1986, Chinese Culture University, Taipei. Works in Taipei.

Chen Shuren 陳樹人 (original surname Shao 韶, 1883–1948, b. Panyu, Guangzhou). *Guohua* painter. Studied under **Ju Lian** in Guangzhou and at Kyoto Municipal College of Art. 1905 joined patriotic Tongmenghui. 1917–22 Tongmenghui representative in Canada. 1913–16 in Japan, graduated with degree in literature from Rikkyō University, Tokyo. After 1922 held various posts in KMT government. One of the "Three Masters of the Lingnan School." Died in Guangzhou, where he had served as editor of *Guangdong Daily*. (*Photo on p. 25*.)

Chen Shuxia 陳淑霞 (b. 1963, Wenzhou, Zhejiang province). Painter. 1987 graduated from CAFA with degree in folk arts. Lecturer in Beijing Institute of Applied Arts. 1991 her still life *Pink Flowers* won silver award at First Annual Exhibition of Chinese Oil Painting, Hong Kong.

Chen Shuzhong 陳樹中 (b. 1960, Liaoning province). Oil painter. 1984 graduated from LXAFA in Shenyang. Specializes in scenes of north China rural life.

Chen, Su-hua Ling. See **Ling Shuhua**

Chen Sui Kang. See **Chen Ruikang**

Chen Tiegeng 陳鐵耕 (1908–70, native of Xingning, Guangdong province). Wood engraver. Important figure in Muling Woodcut Society and Eighteen Art Society in 1930s. During WWII went to northwest China. After 1949 with LXAFA in Shenyang and Guangzhou Academy.

Chen Tingshi 陳庭詩 (Ch'en Ting-shih; 1915–2002, b. Changle, Fujian province). Modern painter and graphic artist. Lost speech and hearing at age eight after falling from a tree; studied *guohua* at thirteen. Self-taught in oil painting. 1945/6 moved to Taiwan, worked nine years as political cadre in the army and as editor in a publishing company. 1956 founding member of the Fifth Moon Group. Settled in Taichung. Noted for abstract compositions printed from cut-out fiber board. 1981 won first prize in the First International Print Biennale in Seoul, South Korea.

Ch'en Ting-shih. See **Chen Tingshi**

Chen Wanshan 陳皖山 (b. 1962, Zhejiang province). Oil painter and sculptor. 1985 graduated in sculpture from ZAFA. Teaches in Beijing. January 1989 became first artist to hold solo show of nude paintings in China Art Gallery.

Ch'en Wen-hsi. See **Chen Wenxi**

Chen Wenji 陳文驥 (b. 1954, Shanghai). 1978 graduated from Graphic Arts Dept. of CAFA. 1985 taught in *Nianhua* and Serial Picture Dept. of CAFA. Later taught in Painting Dept., more recently in Mural Painting Dept. In 1990s developed as innovative printmaker and oil painter with subtle atmospheric technique.

Chen Wenxi 陳文希 (Ch'en Wen-hsi, 1906–91; b. Jieyangxian, Guangdong province). *Guohua* and *xihua* painter. Trained in Chinese and Western art in Xinhua AFA, Shanghai. 1949 settled in Singapore, where he was lecturer in painting in Nanyang AFA. In 1952 visited Bali on painting tour with **Zhong Sibin, Chen Zhongrui,** and **Liu Kang.**

Chen Xianhui 陳獻輝 (Paul Men; b. 1962, Taiwan). Sculptor. Studied in NTNU Art Dept. Works in Taipei.

Chen Xiaonan 陳曉南 (b. 1909, native of Lixian, Jiangsu province). Painter. Graduated from Wuxi Art Academy. Pupil of **Xu Beihong** in Nanjing. 1940 deputy researcher in China Arts Institute, Chongqing. 1947–48 in London on British Council scholarship. Later taught in Guangzhou Academy.

Chen Xiayu 陳夏雨 (b. 1917, Longjing, Taiwan). Sculptor. 1933–42 studied and worked in Tokyo. Retiring to Taiwan, he taught in Taizhong Teachers' College. 1947 withdrew from public life and lived in seclusion in Taizhong.

Chen Xingwan 陳幸婉 (Ch'en Hsing-wan, b. 1951, Taizhong, Taiwan). Ink painter. 1972 completed her studies at National Taiwan Academy of Arts. 1987 exhibited with New Aspects and Modern Chinese Art, National History Museum Taipei, and in Seoul. 1989 first prize for modern paintings of Li Shun-shan Foundation; solo exhibitions in East Asia, US, and Europe. Expressionist.

Chen Xinmao 陳心懋 (b. 1954, Shanghai). Painter. 1976–87 studied in Shanghai and Nanjing. 1980s member of Shanghai avant-garde movement.

Chen Yanning 陳衍寧 (b. 1945, Guangzhou). Realist oil painter specializing in portraits and figure subjects. 1965 graduated from Guangzhou Academy. 1985 visited Australia. 1986 visited Britain; emigrated to US. Thereafter professional painter in New York. 2000 commissioned to paint millennium portraits of Her Majesty the Queen, the Duke of Edinburgh, and Princess Anne.

Chen Yanqiao 陳烟橋 (1912–70, native of Dongguan, Guangdong province). Wood engraver. 1930 active in woodcut movement in Shanghai with **Ye Fu.** During WWII

taught in Chongqing Yu Cai Middle School for talented children. After 1949 worked for CAA. Died after persecution by Gang of Four.

Chen Yanyin 陳研音 (b. 1958, Shanghai). Sculptor and installation artist. BA 1980 in sculpture, ZAFA. MA 2000 in visual arts, Sydney College of Arts. 2000 she had installations in Shanghai Biennale. Lives and works in Sydney and Shanghai. 2001 appointed lecturer in design, NAA Shanghai. Subsequently worked at Shanghai Oil Painting and Sculpture Institute, becoming director in 1993.

Chen Yifei 陳逸飛 (1946–2005, b. Zhenhai, Zhejiang province). Oil painter. Studied in Shanghai College of Art. 1965 founding member of Shanghai Oil Painting and Sculpture Institute. His *Overturning the Dynasty of Chiang Kai-shek* (1977), painted in collaboration with **Wei Jingshan,** was one of the last major historical paintings before art became depoliticized. 1981 went to study in US, settling in New York, where he became highly successful as painter of portraits, landscapes, figure subjects, and nostalgic views of Suzhou. Later became entrepreneur, fashion designer, and film director in Shanghai.

Chen Yiming 陳逸鳴 (b. 1951, Shanghai). Oil painter. Younger brother of **Chen Yifei.** Trained in Shanghai Drama Academy and CAFA, where he became professor. 1981 moved to US.

Chen Yingde 陳英德 (b. 1940, Taiwan). Painter and art critic. Studied art history in NTNU. 1969 continued PhD study in Paris. Later became professional artist and settled in Paris.

Chen Yiqing 陳逸青 (b. 1963, Yunnan province, of Bai nationality). Oil painter. 1986 graduated from CAFA, became a professional artist. 1987 won silver medal in Seventh National Art Exhibition for his painting *Out of Qinghai.*

Chen Yuandu 陳緣督 (1903–67, b. Meixian, Guangdong province). *Guohua* painter. Worked in Beijing. After 1949 taught in CAAC.

Chen Yuping 陳玉平 (b. 1947). Printmaker. Beidahuang (Northern Wilderness) school. 1980s and '90s active in north China.

Chen Yuqiang 陳聿強 (b. 1938, Ningbo, Zheijang Province). Printmaker. 1960 graduated from CAFA. 1980s and '90s active in Hangzhou.

Chen Yuqiang 陳育強 (Chan Yuk Keung; b. 1959, Hong Kong). Mixed-media artist. 1983 graduated from Fine Arts Dept. of Chinese University of Hong Kong. MFA in

painting, Cranbrook Academy of Art, Michigan. Since 1989 teaching in Fine Arts Dept., Chinese University of Hong Kong. Adviser to Hong Kong Museum of Art and Hong Kong Heritage Museum. 2000 finalist for sculpture competition, Hong Kong Central Library.

Chen Yushan 陳語山 (1904–87, native of Xinhui, Guangdong province). *Guohua* painter, calligrapher, and seal carver. Studied Western painting in Guangzhou Municipal College of Fine Art. 1950 settled in Hong Kong.

Chen Yusheng 陳餘生 (Gaylord Chan, b. 1925, Hong Kong native of Putian, Fujian province). Electronics engineer and abstract painter. 1970 graduated from Extramural Studies Dept. of Hong Kong University. 1974 co-founder and first chairman of Visual Arts Society, formed chiefly from fellow graduates of Extramural Studies. 1992 named Artist of the Year by Hong Kong Artists' Guild.

Chen Zhen 陳箴 (1955–2000, b. Shanghai). Artist and installation artist. Studied in Shanghai School of Applied Arts and Institute of Drama. 1985 member of New Tide (Xinchao) movement of modern artists. 1986 enrolled in Ecole Nationale Supérieure des Beaux Arts, Paris. From 1989 participated in many exhibitions in France and around the world, including 1996 Shanghai Biennale. 2000 his installations, including *Fifty Strokes to Each* (1999), were shown in Serpentine Gallery, London, shortly after his death in Paris.

Chen Zhengbo 陳澄波 (Chen Cheng-po, 1895–1947, b. Jiayi, Taiwan). Oil painter. First studied painting under Ishikawa Kin'ichirō. 1917 went to Japan. 1927 graduated from Tokyo AFA. 1929–33 taught in Xinhua AFA, Shanghai. Founding member with **Ni Yide** and **Pang Xunqin** of Storm Society. 1933 returned to Taipei. 1934 cofounder of Taiyang Art Society. Died during February 28, 1947, uprising in Taiwan.

Chen Zhenghong 陳政宏 (b. 1942, Jiayi, Taiwan). Oil painter. Studied in Taipei under **Liao Jichun** and others. 1982 first solo exhibition. Has won many awards.

Chen Zhengxiong 陳正雄 (Robert Cheng-hsiung Chen, b. 1935, Taipei). Oil painter. Educated in Taipei and at University of Maryland (1963). 1981–84 President of Taipei Art Club. Working as professional artist in Taipei.

Chen Zhifo 陳之佛 (Ch'en Chih-fu, *hao* Xueweng 雪翁, 1896–1962, b. Ciqixian, Zhejiang province). Graphic designer and *guohua* painter. 1918 went to study in Crafts and Pictorial Design Dept., Tokyo College of Art. 1923 returned to Shanghai, where he taught in various art colleges and universities, including NCU Nanjing. Principal of Shanghai College of Art. Member of Chinese and Arts committees of UNESCO.

After 1949 director of CAA, held teaching appointments in Nanjing. Although he showed early interest in Western (including modern) art, he is chiefly noted for his birds and flowers influenced by Japanese art and *gongbi* painting. (*Photo on p. 26.*)

Chen Zhonggang 陳仲綱 Wood engraver. Active in 1930s, Guangzhou.

Chen Zhongrui 陳宗瑞 (Ch'en Chong Swee, 1910–85, b. Guangdong province). *Guohua* painter. Trained in Shanghai Academy. From 1931 lived and worked in Singapore, where, in his landscape paintings of Malaysian scenes, he experimented in mixing *guohua* with Western techniques. 1952 visited Bali on a painting tour with **Zhong Sibin, Liu Kang,** and **Chen Wenxi**.

Chen Zhongshu 陳中樞 (Chan Chung Shu, b. 1952, Hong Kong). Painter. 1971 graduated from Hong Kong AFA; 1974 from First Institute of Art and Design. Taught at both institutions. 1995 emigrated to Canada, where he works as professional artist. Has held seven solo exhibitions in Asian countries, France, Canada, and US.

Chen Zifen 陳子奮 (1897–1976, native of Changle, Fujian province). *Guohua* painter. Worked chiefly in Fuzhou. Noted for his paintings of flowers in *baimiao* technique.

Chen Zizhuang 陳子莊 (*hao* Shihu 石壺, Nanyuan 南原, Xialibaren 下里八人, etc., 1913–76, b. Yongchuan, Sichuan province). *Guohua* painter. Began in *gongbi* style. In his early sixties, under the influence of **Huang Binhong** and **Qi Baishi**, changed to *xieyi* style. Teacher in Chengdu Normal University. During Cultural Revolution, Jiang Qing's friend **Zhu Peijun** prevented him from taking part in artistic functions and reduced him to utter poverty. See *also* **Li Huasheng**.

Chendana, Georgette. See **Zhang Liying**

Cheng Conglin 程叢林 (b. 1954, Wanxian, Sichuan province). Oil painter. 1977 entered Sichuan AFA, Chongqing. After graduation in 1982 taught there, then for two years at CAFA. 1986 went to France, then settled in Germany. His best-known work, *Snow on X month X Day 1968*, depicts fighting between rival Red Guard groups in Sichuan. Continued to paint pictures of Tibetan life long after he left China. Guest professor, Sichuan University, Chongqing.

Cheng Ji 程及 (b. 1912, Wuxing, Zhejiang province). Watercolor painter. 1934, after working in north China and Shanghai, joined White Goose Painting Research Society. 1945 one of his paintings exhibited in US. 1947 settled in New York, where he had a long and successful career. After 1972 paid several return visits to China.

Cheng Kar-chun. See Zheng Jiazhen

Cheng Ming. See Zheng Ming

Cheng Shan-hsi. See Zheng Shanxi

Cheng Shifa 程十髮 (b. 1921, Songjiangxian, Jiangsu province, native of Shanghai). *Guohua* painter, illustrator, and calligrapher. 1938 entered *Guohua* Dept. of Shanghai College of Art. Taught there until 1942, when he held solo exhibition in Shanghai. After 1989 on staff of People's Art Publishing House; produced many picture stories, new year pictures, and book illustrations. 1956 became professional painter, Shanghai Academy of Painting and Sculpture. 1959 won second prize at Leipzig International Exhibition of Book Illustration. Director of Shanghai Chinese Painting Academy. Member of CAA, vice-president of Xiling Seal-carving Association. Lives in Shanghai. See *Han mo* 翰墨, no. 48 (1994.1).

Cheng Tsai-tung. See Zheng Zaidong

Cheng Wei-kwok. See Zheng Weiguo

Cheng Ya'nan 程亞男. Sculptor. She was active in 1980s and '90s.

Cheng Yueh-po. See Zheng Yuebo

Cheng Zhang 程璋 (1869–1938, *zi* Dezhang 德璋, *hao* Yaosheng 瑤笙 native of Xin'an, Anhui province). *Guohua* painter. Moved first to Taixing, Jiangsu, and later to Shanghai, where he studied painting with Yang Runzhi. Held successive teaching posts at Qinghua University, in Suzhou, and in Shanghai.

Cheong Soo Pieng. See Zhong Sibin

Cheung Han Hung. See Zhang Hanhong

Cheung Kam Long. See Zhang Jinlong

Cheung, Lucia. See Zhang Yayan

Cheung Shiu-shek. See Zhang Shaoshi

Cheung Yee. See Zhang Yi

Chhuah Thean Teng. See Cai Tianding

Chian, Chia Yu. See Xie Yuqian

Chiang Erhshih. See Jiang Eshi

Chiang Ming Shyan. See Jiang Mingxian

Chin Ch'in-po. See Jin Qinbo

Chin Tung-fang, Jane. See Jin Dongfang

Chiu Tenghiok. See Zhou Jianxu

Ch'iu Ya-ts'ai. See Qiu Yacai

Cho, Y. J. See Zhuo Yourui

Choi Chor-foo. See Cai Chufu

Choi Yau-chi. See Cai Renzi

Chou, Irene. See Zhou Luyun

Chou Kung-lei. See Zhou Gongli

Chou Su-ch'in. See Zhou Xiqin

Chow, C. T. See Zhou Zhentai

Chow, Johnson. See Zhou Shixin

Chow, Josephine Suk-fan. See Zhou Shufen

Chow Sai-chung. See Zhou Shicong

Chow Su-sing. See Zhou Xixin

Chu Chiahua. See Zhu Jiahua

Chu Ge. See Yuan Dexing

Chu Hing-wah. See Zhu Xinghua

Chu Hon-sun. See Zhu Hanxin

clockwise from top left
Cai Xiaoli.
Chang Renxia.
Chang Shuhong. Photo by Michael Sullivan, 1984.
Chang Yu with Robert Frank. New York, 1949.
Chen Shizeng.
Chen Shuren.

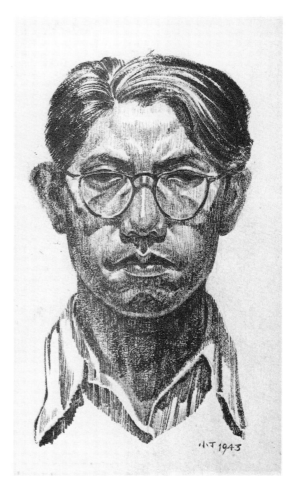

clockwise from top left
Chen Zhifo.
Ding Cong. Self-portrait, 1943.
Dai Shihe, 2004.

Ch'u Ko. See Yuan Dexing

Chu Tat Shing. See Zhu Dacheng

Chu Teh-chun. See Zhu Dequn

Chuah Thean Teng. See Cai Tianding

Chui Tze-hung. See Xu Zixiong

Chung Chen-sun. See Zhong Zhengshan

Chung, Kang L. See Zhong Genglüe

Chung Tai Fu. See Zhong Dafu

Chung, Wilson. See Zhong Zhiren

Cui Zifan 崔子范 (b. 1915, Laiyang, Shandong province). *Guohua* painter. Studied in Beijing with **Wu Changshuo** and **Qi Baishi.** 1940 went to Yan'an, where he graduated from Yan'an Military and Political College and Senior Party School. Also worked as urban administrator. 1956 teacher and vice-president in CAFA. Secretary-general and vice-president of Beijing Academy of Painting. 1980 visited US, Japan, and other countries. 1991 funds raised to establish Cui Zifan Museum in Qingdao.

Dai Dunbang 戴敦邦 (b. 1938, Shanghai). Book illustrator and *guohua* painter. Active in Shanghai. 1980 participated in Grasses (*Caocao*) exhibition. 1980s taught at Jiaotong University Institute of Technology. Noted for his illustrations to *The Dream of Red Mansions* and *Outlaws of the Marsh.* Vice-chairman of Shanghai Daoist Association.

Dai Shihe 戴士和 (b. 1948, Beijing, native of Liaoning province, of Manchu descent). Oil painter. 1976 graduated from Fine Art Dept. of Capital Normal University. 1981 completed postgraduate class in oil painting at CAFA, where he became president of the School of Fine Art and director of the Dept. of Oil Painting. 1988 studied in Repin AFA, Moscow. Has traveled widely in Russia and abroad, including teaching and painting in Glasgow and Sydney. Married to the art historian Chen Weihe. Noted for his portraits of famous artists and for his landscapes and interiors. (*Photo on p. 26.*)

Dai Zhengsheng 戴政生 (b. 1954, Juxian, Sichuan province). Print artist. 1987 graduated from Southwest Normal University. 1990 studied in Sichuan AFA. 1995 studied in CAFA. Returned to Southwest Normal University as associate professor and deputy director.

Dawn, Chen-ping. See Dong Zhenping

De Qin 德欽 (b. 1955, Inner Mongolia). Oil painter. 1979 graduated from LXAFA in Shenyang. Specializes in borderland rural scenes.

Deng Bai 鄧白 (b. 1906, native of Dongguan, Guangdong province). Artist and porcelain specialist. 1929–33 studied in Art Dept. of NCU Nanjing. In West China during WWII. 1950 joined land reform movement. 1954 visited USSR and Poland. 1958 director of Crafts Dept., ZAFA. Active in research in history of Chinese porcelain.

Deng Fen 鄧芬 (*zi* Songxian 誦先, *hao* Tanshu 曇殊, Congxin 從心, 1894–1963, native of Songxian, Guangdong province). Professional *guohua* painter, chiefly of figures. Worked with An Zhichong in organizing Guihai Painting Cooperative. Became art teacher. During and after WWII spent time between Hong Kong and Macao. Noted for combining figures with landscapes, often with symbolic overtones.

Deng Jianjin 鄧箭今 (b. 1961, native of Guangdong province). Oil painter. 1986 graduated from Fine Art Dept. of Jingdezhen Porcelain Academy. Became associate professor in Guangzhou Academy.

Deng Ke 鄧柯 (b. 1936, Shanghai, native of Suzhou). Self-taught painter. From 1955 worked in Tianjin People's Art Publishing House. 1960 joined Tianjin Painting Academy.

Deng Lin 鄧林 (b. 1941, Shexian, Hebei province). Painter. Daughter of Deng Xiaoping. 1962–67 studied in Chinese Painting Dept. of CAFA. 1977 became professional painter. 1979 deputy director of bird and flower studio in Beijing Academy of Painting. After 1986 became abstract expressionist painter, some of whose compositions, inspired by decoration of Neolithic pottery, were translated, most unsuitably, into silk tapestry.

Deng Ningzi 鄧凝姿 (Stella Tang Ying Chi, b. 1956, Hong Kong). First trained as teacher, then received BA in fine art from Goldsmith's College, University of London. Exhibitions coordinator for Hong Kong Arts Centre Exhibitions Dept. Since 1999 full-time lecturer, Art School of Hong Kong Arts Centre. 1996 received Visual Art Award in Hong Kong Art Biennial.

Deng Rongzhi 鄧榮之 (Tang Wing Chi, b. 1946, Hong Kong). Printmaker. 1965 started to paint. For seven years chairman of Hong Kong Print Artists' Association. 1998 held his first solo exhibition, The Charms of Hong Kong.

Deng Xuefeng 登雪峰 (b. 1929, Nanye, Sichuan province). *Guohua* painter and Western-style watercolor painter. After studying art in Taiwan and participating in solo and group exhibitions in Taiwan, Korea, Singapore, and the UK, became vice–secretary general of Chinese Fine Arts Association, Taipei.

Di Baoxian 狄葆賢 (*zi* Chuqing 楚青, *hao* Pingzi 平子, 1872–1949, native of Liyang, Jiangsu province). *Guohua* painter and collector. Pupil of **Wu Changshuo.** Studied in Japan. On return worked in Youzheng Book Co. Active in Shanghai *guohua* circles. Known for his landscapes in both academic and literati styles.

Ding Cong 丁聰 (Xiao Ding 小丁, b. 1916, Shanghai). Cartoonist and illustrator. Son of cartoonist **Ding Song.** Studied part-time in Shanghai Meizhuan. Before WWII edited pictorial magazines in Shanghai. Active in Hong Kong and later in west China and border area during WWII. 1946 back to Shanghai. 1947–48 in Hong Kong, worked for several periodicals, active member of Renjian Huahui with Mao Dun and other Democratic League refugees from the KMT. 1948 visited Hong Kong. After 1949 on staff of *China Pictorial*, Beijing. 1957 branded a Rightist; not cleared until 1979. Noted for social satire and illustrations to works of Lu Xun and other modern Chinese writers. His most famous works are two satirical scrolls, *Xianxiangtu* 現象圖 [Images of today] (Chengdu, 1944) and *Xianshitu* 現實圖 [The reality of today] (Hong Kong, 1947). See *Ding Cong* 丁聰 (Beijing, 1993). (*Self-portrait on p. 26.*)

Ding Fang 丁方 (b. 1956, Shanxi province). Oil painter. MA 1986 in oil painting, Nanjing Academy. Professional artist and member of avant-garde movement. 1984 journeyed to Tibet. Since 1990s painting heavy landscapes in oils suggestive of Tibet and dark cities.

Ding Fuzhi 丁輔之 (1879–1949, native of Hangzhou). *Guohua* painter, bibliophile, and seal carver. Noted for paintings of plum blossoms and fruits in which he employed a pointillist technique. 1904 founding member of Xiling Seal-carving Association.

Ding Lisong 丁立松 (b. 1938, native of Tongzhou, Jiangsu province). Graphic artist. Active 1980s and '90s.

Ding Shaoguang 丁紹光 (Ting Shao Kuang, b. 1939, Shanxi province). Decorative artist. Studied decorative art under **Pang Xunqin.** 1962 taught in art school in Kunming. 1979–80 completed huge decorative wall panel for Great Hall of the People. Also helped **Yuan Yunsheng** with drawings of Dai people of Xishuangbanna, which Yuan used in his wall paintings for the restaurant in Beijing Airport (1980). 1980 went to US; works in Los Angeles. See Ron Segal, ed., *The Art of Ting Shao Kuang* (Tokyo, 1989).

Ding Song 丁悚 (1891–1972). Cartoonist. Father of **Ding Cong.** 1912 studied under **Zhou Xiang** in Shanghai. Later taught, edited journals, and drew cartoons in Shanghai. 1937 went to Hong Kong, where he was active in Renjian Huahui.

Ding Xiongquan 丁雄泉 (Walasse Ting; b. 1929, Shanghai). Self-taught painter and poet. 1949 left China. 1953 went to Paris, where he joined avant-garde COBRA group. 1963 settled in US. 1960s abstract painter; later developed expressionist figurative style. Lives in Amsterdam.

Ding Yanyong 丁衍庸 (Ting Yen-yung, *zi* Shudan 叔旦, 1902–78, b. Mouming, Guangdong province). *Guohua* and oil painter. 1920 studied in Tokyo AFA. 1925 returned to Shanghai, taught Western painting at Shanghai College of Art, Xinhua AFA, and Guangdong Provincial Art Academy in Guangzhou. During WWII in west China. 1949 settled in Hong Kong. After 1957 teacher and chairman of Fine Art Dept., New Asia College. 1973 held exhibition of his work in Paris. Long a prominent figure on the Hong Kong art scene, he was chiefly known for his eccentric figure paintings. (*Self-portrait on p. 37.*)

Ding Yi 丁乙 (original name Ding Rong 榮, b. 1962, Shanghai). 1983 graduated from Shanghai Arts and Crafts Institute. Member of post-1989 avant-garde movement. 1990 graduated from *Guohua* Dept., College of Fine Arts, Shanghai University. Around 1988 started to paint "cross series"—all-over pattern of tiny crosses in various colors, with texture of textiles. 1990s taught in CAAC. Later returned to Shanghai, where he set up an independent studio.

Ding Zhengxian 丁正獻 (b. 1914, Shengxian, Zhejiang province). Wood engraver and pastel artist. 1934–37 at Shanghai Meizhuan. 1940–45 with Guo Moruo in West China United Front art movement. 1982 professor in Print Dept. of ZAFA.

Ding Zhiren 丁志仁 (Ting Chih Jen, b. 1915, Shanghai). Painter. During WWII traveled extensively in west China. 1949 moved to Hong Kong. 1984 chairman of Hong Kong Chung Kok Chinese Art Club. Practiced both Chinese and Western painting.

Dong Jiansheng 董健生 (b. 1936, Tangshan, Hebei province). Oil painter and wood engraver. 1953 entered teachers' training college in Hebei. 1957 labeled Rightist and sent to countryside for 22 years. 1979 cleared. 1980 deputy director of Hebei Woodblock Print Research Society. 1981 admitted to Woodcut Print Dept. of CAFA, studied with **Li Hua.** 1999 appointed director of Art Creation Committee, Hebei Artist's Association. Member of Hebei Provincial Art Academy.

Dong Kejun 董克俊 (b. 1939, Chongqing). Self-taught wood engraver from worker background. Settled in Guiyang. Chairman of Guizhou branch of CAA. Noted for his animals and minority figures.

Dong Kingman. See **Zeng Jingwen**

Dong Qingyi 董慶義 (Tung Hing Yee, b. 1946, Shanghai). Painter and calligrapher. Eclectic style using various techniques. 1996 published his album, *The Art of Tung Hing Yee*.

Dong Qizhong 董其中 (b. 1935, native of Jiangxi province). Wood engraver. 1958 graduated from Beijing Art Normal School. Member of Shanxi Art Academy.

Dong Shouping 董壽平 (1905–97, Hongdong, Shanxi province). *Guohua* painter. 1926 graduated from art college in Beijing. 1930 set up as professional bird and flower painter and connoisseur, later developed as landscapist. During WWII in Chengdu, traveled, made his living as landscape painter. 1953 joined staff of Rongbaozhai art publishing house, Beijing. After Liberation, radicals called him a member of the "Guesthouse School of Painting." Honorary member, Beijing Chinese Painting Research Society.

Dong Xiwen 董希文 (1914–73, native of Shaoxing, Zhejiang province). Oil painter. 1933 studied in Suzhou Academy. 1934–37 studied in Hangzhou Academy. 1943–46 assisted **Chang Shuhong** at Dunhuang. 1946 taught under **Xu Beihong** in NAA Beijing. 1949 professor at CAFA. 1953 painted huge canvas of declaration of the founding of the PRC at Tiananmen. 1954/5 figure of Gao Gang painted out. 1972 figure of Liu Shaoqi painted out. 1976 both painted in again after fall of Gang of Four. Suffered severely in Cultural Revolution. Died of cancer. Friend of **Wu Guanzhong** and teacher of, among others, **Pang Tao**, who greatly admired him.

Dong Yangzi 董陽孜 (Grace Yang Tse Tong, b. 1942, Zhejiang province). Calligrapher. BA from NTNU. MFA, University of Massachusetts, Amherst. Many exhibitions of her work have been held worldwide. 1998 subject of documentary film made in San Francisco by Dr. Shirley Sun.

Dong Zhengyi 董正誼 (b. Huxian, Shaanxi province). Peasant painter. Active in 1960s.

Dong Zhenping 董振平 (Dawn Chen-ping, b. 1948, Jiangsu province). Sculptor. Graduated from NTNU. MFA from Utah State University. Works chiefly in steel and stone. Winner of many awards. 2003 living in Taipei.

Du Dakai 杜大愷 (b. 1943, Henan province). Painter in various media. 1980 graduated from Postgraduate Dept. of CAAC, became professor in Fine Arts College of Qinghua University and dean of Painting Faculty. Noted for his semiabstract paintings of nature, flowers, and landscapes.

Duan Haikang 段海康 (n.d.). Sculptor. 1988 graduated from CAFA.

Ecke, Betty. See **Zeng Youhe**

Fan Bo 范勃 (b. 1966, Tianjin). Oil painter. Studied art in Tianjin. 1995 graduated in oil painting from Guangzhou Academy, where he become a teacher of oil painting.

Fan Changqian 范昌乾 (1908–87, native of Jieyang, Guangdong province). *Guohua* painter. Graduated from Xinhua AFA and Changming College of Fine Art. Influenced by **Wang Zhen** and **Wang Xian**. Settled in Hong Kong.

Fan Zeng 范曾 (b. 1938, Nantong, Jiangsu province). *Guohua* painter. Studied in Nankai University and CAFA under **Wu Zuoren, Li Keran,** and others. Active in Beijing, where he taught in the Academy of Decorative Arts. 1986 dean of Oriental Art Dept., Nankai University, Tianjin. Well-connected in official circles, admired in Japan. Noted for his paintings of historical figures and portraits. 1991 left for Europe; later returned to China.

Fang Chao-ling. See **Fang Zhaolin**

Fang Chun-pi. See **Fang Junbi**

Fang Ganmin 方干民 (1906–84; Wenlinxian, Zhejiang province). Oil painter. Studied in Shanghai Meizhuan and (1926–29) under Laurens at the Ecole Nationale Supérieure des Beaux Arts, Paris. Taught in Xinhua AFA, Shanghai, and Hangzhou Academy. During WWII worked on propaganda paintings for KMT government. 1948 had studio in Shanghai. 1959 returned to teach at ZAFA.

Fang Jizhong 方濟眾 (1923–87; b. Shaanxi province). *Guohua* painter, well known for his goats. 1946–47 studied under **Zhao Wangyun**. After 1949 member of Friendship Association, Xi'an, Shaanxi province.

Fang Jun 方駿 (b. 1943, Guanyunxian, Jiangsu province, native of Hexian, Anhui province). *Guohua* painter. 1965 graduated from Nanjing Normal University; MA from Nanjing Academy, where he is now (2004). Professor of Chinese Painting and director of Art Dept. See *Compendium of Chinese Painters of the Second Half of the*

Twentieth Century: New Literati Painting, Fang Jun (Shijiazhuang, 1997); *Master-pieces of Landscape Painting by the Contemporary Master Fang Jun* (Beijing, 2000); and *A Selection of Fine Works by Contemporary Painters from Jiangsu: Fang Jun* (Nanjing, 2002).

Fang Junbi 方君璧 (Fang Chun-pi, 1898–1986; native of Fuzhou). Oil and *guohua* painter. 1912 went to Paris, worked at Académie Julian. 1919 admitted to Ecole des Beaux Arts first in Bordeaux, then from 1920 in Paris. 1922 married the poet Tsen Tsou-ming (Zeng Zhongming 曾仲鳴), secretary of the Sino-French College in Lyon. 1924 exhibited for first time in the Paris Salon. 1925 returned to China, taught in Guangdong University, Guangzhou. 1926–30 stayed in Paris, then back to China again. In 1943 met **Qi Baishi** in Beijing. 1949–56 lived in Paris. 1957–66 in US, with frequent visits to the East Asia. Visited Beijing in 1972 and again in 1978, when she held a solo exhibition. 1979 settled in Taipei.

Fang Lijun 方力鈞 (b. 1963, Handan, Hebei province). Professional painter, member of avant-garde movement. 1983 graduated from Mural Painting Dept. of CAFA. 1989 graduated from Printmaking Dept. of CAFA. 1989 participated in China/Avant-Garde exhibition, showing his satirical paintings of laughing skinheads (later described as "Political Pop"). From later 1990s, developed huge-scale satirical woodcuts of the same subject. Subsequent international exhibitions include Shanghai Biennale 2000. 2004 living in Beijing as a professional artist. (*Photo on p. 37.*)

Fang Limin 方利民 (b. 1964, Quzhou, Zheijiang province). Print artist. Graduated from NAA Hangzhou. 1994 awarded Tomihari Prize in Japan for his print *Expressions of Western Zhejiang*. His prints of lotus plants show influence of ink painting.

Fang Rending 方人定 (1901–75, native of Zhongshan, Guangdong province). *Guohua* painter, member of Lingnan school. 1923 studied in Chunshui Academy under **Gao Lun**. 1929 studied at Kawabata Art Academy, Tokyo. 1935, after joining China Independent Art Society (Zhongguo Duli Meishu Xiehui) in Tokyo, he returned to China, worked in Guangzhou and Hong Kong. Became vice-director of Guangzhou Painting Academy. Noted for his figure painting, which showed strong Japanese influence.

Fang Shaohua 方少華 (b. 1962, Shashi, Hubei province). Painter. 1979–83 studied oil painting in Art Academy of Hubei province. 1988 MA. 1988 lecturer in Hubei Art Academy. 2000 exhibited paintings expressive of the confusion and conflict of modern urban life in Shanghai Biennale.

Fang Xiang 方向 (b. 1967, Shantou, Guangdong province). Painter. 1988 graduated from Traditional Painting Dept. of Guangzhou Academy. Became professional artist

attached to Guangdong AFA. 1998 large decorative garden scenes and interiors, with flowers, exhibited in Shanghai Biennale.

Fang Yong 方鏞 (1900–?, Chengdu, Sichuan province). Oil painter. Began as *guohua* artist. 1919 went to Paris where he developed as an oil painter in the impressionist style, in the school of Pissarro. Also made decorations in lacquer. 1948 returned to China, where he died in obscurity.

Fang Yun 方匀 (n.d.). Known as textile pattern designer. Late 1920s taught at Hangzhou Academy. Only woman designer to have work selected for the cover of the innovative magazine *Contribution* (March 1928).

Fang Zengxian 方增先 (b. 1931, Lanxixian, Zhejiang province). *Guohua* painter, especially of north China rural life. Also painted serial pictures. Graduated from, and later associate professor and chairman of, *Guohua* Dept. of ZAFA. Professor and head of Shanghai Academy.

Fang Zhaolin 方召麟 (Fang Chao-ling, b. 1914, Wuxi, Jiangsu province). Painter and calligrapher. 1930 studied under Tao Peifong. 1937 studied modern European history at Manchester University, England. During WWII traveled widely. 1949 settled in Hong Kong. Her husband's death in 1950 left her a widow with eight young children. 1953 studied under **Zhang Daqian, Qian Songyan,** and **Zhao Shao'ang.** 1994 held retrospective exhibition in Hong Kong Museum of Art, which published the catalogue *The Passionate Realm.* See also *Portfolio Fang Zhaoling* [sic] (Hong Kong, 1984). Prominent figure on Hong Kong art scene for many years.

Fay, Ming. See **Fei Mingjie**

Fei Chengwu 費成武 (1914–2001, b. Suzhou). Painter. Pupil of **Xu Beihong.** 1947 sent to Britain on British Council scholarship. There he gave up *xihua* for *guohua*, married the painter **Zhang Jingying**, and settled in London.

Fei Mingjie 費明杰 (Ming Fay; b. 1943, Shanghai). Painter and sculptor. 1952 moved with his family to Hong Kong. 1961–65 studied design at Columbus College of Art and Design, Ohio. 1966–67 studied sculpture in Kansas City Art Institute. 1967–70 studied sculpture at University of California, Santa Barbara, MFA. From 1990s living in New York, where he teaches at William Paterson College.

Fei Xinwo 費新我 (1903–92, native of Wuxing, Zhejiang province). Calligrapher, oil and *guohua* painter. 1934 entered White Goose Preparatory Painting School in

Shanghai to study Western painting. 1958 exhibited in Moscow and, as a result of illness, started to practice calligraphy with left hand. Wrote inscribed boards for many beauty spots and memorial halls.

Fei Yifu 費以復 (1913–82, b. Jiangsu province). Oil painter. Graduated from Suzhou Academy under **Yan Wenliang**. Worked in Shanghai Health Dept. until 1948. After Liberation taught in ZAFA, Hangzhou. 1982 trip to Xinjiang. Died of illness on way home to Hangzhou.

Feng Bin 馮斌 (b. 1952, Chengdu, Sichuan province). *Guohua* painter. 1981 graduated from Chinese Painting Dept., Sichuan AFA. Until recently, director of Sichuan Fine Art Institute Art Museum. Professor of traditional painting, Dept. of Sichuan Fine Art Institute. Responsible for developing new approach to traditional painting. Specializes in painting monks and architecture of Tibetan Sichuan. See Chengdu Museum of Contemporary Art, *Eternal Present: Feng Bin, 1997–2000* (Chengdu, 2001).

Feng Chaoran. See **Feng Jiong**

Feng Fasi 馮法禩 (b. 1914, Anhui province). Oil painter. 1933 studied under **Xu Beihong, Yan Wenliang,** and **Pan Yuliang** in NCU Nanjing. 1938 studied in LXALA in Yan'an. 1939 taught in Sichuan. 1946–49 worked in Chongqing, Beijing, and Tianjin. 1950 head of Painting Dept. of CAFA and director of oil painting section. Strongly influenced by Soviet realism. 1957 painted his best-known work, *The Heroic Death of Liu Hulan.* 1958 one of the designers of Martyrs' Memorial, Beijing.

Feng Gangbai 馮鋼百 (1883–1984, b. Xinhui, Guangdong province). Oil painter. From labourers' family. 1904 went to find work in Mexico, then to San Francisco to study painting. Circa 1921 met **Li Tiefu**, who made a good portrait of him in 1934. 1921 returned to China, taught in Guangzhou College of Fine Arts. With **Hu Gentian** and other students of Western art, he founded the Chishe 赤社 (Purple, or Red, Society), which survived till 1931. 1945 went to Hong Kong. After 1948 returned to China, lived in Guangzhou.

Feng Guodong 馮國東 (b. 1948, Panyuxian, Guangdong province). Oil painter.

Feng Jiong 馮迵 (*zi* Chaoran 超然, *hao* Dige 滌舸, Songshan jushi 嵩山居士, 1882–1954, native of Changzhou, Jiangsu province). *Guohua* painter and calligrapher. Active in Suzhou and Shanghai, where he was associated with **Wu Changshuo, Wu Hufan,** and other *guohua* artists; made his living by selling paintings and teaching. Among his many pupils was **Lu Yanshao.** Later moved to Taiwan.

Feng Kanghou 馮康矦 (1901–83, native of Panyuxian, Guangdong province). Calligrapher, seal carver, and amateur painter. Worked for Typecasting and Printing Bureau, ROC. In later years settled in Hong Kong.

Feng Mengbo 馮夢波 (b. 1966, Beijing). Mixed-media artist, computer artist, and oil painter. 1991 graduated from Design Dept. of CAFA. Became professional artist and member of Beijing avant-garde. Since mid-1990s has worked with digital and video art creating computer games and videos, many inspired by Cultural Revolution model operas. Continues to paint in oils in a style closely related to his digital and video works. Lives and works in Beijing, teaching in CAFA. (*Photo on p. 37.*)

Feng Mingqiu 馮明秋 (Fung Ming-chip, b. 1951, Guangdong province). Painter and calligrapher, playwright and director. Raised in Hong Kong. 1977 moved to New York. From 1986 living between New York and Taiwan. From May 1982, exhibitions in Hong Kong, New York, and London. 1999 solo exhibition, Taipei Fine Arts Museum. 2004 resident artist, Jesus College, Cambridge University. Works to expand the possibilities within the tradition of calligraphy. Noted for his innovative seal carving, experimental calligraphy, and free-standing bronze sculptural forms related to calligraphy.

Feng Xuefeng 馮雪峰 (1903–67). Wood engraver. 1930 played key role with Lu Xun in promoting radical woodcut movement, centered around the Shanghai Branch of the Eighteen Art Society.

Feng Yongji 馮永基 (Fung Wing-kee, Raymond, b. 1952, Hong Kong). 1978 BA in architecture, Louisiana State University. 1985 graduated from Extramural Studies Dept., Chinese University of Hong Kong, with certificate in Chinese painting. Founding member of ink movement and well-known architect in Hong Kong. Granted numerous awards for architectural design and fine art. 1990 was one of ten people to win Outstanding Young Person's Award.

Feng Zhongrui 馮中睿 (Fong Chung-ray, b. 1933, Nanyang, Henan province). Abstract painter. 1949 moved to Taiwan. 1954 graduated from Political Cadre School, assigned to Navy. 1954 founded Four Seas Artists Association. 1956 joined **Liu Guosong** in Fifth Moon Group.

Feng Zikai 豐子愷 (1898–1975, b. Shimenwan, Zhejiang province). *Guohua* painter, graphic artist, cartoonist, and essayist. 1915 studied art and music in Shanghai under **Li Shutong**, who influenced his conversion to Buddhism. 1920 co-founder, with **Liu Zhiping**, of Shanghai Private Arts University. 1921 went to Japan to study oil painting, returned same year, taught and drew cartoons, notably of the life of children. 1928

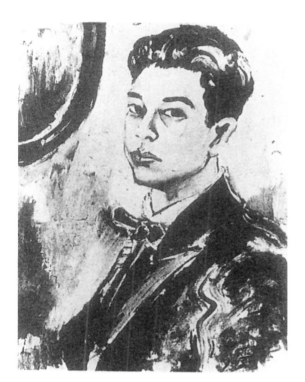

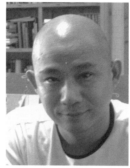

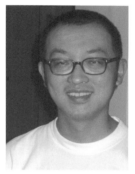

clockwise from left
Ding Yanyong. Self-portrait, c. 1921.
Fang Lijun.
Feng Mengbo.

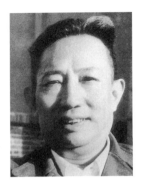
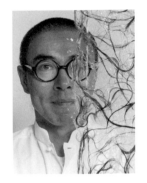
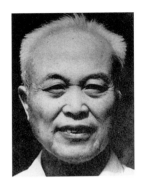

on staff of Kaiming Book Co., which published his *History of Western Art* (*Xiyang meishu shi*). Later assistant professor in Zhejiang University, professor in NAA Chongqing. 1954 director of CAA. 1960 president of Shanghai Academy. 1962 vice-chairman of Joint Federation of Literature and Arts World in Shanghai. In addition to the sketches of daily life and of children, for which he is best known, he compiled six volumes of Buddhist cartoons, *Husheng huaji* 護生畫集 [Collection on the preservation of life] (Shanghai, 1928–69). Harshly treated during Cultural Revolution. Died of lung cancer in Shanghai. Subject of a sympathetic study by Christoph Harbsmeier, *The Cartoonist Feng Zikai* (Oslo, 1984), and a more comprehensive work by Geremie R Barmé, *An Artistic Exile: A Life of Feng Zikai (1898–1975)* (Berkeley, 2002).

Fong Chung-ray. See **Feng Zhongrui**

Fu, Alixe. See **Fu Qingli**

Fu Baoshi 傅抱石 (1904–65, b. Nanchang, Jiangxi province). *Guohua* painter. Son of a poor umbrella repairer. 1914 apprenticed to a ceramic shop. 1921 graduated from Jiangxi College of Education, Nanchang; taught there. 1933–35, with encouragement from **Xu Beihong,** studied in Tokyo Academy of Art. There he was encouraged by Yokoyama Taikan to study Chinese art and was a student of Kosugi Hōan. 1935–49 professor in NCU Nanjing, later Chongqing. 1949 head of Jiangsu Chinese Painting Academy. 1957 sent on painting tour to Eastern bloc countries. 1959 collaborated with **Guan Shanyue** in wall painting *Such is the Beauty of Our Mountains and Streams* for the Great Hall of the People, Beijing. 1960 chairman of Jiangsu branch of CAA. Close friend and protégé of Guo Moruo, whom he had met in Tokyo in 1933. Author of several books on Chinese painting. Died in Nanjing of cerebral hemorrhage. During Cultural Revolution the Red Guard dug up his grave and scattered the ashes. One of the most distinguished landscape painters of the twentieth century, whose work was influenced by Shitao and, some say, by Japanese art. See Jinling Calligraphy and Painting Society, *Fu Baoshi huaji* 傅抱石畫集 [Collected paintings of Fu Baoshi] (Nanjing, 1981); *Han mo* 翰墨, nos. 9 and 11 (1990.10, 11), complete issues, and no. 19 (1991.8) on his relationship with Guo Moruo. (*Photo on p. 38.*)

Fu Duoruo 傅鐸若 (Dora Fugh Lee, n.d.). Painter and sculptor. Born 1930 into Manchu family in Beijing, where she studied *guohua* under **Yan Shaoxiang,** beginning when she was eleven. 1949 went with her husband to Japan, where she worked as illustrator. 1955–56 studied under **Pu Ru** in Japan. 1957 settled in Washington, D.C., where she studied sculpture under Pietro Lazzari, and continued her work as an amateur painter. One-artist shows at Peers' Club, Tokyo; China Institute, New York; Pacific Gallery, Hong Kong; Franz Bader Gallery, Washington, D.C. (1985); Courtyard Gallery, Beijing (2000).

Fu Hua 富華 (b. 1928 in Northeast, of Manchu descent). *Guohua* painter. Commissioner of Shanghai Huayuan before Cultural Revolution, during which he was persecuted. Moved to London. Held exhibitions for years in the Mall Gallery, London.

Fu Luofei 符羅飛 (1896–1971, b. Hainan). Oil painter. 1935–38 studied painting and sculpture in Italy and Paris. 1926 joined CCP. 1946 co-founder of Renjian Huahui, Hong Kong. After 1949 taught in Architecture Dept. of Huanan Gongxueyuan, Guangzhou.

Fu Qingli 傅慶豐 (Alixe Fu, b. 1961, Yunlin, Taiwan). Painter and lithographer. 1985 graduated from Chinese Culture University, Taipei. 1987 left for France, where he studied lithography in Hadad's studio. Settled in Paris.

Fu Shen 傅申 (b. 1936, Shanghai). Painter, calligrapher, historian, museum curator. MA from NTNU. PhD Princeton University. After spending some years on staff of Sackler Gallery, Washington, he taught in Art History Dept. of NTNU, Taipei, till his retirement.

Fu Shuda 傅叔達 (?–1960). *Guohua* painter. Trained in Beijing. 1937 went to US, where he was engaged in book illustration. Dec. 1941 in Hong Kong. Escaped to Chongqing, where he worked for Chinese Industrial Cooperatives; then, after teaching in Guilin, worked for British government in India. 1945 in Singapore at the Japanese surrender. 1948 returned to Shanghai, where he worked as professional artist. After 1949, suffered from cancer. 1960 died during or after a period of imprisonment. His wife, a teacher, was also imprisoned.

Fu Tianqiu 傅天仇 (b. 1920, Nanhai, Guangdong province). Sculptor. 1942 studying sculpture in Chongqing. 1947 went to Shanghai and Nanjing, did satirical anti-KMT and anti–civil war sculpture. 1949, after two years in Hong Kong, returned to Beijing, where he joined faculty of CAFA and worked in Beijing Historical Museum. 1959 did *Wuchang Uprising* panel for Heroes Monument in Tiananmen Square.

Fu Zhongwang 傅中望 (b. 1956, Wuhan). Sculptor. 1982 graduated from CAFA. Teacher at Hubei AFA.

Fung Ming-chip. See Feng Mingqiu

Fung Wing-kee, Raymond. See Feng Yongji

Gao Hong 高虹 (b. 1926, native of Hubei province). Oil painter, famous for his history painting. With Political Dept. of Chinese Military Museum.

Gao Jianfu. See **Gao Lun**

Gao Lun 高崙 (*zi* Queting 爵廷, *hao* Jianfu 劍父, 1879–1951, native of Panyuxian, Guangdong province). *Guohua* painter, founder of Lingnan school. 1892 began to study painting under **Ju Lian**. 1903 studied sketching in Guangzhou with a French teacher. 1906 organized Chinese Painting Research Society. 1906 went to Tokyo for further study. There he joined Hakuba Kai (White Horse Society) and Taiheiyō Gakai (Pacific Painting Society), artists interested in European art. 1908 to Shanghai. 1912 published *The True Record* (*Zhenxiang huabao*). 1918 returned to Guangzhou. 1923 founder of Chunshui Academy. 1930 went to India. 1936 professor in NCU Nanjing. 1938 to Macao. 1945 returned to Guangzhou. 1949 moved back to Macao, where he died. He was a key figure in the movement, under strong Japanese influence, to modernize *guohua* by introducing such Western techniques as realistic drawing and shading. The movement he and his brother **Gao Weng** founded had many followers in Guangzhou and Hong Kong, but little influence outside south China. See Chen Xiangpu 陳薌普, ed., *Gao Jianfu de huihua yishu* 高劍夫的繪畫藝術 [Gao Jianfu: His life and paintings] (Taipei, 1991).

Gao Qifeng. See **Gao Weng**

Gao Weng 高翁 (*zi* Qifeng 奇峰, 1889–1933, native of Panyuxian, Guangdong province). *Guohua* painter, key figure in Lingnan school. Younger brother of **Gao Lun**. 1907 studied in Japan. 1912 returned to Shanghai, co-editor of *The True Record* (*Zhenxiang huabao*). 1918 back to Guangzhou, where he set up his Tianfeng teaching studio; among his students were **Zhao Shao'ang, Zhang Kunyi** (his daughter by adoption), **Huang Shaoqiang,** and **He Qiyuan**. 1933 appointed representative of Chinese government to Sino-German Art Exhibition in Berlin, but died in Shanghai before he could leave for Europe.

Gao Xiaohua 高小華 (b. 1955, Nanjing). Oil painter. Active in Sichuan in 1980s and '90s.

Gao Xingjian 高行健 (b. 1940, Taizhou, Jiangxi province). Writer and painter. 1957–62 studied French in Beijing Institute of Foreign Languages. Worked as translator. First known as playwright. By 1982 involved in debates about modernism and realism in art in Beijing. Did not take up painting seriously until 1987, when he went to Paris. Honored by French government with title Chevalier de l'Ordre des Arts et des Lettres. 1998 became French citizen. 2000 *Soul Mountain* (*Lingshan*), completed in 1989, earned him the Nobel Prize for Literature. Has since become known for his expressionistic landscape paintings in ink. See Muriel Rausch, *Gao Xingjian: Pour une autre esthé-*

tique [Gao Xingjian: Toward an alternative aesthetic] (Paris, 2001), and Michel Draguet, *Gao Xingjian: Le goût de l'encre* [Gao Xingjian: The taste of ink] (Paris, 2002).

Gao Xishun 高希舜 (1895–1982, b. Hunan province). *Guohua* painter. 1915 classmate of Mao Zedong in Changsha. 1919 entered Beijing Higher Normal College Art Institute; taught Chinese painting there after graduation, becoming a close friend of **Qi Baishi** and **Chen Banding.** 1927 went to Japan, where he studied under Yokoyama Taikan and others. 1929 president of Jinghua College of Fine Arts, Beijing. His paintings show some Western influence, the result of his study of Nihonga style in Japan. During WWII retired in Hunan. 1949 returned to Beijing, where he was president of Jinghua Art Academy.

Gao Yong 高邕 (*zi* Yongzhi 邕之, *hao* Li'an 李盦, Longgong 聾公, 1850–1921, native of Renhe, Zhejiang province). *Guohua* painter and calligrapher. Candidate for magistracy in Jiangsu province but spent his artistic career in Shanghai. 1909 was one of the founders of Yuyuan Calligraphy and Painting Benevolent Association, Shanghai. Member of the circle of **Wu Changshuo** and Ren Yi. Noted for his landscapes in the style of Shitao and Bada Shanren.

Gao Zhenbai 高貞白 (1906–92, native of Chenghai, Guangdong province). *Guohua* painter, seal carver, and journalist. Pupil of **Pu Ru.** After studying in London, settled in Hong Kong as journalist and amateur painter.

Ge Pengren 葛鵬仁 (b. 1941, Jilin province). Oil painter. 1966 graduated from CAFA, where he studied in Studio 1 under **Lin Gang.** 1980s MFA; became teacher of oil painting in Studio 4 of CAFA.

Geng Jianyi 耿建翌 (b. 1962, Zhengzhou, Henan province). Painter. 1985 graduated from Oil Painting Dept. of ZAFA. Mid 1980s, member of New Space Group. Apart from a nine-month visit to Beijing in 1994, he has remained in Hangzhou. Teaches in Fashion Design Dept. of Zhejiang Silk Institute. Late 1980s and 1990s member of avant-garde. Works in various media, including photography. 2004 participated in Shanghai Biennale.

Gu Bingxin 顧炳鑫 (1923–2001, native of Shanghai). *Guohua* and *xihua* painter. Studied art in Shanghai. Active for many years in art administration and publishing in Shanghai. Practiced *guohua*, Western-style portraits, woodcuts, and book illustration. See *Gu Bingxin huaji* 顧炳鑫畫集 [Collected paintings of Gu Bingxin] (Shanghai, 2002).

Gu Dexin 顧得鑫 (b. 1962, Beijing). Self-taught artist, Active in post-1989 avant-garde movement. Member of New Analysts Group, whose aim was to "extinguish

individuality" and "escape from the conventional creative art," with Wang Luyan, Chen Shaoping, and others. 2004 living in Beijing as professional artist.

Gu Gan 古干 (b. 1942, Changsha, Hunan province). Painter and calligrapher. Studied in CAFA under **Ye Qianyu, Huang Miaozi,** and **Zhang Zhengyu.** Also studied Western art. 1985 chairman of Society of Modern Chinese Calligraphy. 1987–93 lectured at University of Bonn and Institute of Fine Art, Hamburg. 1997 chairman of Modern Calligraphy and Painting Society of China. Editor of fine art section of People's Literature Publishing House. Hon. adviser to World Calligraphers' Association. Since 1987 has exhibited in Bonn, Hamburg, Köln, London, and New York. Best known for his semi-abstract calligraphy.

Gu Kunbo 顧坤伯 (1905–70, b. Wuxi). *Guohua* painter. 1923 graduated in engineering from Suzhou Industrial College, then studied painting in Shanghai Academy. From 1926 taught painting in Shanghai. 1932 set up painting correspondence course with **Huang Binhong, Zhang Daqian, Pan Tianshou,** and others. Stayed in Shanghai during WWII. 1957 joined staff of ZAFA. See *Han mo* 翰墨, no. A15 (1996).

Gu Linshi 顧麟士 (*zi* Heyi 鶴逸, *hao* Xijin 西津, 1865–1930, native of Suzhou). *Guohua* painter, Shanghai school. Pupil of **Wu Changshuo.** Specialized in landscapes. Active in Suzhou. Inherited the noted Guoyunlou 過雲樓 collection formed by his grandfather, Gu Wenbin (1811–89).

Gu Mei 顧媚 (Koo Mei, b. 1934, Guangzhou, native of Suzhou). Painter, actress, and singer. 1950 moved to Hong Kong, began to study painting under **Zhao Shao'ang** and **Lü Shoukun.** Later settled in North America, practicing as landscape painter in Vancouver.

Gu Qingyao 顧青瑤 (Koo Tsin-yaw, *hao* Lingshu 靈姝, 1896–1978, native of Suzhou). *Guohua* painter. 1896 family (connoisseurs and collectors) moved to Shanghai. Educated privately. 1934 founded Chinese Calligraphy and Painting competition for women. 1954 moved to Hong Kong; teacher of **Huang Zhongfang.** Lecturer in Fine Art Dept. of New Asia College. 1972 emigrated to Toronto, Canada. 1979 memorial exhibition of her work by Urban Council and Hong Kong Museum of Art.

Gu Shengyue 顧生岳 (b. 1927, native of Zhoushan, Zhejiang province). Graphic artist and *gongbi*-style figure painter. 1948 graduated from Shanghai Academy. 1950 professor in ZAFA.

Gu Wenda 谷文達 (Wenda Gu, b. 1955, Shanghai). Painter, calligrapher, performance and installation artist. Educated at Shanghai School of Arts and Crafts, graduated 1976. 1981 MFA, ZAFA, where he studied under **Lu Yanshao.** 1981 associate professor

in Chinese Painting Dept., ZAFA. 1983–86 developed his fake characters in seal script in the "pseudo-ideographic" series and did tapestry installations in the studio of his teacher, Marny Varbanov. 1987 moved to the US. 1989–90 associate professor of studio arts, University of Minnesota. Has since mounted a number of spectacular installations, many using human hair, including *United Nations: Babel of the Millennium* (1999), and *Forest of Stone Tablets* in New York and Xi'an. Lives in New York with his wife, Kathryn Scott. See Mark H. C. Bessire, ed., *Wenda Gu: Art from Middle Kingdom to Biological Millenium* (Cambridge, MA, 2003). (*Photo on p. 38.*)

Gu Xiong 顧雄 (b. 1953, Chongqing). Painter, performance and installation artist. 1985 MA, Sichuan AFA, Chongqing. 1990 moved to Canada. Lives and works in Vancouver.

Gu Yi 古儀 (original name Li Guoyi 勵國儀, b. 1948, Shanghai). *Guohua* painter and illustrator. Graduated from ZAFA. Noted for her winsome paintings of women in traditional settings wearing elaborate costumes, and for her illustrations, e.g., to *The Dream of Red Mansions.*

Gu Yuan 古元 (1919–96, b. Zhongshan, Guangdong province). Woodcut artist. 1938 went to Yan'an, studied wood-engraving at LXALA. 1942 participated in Yan'an Forum. 1949–53 visited Czechoslovakia, Bulgaria, Vietnam, and Japan. 1974–77 taught in May Seventh College of Arts (previously and subsequently CAFA). 1985 president of CAFA. For many years a leading figure in left-wing graphic art and print movement. His late watercolor landscapes are of high quality. (*Photo on p. 38.*)

Guan Ce 管策 (b. 1957, Nanjing). Painter. 1981 graduated from Nanjing Normal University. Teacher in Nanjing Xiaoqing Normal School. Became abstract painter and member of avant-garde movement. Lives and works in Nanjing. Abstract expressionist. 2000 showed works in mixed media in Shanghai Biennale.

Guan Huinong 關蕙農 (Kwan Wai Nung, 1878–1956, native of Guangzhou). Lineal descendant of Lam Qua, an early nineteenth-century Western-style Guangzhou painter. Learned Western drawing from his brother, Kwan Kin Hing. Studied *guohua* under **Ju Lian**. 1911 art director for *South China Morning Post,* Hong Kong. 1915 set up his own printing company, Asiatic Litho. Produced many calendars and posters.

Guan Liang 關良 (1900–1986, b. Panyuxian, Guangdong province). Painter, especially of landscapes and Beijing Opera figures. 1918 studied oil painting in Tokyo under Fujishima Takeji. 1922, after graduating, returned to China, taught in various colleges in Shanghai, Guangzhou, and Wuchang. 1927 joined Nationalist Expediting force to eliminate northern warlords. In west China during WWII. 1950s held many

exhibitions in China. 1957 exhibited in West Germany. 1983 professor in ZAFA. Vice-chairman of Shanghai Artists Association. (*Photo on p. 38.*)

Guan Qingzhi 關慶志 (1895–1958, b. Jilin province). Watercolor painter, gouache painter, and etcher. 1931, after studying in Beijing University, went to London, where he studied in Royal Academy of Arts, and traveled in Europe. Returning to China, taught in Beijing National Art Academy, Yanjing University, Qinghua University, and elsewhere in Beijing.

Guan Shanyue 關山月 (original name Zepei 澤霈, *zi* Ziyun 子雲, 1912–2000, Guangzhou). *Guohua* painter, Lingnan school. 1940, already teaching painting, started to study under **Gao Lun**, who gave him the name Shanyue. Spent WWII in west China, chiefly in Chengdu. 1943 made more than eighty copies of details of the Dunhuang frescoes. 1946 professor and chairman of Chinese Painting Dept. of Guangzhou Municipal Art Academy. 1949 moved to Hong Kong, joined Renjian Huahui. After Liberation, returned to China; professor at various art colleges in Guangzhou. 1983 vice-chairman of CAA. Active in Party cultural politics. See Keshan Art Gallery, *Chinese Paintings by Guan Shan-yue: Hometown Affection* (Taipei, 1991), and Guan Shanyue, *Guan Shanyue lin mo Dunhuang bi hua* 關山月臨摹敦煌壁畫 [Cave paintings of Dunhuang copied by Guan Shanyue] (Hong Kong, 1991). See also **Fu Baoshi**.

Guan Songfang 關松房 (*zi* Xiongyun 雄云, *hao* Xing 行, 1901–82, native of Beijing, of Manchu descent). *Guohua* painter. Made deep study of work of old masters. 1925 formed Pine Wind Painting Society (Song feng huashe 松風畫社) with **Pu Jin, Pu Ru,** and others. After Liberation painted many modern subjects in traditional technique. From 1957, member of Beijing Chinese Painting Academy.

Guan Wei 關偉 (b. 1957, Beijing). Painter and lithographer. Son of opera singer, grandson of Manchu bannerman. Graduated from Art Dept. of Beijing Normal College. Active in post-1989 avant-garde movement. 1989 artist in residence at Tasmania School of Art, Australia. Ironical surrealist. 1990 returned to settle in Australia; lives and works in Sydney.

Guan Zhizhong 管執中 (Kuan Chih-chung, b. 1931, Henan province). Painter. 1947 graduated from Fine Art Dept. of Henan 93 District United Normal School. 1967–71 went to Taiwan, studied Western painting theories and became an advocate of the modernizing movement in Chinese ink painting. Exhibited in artists' collective exhibitions. Since then participated in many exhibitions in Taiwan, Hong Kong, Malaysia, Tokyo, and Europe. 1981 one of the founders in Taipei of the International Contemporary Ink Painting League.

Guan Zilan 關紫蘭 (1902–86, b. Shanghai, native of Nanhai, Guangdong province). Painter of independent means. Pupil and intimate friend of **Chen Baoyi**, who gave her a fine flower painting as a wedding present. 1927 visited Japan to further her study of Western art.

Guo Beiping 郭北平 (b. 1949, native of Shanxi province). Oil painter. 1983 graduated from postgraduate class in oil painting in Guangxi AFA. Became professor in Xi'an AFA. Paints chiefly portraits and figure studies.

Guo Bochuan 郭柏川 (1901–74, b. Tainan, Taiwan). Painter. 1926–37 studied oil painting in Tokyo. 1937 returned to Beijing, taught art with **Qi Baishi** and **Xu Beihong** in NAA Beijing. During WWII stayed in Beijing; painted and toured with Umehara Ryūzaburō, who influenced his style. 1948 settled in Taiwan. 1952 founded Tainan Art Research Association. Noted for oil paintings on paper.

Guo Chengyi 郭成義 (n.d.). Peasant artist. 1980s and '90s active in Nantong, Jiangsu province.

Guo Chuanzhang 郭傳墇 (*zi* Xiaoxi 肖熙, b. 1912, native of Shandong province). *Guohua* painter, chiefly of landscapes. Member of Beijing Academy of Painting.

Guo Dawei 郭大惟 (b. 1919, native of Beijing). *Guohua* painter. Studied under **Qi Baishi** and in Nanjing. 1954 settled in US; lives in New Jersey. Specializes in figure and genre subjects.

Guo Hanshen 郭漢深 (Kwok Hon Sum, b. 1947, native of Guangdong province). Painter. Graduated from Fine Art Dept. of NTNU, Taipei. Studied ink brush painting in the Extramural Studies Dept., Chinese University of Hong Kong. Works in Hong Kong. Has held solo exhibitions in Hong Kong and US.

Guo Huairen 郭懷仁 (b. 1943). Painter and printmaker. Studied in CAFA under **Pang Tao**. Worked in New York and later in Beijing. Noted for realist/symbolist paintings of life in Beijing in 1920s.

Guo Jin 郭晉 (b. 1964, Chengdu, Sichuan province). Painter. Brother of **Guo Wei**. 1990 graduated from Faculty of Oil Painting in Sichuan AFA, Chongqing, where he became lecturer. Noted for his children, babies, and dolls in state of decay. Since the birth of his daughter, his paintings of children have become more cheerful.

Guo Juanqiu 郭娟秋 (Kuo Chuan-chiu, b. 1958, Taiwan). Photojournalist and amateur artist. She works in Taiwan.

Guo Menghao 郭孟浩 (Kwok Mang-ho; b. 1947, Guangdong province). Grew up in Hong Kong. 1978–80 instructor in Hong Kong Polytechnic. 1975 received Urban Council Fine Arts award for sculpture. 1980 moved to US; attended classes in Art Students League, New York. 1990s traveling often between New York, Hong Kong, and Seoul. 1996 large installation in Wucius Wong's exhibition Mutations of Ink and Paper (New York) reminiscent of **Gu Wenda**'s earlier installation in Hangzhou.

Guo Qixiang 郭其祥 (native of Sichuan province). Sculptor. Active in 1970s and '80s.

Guo Ren 郭軔 (Lucas Kuo-Jen, b. 1928, Beijing). Oil painter. Studied in NAA Beijing and ZAFA. 1960 graduated from Escuela Central de Bellas Artes de San Fernando in Madrid. 1961 founded Neovisualismo. Later settled in Taipei, where he became professor in Fine Art Dept. of NTNU. Abstract expressionist. 1981 founding member of Taipei Art Club.

Guo Runlin 郭潤林 (b. 1940, Shanghai). Painter. Since 1960, worked as designer in Triumphant Song Radio Factory. 1979 member of the Grasses.

Guo Runwen 郭潤文 (b. 1955, native of Zhejiang province). Oil painter. 1982 graduated from Stage Design Dept. of Shanghai Drama Academy. 1988 completed his study of oil painting at CAFA. Appointed to Oil Painting Dept. of Guangzhou Academy. Hyperrealist Western-style figure studies.

Guo Wei 郭偉 (b. 1960, Chengdu, Sichuan province). Painter. Brother of **Guo Jin**. 1989 graduated from Printmaking Dept. of Sichuan AFA, Chongqing. Became a professional artist. Noted for his often contorted or distressed draped figures painted in hyperrealist style, shown, e.g., in China's New Art, Post-1989 exhibition (Hong Kong, 1993).

Guo Weiqu 郭味蕖 (1908–71, native of Weifang, Shandong province). *Guohua* painter of birds and flowers and calligrapher. Graduated from Western Painting Dept. of Shanghai College of Arts. Did research on Chinese painting in Palace Museum, Beijing. Studied painting theory and connoisseurship with **Huang Binhong**. After 1949 taught in CAFA. From 1959 director of bird and flowers section, CAFA. Died after persecution by the Red Guard. A memoir by his son, **Guo Yizong**, was published in *Chinese Literature* (September 1980). He wrote a number of books on Chinese painting, including *Song Yuan Ming Qing huajia nianbiao* 宋元明清畫家年表 [Chronology of Song, Yuan, Ming and Qing artists] (Beijing, 1958). See Ye Qianyu, ed., *Guo Weiqu huaji* 郭味蕖畫集 [Collected paintings of Guo Weiqu] (Beijing, 1984).

Guo Xuehu 郭雪湖 (b. 1908, Taipei, Taiwan). *Guohua*, gouache, and oil painter. Trained in Japan; later worked in Taiwan. Pioneer member of New Taiwan Art Movement.

Guo Ying 郭瑛 (Kwok Ying, b. 1977). Artist. 2000 graduated from Dept. of Fine Arts, Chinese University of Hong Kong. Since 1998 she has participated in various group shows and organized solo exhibitions. 2001 awarded Fine Arts Award, Hong Kong Art Biennial Exhibition. 2003 went to study in England on British Chevening Postgraduate Scholarship awarded by Hong Kong British Council.

Guo Yizong 郭怡琮 (b. 1940, native of Weifong, Shandong province). *Guohua* painter, especially of flowers. Son of **Guo Weiqu**. From 1959 studied *guohua* in Chinese Painting Dept. of Beijing Art Research Institute. Teaches Chinese painting in Beijing Academy of Painting.

Guo Zhengshan 郭正善 (b. 1954, Hubei province). Oil painter. Professor in Arts Academy of Hubei province. Noted for his still lifes of pots influenced by Georgio Morandi. 1996 exhibited in Shanghai Biennale.

Ha Bik-chuen. See **Xia Biquan**

Ha Ding 哈定 (b. 1923, Nanjing, Jiangsu province, of Hui nationality). Oil and watercolor painter. Student of Zhang Chongwen in CAFA, where he had his own studio. When it was closed, he was forced to produce "factory paintings" for cheap Hong Kong galleries. 1974 attacked by Jiang Qing in "black painting" campaign.

Ha Qiongwen 哈瓊文 (b. 1925, Beijing, of Hui nationality). 1949 graduated from Fine Art Dept., Chongqing Central University. Taught in Art Dept. of South China PLA Military University. 1953 moved to Beijing to work in the military's Cultural Dept. Gained recognition for his portrayal of military heroes during the Korean War and for subsequent work during the Cultural Revolution.

Hai Bo 海波 (b. 1962, Jilin province). Printmaker. Studied in Jilin Academy of Art and CAFA. Has worked in etching and oil painting. More recently worked with manipulated photographs, chiefly of figures in landscapes. Lives in Beijing.

Hai Rihan 海日汗 (b. 1958, Zhalute, Inner Mongolia). Painter. Graduated from Art Dept. of NCU. Worked in Beijing Cultural Palace. From 1984 taught in Art Dept. of Inner Mongolia Normal University. 1998 ghostly figural compositions exhibited in Shanghai Biennale.

Han Likun 韓黎坤 (b. 1938, Suzhou). Wood engraver and calligrapher. Worked in Northeast and in Suzhou. 1980 graduated from ZAFA; 1992 chairman of Graphic Arts Dept. there. Visited Japan and Germany. 1991 won first prize in National Art

Exhibition. Some of his prints embody elements derived from *wenrenhua* and archaic pictographs.

Han Meilin 韓美林 (b. 1936, native of Jinan, Shandong province). Designer and animal painter. Studied painting in Jinan. Graduated from CAAC, where he studied under **Pang Xunqin.** Became specialist in Institute of Arts and Crafts, Shandong, and later in Anhui. 1980 exhibition of his work toured twenty-one cities in US. Lives in Beijing, where he has a large studio.

Han Tianheng 韓天衡 (b. 1940, Suzhou). *Guohua* painter and seal carver. Studied under **Xie Zhiliu, Lu Yanshao,** and others. 1987 acting director of Shanghai Painting Academy.

Han Xiangning 韓湘寧 (b. 1939, Chongqing, Sichuan province, native of Hunan). Painter and printmaker. 1960 graduated from Dept. of Fine Arts, NTNU. Member of Fifth Moon Group. 1968 settled in US. Abstract expressionist. Later in US became a realist and worked in computer images. 2003 living in New York.

Han Xin 韓辛 (b. 1955, Shanghai). *Guohua* painter, later changed to oils and gouache. In 1974 "black painting" exhibition in Shanghai, he was selected as youngest target. Rehabilitated after Cultural Revolution. Worked in Shanghai. From 1980 studied in Shanghai Academy. Works shown widely in China. 1981 married an American woman and emigrated to US. 1982 exhibited at Asia Foundation, San Francisco, and 1983 in Oakland.

Han Yue 韓樾 (b. 1933, native of Anqiu, Shandong province). *Guohua* and oil painter, sculptor and stage designer. With PLA Art Academy.

Han Zhixun 韓志勳 (Hon Chi-fun, b. 1922, Hong Kong, native of Guangdong province). Painter. From 1969 studied lithography and etching at Pratt Institute, New York, on a Rockefeller III Fund fellowship. Member of Circle Group, Hong Kong. 1960s developed into abstract expressionist. 1968–80 taught art in Hong Kong University and Chinese University of Hong Kong. 1992–2000 lived in Canada, returning to Hong Kong to paint and practice calligraphy.

Hao Boyi 郝伯義 (b. 1938, Moupinxian, Shandong province). Print artist. After studying at LXAFA in Shenyang, went with PLA to Beidahuang, where he was discovered by **Zhang Zuoliang** and **Chao Mei.** Became key figure in Beidahuang (Northern Wilderness) school.

He Baili 何百里 (Paklee Ho, b. 1945). Expressionist *guohua* painter.

He Daqiao 何大橋 (b. 1961, Harbin, Heilongjiang province). Realist oil painter. 1983 graduated from PLA Art Academy. Known for his paintings of military and historical subjects and, more recently, for his still lifes and nudes.

He Datian 賀大田 (b. 1950, Changsha, Hunan province). Oil painter. Prominent in Hunan art circles. Notable for his paintings of courtyards and house interiors.

He Duoling 何多苓 (b. 1948, Chengdu, Sichuan province). Oil painter. 1982 completed graduate study in Sichuan AFA. Later taught in Chengdu Painting Academy. 1985 visited US, lectured at MIT. Developed realistic style, especially of Tibetan subjects, influenced by Andrew Wyeth. His later work includes lyrical nude and female figures in garden and landscape settings. (*Photo on p. 38.*)

He Haixia 何海霞 (original name He Ying 何瀛, 1908–98, Beijing). Conservative *guohua* painter. At sixteen apprenticed to *guohua* artist. 1927 entered NAA Beijing. Member of Hu She Painting Society. 1934 became **Zhang Daqian**'s student. During WWII stayed in Beijing in great poverty, supporting himself by selling copies of famous paintings. 1945 went to work with Zhang Daqian in Chengdu, where he copied ancient paintings under Zhang's guidance. 1983 vice-president of Shaanxi Studio of Painting, Xi'an.

He Huaishuo 何懷碩 (b. 1941, Guangzhou). *Guohua* painter. Landscape painter in Lingnan tradition, although influenced also by his teachers **Fu Baoshi** and **Li Keran**. 1961, after two years in Hubei Academy of Arts, moved via Hong Kong to Taipei. 1965 graduated from NTNU Art Dept. Became teacher in Art Dept. of College of Chinese Culture, Yangmingshan, Taipei. Has exhibited widely in Taiwan and abroad. 1984 created a major work, his *Four Seasons* handscroll, which shows abstract expressionist tendencies. 2003 living in Taipei.

He Jianshi 何劍士 (1877–1915, native of Hainanxian, Guangdong province). Cartoonist. Editor-in-chief of *Shishi huabao*, Guangzhou.

He Kedi 何克敵 (b. 1928, native of Nanhai, Guangdong province). Oil painter. 1947 enrolled in Guangzhou School of Art. Since 1950 devoted himself to oil painting in Huanan Institute of Literature and Art, Guangzhou.

He Kongde 何孔德 (b. 1925, native of Sichuan province). Oil painter. 1942 started to study art in Chongqing. 1950 joined propaganda team in Korean campaign. 1955 entered CAFA, studied under Konstantin Maksimov, later taught there in Studio 2. 1958 branded a Rightist for upholding oil painting. Noted for his realistic propaganda paintings.

He Qingji 何慶基 (Oscar Ho, b. 1956, Hong Kong). Painter. 1980 BFA University of Saskatchewan, Canada. 1983 MFA, University of California, Davis. Has lectured at Hong Kong University, Chinese University of Hong Kong, and Hong Kong Polytechnic. Founding president of Hong Kong branch of International Association of Art Critics. 1998–2001 exhibition director of Hong Kong Arts Centre. Currently senior research officer in cultural policy at Home Affairs Bureau. Noted for his expressionistic ink paintings of Hong Kong life.

He Qiyuan 何漆園 (1899–1970, native of Shunde, Guangdong province). Lingnan school landscape painter. Studied under **Gao Weng**. Later settled in Hong Kong.

He Sen 何森 (b. 1968, Yunnan province). Painter. 1990 graduated from SichuanAFA, Chongqing. Active in post-1979 avant-garde movement. "Cynical realist."

He Tianjian 賀天健 (*zi* Qianqian 乾乾, *hao* Renxiang Jushi 紉香居士, 1891–1977, native of Wuxi, Jiangsu province). Self-educated professional *guohua* painter. Active in Shanghai and Wuxi. 1931 one of founders of China Art Association. Member of several other groups for promotion of *guohua* and seal carving. Edited *Chinese Painting Monthly* (*Guohua yuekan* 國畫月刊) and *Painting Monthly* (*Huaxue yuekan* 畫學月刊) and sold paintings for a living. Remained in Shanghai during WWII. After establishment of PRC, appointed deputy head of Shanghai Painting Academy. 1962 deputy chairman of Shanghai branch of Chinese Artists Association. 1967–70 condemned to hard labor and writing confessions. Noted for his landscapes of south China. See *Han mo* 翰墨, no. 30 (1992.7).

He Weimin 何為民 (b. 1964, Mudanjiang, Heilongjiang province). Print artist and painter. Studied in Harbin Normal University and LXAFA in Shenyang. After working as professional artist, he earned a doctorate at University of Belfast on Muban Foundation scholarship. Currently postdoctoral fellow at Ashmolean Museum, Oxford.

He Weipu 何維樸 (*zi* Shisun 詩孫, *hao* Panzi Daozhouren 盤止道州人, 1842–1922, native of Daoxian, Hunan province). *Guohua* painter, poet, calligrapher, seal carver and late Qing court official. 1867 *jinshi* degree. Grandson of He Zijing, master of Shanghai school.

He Wenlüe 賀文略 (b. 1920, native of Yulin, Shanxi province). *Guohua* painter in literary and academic *gongbi* style. Graduated from Guangzhou Municipal Fine Art College. 1945 moved to Hong Kong. 1992 settled in US. Noted for his flower paintings and calligraphy in "thin gold" style of Song dynasty emperor Huizong (r. 1101–25).

He Xiangning 何香凝 (1878–1972, b. Hong Kong, native of Nanhaixian, Guangdong province). *Guohua* painter, especially of flowers. Born into large feudal family in Hong Kong. After her marriage to Liao Zhongkai, one of Sun Yat-sen's closest supporters, she went to Japan, where she studied painting under Tanaka Raishō in Tokyo Women's Arts School. 1910 returned to China (Shanghai and Guangzhou). After her husband's assassination in 1925, she went to Hong Kong. 1949 returned to north China, where she became prominent in CCP affairs. Collaborated in painting large compositions with, among others, **Wang Zhen, Pu Quan, Pu Jin, Ye Gongchuo, Hu Xiquan, Wang Xuetao, Fu Baoshi** and **Pan Tianshou**. See Liao Chengzhi 廖承志, *He Xiangning Zhongguohua xuanji* 何香凝中國畫選集 [Selection of traditional Chinese paintings by He Xiangning] (Guangdong, 1979).

He Ying. See **He Haixia**

He Youzhi 賀友直 (b. 1922, Zhejiang province). Graphic artist. Settled in Shanghai. 1952 joined New Art Press and attended drawing classes under **Yan Wenliang**. Noted for his serial book illustrations (*lianhuanhua*) in ink line.

He Zhaoji 何兆基 (Ho Siu-kee, b. 1964, Hong Kong). Performance artist. Lives in Hong Kong. Undergraduate degree from Chinese University of Hong Kong. 1995 MFA from Cranbrook Academy of Art, Michigan. 1996 São Paulo Biennale. 1998 exhibited at Inside Out: New Chinese Art (San Francisco and New York).

He Zhaoqu 何肇衢 (b. 1931, Taiwan). Abstract painter. Graduated from Taipei Normal School. Winner of many distinctions abroad, including Cannes and Tokyo.

Ho Kang. See **Huo Gang**

Ho, Oscar. See **He Qingji**

Ho, Paklee. See **He Baili**

Ho Siu-Kee. See **He Zhaoji**

Hon Chi-fun. See **Han Zhixun**

Hong Hao 洪浩 (b. 1965, Beijing). Painter and printmaker. 1989 graduated from Printmaking Dept. of CAFA. "Political pop" artist active in post-1989 avant-garde movement. Lives and works in Beijing. 2000 exhibited photographs and distorted "maps" in Shanghai Biennale, often as satirical comments on consumerist society. 2005 exhibition at Cantor Center for Visual Arts, Stanford University. (*Photo on p. 38.*)

Hong Jiuguo 洪救國 (Ang Kiukok, b. 1931). Painter. As young man, trained in *guohua* techniques. Later studied Western art at University of Santo Tomas, Manila. After teaching art in Sula, returned to settle in Manila. A trip to US in 1965 with his teacher, Manasala, and the sight of Picasso's *Guernica* profoundly affected his style. Noted for his paintings of the Crucifixion and of cockfights.

Hong Ling 洪凌 (b. 1955, Beijing). Oil painter. 1979 she graduated in fine art from Beijing Capital Normal University. 1987 completed training in oil paintings in CAFA, where she became a lecturer in Studio 3. 1996 solo exhibition in Paris. 1997 participated in Venice Biennale. Exhibits widely abroad. Specializes in luxuriant impressionist landscapes.

Hong Qiang 洪強 (Hung Keung, b. 1970, China). Painter. Has lived in Hong Kong since 1973. 1975 BA from Dept. of Fine Art, Chinese University of Hong Kong. 1995 MA from St. Martin's College of Art and Design, London. 1994 won Hong Kong's "Most Promising Artist Award." Has won many international distinctions for his work in mixed media, including computer graphics.

Hong Qing 洪青 (1913–79, native of Jiangxi province). First trained as designer in France. Returned to China to teach design at Shanghai Meizhuan. After Liberation, practiced architectural design in western provinces.

Hong Ruilin 洪瑞麟 (1912–96, Taipei). Western-style painter. Studied under Ishikawa Kin'ichirō in Taipei. 1930–36 in Tokyo Academy. Returned to Taipei to join Taiyang Art Society, founded Mouve group. Later settled in US. 1987 exhibition Hong Ruilin's Art World held in Taipei. His work shows influence of Georges Rouault.

Hong Ruisheng 洪瑞生 (b. 1940, Xiamen, Fujian province). Oil painter. 1959 entered CAFA. 1962 studied in **Wu Zuoren**'s studio. 1964 graduated. 1985 began teaching in Fine Art Dept., Normal College of Xiamen University.

Hong Shiqing 洪世清 (b. 1929, native of Jingjiang, Fujian province). Professor and sculptor in ZAFA. In 1980s spent several years carving images on rocks of Dalu Island near Hangzhou.

Hong Tong 洪通 (1920–87, b. Tainan, Taiwan). Painter. From poor background. In 1970s took up painting, specializing in decorative fantasy and mythical images. 1976 held his first exhibition in Taipei, since when he has achieved fame in Taiwan.

Hong Xian 洪嫻 (Hung Hsien, Margaret Chang, b. 1933, Yangzhou). Painter. During WWII in Chongqing. Later moved to Taiwan, where she studied *guohua* under

Pu Ru, Huang Junbi, and **Jin Qinbo** and oil painting under **Liao Jichun.** Member of Fifth Moon Group. Enrolled at Northwestern University, Evanston, Illinois, where she studied under George Cohan. Married architect T. C. Cheng. Became semiabstract landscape painter in both traditional and Western media. Has lived in US since 1958.

Hong Zhu'an 洪祝安 (b. 1955, Shanghai). Painter. 1973–76 studied in Shanghai Arts and Crafts Institute, where from 1976–89 he was lecturer. After a year in Chongqinq, he spent 1989–93 in Sidney. 1996–present living in Singapore, lectured at LaSalle-SIA College of Art. Solo exhibitions in Hong Kong and Singapore. 1994 Painting of the Year Grand Award, Singapore.

Hongyi. See **Li Shutong**

Hou Beiren 侯北人 (b. 1917, Liaoning province). Painter. Studied under **Huang Binhong** and Cheng Shiqian at Beijing Normal University, and at a college in Kyūshū. 1948 went to Hong Kong. 1956 moved to US, where he settled in the Bay Area south of San Francisco, practicing painting in his spare time.

Hou Dechang 侯德昌 (b. 1934, Huixian, Henan province). *Guohua* painter and calligrapher. Trained in CAAC, where he later taught. 1974 collaborated with **Bai Xueshi** in landscape of Great Wall. 1977 did calligraphic inscription for Mao Zedong Memorial Hall. 1982 his landscape was exhibited in Paris Salon. 1986, 1988 solo exhibitions in US and Singapore.

Hou Jinlang 侯錦郎 (b. 1937, Jiayi, Taiwan). Painter. 1963 graduated from Fine Art Dept. of NTNU. 1967–89 studied and worked in Paris. Returned to hold first solo exhibition in Taipei in 1989.

Hou Ning 侯寧 (Ning Hou, b. 1957, Shanghai). Painter. 1979–81 studied in Art School, which became Fine Arts Dept. of Shanghai University. 1985 MFA; settled in San Francisco. 1989 moved to Locke, California, where he takes pupils and practices as independent artist.

Hou Yimin 侯一民 (b. 1930, native of Gaoyangxian, Hebei province, of Mongol descent). Oil painter. After starting art classes in 1946 in National Beiping Art College, he enrolled in CAFA, where he studied under Konstantin Maksimov. Graduated from CAFA, of which he became vice-president. A dedicated Communist, he became noted both for his large oil paintings and for *nianhua* on political themes, especially during the Cultural Revolution. Also involved in designing Chinese currency.

Hsia I-fu. See **Xia Yifu**

Hsieh, Lalan Ching-lan. See Xie Jinglan

Hu Dinglu 胡汀鷺 (1886–1943, native of Wuxi, Jiangsu province). *Guohua* painter. Specialized in bird and flower paintings influenced by Zhang Xiong and Ren Yi; also did some landscapes. Taught in Nanjing Academy.

Hu Gentian 胡根天 (original name Hu Yugui 胡毓桂, 1892–1985; native of Kaipingxian, Guangdong province). *Guohua* and oil painter. 1915–20 studied Western art in Tokyo. 1921, after returning to Guangzhou, joined Chishe (Purple Society) with **Feng Gangbai.** 1926 appointed director of new Guangzhou Municipal Art College, Guangzhou Shili Meishu Zhuanwen Xuexiao. Thereafter taught in Hong Kong, Nanjing, and Guangzhou.

Hu Gui 胡圭 (b. 1906, native of Jiangsu province). 1926 entered Shanghai Meizhuan. 1927 went to Southeast Asia. 1930–35 studied painting in Paris under Alfred Bastien and others. Returning to China, he held a succession of posts teaching oil painting. Active in organizing patriotic art society in WWII, after which he taught in Hangzhou and Shanghai.

Hu Jieqing 胡絜青 (*zi* Huchun 胡春, *hao* Yanyai 燕崖, 1905–2001, Beijing). *Guohua* artist and wood engraver. 1925 graduated from Women's Division of Beijing Normal College. 1931 graduated from Chinese Dept. of Beijing Normal University. During WWII in Chongqing. 1950 returned to Beijing, active in cultural affairs and women's art. Did collaborative painting in Beijing Hotel with **Chen Nian, Hu Xiquan,** and others. Her woodcut illustrations include those to the works of her husband, the novelist Lao She.

Hu Kao 胡考 (1912–94, b. Yuyao, Zhejiang province). *Guohua* painter, especially of birds and flowers. Studied Western art at Xinhua AFA, Shanghai, graduated 1932. In 1930s became known for his cartoons. Went to Yan'an, where in 1940s he wrote long narrative poems. After 1949 became chief editor of *China Pictorial*. Disappeared in the political storms of late 1950s to 1970s, spending some years in banishment to the far southeast. Early 1980s reappeared as novelist, portrait artist, and traditional painter influenced by Bada Shanren (1625–1705) and Xu Wei (1521–93).

Hu Kemin 胡克敏 (b. 1910, native of Wujin, Jiangsu province). *Guohua* and Western-style painter. 1928 graduated from Shanghai Academy. 1935–38 in charge of publicity for Chinese Air Force; painted aviation and war scenes. After WWII went to Taiwan, where he taught Chinese and Western painting and executed large murals for Historical Museum. Later professor at National Art Academy and secretary of Chinese Painting Association, Taipei.

Hu Kuilian 胡奎連 (active ca. 1958). Zhejiang peasant painter.

Hu Peiheng. See **Hu Xiquan**

Hu Qizhong 胡奇中 (b. 1927, Jinyunxian, Zhejiang province). Painter. Self-taught. 1950 went to Taiwan with Marine Corps. 1952–58 became professional portrait painter. 1957 founder of Four Seas Artists Association. 1961 member of the Fifth Moon Group. 1970 went to US.

Hu Ruosi 胡若思 (b. 1916, native of Zhenjiang, Jiangsu province). *Guohua* painter of landscapes. After 1949, member of Jiangsu Chinese Painting Academy.

Hu Shanyu 胡善餘 (1909–93, b. Guangzhou to family of overseas Chinese). Oil painter. 1929 briefly studied in Hangzhou under **Lin Fengmian** and **Cai Weilian.** 1932–35 studied in Paris. On return to China, taught in Guangzhou Academy. In Chongqing during WWII. From 1950 taught in Hangzhou Academy until his death.

Hu Xiquan 胡錫銓 (*zi* Peiheng 佩衡, *hao* Lengan 冷庵; 1892–1962; Zhuoxian, Hebei province; of Mongolian descent). *Guohua* and oil painter. 1919–22, encouraged by Cai Yuanpei, he became director of Painting Methods Research Dept. of Beijing University. 1927 founded first correspondence school in Chinese landscape painting. After 1949, teacher in Chinese painting studio and member of Chinese Painting Research Society. Edited painting monthly *Hushe yuekan* 湖社月刊 and wrote several books on technique and theory of landscape painting.

Hu Yefo 胡也佛 (b. 1908, native of Yuyao, Zhejiang province). *Guohua* painter and commercial artist. Trained in Shanghai. Worked as editor for art section of Shanghai Commercial Press. Painted landscapes and female figures.

Hu Yichuan 胡一川 (1910–2000; b. Yongding, Fujian province). Oil painter and woodcut artist. Married to **Yao Fu.** 1925 studied in Xiamen. 1929 entered Hangzhou Academy, member of Eighteen Art Society and League of Left-Wing Artists. Studied Chinese painting under **Pan Tianshou,** Western painting, and woodcut. 1937 went to teach in LXALA in Yan'an. December 1948 one of a group of cadres put in charge of what later became CAFA. 1949 professor in CAFA. Since 1958 president of Guangzhou Academy. 1960 briefly in Moscow. 1984 official retrospective exhibition in Beijing.

Hu Yongkai 胡永凱 (b. 1945; native of Wuxing, Zhejiang province). 1979 founded Sea Winds Art Association (Haifeng Huahui), in Shanghai. Taught in College of Fine Art of Shanghai University. 1988 moved to Hong Kong. Later settled in US. Paints in decorative style.

Hu Yuji 胡宇基 (Henry Wo Yue Kee, b. 1927, native of Dongguan, Guangdong province). Painter. Moved to Hong Kong, where he studied Western Art with **Liu Junren.** 1949 studied under **Zhao Shao'ang.** 1975 emigrated to US, where he established himself as a professional artist of the Lingnan school. His later work became more abstract.

Hu Zhenyu 胡振宇 (b. 1939, Ningboxian, Zhejiang province). Oil painter. 1964 graduated from Oil Painting Dept. of ZAFA; 1980 completed postgraduate study there. 1984–86 in Royal AFA, Brussels. Returned to Hangzhou to become associate professor and dean of Oil Painting Dept. in ZAFA. Realist.

Hua Junwu 華君武 (b. 1915, Wuxi, Jiangsu province). Cartoonist. 1936–38 worked as bank clerk in Shanghai. 1938 went to Yan'an, worked for *Liberation Daily.* 1949 put in charge of art dept. of *People's Daily.* Since 1953, key figure in political control of CAA. Although an orthodox Communist ideologue, he was branded a Rightist in 1957 and persecuted during Cultural Revolution.

Hua Sanchuan 華三川 (b. 1930, Ningbo, Zhejiang province). Graphic artist and illustrator. Active from 1950s.

Hua Tianyou 滑田友 (1902–86, native of Huaiyin, Jiangsu province). Sculptor. Before 1930, encourage by **Xu Beihong,** he studied art and art history in Xinhua AFA, Shanghai. 1933 studied sculpture under Bauchard and worked in Paris. 1936, after a long struggle with parents, his standing figure earned bronze medal at Paris Salon and a scholarship that enabled him to continue his studies. 1941 won silver medal, Paris Salon; 1942 won gold medal. 1947 returned to China, professor in NAA Beijing. 1959 one of chief sculptors of Heroes' Memorial in Tiananmen Square.

Huang Anren 黃安仁 (b. 1924, Yangjiangxian, Guangdong province). *Guohua* painter. 1947 graduated from Guangzhou Municipal College of Art. 1949 joined PLA. Active in affairs of CAA, organizing exhibitions and so on.

Huang Banruo 黃般若 (Wong Po Yeh, *zi* Boruo 波若, 1901–68, b. Guangzhou). *Guohua* painter and connoisseur. Pupil of his uncle, the painter Huang Shaomei. 1923 founded, with others in Guangzhou, the Guihai Painting Research Society. 1924–40 active chiefly in Guangzhou and Hong Kong. 1941 returned to Guangzhou. 1968 settled in Hong Kong. Specialized in landscapes, sometimes with Buddhist figures. See Mayching Kao, Huang Miaozi, and Cheng Kar-chun, *The World of Wong Po-Yeh* (Hong Kong, 1995).

Huang Binhong. See **Huang Zhi**

Huang Buqing 黃步青 (b. 1948, Zhanghua, Taiwan). Installation artist. 1976 BA in fine arts, Taipei. 1987 MA in plastic arts, University of Paris, St.-Denis. Living in Tainan, Taiwan. "Picnic" installations exhibited in 1999 Venice Biennale, 1999 Kaohsiung, 2000 Shanghai Biennale, etc.

Huang Chih-yang. See **Huang Zhiyang**

Huang Dongran 黃東然 (1898–1947, b. Jilin province). 1919 went to USSR. 1920 to Shanghai, then entered Shanghai Meizhuan to study oil and watercolor painting. 1923 joined CCP. 1924 went to Northeast, joined revolutionary movement. 1929 went to Lyon, France, with **Chang Shuhong, Lü Sibai, Liu Kaiqu, Wang Linyi.** 1937 returned to west China; traveled widely in west and north China and Xinjiang.

Huang Dufeng 黃獨峰 (*hao* Rongyuan 榕園, 1913–70, Guangdong province). Painter, Lingnan school. Early influenced by Ren Bonian. 1931 studied under **Gao Lun** in Chunshui Academy, Guangzhou. 1936 studied briefly in Japan. 1939 in Hong Kong, associated with **Fang Rending** and others. During WWII in west China. 1946 to Guangzhou and Hong Kong. Thereafter traveled widely, holding solo exhibitions and attending meetings. 1980s principal of Guangxi AFA.

Huang Ernan 黃二南 (1883–?, Hebei province). *Guohua* painter. At age of twenty, went to work in Japan, where he earned a gold medal for painting landscape and flowers with his tongue. Returning to China, he founded an art school in Shandong.

Huang Fabang 黃發榜 (b. 1938, Jiangling, Hubei province). *Guohua* and oil painter. Trained in ZAFA. Worked for some years in Hubei. 1984 joined staff of ZAFA, teaching *guohua*. Noted for his 1985 oil portrait of his teacher, **Pan Tianshou.**

Huang Gengqing 黃耿卿 (*zi* Shan Weng 山翁, b. 1927, Hong Kong). Painter. Educated in Guangzhou. 1952 returned to Hong Kong, 1956 graduated from Hong Kong AFA. 1981 completed diploma in modern Chinese ink painting in Extramural Studies Dept., Chinese University of Hong Kong. Became school teacher. 1987–88 chair of Federation of Asian Art Associations. Paints in various media, including Chinse ink and watercolor.

Huang Guangnan 黃光男 (b. 1944, Kao-hsiung, Taiwan). *Guohua* painter. MA from NTNU; became professor there. Director of Taipei Fine Art Museum, where he was active in promoting contemporary Chinese art. Director of National Museum of History, Taipei. Author of fifteen books on traditional and modern Chinese art.

Huang Guanyu 黃冠余 (b. 1945, Nanhaixian, Guangdong province). Oil painter, influenced by Gustav Klimt. Active in Beijing in late 1960s and 1970s. Graduated from CAFA High School. Taught in CAAC. Also active in theater.

Huang Huanwu 黃幻吾 (1906–85, native of Xinhui, Guangdong province). *Guohua* painter. 1928–36 studied and later taught *guohua* in Guangzhou. 1936–47 traveled in Southeast Asia, Japan, the Philippines, and North America. 1947 joined Painting Academy. From 1961 member of Wenhuaguan (Palace of Culture). Noted for his bird and flower paintings, stylistically related to Lingnan school.

Huang Huei-shyong. See **Huang Huixiong**

Huang Huixiong 黃輝雄 (Huang Huei-shyong, b. 1941). Sculptor. Active in Taipei.

Huang Jinlong 黃金龍 (Ung Kim Leng, b. 1958, Cambodia). Oil painter. Trained in Ecole Nationale Supérieure des Beaux Arts, Paris. Silver medal in Paris Salon and gold medal in ICAR Salon, Chambéry, France. 1995 living in Neuilly-Plaisance, France.

Huang Jinsheng 黃金聲 (b. 1935, Jilin province). Oil painter. 1956–61 studied under **Wu Zuoren** in CAFA. 1964–91 taught oil painting in Beijing Normal College.

Huang Jinxiang 黃金祥 (b. 1943, Wenzhou, Zhejiang province). Oil painter. 1968 graduated from ZAFA, where he became a teacher of oil painting. 1983 commissioned to paint large mural for Shanghai Hotel. Many exhibitions in US.

Huang Jinyu 黃錦玗 (b. 1944, native of Qidong, Jiangsu province). Printmaker. Active in Nanjing in 1980s and 1990s.

Huang Jixing 黃紀興 (n.d.). Nephew of the liberal educator Cai Yuanpei (Cai's wife's brother's son). Studied in Paris, where Cai kept a close eye on him. Later taught art at Hangzhou Academy.

Huang Junbi 黃君璧 (*hao* Junweng 君翁, 1898–1991, b. Nanhai, Guangzhou). *Guohua* painter. 1914 started to study painting under Li Yaoping. Organizer of Guihai Painting Cooperative, then Chinese Painting Research Society. 1922 studied Western painting in Guangzhou. 1926 met leading *guohua* artists in Shanghai. 1934 studied in Japan. 1938 moved to Sichuan. 1941 head of Chinese painting Dept., NAA Chongqing, under **Xu Beihong**. 1939 visited Emei shan with **Zhang Daqian**. 1949 moved to Taiwan. Professor and head of art Dept. of NTNU. 1957, 1966, and 1969 visited US. 1960

fellow of Brazil Arts Institute. A prominent art teacher in Taipei, where his style combined elements from Western art, Song classicism, and the technique of Shiqi (Kuncan). Has held many solo exhibitions worldwide. See Ch'en Ch'ang-hua 陳長華, ed., *Huang Junbi huaji* 黃君壁畫集 [Collected paintings of Huang Junbi] (Taipei, 1978); and Yin Meng Lo and Shui Yun Chai, *One Hundred Paintings by Master Junbi Huang* (New York, 1987).

Huang Junshi 黃君實 (Kwan S. Wong, b. 1934, Taishan, Guangdong province). Calligrapher and *guohua* painter. BA Hong Kong University. MA Kyoto University. 1972 settled in US. Vice-president of Chinese painting at Christie's New York.

Huang Leisheng 黃磊生 (Wong Lui-sang, b. 1928, Guangzhou, Guangdong province). Painter, Lingnan school. After studying under **Zhao Shao'ang** in Hong Kong, founded East Wind Art Studio. 1960 settled in San Francisco as professional artist. Many one-artist shows in US and Taiwan, where he eventually settled.

Huang Lu 黃魯 (Wong Lo, Stephen, b. 1958, Hong Kong). Painter. Studied oil painting in Singapore under An Hung. 1978 studied *guohua* under **Yang Shanshen**. Professional oil and *guohua* painter in Hong Kong, where he has held two solo exhibitions.

Huang Miaozi 黃苗子 (b. 1913, native of Zhongshan, Guangdong province). Calligrapher and art critic. With People's Art Press. 1931 **Ye Qianyu** introduced him to make cartoons for *Shanghai manhua* 上海漫畫. 1948 drawing cartoons in Hong Kong. Godfather of **Ding Cong**. 1989–95 in Brisbane, Australia, with his wife, **Yu Feng**. 1999 they returned to settle in Beijing.

Huang Mingchang 黃銘昌 (b. 1952, Hualian, Taiwan). Oil painter. Studied in Taiwan. 1977 went to Paris; 1984 graduated with distinction in oil painting from Ecole Nationale Supérieure des Beaux Arts. His closely textured paintings show influence of Andrew Wyeth. 1985 returned to teach in Taipei, where exhibition of his works painted in Paris was held that year.

Huang Mingzong 黃明宗 (Wee Beng-chong, b. 1938, Singapore). Sculptor, *guohua* painter, and graphic artist. Studied in Nanyang Academy in Singapore and Sculpture Dept. of Ecole Nationale Supérieure des Beaux Arts, Paris. 1964 founding member of Singapore Modern Art Society.

Huang Peizhong 黃培中 (b. 1944, Rugao, Jiangsu province). Printmaker and illustrator. Active in Nanjing.

Huang Pin-hung. See **Huang Zhi**

Huang Qiuyuan 黃秋園 (*zi* Mingqi 明琦, *hao* Dajuezi 大覺子, Ban'geseng 半個僧, Qingfenglaoren 清風老人, Tuisou 退叟, 1913–79, b. Nanchang, Jiangxi province). *Guohua* landscape, flower and figure painter. Self-taught. Before 1949 worked in bank. Later became active promoter of traditional painting, founding Nanchang Chinese Painting Research Society. Died of stroke while completing a 15-meter scroll of Lushan. At his 1986 retrospective exhibition, **Li Keran** greatly admired his work. Not well known as painter in his lifetime. 1986 posthumously honored as professor in CAFA. See *Han mo* 翰墨, no. 46 (1993.11).

Huang Rongcan 黃榮燦 (1916–52, native of Chongqing, Sichuan province). Wood engraver. Active in 1930s and '40s. Studied in NAA Kunming. During WWII active in southwest China. 1946 went to Taiwan.

Huang Rouchang 黃柔昌 (b. 1955, Nanjing). *Guohua* painter. 1982 graduated from Nanjing Normal University. 2004 vice-director of Painting Dept. of Nanjing Normal University Art Academy; director and assistant professor in Chinese Painting Research Institute, Nanjing. Specializes in delicately painted female beauties.

Huang Rui 黃銳 (b. 1952, Beijing). Oil painter. 1968–75 sent to countryside in Inner Mongolia. 1978–81 co-publisher of radical magazine *Jintian* 今天 with Bei Dao and Mang Ke. 1984 severe criticism drove him to take refuge in Tokyo, where he married a Japanese woman and developed into an installation artist. Founding member of the Stars and leading activist. Later returned to work in Beijing, where he helped to found Beijing Tokyo Art Projects in Factory 798. 2004 director of First Dashanxi International Art Festival at the Factory.

Huang Shanshou 黃山壽 (*zi* Xuchu 旭初, *hao* Xuchilaoren 旭遲老人, 1855–1919, native of Wujin, Jiangsu province). *Guohua* painter. Served briefly as minor official before settling in Shanghai. After 1940 active in Shanghai as professional painter and teacher. Noted for his blue-and-green landscapes and for his calligraphy, especially his clerical script (*lishu*).

Huang Shaoqiang 黃少強 (*hao* Zhilu 止廬, Xin'an 心庵, 1901–42, b. Nanhai, Guangdong province). Watercolorist and *guohua* painter. 1920 began to study painting with **Gao Lun** and **Zhao Shao'ang**. Ran Lingnan art school with Zhao Shao'ang. Briefly in Hong Kong. 1935 started People's Painting Studio (Minjian Huaguan) in Guangzhou, promoting paintings from common life. Died of illness in Foshan.

Huang Shiying 黃士英 (n.d.). 1934 caricaturist on staff of short-lived magazine *Shenghuo manhua* 生活漫畫, focusing primarily on war and politics. Also wrote critiques and essays on role of caricature in contemporary society.

Huang Tushui 黃土水 (1895–1930, native of Taiwan). Sculptor. Trained and worked in Tokyo.

Huang Wenbo 黃文波 (b. 1941, native of Nanning, Guangxi province). Oil painter. 1959–64 studied in Guangzhou Academy; after graduation 1964 became a teacher there.

Huang Wennong 黃文農 (?–1934). Cartoonist working in Shanghai in 1920s and early '30s.

Huang Xianzhi 黃顯之 (1907–?, native of Hunan province). Oil painter. Studied under **Lin Fengmian** in Hangzhou, where he was member of radical Eighteen Art Society. 1931–35 studied in France. During WWII taught in Guilin and NCU Chongqing. After war taught in Nanjing University.

Huang Xiaokui 黃孝逵 (Wong Hau-kwei, b. 1946). Graduated from China Textile University, Shanghai. 1978 moved to Hong Kong to establish his own business. 1990 started ink painting as hobby. 1997 first individual exhibition, Beijing. 1998 his works selected for Ninth China National Art Exhibition; one of them, *Wishes of God*, received commendation.

Huang Xinbo 黃新波 (1916–80, native of Guangzhou). Wood engraver and painter. In his early years, worked under patronage of Lu Xun in Shanghai; member of the League of Left-Wing Artists. 1937–41 active in anti-Japanese propaganda. 1946 went to Hong Kong, member of Renjian Huahui. 1949 back to Guangzhou, where he was active in art projects for the city. 1979 vice-chairman of CAA.

Huang Xuanzhi 黃玄之 (b. 1924, Yixingxian, Jiangsu province). Graphic artist. 1947 graduated from Western Painting Dept. of Suzhou Academy, then teacher and art editor. After 1954 teacher of graphics, especially *shuiyin* woodblock printing, in ZAFA.

Huang Yan 荒烟 (1920–89, native of Guangdong province). Wood engraver. Worked in Yan'an and liberated areas during and after WWII. After 1950 art editor of *Guangming ribao*.

Huang Yanghui 黃養輝 (b. 1911, native of Wuxi, Jiangsu province). *Guohua* painter and calligrapher. Studied under **Xu Beihong** in Chongqing. In Guilin, trained art teachers for Guangxi province. During WWII, Wendell Wilkie, President Roosevelt's roving ambassador who visited China, organized exhibition of his paintings in US. 1946 assistant professor in NAA Beijing. Later professor in Xuzhou AFA.

Huang Yao 黃堯 (1914–87, b. Shanghai). Painter and calligrapher. 1933–37 editor and journalist for *Shanghai News*. 1936 helped organize first national cartoon exhibition. During WWII traveled widely in west China publishing books of cartoons. 1946–47 in Vietnam. 1947–51 in Hong Kong. 1951–56 in Thailand. 1956 settled in Malaysia, teaching, painting, and publishing. 1976 settled in Kuala Lumpur. 2001 retrospective in Singapore Art Museum.

Huang Yishi. See **Huang Shaoqiang**

Huang Yonghou 黃永厚 (b. 1930, Fenghuang, Hunan province). Brother of painter **Huang Yongyu.** Member of Anhui Painting Academy, Hefei.

Huang Yongping 黃永砅 (b. 1954, Xiamen, Fujian province). Installation artist. 1982 graduated from ZAFA. Leader of Xiamen Dada, which held controversial exhibitions in 1986. Since 1989 has lived and worked in Paris, exhibiting his installations worldwide. 1989 participated in group exhibition Magiciens dela terre, Centre Pompidou, Paris. 1999 exhibited in 48th Venice Biennale. 2000 Shanghai Biennale. 2003 Venice Biennale. 2005 Cantor Center for Visual Arts, Stanford University.

Huang Yongyu 黃永玉 (b. 1924, Fenghuang, Hunan province). Painter, wood engraver, and graphic artist. Worked in porcelain factory when young. During WWII studied with **Li Hua** and **Lin Fengmian** in Chongqing. 1946 studied woodcut in Shanghai. 1948 went to Taipei and Hong Kong; art editor of *Dagongbao*, member of Renjian Huahui. 1953 returned to China, taught graphic art at CAFA. 1966–72, with **Huang Zhou, Shi Lu,** and **Ya Ming,** sent to countryside to work as peasant. 1978 designed landscape tapestry of Mao Zedong Memorial Hall. 1989 settled in Hong Kong for some years having successful career as professional artist. Later returned to Mainland and built himself houses in Beijing and his native Fenghuang. See Huang Miaozi 黃苗子, ed., *Huang Yongyu* 黃永玉 (Hong Kong, 1989); and Li Hui 李輝, *Huang Yongyu,* 黃永玉, *Zhongguo jindai mingjia huaji* 中國近代名家畫集 [Famous modern Chinese painters] (Beijing, 1999). (*Portrait on p. 66.*)

Huang Zhi 黃質 (Huang Binhong/Pin-hung 賓虹, Huang Zhi, *hao* Pucun 樸存, Yuxiang 予向, 1865–1955, b. Jinhua, Zhejiang province, native of Shexian, Anhui province). *Guohua* painter, connoisseur, and art scholar. Trained for official career, but failed civil service examinations several times before devoting his life to art. In his early years he was much involved with art scholarship and publishing, being chief compiler of *Meishu congshu* (1911–47), the great anthology of writings on painting. Studied *guohua* independently in Shanghai, where he lived from 1909 to 1937. 1920 changed his *mingzi* from 濱虹 to 賓虹. 1926 organized Chinese Calligraphy, Painting,

and Seal-carving Society. 1928 appointed professor in Xinhua AFA, Shanghai. 1929 founding principal of Zhongguo Wenxue Yuan. 1937 went to Beijing, taught in Painting Academy. At this time his eyesight began to deteriorate, although the works he painted in the 1940s are among his finest. Spent WWII in Beijing where, in 1941, he refused offer of directorship of Beijing Art Museum and refused to attend eightieth birthday celebrations arranged for him by the Japanese. 1948 appointed professor in NAA Hangzhou. Also taught in several other colleges. His paintings of the years between 1943 and 1955 were characterized as "thick, dark, dense and heavy," although this description applies more particularly to his work of the early 1950s. After an operation for double cataracts in 1953 his eyesight greatly improved, and his last works were in a free style. He was the leading figure in the revived Anhui school of scholarly landscape painting; much admired by, among others, **Li Keran.** Member of many literary and art societies, including the Literature and Art Society (Wenmei hui). Exhibited with the Bees Society (Mifeng huahui), founded in 1929, although not a member. 1953 named Outstanding Artist of the Chinese People in honor of his ninetieth birthday. His collection, bequeathed to the state, is in the Zhejiang Provincial Museum, and his house in Hangzhou has become a museum. His writings include *Guhuawei* 古畫微 (A detailed study of ancient paintings) and *Binhong huayulu* 賓虹畫語錄 (*[Huang] Binhong's Notes on Painting*). See Jason Kuo, *Innovation Within Tradition: The Painting of Huang Pin-hung,* with contributions by Richard Edwards and Tao Ho (Williamstown, Mass., 1989); Yang Lizhou 楊力舟 et al., *Huang Binhong jingpinji* 黃賓虹精品集 [Masterpieces of Huang Binhong] (Beijing, 1991); *Homage to Tradition: Huang Binhong (1865–1955)* (Hong Kong, 1995); Wang Zhongxiu 王中秀, ed., *Huang Binhong wenji* 黃賓虹文集 [Collected writings of Huang Binhong], 6 vols. (Shanghai, 1999); *Han mo* 翰墨, no. 15 (1991.4), whole issue; Chen Fan 陳凡, ed., *Huang Binhong huayulu* 黃賓虹畫語錄 [Huang Binhong on painting] (Shanghai, 1961). (*Portrait on p. 65.*)

Huang Zhichao 黃志超 (Dennis Hwang, b. 1941, Hunan province). Painter. Went to Taiwan, where he taught in several institutions. 1971 exhibited in New York. 1972 settled in New York. Abstract painter, influenced by New York school.

Huang Zhiyang 黃志陽 (b. 1965, Taipei.) Artist. 1989 graduated from China Culture University, Taipei. Ink paintings, chiefly of figures, shown at 46th Venice Biennale (1995); Inside Out, New Chinese Art exhibition (San Francisco and New York, 1998); and in Contemporary Art in Taiwan tour (Australia, 1998–99).

Huang Zhongfang 黃仲方 (Harold Wong, b. 1943, Shanghai). *Guohua* painter. Son of the collector Huang Baoxi. 1948 family settled in Hong Kong. Studied painting under **Gu Qingyao.** 1977 founded Hanart TZ Gallery, Hong Kong. 1990 returned to

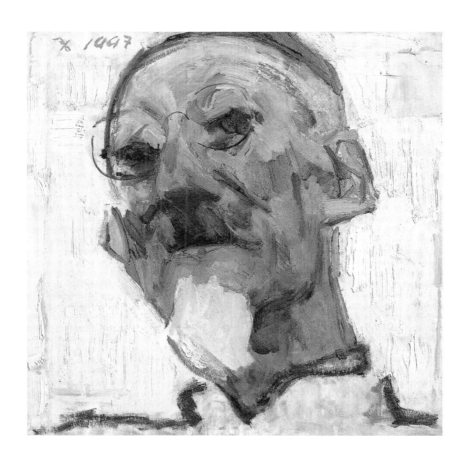

Huang Zhi (Huang Binhong). Portrait by Dai Shihe, 1997.

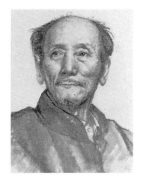
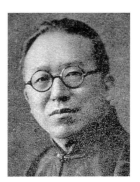

clockwise from left
Huang Yongyu. Portrait (detail) by Jin Shangyi.
Jiang Zhaohe. Self-portrait (detail).
Jin Cheng, 1917.

painting full time. Conservative artist of distinction, whose work shows influence of **Huang Binhong**. 1999 major retrospective exhibitions in Hong Kong (Fung Ping Shan Art Gallery) and in Shanghai. See Lu Fusheng 盧輔聖, ed., *Huang Zhongfang huaji* 黃仲方畫集 [Collected paintings of Huang Zongfang] (Shanghai, 1999).

Huang Zhou 黃冑 (b. 1925, Lixian, Hebei province). *Guohua* painter. Studied under **Zhao Wangyun** in Xi'an. After 1945 joined KMT army. Condemned early in Cultural Revolution. 1966–72, with **Huang Yongyu, Shi Lu,** and **Ya Ming,** sent to countryside to work as peasant. 1974 denounced again by Jiang Qing. Noted for his paintings of Xinjiang people, horses, horsemen, and donkeys.

Hui, Pat Suet-bik. See **Xu Xuebi**

Hui Xiaotong 惠孝同 (1902–79, native of Beijing). *Guohua* painter, chiefly of landscapes. 1920 joined Chinese Painting Research Society. 1927, with **Hu Xichuan** and others, established Hu She Painting Society and became head of Tianjin branch. Visited Japan with members of the society. After 1949 active in *guohua* movement in Beijing.

Hung Hoi. See **Xiong Hai**

Hung Hsien. See **Hong Xian**

Hung Keung. See **Hong Qiang**

Hung Liu. See **Liu Hong**

Huo Gang 霍剛 (Ho Kang, b. 1932, Nanjing). Painter. Studied under Li Zhongshang. 1964 studied in Barcelona, Paris, Vienna, Zürich. From 1965 living in Milan. Founding member of international art group Ton Fan. Abstract expressionist. Has exhibited widely in Taiwan and Europe, especially Italy.

Hwang, Dennis. See **Huang Zhichao**

Jao Tsung-i. See **Rao Zongyi**

Ji Cheng 汲成 (b. 1942, Yunnan province). Oil painter. Studied in CAFA under **Wu Zuoren** and **Ai Zhongxin**. Since 1973 teaching in Tianjin Academy.

Ji Dachun 季大純 (b. 1968, Nantong, Jiangsu province). Oil painter and mixed-media artist. 1993 BA in oil painting from CAFA. 1999 and 2000 solo exhibitions in China. 2000 exhibited in Shanghai Biennale.

Ji Kang 季康 (*zi* Ningfu 寧復, b. 1909, Shigu, Zhejiang province). Painter of flowers, insects, crabs, etc. Traditional school. Studied in Shanghai. Lives in Beijing.

Jia Difei 賈滌非 (b. 1957, native of Jilin province). Oil painter. 1983 graduated from LXAFA in Shenyang. Became professor in Fine Art Dept. of Jilin Art Academy.

Jia Haoyi 賈浩義 (b. 1938, native of Hebei province). *Guohua* painter. 1961 graduated from CAFA. Member of Beijing Academy of Painting.

Jia Youfu 賈又福 (b. 1942, Xiaoning, Hebei province). *Guohua* painter. 1965 graduated from CAFA, where he studied under **Li Keran**. Associate professor in CAFA. Well known for his paintings of Taihang mountains.

Jian Jinglun 簡經綸 (1888–1950, native of Panyu, Guangdong province). *Guohua* painter, calligrapher, and seal carver. 1937 settled in Hong Kong, where he pursued career as professional artist and teacher.

Jiang Baolin 姜寶林 (b. 1942, Penglaixian, Shandong province). *Guohua* painter. 1962–67 studied under **Lu Yanshao** and **Pan Tianshou** in ZAFA. 1977–79 studied under **Li Keran** in CAFA. 1981 graduated in *guohua* from CAFA. 1994 professor in ZAFA. 1967 arrested as counter-revolutionary and imprisoned for one month with Pan Tianshou and others. 1989 his works published in Taiwan, held one-man show in Kao-hsiung. 1993 judge in first national landscape exhibition in Beijing. 1994 solo exhibition in Hong Kong. 1996 guest professor at CAFA.

Jiang Bibo 江碧波 (b. 1939, Zhejiang province). Mixed-media artist and printmaker. Her father, Jiang Mi 江枚, was a painter and wood engraver. 1962 graduated from Sichuan AFA, Chongqing. 1929 visited Japan. 1982 exhibited at Paris Spring Salon. Has since exhibited in Canada, the US, and Sichuan.

Jiang Changyi 蔣昌一 (b. 1943, Xiangxiang, Hunan province). Oil painter. 1966 graduated Nanjing Academy. Since 1988 president of Shanghai Oil Painting and Sculpture Academy.

Jiang Dahai 江大海 (b. 1947, native of Beijing). Painter. Graduated from Oil Painting Dept. of CAFA; later taught at high school affiliated with CAFA. Studied in France.

Jiang Danshu 姜丹書 (1885–1962, native of Jiangsu province). Calligrapher and *guohua* painter. Studied in Liangjiang Sifan Xuetang, which included the first rudimentary art school in China. 1920 joined reformist Chinese Society for Aesthetic Education in Shanghai, which published the influential journal *Meiyu* 美育 (Aes-

thetic education). Active in administration of art schools, chiefly in Shanghai and Hangzhou.

Jiang Eshi 蔣諤士 (Chiang Erhshih, b. Yangzhou, Jiangsu province). Traced his ancestry to the eighteenth-century court painter Jiang Tingxi. Studied under Yangzhou scholars and in late 1930s under **Huang Binhong.** During WWII in Shanghai, later on staff of Museum and Art Gallery in Guilin. After 1949 left for Hong Kong and New York. In 1960s had houses in Marbella and Lucerne. Made a fortune as a dealer.

Jiang Feng 江豐 (original name Zhou Jiefu 周介福, a.k.a. Zhou Xi 周熙, Zhou Lin 周林, Gao Gang 高崗, 1910–82, Shanghai). *Guohua* and oil painter and woodcut artist. Member of Yiba Yishu. Trained in Shanghai White Goose Preparatory Painting School. 1932 joined CCP. 1938 went to LXALA in Yan'an. 1949 part of Military Control Commission in charge of Hangzhou Academy, of which he was briefly president. 1950 became president of CAFA. 1958 disgraced as loser in power struggle with Ministry of Culture over his attempt to promote updated and reformed *guohua.* 1979 restored to favor as director of CAFA and chairman of newly restored CAA. Died suddenly of heart attack at Party meeting in midst of heated debate on modern art.

Jiang Guofang 姜國芳 (b. 1951, Shangjiang *xian,* Jiangxi province). Oil painter. 1978 graduated from CAFA. Realistic painter of historical and figure subjects who has exhibited worldwide.

Jiang Haicheng. See **Ai Qing**

Jiang Handing 江寒汀 (1903–63, b. Changshu, Jiangsu province). *Guohua* painter. Taught in Shanghai Chinese Painting Academy, where he was noted for birds and flowers.

Jiang Hongwei 江宏偉 (b. 1957, Wuxi, Jiangsu province). *Guohua* painter. 1977 graduated from Nanjing Academy, where he has since became assistant professor. 1984–2002 participated in sixteen exhibitions in China, Japan, Europe, Singapore, and US. See Civic and Municipal Affairs Bureau of Macao, *Flowers and Birds: Jiang Hongwei's Chinese Paintings* (Macao, 2002); and *Contemporary Fine-line Style Bird and Flower Paintings: Jiang Hongwei* (Beijing, 2002).

Jiang Mingxian 江明賢 (Chiang Ming Shyan, b. 1942, Taichung, Taiwan). *Guohua* landscape painter. 1968 BA from NTNU. 1974 MFA, La Escuela Superior de Bellas Artes de San Fernando, Madrid. 1975 studied art history in New York University. Many visits to US and other countries. 1979 associate professor at Donghai University,

Taiwan. 2002 chair of Fine Art Dept. at NTNU. 1980 solo exhibition in National Museum of History, Taipei, and in Mikimoto Gallery, Tokyo.

Jiang Tiefeng 蔣鐵峰 (b. 1938, Ningbo, Zhejiang province). Painter. Student of **Huang Yongyu** and **Pang Tao.** 1985 she went to teach in Academy of Kunming, Yunnan. 1980s leading member of Modern Heavy Color Group.

Jiang Wenzhan 江文湛 (b. 1940, Tancheng, Shandong province). *Guohua* painter. 1980 graduated from postgraduate class in Traditional Chinese Painting Dept. of Xi'an AFA, where he remained as teacher. 1986 vice-president of Xi'an Painting Institute. 1998 exhibited chiefly birds and flowers in Shanghai Biennale.

Jiang Xiaojiang 江小鶼 (Jiang Xin 江新, 1893–1939, native of Wuxian, Jiangsu province). Sculptor. Before 1930s spent two years in France. From 1926 in Shanghai, close friend of **Xu Beihong** and Xu Zhimo, for whose works he designed book covers. Member of Heavenly Horse Society (Tianma hui). 1927–28 formed Yiyuan Art Academy in Shanghai with **Wang Jiyuan, Pan Yuliang,** and others. 1928 created monumental bronze equestrian figure of Chen Yingshi set up beside West Lake, Hangzhou.

Jiang Xiaoyou 蔣孝遊 (b. 1911, native of Haiyuxian, Zhejiang province). *Guohua* painter. Graduated in design from Xinhua AFA, Shanghai, then turned to *guohua*. Stayed in Shanghai during WWII. Worked as commercial artist. After 1949 active in Shanghai and Anhui.

Jiang Yan 姜燕 (1920–58, native of Wuchang, Hubei province). *Guohua* painter. She graduated from NAA Beijing.

Jiang Yonggen 蔣永根 (active ca. 1958). Peasant painter. Active in Jiangsu province.

Jiang Yun 姜筠 (*zi* Yingsheng 穎生, *hao* Yixuan 宜軒, Daxiong shanmin 大雄山民, 1847–1919, native of Huaining, Anhui province). *Guohua* painter, poet, and calligrapher. Lived in Beijing. His pupil **Xiao Sun** and perhaps others ghost-painted for him.

Jiang Zhaohe 蔣兆和 (1904–86, native of Luzhou, Sichuan province). *Guohua* painter, also self-taught in Western realistic technique. 1929 exhibited street scene in oils in National Ministry of Education Art Exhibition. Early 1930s taught painting in Nanjing and Shanghai. 1935 went to Beijing, where he remained during WWII. After 1945 visited Hong Kong briefly. Famous for his realistic figure paintings, especially his huge *Refugees* of 1942–43, which was partly destroyed. For many years taught in CAFA. After 1949 with Hangzhou Academy. The poetic realism of his work before 1949 was replaced after Liberation by a bland optimistic tone. For a study of *Refugees*

and his whole career, see Xin Ping 許平, *Liumintu di gushi* 流民圖的故事 [The story of Refugees] (Beijing, 2004). (*Self-portrait on p. 66.*)

Jiang Zhaoshen 江兆申 (*zi* Shuyuan 菽原, 1925–96, b. Shexian, Anhui province). *Guohua* painter and art scholar. 1949 moved to Taiwan, where he studied under **Pu Ru**. He did research in US and served as deputy director of National Palace Museum, Taipei, retiring in 1991. Noted for his studies of Tang Yin, of literati painting, and of Zhang Daqian. See *Han mo* 翰墨, nos. 34 and 35 (1992.11, 12).

Jiang Zhenghong 蔣正鴻 (b. 1936, native of Zhejiang province). Woodcut engraver. 1956 studied graphic art at CAFA. 1960 professor at Central Minorities Institute. 1977 with Mural Dept. of CAAC.

Jin Bihui. See **Jin Dongfang**

Jin Cheng 金城 (*zi* Gongbo 鞏伯, Gongbei 棋北, Shaocheng 紹城, *hao* Beilou 北樓, 1878–1926, native of Wuxing, Zhejiang province). *Guohua* painter. Studied law in UK; became an industrialist. Shortly after Revolution of 1911 he founded Hu She Painting Society in Beijing and published *Hushe yuekan* 湖社月刊 to promote study of Song and Yuan painting, which had a wide influence for some years among Beijing traditionalists. 1920 he and **Chen Hengke** cofounded Chinese Painting Research Society in Beijing. 1921 and 1924 visited Japan. Known to foreigners as Kung-pah King, he was not a great painter, but a capable editor and organizer. (*Photo on p. 66.*)

Jin Daiqiang 靳埭強 (Kan Tai-keung, b. 1942, Guangdong province). *Guohua* painter. 1957 settled in Hong Kong. Studied in Extramural Studies Dept. of Hong Kong University. 1978–83 teaching member of One Art Society. Since 1984 teaching painting in Hong Kong Polytechnic. 1981 won Hong Kong Urban Council Fine Arts Award. Known for his semiabstract landscape paintings. Has held solo exhibitions in Hong Kong, Macao, and US.

Jin Dongfang 金東方 (Jane Chin Tung-fang, changed name to Jin Bihui 金碧輝, b. Changzhou, Jiangsu province). Oil painter, calligrapher, playwright, essayist, and journalist. With **Pang Tao**, trained under **Guan Liang** and **Lin Fengmian** in Hangzhou Academy. For some years she taught in Guangxi Art Academy. 1966 settled in Hong Kong. 1974–91 devoted herself to writing, then returned to painting. 1992 held her first solo exhibition in Changzhou. Noted for her Beijing Opera series and semiabstract calligraphic compositions.

Jin Gao 金高 (b. 1930, Beijing). Painter. Graduated from CAFA, then lived and painted in Mongolia for thirty years. 1952 graduated from CAA. 1960 member of CAA.

Art editor of *Inner Mongolia Art*. 1984 settled in US with her husband, sculptor **Wang Jida**.

Jin Gongbo. See **Jin Cheng**

Jin Jialun 金嘉倫 (King Chia-lun, b. 1936, Shanghai). Painter. Trained in NTNU; MFA from Chicago Art Institute. Earlier works are contemporary in style, including hard-edge and avant-garde. Later work more traditional. In charge of art program in Extramural Studies Dept. in Hong Kong University. Since 1967 teaching design at New Asia College, Chinese University of Hong Kong.

Jin Jieqiang 靳杰強 (Kan Kit-keung, b. 1943, Panyu, Guangdong province). Painter. 1957 moved to Hong Kong, where he studied physics in Chinese University of Hong Kong. 1968 to University of Florida. 1975 PhD in physics at University of Maryland. 1990s working as physicist and painting at home in Bethesda. *Guohua* style based on traditional technique, but realistic. 1996 huge four-panel painting of *Niagara Falls XII* (1996) in Wucius Wong's exhibition Mutations of Ink and Paper, New York. Settled on retirement in Washington, D.C.

Jin Qinbo 金勤伯 (Chin Ch'in-po, Ginpoh Y. King, b. 1911, Wuxing, Zhejiang province). Painter. Nephew of **Jin Cheng**. His father, Jin Qionglin, was a collector. Born into prominent industrialist family. 1933 graduated from Yanjing University with BA in liberal arts. 1937 caught in Beijing by Japanese occupation. 1947 father sent him to England and France for further study. 1949 to Taiwan. 1950 joined faculty of NTNU with **Pu Ru** and **Huang Junbi**. 1959 to Rhode Island School of Design as visiting professor. Early 1960s taught in Iowa City, where his paintings showed influence of abstract expressionism. Later taught in New Asia College, Chinese University of Hong Kong, 1966 returned to Taiwan, where he taught in several colleges. 2004 held solo exhibition in National History Museum, Taipei.

Jin Shangyi 靳尚誼 (b. 1934, Jiaozuoxian, Henan province). Oil painter. 1987 graduated from CAFA, where he was a student of Konstantin Maksimov. Studied oil painting in Germany. Also studied Dunhuang and Yonglegong murals and toured Tibetan areas of Gansu and Xinjiang. 1979 vice-president of CAFA; later president.

Jin Weitian 靳微天 (Kan May-tin, b. 1916, native of Guangdong province). Watercolor painter. 1937 founded Parkway Studio in Hong Kong. Since then has taught painting in a number of schools and teachers' training courses in Hong Kong and New Territories. 1959 appointed tutor for adult education section, Education Dept. of Hong Kong.

Jin Xuecheng 金學成 (1905–89/90, b. Fengxian, Jiangsu province). Sculptor. 1935 graduated from Tokyo Academy. 1980 still living in Beijing.

Jin Ye 金冶 (b. 1913, Shenyang, Liaoning province). Oil painter and art theorist. 1943 taught in Beijing in studio of Japanese artist Ōyama. After WWII taught in ZAFA. 1980s chief editor of *Xin meishu* 訢美術. 1985 retired.

Jin Zhiyuan 金志遠 (1930–84, native of Jiangsu province). *Guohua* painter, chiefly of landscapes. Studied in CAFA Beijing. Later joined Jiangsu Chinese Painting Academy in Nanjing.

Jing Kewen 景柯文 (b. 1965, native of Qinghai province). 1986 graduated from Oil Painting Dept. of Xi'an AFA; became lecturer there and director of Studio 4.

Ju Lian 居廉 (1828–1904, native of Panyu, Guangdong province). *Guohua* painter, chiefly of flowers. Had numerous concubines and students, and was important influence on **Gao Weng** and **Chen Shuren**.

Ju Ming. See **Zhu Ming**

Kan Kit-keung. See **Jin Jieqiang**

Kan May-tin. See **Jin Weitian**

Kan Tai-keung. See **Jin Jieqiang**

Kang Ning 康寧 (b. 1950, Jiang'an, Sichuan province). Print artist. Graduated from Sichuan AFA, where he taught in the Printmaking Dept. Some of his monochrome prints show influence of Pablo Picasso.

Kang Shiyao 康師堯 (b. 1921, Kaifeng, Henan province). *Guohua* painter. Studied in Wuchang Art and Technical School. 1944 went to Xi'an. Joined Xi'an Municipal Arts and Crafts Research Institute. 1958, during Great Leap Forward, was one of a group of artists—including **Shi Lu, Fang Jizhong,** and **He Haixia**—who created a flourishing school of *guohua* landscape painting with local character.

Kang Zuotian 亢佐田 (b. 1941, Shanxi province). *Guohua* painter. Active in Yanbei area of Shanxi.

King Chia-lun. See **Jin Jialun**

King, Ginpoh Y. See **Jin Qinbo**

King, Kung-pah. See Jin Cheng

Kong Boji 孔柏基 (b. 1932, Shanghai, native of Jinhua, Zhejiang). From 1956 taught in art faculty of Shanghai Drama Academy. 1979 and 1983 visited Dunhuang and Gongle Palace, which greatly influenced his work. Has exhibited in Japan, New York, and London.

Koo Mei. See Gu Mei

Koo Tsin-yaw. See Gu Qingyao

Kuan Chih-chung. See Guan Zhizhong

Kuang Hui-ting. See Kuang Yaoding

Kuang Yaoding 鄺耀鼎 (Kuang Hui-ting, Kwong Yeu Ting, Kwong Yaü-ting; b. 1922, Macao). Oil painter and printmaker. 1949 graduated with MA in landscape design, Kansas State University. 1956 studied in England, France, and Italy. 1957 group exhibition, New Vision Centre Gallery, London. Returned to Hong Kong. 1978, after teaching in several institutions, appointed lecturer in fine art in Chinese University of Hong Kong. On retirement, he settled in Vancouver.

Kuo Chuan-chiu. See Guo Juanqiu

Kuo-Jen, Lucas. See Guo Ren

Kwan Wai Nung. See Guan Huinong

Kwok Hon Sum. See Guo Hanshen

Kwok Mang-ho. See Guo Menghao

Kwong Yaü-ting. See Kuang Yaoding

Kwong Yeu Ting. See Kuang Yaoding

Kwok Ying. See Guo Ying

Lai Chi-man. See Li Zhiwen

Lai Chunchun 賴純純 (Lai Jun, Jun T. Lai, b. 1953, Taipei). Sculptor and printmaker. Studied in Taipei, Japan, and 1980–82 at Pratt Institute, New York. Works in cement

and steel. She has held solo exhibitions in Taiwan, Tokyo, and US. 2003 living in Yangmingshan, Taipei.

Lai Chusheng 來楚生 (1903–75, native of Zhejiang province). *Guohua* painter and calligrapher. Studied in Shanghai Meizhuan under **Wu Changshuo**, then taught there and in Xinhua AFA. 1956 joined Shanghai Painting Academy. Specialist in birds, flowers, animals, and painting of glassware.

Lai Fengmei 賴鳳美 (Lai Foong-moi, b. 1930s, Malaysia). Oil painter. Trained in Nanyang Academy, Singapore. 1955–59 she studied in Paris. Returned to teach in Nanyang Academy.

Lai Foong-moi. See **Lai Fengmei**

Lai Jun. See **Lai Chunchun**

Lai, Jun T. See **Lai Chunchun**

Lai Kit-cheung. See **Li Jiexiang**

Lai Ming. See **Li Ming**

Lai Ming Hoi, Victor. See **Li Minghai**

Lai Shaoqi 賴少其 (1915–2000, Puning, Guangdong province). Painter and calligrapher. 1937 graduated from Guangdong Provincial Art College, where he joined Modern Woodcut Society. 1939 supported Woodcut Society in Guangxi, edited *Salvation Woodcut* and *Woodcut Art Monthly*. After Liberation became active in Shanghai in political control of the arts.

Lai Tianchang 賴恬昌 (b. 1921, native of Zengcheng, Guangdong province). Calligrapher and painter. Former director of Extramural Studies Dept., Chinese University of Hong Kong. Has published more than thirty books on Chinese painting and painters. 1980s took up painting after his retirement. His landscapes combine Chinese elements with influence of Claude Monet and Henri Matisse.

Lam Tianxing. See **Lin Tianxing**

Lan Yinding 藍蔭鼎 (Ran In-ting, 1903–79, b. Taipei). Oil and watercolor painter. Studied in Taipei under Ishikawa Kin'ichirō. 1930, after brief visit to Tokyo, he returned to teach in Taipei. 1942 toured Japanese-occupied China and Korea. After

WWII continued to work in Taipei, serving on staff of a journal and painting watercolors. Held solo exhibition in Historical Museum; visited US.

Lau Chai Fat. See Liu Qifa

Lau Ping-hang. See Liu Bingheng

Lau Wai-ki. See Liu Weiji

Lee, Aries. See Li Fuhua

Lee Chue-shek. See Li Zhushi

Lee, Chun-yi. See Li Chunyi

Lee, Dora Fugh. See Fu Duoruo

Lee Fu-hung. See Li Fuhong

Lee, I-hung. See Li Yihong

Lee Joo For. See Li Ruhuo

Lee Kar-siu. See Li Jiazhao

Lee Kwok-hon. See Li Guohan

Lee Qum-pui. See Li Kunpei

Lee Shi-chi. See Li Xiqi

Lee Wai-on. See Li Wei'an

Lei Guiyuan 雷圭元 (1905–89, Jiangsu province). Painter, graphic artist, and designer. Studied in NAA Beijing. 1929 went to study in Paris. 1931 returned to China to teach in Hangzhou Academy. During WWII head of Art Dept. of Sichuan University, Chengdu. 1945 returned to Hangzhou. 1956 appointed deputy director of CAAC. 1966 editorial member of *Meishu* 美術.

Lei Langliu 雷浪六 (Lui Long-luk, 1902–84, native of Taishan, Guangdong province). *Guohua* and Western-style painter, sculptor, seal carver, essayist, and poet. 1922 graduated from National University of Art, Tokyo. 1920s and '30s taught in Shang-

hai. 1940 settled in Hong Kong, where he became chairman of the Hong Kong Chung Kok Chinese Art Club.

Leng Jun 冷軍 (b. 1963, native of Sichuan province). Oil painter and mixed-media artist. 1984 graduated from Oil Painting Dept. of Wuhan Teachers and Training College, Hankou branch. Vice-president of Wuhan Art Academy. Noted for his paintings of engines and machinery.

Leung Chi Wo. See Liang Zhihe

Leung Kui-ting. See Liang Juting

Leung Mee-ping. See Liang Meiping

Leung Pak-yu. See Liang Boyu

Li Ai-wei 李愛薇 (b. 1932, Shanghai). Artist. 1952–58 studied under **Lin Fengmian** in Shanghai. Married Swiss husband. 1958 left for Hong Kong. 1972 set up her studio at Blonay on Lake Geneva.

Li An. See Li Shutong

Li Baijun 李百鈞 (b. 1941, native of Shandong province). Artist. 1963 graduated from Shandong AFA, Jinan, where she became a teacher. Specializes in New Year pictures.

Li Bangyao 李邦耀 (b. 1954). Painter. 1978 graduated from Hubei AFA. Became associate professor in Art Dept. of South China Normal University. Exhibitions include First Biennial Art Exhibition, Guangzhou, 1992.

Li Binggang 李秉剛 (b. 1947, native of Xinmin, Liaoning Province). Oil painter with the military.

Li Binghong 黎冰鴻 (1913–86, native of Dongguan, Guangdong province). Oil painter. 1913 went to Hong Kong, worked in bookshop, designed for cinema. 1937 to west China, joined anti-Japanese art campaign. 1946 joined New Fourth Army and CCP. After Liberation joined Oil Painting Dept. of East China Campus (later ZAFA). He was also a staff artist for Shanghai People's Art Press. Contributed to "history painting" program for museums. Vice-president of ZAFA.

Li Chaoshi 李超士 (1893–1971, b. Vietnam, native of Dongguan, Guangzhou province). Oil painter. 1911 taken from middle school in Shanghai to England. 1913 taken to Paris, where he began to study painting. 1919 returned to China after graduation.

Active in Western art world of Shanghai. Founder—with **Lin Fengmian, Wu Dayu,** and others—of Art Movement Society. 1921 participated in third exhibition of Tianma-hui and was appointed professor in Shanghai Meizhuan. After Liberation taught in CAFA, Shandong Normal College, and elsewhere.

Li Chundan 李春丹 Wood engraver. 1929 founding member of radical Eighteen Art Society, Shanghai.

Li Chunyi 李群毅 (Chun-yi Lee; b. 1965, Gaoxiong, Taiwan). 1988 BA Chinese University of Hong Kong. 1997 MFA Tunghai University, Taichung, Taiwan. Painter, student of **Liu Guosong.** 1989 first solo exhibition at Triform Art Gallery, Taipei. Many group exhibitions since. "Symbolic" landscapes with Buddhist heads, *gigaku* masks, and cross-shaped motifs influenced by **Liu Guosong** and **Wang Wuxie.**

Li Dongping 李東平 (native of Meixian, Guangdong province). Painter. Trained in Japan. Early 1930s returned to Shanghai. 1934 in Shanghai, member of China Independent Art Association (founded that year by Chinese art students in Japan), which held its first exhibition in Guangzhou in 1935. 1935 participated in NOVA avant-garde exhibition in Shanghai.

Li Fangbai 李方白 (b. 1915, Hebei province). Traditional landscape painter. Associated with Beijing Art Co.

Li Fengbai 李風白 (b. 1910, Zhejiang province). Oil painter, watercolorist, and sculptor. 1925 went to Paris. 1927 entered Académie des Beaux Arts, where studied under Boucher and became leader, with **Hua Tianyou,** of Chinese art students. 1928–33 taught in Hangzhou Academy. 1933–53 returned to Paris, where in 1946 joined CCP. 1953 back to Beijing, worked at Foreign Languages Press. 1983 returned to Hangzhou.

Li Fenggong 李鳳公 (1883–1967, native of Dongguan, Guangdong province). *Guohua* painter. 1912 founded correspondence school of watercolor painting; set up Guangzhou Sculptural Art Co. to popularize casting with plaster. After 1938 lived and taught in Hong Kong, where he served as chairman of Hong Kong Chung Kok Chinese Art Club. Published several books on painting and seal engraving.

Li Fenglan 李風蘭 (b. 1933, Guangming, Huxian, Shanxi province). Huxian peasant painter. 1958 began painting; active in 1960s and '70s. Visited Japan with her work.

Li Fuhong 李撫虹 (Lee Fu-hung, original name Li Yaomin 耀民, *zi* Zhaoren 照人, 1902–90, native of Xinhui, Guangdong province). *Guohua* painter and calligrapher. Studied painting under **Gao Jianfu,** taught in Guangzhou, and later settled in Hong

Kong, where he taught in various institutions, including Extramural Studies Dept. of Chinese University of Hong Kong. Founding member and chairman and executive secretary of Hong Kong Chung Kok Chinese Art Club.

Li Fuhua 李福華 (Aries Lee, b. 1943, Hong Kong). Painter and designer. Studied in Tokyo National University of Arts until 1977, then in Düsseldorf. Works in Hong Kong.

Li Geng 李庚 (b. 1950, Beijing). *Guohua* painter. Son and pupil of **Li Keran**, and sculptress Zou Peizhu 鄒佩珠. Studied in Tokyo University of Art. 1982–83 held solo exhibitions in Japan.

Li Guijun 李貴君 (b. 1964, Beijing). Oil painter. 1984 entered Studio 1 at CAFA, where in 1988 he became a teacher. His highly finished oil paintings have been widely exhibited in China and abroad.

Li Guo'an. See **Li Ming**

Li Guohan 李國翰 (Lee Kwok-hon, b. 1950, Hong Kong). Realist oil painter. Studied in Hong Kong and, from 1971, in Ecole Nationale Supérieure des Beaux Arts in Paris. 1976 settled in Paris.

Li Guorong 李國榮 (Li Kwok Wing, b. 1929, Hong Kong). Painter, etcher, and printmaker. From 1956 art lecturer in Grantham College of Education and member of Hong Kong Artists Association. Published *Le Clodo [sic] du dharma: 25 poèmes de Han-shan, calligraphies de Li Kwok-Wing* (Paris, 1975).

Li Guoyi. See **Gu Yi**

Li Hongren 李宏仁 (b. 1931, Beijing). Painter and graphic artist. 1953 graduated from CAFA. 1985 associate professor and head of lithography section of CAFA. 1983 visited Britain, worked for two months in Manchester. 1986 invited to participate in Ninth Print Biennale, Bradford, UK.

Li Hu 李斛 (1919–75, b. Dazu, Sichuan province). *Guohua* painter. Studied under **Xu Beihong** in NCU Nanjing. During WWII in Chongqing. After 1949 lectured in Chinese Painting Dept. of CAFA. Noted for lyrical landscapes combining Chinese and Western techniques.

Li Hua 李華. See **Li Huayi**

Li Hua 李樺 (*zi* Junying 俊英, 1907–94, b. Panyu, Guangdong province). Wood engraver and ink painter, chiefly of figure subjects. 1925 graduated from Guangzhou

Academy. Went to Japan for further study. 1930 returned to China to teach in his alma mater. Founder of Modern Woodcut Society in Guangzhou, closely associated with Lu Xun. 1945 went to Shanghai, where his famous print *Roar China!* became a powerful expression of anti-imperialist and anti-Japanese feeling. Active in anti-Japanese propaganda during WWII. 1949 professor in Graphic Arts Dept. of CAFA, then chairman of Chinese Wood Engravers Association. A leading figure in political control of arts; vigorous opponent of all forms of modern art. (*Photo on p. 124.*)

Li Huaji 李華吉 (b. 1931, Beijing). Oil painter. 1959 graduated from CAFA, where he studied under **Dong Xiwen** and **Luo Gongliu;** remained there teaching oil painting. Member of Oil Painting Research Society. Executed decorative paintings for Beijing Airport and Yanjing Hotel with his wife, **Quan Zhenghuan.** Director of Wall Painting Dept. of CAFA. More recent works include exquisitely painted small oils, notably of ritual objects and of smoggy atmosphere of Beijing.

Li Huanmin 李煥民 (b. 1930, Beijing). Wood engraver and decorative artist. 1951 graduated from CAFA. Council member of CAA and Chinese Graphic Artists Association, and vice-chairman of Sichuan branch of CAA. Winner of first prize at National Youth Exhibition and silver medal at Sixth National Art Exhibition.

Li Huasheng 李華生 (b. 1944, Yibin, Sichuan province). Painter. First learned Western methods of drawing and oil paintings under Yu Jiwu (b. 1900, a former pupil of **Lin Fengmian**), then traditional styles and seal carving under Zeng Youshe (d. 1985) and Guo Manchu (b. 1919) in the Chongqing Culture Hall. 1972–76 came under the liberating influence of **Chen Zizhuang,** developing expressionist ink paintings (chiefly landscape) for which he is best known. 1985 elected honorary member of Sichuan AFA. 2000 exhibited in Shanghai Biennale, his close-textured works in ink purged of all expressionist elements of his earlier painting. His turbulent career is well documented in Jerome Silbergeld, *Contradictions: Artistic Life, the Socialist State, and the Chinese Painter Li Huasheng* (Seattle and London, 1993). (*Photo on p. 101.*)

Li Huayi 李華弋 (b. 1948, Shanghai). Painter. As a child in Shanghai encountered Wang Jimei (son of **Wang Zhen**). Later studied under **Zhang Chongren.** 1982 moved to San Francisco. To avoid confusion with a well-known Taiwanese forger, he changed his name from Li Hua to Li Huayi (although he continued to use the Li Hua seal as well). His work on first arriving in America was eclectic, some of it inspired by archaic bronze motifs. Later it tended to follow and reinterpret classical models such as Fan Kuan and Li Tang.

Li Hui'ang 李慧昂 (b. 1954, native of Hebei province). Oil painter. Studied in Sichuan AFA. Bronze medal in Second National Youth Art Exhibition.

Li Ji 李季 (b. 1963, Kunming, Yunnan province). 1987 graduated from Sichuan AFA, Chongqing. 1990 completed his graduate studies in printmaking at CAFA. Known for his satirical figure paintings in oils.

Li Jianchen 李劍晨 (1900–2002, native of Neihuang, Hunan province). Painter and architect. 1926 graduated from Peiping National Art College. Taught in Kaifeng Normal College for some years. 1941 professor of architecture in NCU Chongqing. Wrote several books on watercolor painting, Chinese painting, seal carving, etc. 1980 solo exhibition of his watercolors in National Art Gallery, Beijing.

Li Jiazhao 李加兆 (Lee Kar-siu, b. 1949, Guangzhou). Oil painter. 1971 moved to Hong Kong. 1975 went to London to study in Sir John Cass (Guildhall) School of Art. Settled in Paris.

Li Jiexiang 李潔祥 (Lai Kit-cheung, b. 1950). Hong Kong artist. Photo-realist. 1976 settled in Paris.

Li Jin 李津 (b. 1958, Tianjin). Painter. Parents were Communist senior cadres. 1983 graduated from Painting Dept. of Tianjin Academy where he became professor in Dept. of Art Education. Active in avant-garde. Known for his somewhat satirical figure paintings.

Li Jinfa 李金髮 (1900–74, native of Meixian, Guangdong province). *Guohua* painter, sculptor. Early 1930s studied in Paris. 1924 returned to China. 1925 first major commission for bust of his patron, Cai Yuanpei. 1928–30 taught in Hangzhou Academy, later in Guangzhou. Did many memorial statues. Chief contributor to *Meiyu zazhi* 美育雜誌.

Li Jingkang 李景康 (1891–1960, native of Nanhai, Guangdong province). Amateur painter. Active in Hong Kong education. Taught a number of art courses and became a renowned collector of Yixing pottery.

Li Junyi 李君毅 (b. 1966, Kao-hsiung, Taiwan). *Guohua* painter. 1970 moved with his family to Hong Kong. While studying biochemistry at Chinese University he was encouraged by **Liu Guosong** to switch to painting. 1988 awarded French government scholarship to study in France. Returning to Taiwan, held his first solo exhibition in 1989 in Taipei. 1991 solo exhibition in CAFA gallery, Beijing. Works as professional artist in Taichung.

Li Junying. See **Li Hua**

Li Keran 李可染 (1907–89, native of Xuzhou, Jiangsu province). *Guohua* painter. Grew up on a farm. From 1923 studied oil painting under **Liu Haisu** in Shanghai Meizhuan; later student of **Qi Baishi, Huang Binhong,** and, from 1929, **Lin Fengmian** and André Claudot in Hangzhou. Inspired by the ideas of Kang Youwei, he sought to combine the realism of Renaissance painting and the chiaroscuro of Rembrandt with the expressive power of Chinese calligraphy; strongly influenced by the example of **Wu Changshuo**. 1931 member of Eighteen Art Society. Taught in Wuhan, where he joined Guo Moruo's art propaganda team, then in Sichuan. 1944, at Li's wedding to the sculptor Zou Peizhu, Lin Fengmian was best man. 1946 joined **Xu Beihong** in NAA Beijing. After 1950 professor in CAFA. After 1954 traveled in China and visited Eastern Europe. Famous for landscapes, herd boys, and buffaloes. During Cultural Revolution, he was denounced by Jiang Qing for his "black" paintings and sent for one year to work in the fields. 1974 retired into seclusion, refusing to paint the kind of pictures demanded of him. But after the death of Mao Zedong, his reputation soared, and his style of painting gained wide influence, with many imitators. Subject of a major study by his pupil Wan Qingli, *The World of Li Keran, 1907–1989* (Beijing, 2000); see also *Han mo* 翰墨 no. 10 (1990.4), complete issue, and nos. 25 (1992.2), 26 (1992.3), 43 (1993.8). (*Photo on p. 101.*)

Li Kuchan. See **Li Yingjie**

Li Kunpei 李焜培 (Li K'un-pei, Lee Qum-pui, b. 1934, Guangzhou). Watercolor painter, Western style. 1959 graduated from NTNU Art Dept., became professor. 1981 founding member of Taipei Art Club.

Li Kwok Wing. See **Li Guorong**

Li Liudang 李流丹 (b. 1920). Grew up in Indonesia. Western-style artist specializing in oil painting and woodcut. During WWII went to Chongqing, where he became a student of **Xu Beihong**. From 1952 taught in various art colleges in Hong Kong. 1982 founded Hong Kong Painters Association.

Li Manfeng 李曼峰 (1913–88, b. Guangzhou). Cantonese Lingnan-style and *guohua* artist. 1932 went to Indonesia. 1949 moved to Netherlands. 1952–55 painting in Indonesia. Specialized in fishes and flowers. Died in Singapore.

Li Meishu 李梅樹 (1902–83, b. Sanxia, Taiwan). Oil painter. Studied under Ishikawa Kin'ichirō in Taipei and, from 1928, in Tokyo. On his return helped found Taiyang Art Society. 1977–83 president of Fine Art Association of ROC. Pioneer of Western art movement in Taiwan. 1990 memorial gallery opened in Sanxia.

Li Ming 黎明 (Lai Ming, original name Li Guo'an 李國安, b. 1929, native of Nanhai, Guandong province). Painter. Studied painting under Luo Baoshan and, from 1944, under **Gao Lun**. 1953 moved to Hong Kong, where he met **Yang Shanshen** and opened his own teaching studio. For many years he has been active in teaching and promoting art in Hong Kong. His work shows technical mastery in tradition of Lingnan school.

Li Minghai 黎明海 (Victor Lai Ming Hoi, b. 1960, Hong Kong). Painter. 1987 BA in education from Liverpool University. 1990 MA from Royal College of Art. 1993–94 traveled in US on Asian Cultural Council fellowship. 2001 PhD in art history from Lancaster University. Senior lecturer in Creative Arts Dept. of Hong Kong Institute of Education.

Li Mingjiu 李明久 (Changbai Man, b. 1939, Jilin province). Painter. 1960 enrolled in Harbin College of Art, graduating in 1964. Worked as art editor. 1978 began to teach painting in Art Dept. of Hebei Normal University. Awarded bronze medal in Sixth National Art Exhibition. See Sui Fai Wing, ed., *Li Mingjiu Shanshui huaxuanji* [Selected landscapes of Li Mingjiu] (Hong Kong, 1994).

Li Qimao 李奇茂 (b. 1931, Woyang *xian*, Anhui province). Ink painter. After WWII moved to Taiwan, where he studied in Art Dept. of Military College, graduating in 1956. 1976 became dean of Arts Faculty of National Taiwan AFA. 1962 won gold award at Fifth National Art Competition.

Li Qingping 李青萍 (1910–2004). Oil painter. 1930s studied in Xinghua Academy, Shanghai. Before WWII went to Malaysia, where he met **Xu Beihong**. Early '40s returned to Shanghai, where his work was appreciated by the Japanese; visited Japan. 1945 returned to Shanghai. After 1949 worked in People's Art Publishing House.

Li Qiujun 李秋君 (*zi* Qiu 秋, 1898–1972, native of Zhejiang province). *Guohua* painter, literary school. Noted for her figures, flowers, landscapes in *jinbi* (gold and green) technique. 1934 cofounder, with **He Xiangning** and others, of Chinese Women's Art Association (Zhongguo nuzi shuhua hui). Member of Shanghai Chinese Painting Academy. Worked in Shanghai.

Li Quanwu 李全武 (b. 1957, Wuhan). Oil painter and graphic artist. Studied in Wuhan and CAFA, later returning to Wuhan as professor. Subsequently settled in US. Noted for portraits and figure studies painted in meticulous technique.

Li Qun 力群 (b. 1921, native of Shanxi province). Wood engraver. 1932 entered ZAFA Hangzhou. 1933 a founder of League of Left-Wing Artists. 1940 teaching in LXALA in Yan'an, where, in 1942, he was present at the Forum in Literature and Art. After

1949 vice-chairman of China Woodcut Association and active in political control of arts. 1952 moved to Beijing, worked in editorial office of People's Fine Arts Publishing House. Later assistant editor of *Meishu* 美術 and *Banhua* 版畫.

Li Ruhuo 利如火 (Lee Joo For, b. 1929, Penang, Malaysia). Painter and graphic artist. 1957–64 studied art in England. Later returned to teaching art in Kuala Lumpur. Controversial modernist.

Li Ruinian 李瑞年 (1910–85, b. Tianjin). Oil painter, chiefly of landscapes. 1933 graduated from NAA Beijing, went for further study to Royal AFA, Brussels, and to Paris. 1937 returned to China. During WWII in Kunming, then with **Xu Beihong** in Chongqing. From 1946, taught in Beiping National Art College and other institutions in capital. 1961 set up studio with **Wei Tianlin.** 1981 solo exhibition in CAFA gallery.

Li Ruiqing 李瑞清 (*hao* Qingdaoren 清道人, 1876–1920, native of Linchun, Jiangxi province). Qing official, member of Hanlin Academy, and amateur *guohua* painter and calligrapher. After 1900 president of Liangjiang Shifan Xuetang, where in 1905 the first Western-style art classes were held. After Revolution of 1911 settled in Shanghai, making his living by selling his paintings and teaching. Among his students in calligraphy was **Zhang Daqian.**

Li Shan 李山 (b. 1926, Qingdao). *Guohua* painter. Graduated from ZAFA. Pupil of **Pan Tianshou.** Later in Nanjing, influenced by **Fu Baoshi.** After graduating went to Xinjiang as editor for *Xinjiang Pictorial*. Painted Uighurs. During 1960s went to Nanjing; before Cultural Revolution taught in Jiangsu Academy. 1981 vice-president of Nanjing Artists Association.

Li Shan 李山 (b. 1944, Heilongjiang province). Oil painter. Studied Soviet-style oil painting in Harbin. 1968 graduated from Shanghai Drama Academy, where he became teacher of theatrical design. Symbolist-surrealist, member of Shanghai avant-garde. 1993 his art featured in China's New Art, Post-1989 exhibition (Hong Kong). 1998 exhibited in Inside Out: New Chinese Art (San Francisco and New York). Best known for his satirical "portraits" of Mao Zedong. Lives in Shanghai.

Li Shaowen 李少文 (b. 1942, Beijing, native of Shandong province). *Gongbi* painter and graphic artist. Studied Western painting in Beijing Fine Art Normal College. 1960 began to study *guohua*. 1978 graduate student of **Ye Qianyu** in CAFA, where he joined teaching staff in 1980. Noted for his book illustrations.

Li Shaoyan 李少言 (1918–95, b. Linyin, Shandong province). Wood engraver. 1938 joined CCP in Yan'an. 1950s and '60s promoted social realism in Sichuan. Art editor

and vice-director of Sichuan AFA. From 1951 chairman of Sichuan Artists Association. Influential figure and long-time opponent of progressive artists such as **Chen Zizhuang** and **Li Huasheng.**

Li Shi-chi. See **Li Xiqi**

Li Shinan 李世南 (b. 1940, native of Shaoxing, Zhejiang province). Expressionist figure painter and calligrapher. After working in Xi'an Arts and Crafts Institute, taught in Institute of Arts and Crafts, Qinghua University, Beijing.

Li Shiqiao 李石樵 (1908–95, b. Xinzhuang, Taipei county, Taiwan). Oil painter. 1929–36 studied at Taipei Teachers' College under Ishikawa Kin'ichirō, who helped him gain admission to Tokyo College of Art. 1944 returned to Taipei as independent artist with high reputation, which was eclipsed after WWII. Lived to see his position as pioneer Impressionist restored. 1963 joined staff of NTNU. 1977 retired. 1981 cofounder of Taiyuan Art Society. Eclectic Impressionist, influenced by Umehara Ryūzaburō. 1985 moved to Seattle to live with his daughter.

Li Shuang 李爽 (b. 1957, Beijing). Painter. Self-taught. Member of Stars. Stage designer for Chinese Youth Art Theatre. 1983 she emigrated to France, settled in Paris.

Li Shuoqing 李碩卿 (*zi* Yuntian 雲田, b. 1908, Quanzhou, Fujian province). *Guohua* painter. From 1927 trained in Western art in Xinhua AFA, Shanghai. Student of **Wang Xian** and **Pan Tianshou.** After Liberation worked chiefly in Quanzhou Arts and Crafts Factory. Painted genre subjects.

Li Shutong 李叔同 (Hongyi 弘一, *zi* An 岸, *hao* Xishuang 息霜, Kuanglu 壙廬, 1880–1942, b. Tianjin). Painter, calligrapher, poet, and musician. After 1898 Hundred Days of Reform failed, lived in French Concession of Shanghai. 1905–10 studied in Tokyo Art School under Kuroda Seiki. 1911 founder of Wenmeihui, Shanghai. Favorite pupil of Cai Yuanpei. 1912 taught at Zhejiang Normal College; art and literary editor of *Taipingyang bao*. 1918 became monk in Hangzhou, taking the name Hongyi; painted Buddhist pictures and did calligraphy. Pioneer in introducing Western arts, including commercial art, woodcut, theater, and music, into China. Influenced **Lü Fengzi, Liu Haisu, Xu Beihong,** and especially **Feng Zikai,** who illustrated and published a collection of Li's songs. His works have been collected by the Master Hongyi–Feng Zikai Research Center in Hangzhou Teachers' Training College. Wrote textbook on Western art that he refused to publish after he became a monk. Died in Quanzhou, Fujian province. (*Self-portrait on p. 101.*)

Li Tianxiang 李天祥 (b. 1928, Hebei province). Oil painter. Studied in NAA Beijing. 1953–59 studied in Leningrad Academy. From 1961 taught oil painting in Soviet

style in Studio 2 at CAFA, inaugurated by **Luo Gongliu.** 1985 director of newly established Shanghai Art Institute.

Li Tianyuan 李天元 (b. 1965, Heilongjiang province). Oil painter. 1988 graduated from Wall Painting Dept. of CAFA. Many medals, including gold medal for his painting *The Seductress* in 1991 Exhibition of Chinese Oil Painting in Hong Kong.

Li Tiefu 李鐵夫 (original name Li Yutian 李玉田, 1869–1952, native of Guangdong province). Oil painter, watercolorist, and sculptor. 1887 taken to US, then to England, where he studied in Arlington Art School. 1913 went to New York to study painting; worked there under influence of John Singer Sargent, William Merritt Chase, and Winslow Homer. 1930–42 worked in Hong Kong, where he had his first solo exhibition in 1935. 1943–47 lived in China. 1947–49 back to Hong Kong. 1950 professor in Hua'nan Art and Culture Institute, Guangzhou. A number of his early portraits in oils survive. See Chi Ge, ed., *Li Tiefu* (Taipei, 1996).

Li Wei'an 李維安 (Lee Wai-on, b. 1937). Painter. Active in Hong Kong since 1964. Member of In Tao Art Association. 1973 completed 3400 sq. ft. mural for Furama Hotel, Hong Kong. Teacher in Chinese University of Hong Kong.

Li Wenhan 李文漢 (b. 1924, native of Anhui province). Painter. Studied in Shanghai Meizhuan under **Liu Haisu.** 1949 went to Taiwan. Joined Ton Fan Group. Semiabstract style.

Li Xinping 李新平 (b. 1959, Beijing). Oil painter. 1982 graduated from CAFA. 1993–94 in St. Petersburg. Teacher in Beijing Normal College. Noted for figure subjects showing influence of Gustav Klimt, Frank Brangwyn, and Marie Laurencin.

Li Xiongcai 黎雄才 (1910–2001, Gaoyaoxian, Guangdong province). Landscape painter, Lingnan school. 1926–31 student of **Gao Lun.** 1932–35 studied in Japan at Tokyo AFA. From 1935 taught in Guangzhou and Chongqing. After 1949 taught in several art colleges in Guangzhou. Became deputy director and professor in Guangzhou Academy, vice-chairman at Guangdong Province Art Society. 1979 visited North Korea and Japan. 1982 solo exhibition in Hong Kong. 1983 visited Philippines, Thailand, and Canada; painted two large landscapes for Chinese Embassy in Ottawa. Prominent member of Lingnan School.

Li Xiqi 李錫奇 (Li Shi-chi, b. 1938, Beishan, Jinmen, Fujian province). 1949 family lost everything in attack on Jinmen. 1955–58 studied fine art in Taipei Normal College. 1959 exhibited with other young artists in Paris. 1959–65 exhibition in São

Paulo Biennale. Since then many traveling exhibitions in US, Hong Kong, Taipei, and Europe. 1963 joined avant-garde Ton Fan Group. Managed two modern print galleries in Taipei. Won a number of international awards for his prints. 1996 one-artist show in Taipei Fine Art Museum.

Li Xiuqin 李秀勤 (b. 1953, Qingdao). Sculptor. Graduated in 1982 from Sculpture Dept. of ZAFA. 1988 awarded scholarship to study in Glasgow. 1990 studied for her MA in sculpture in Manchester. 1999 received grant to study in Washington State University. Solo exhibitions in Washington State Univ. (1999) and Hangzhou (1993 and 1995). Currently associate professor of sculpture in ZAFA.

Li Xiushi 李秀實 (b. 1936, native of Liaoning province). Oil painter. 1961 graduated from Oil Painting Dept. of CAFA. Worked in Heilongjiang. 1988 returned to Beijing. Council member of Chinese Oil Painting Association.

Li Xubai 李虛白 (b. 1940, Fuzhou, Fujian province). *Guohua* painter and poet. From 1960s studied literature, poetry, and painting in Fuzhou with Ms. Liu Heng. 1979 moved to Hong Kong, where he married Fong Li. 1996 moved to Ottawa, Canada. 2005 living in Waterloo, Ontario.

Li Yan 李燕 (*zi* Zhuangbei 壯北, b. 1943, Beijing). *Guohua* painter. 1966 graduated from *Guohua* Dept. of CAFA, where he studied under **Li Yingjie**. 1973 worked with Rongbaozhai art publishing house. 1979 on staff of CAAC. Specializes in painting birds, animals and flowers.

Li Yan 李燕 (b. 1956, Longkou, Shandong province). Oil painter. 1982 graduated in oil painting from Qufu Teacher's University. 1989–90 studied in Dept. of Mural Painting of CAFA. Became lecturer in Shandong Light Industrial College. Has won many prizes. 1996 her hyperrealist studies exhibited in Shanghai Biennale.

Li Yanshan 李研山 (*zi* Juduan 居端, *hao* Yanshan 研山, 1898–1961, b. Xinhui, Guangdong province). *Guohua* painter. Studied law and Western painting in Beijing University. Returned to Guangzhou and joined Chinese Painting Research Society. 1931 principal of Guangzhou Municipal College of Art. During WWII lived in Hong Kong and Macao. 1949 settled in Hong Kong, where he became a traditional artist.

Li Yanzhou 李延洲 (b. 1954, native of Heilongjiang province). Oil painter. 1978 graduated from Oil Painting Dept. of CAFA. 1990 MA in stage design from Central Drama Academy. Works as independent professional painter.

Li Yihong 李義弘 (I-hung Lee, b. 1941, Tainan, Taiwan). Painter and photographer. 1966 graduated from National Taiwan AFA, also studied under **Jiang Zhaoshen.** Teaches in Taiwan and exhibits in Asia and US.

Li Yimin 李逸民 (n.d.). Traditional-style painter of birds and flowers. PLA general.

Li Yingjie 李英杰 (known by his *zi* Kuchan 苦禪, *hao* Ligong 勵公, Ying 英, Chaosan 超三, 1899–1983, native of Gaotangxian, Shandong province). *Guohu*a painter. 1919 went to Beijing, where he entered work-study program at Beijing University. Joined Amateur Painting Research Association, where he learned drawing under **Xu Beihong.** 1920 entered Beijing University to study language, then transferred to National Beijing College of Art; graduated 1925. Meantime started to learn bird and flower painting under **Qi Baishi.** 1925 went to Hangzhou. 1930 professor of Chinese painting in Hangzhou Academy. 1927, with **Zhao Wangyun** and others, founded short-lived Thunderers' Art Society (Houhong Yishu She). 1946 joined **Xu Beihong** in NAA Beijing. After 1949, professor in CAFA. Noted especially for his flowers, fish, and eagles. (*Photo on p. 101.*)

Li Yishi 李毅士 (1886–1942, native of Wujin, Jiangsu province). Oil painter. 1903–16 studied in Japan and in Glasgow, Scotland. 1916 teacher in Beijing University School of Engineering. 1922, with **Wang Yuezhi, Wang Ziyun,** and **Wu Fading,** founded Apollo Art Research Institute. 1920s illustrated Bai Juyi's "Song of Unending Sorrow." 1926–37 taught in NCU Nanjing. 1930s changed his style to satirical painting. Taught in Chongqing during WWII. Died in Guilin.

Li Yong 李勇 (b. 1963, Jinan, Shandong province). Painter. 1985 graduated from Fine Art Faculty of Shandong AFA with BA in Literature. Full-time painter in Shandong Provincial Art Gallery. Paints chiefly semiabstract landscape subjects. Has won awards at a number of exhibitions in China.

Li Yongcun 李永存 (Bo Yun 薄雲, b. 1948, Shanxi province). Painter. 1967 graduated from CAFA Middle School. 1980 MFA in art history from CAFA; began teaching theory of art at CAAC. 1979–80 played leading role in Stars exhibitions.

Li Youxing 李有行 (1905–82, Sichuan province). Oil painter. Studied under **Xu Beihong** in Nanjing, later in Paris. During WWII director of Sichuan Provincial Academy of Art, Chengdu. After 1949 professor in Sichuan AFA, Chongqing.

Li Yuanheng 李元亨 (b. 1936, Taizhong, Taiwan). Oil painter. 1959 graduated from NTNU. 1966 to Paris to study oil painting and sculpture. Settled in Paris.

Li Yuanjia 李元佳 (b. 1932, Guangxi province). Painter. Founder of international avant-garde Ton Fan Group and of Punto movement. 1965 settled in Bologna, Italy.

Li Yuchang 李玉昌 (b. 1937, native of Hebei province). Oil painter. 1962 graduated from Oil Painting Dept. of CAFA. Became director of Education Dept. of Beijing Painting Academy.

Li Zefan 李澤藩 (1906–89, b. Xinzhu, Taiwan). Oil and watercolor painter. Studied under Ishikawa Kin'ichirō in Taipei and in Tokyo. Active teaching painting in Taipei after WWII. 1973–74 visited Europe and America. Considered himself an art educator rather than artist.

Li Zhigeng 李志耕 (n.d., native of Dinghai, Zhejiang province). Wood engraver. Active in 1930s and '40s. Studied painting in Shanghai. 1932 joined National Salvation Dramatic Troupe. Later went to Chongqing, joined Chinese Wood Engravers Research Association.

Li Zhiwen 黎志文 (Lai Chi-man, b. 1949, Hong Kong). Sculptor. 1973 graduated from National Taiwan AFA. 1974–77 worked in Carrara, Italy. 1977–79 in US. Has participated in many group exhibitions in various countries.

Li Zhongliang 李忠良 (b. 1944, Beijing, native of Shanghai). Oil painter. Graduated from ZAFA; 1985 joined staff. Became professional artist in Beijing Painting Academy. Noted for heavy painting of Tibetan scenes and for nudes.

Li Zhongnian 李忠年 (n.d.). Printmaker. Active in Yunnan province in 1980s and '90s.

Li Zhongsheng 李仲生 (1911–84, b. Renhuaxian, Guangdong province). Oil painter. After studying painting in Guangzhou Academy and Shanghai Meizhuan, where he was introduced to modern art movement, he went to Japan. 1937 returned to China. Advocated modernism in Guangzhou and Chongqing during WWII. 1949 left for Taiwan, where, as abstract expressionist, he played a prominent role in avant-garde art.

Li Zhongyun 李仲耘 (b. 1918, Ninghe, Hebei province). First taste of design came when he was employed as staff artist by Star Printing House in Tianjin. 1946 began formal studies in art at Furen University, Beijing. From 1949 worked in China's film industry, preparing credit titles and designing sets. During 1960s his cover illustrations for the magazine *Popular Science* were prime examples of his interest in merging documentary realism with strong sense of imagination.

Li Zhushi 李柱石 (Lee Chue-shek, b. 1919, native of Hong Kong). Amateur *guohua* painter. After career in law and commerce, settled in Hong Kong, where he devotes himself to painting.

Li Zisheng 李梓盛 (b. 1919, native of Yanchang, Shanxi province). *Guohua* and oil painter. 1940 studied in LXALA in Yan'an. Worked in Northwest during and after WWII. 1953 went to study in CAFA, then moved to Xi'an. 1958 active in "national forms and local color" movement of Great Leap Forward.

Li Ziyou 李自由 (original name Li Dan 李丹, b. 1932, Nan'anxian, Fujian province). Oil painter. 1950 entered art academy in Xiamen. 1951–55 studied oil painting in CAFA. Active chiefly in Guizhou province.

Li Zongjin 李宗津 (1916–77). Oil painter. 1938 graduated from Suzhou Academy. In Guizhou during WWII. Hired by **Xu Beihong** as professor in National Institute of Fine Arts, Chongqing. Also taught in Architecture Dept. of Qinghua University and Oil Painting Dept. of CAFA. Large works in China Museum of Revolutionary History and Meishuguan. Active and influential in 1950s. 1957 victim of Anti-Rightist campaign against **Jiang Feng;** expelled from CCP. Professor at CAFA and Beijing Film Academy.

Liang Baibo 梁白波 (native of Guangzhou). Painter and cartoonist. Studied oil painting in Shanghai and in Hangzhou Academy. For a time in the 1930s she was a close friend of **Ye Qianyu.** During WWII traveled to Tibet. After WWII settled in Taiwan.

Liang Baoci 梁寶慈 (n.d.). Painter, modern school, and industrial designer. Studied in US. 1939 set up industrial arts center in Shanghai. Settled in Malaysia.

Liang Boyu 梁伯譽 (Leung Pak-yu, 1901–79, native of Shunde, Guangdong province). Conservative *guohua* painter. Member of Chinese Painting Research Society in Guangzhou, where he studied under Li Yaoping. 1932 settled in Hong Kong, where he served as executive director of Hong Kong Chinese Art Club.

Liang Dingming 梁鼎銘 (1898–1959, b. Shanghai, native of Shunde, Guangdong province). Oil painter. Studied in France. During WWII taught in Chongqing and painted large war and historical pictures in Western style. 1946 president of Zhongzheng Art Academy in Jilin. Active in Guomindang politics. 1947 went to Taiwan, where he took up *guohua;* fond of painting horses. His brothers Zhongming 中銘 and Yuming 又銘 (1905–84) also painted propaganda pictures during WWII.

Liang Dong 梁棟 (b. 1926, Liaoning province). Printmaker. 1954 graduated from CAFA. Became associate professor and deputy director of Graphic Art Dept., CAFA.

Liang, Evelyna Yee Woo. See **Liang Yihu**

Liang Juhui 梁矩輝 (b. 1959, Guangdong province). Installation artist. 1989–92 studied at Guangzhou Academy. Member of Southern Artists Salon, Long Tail Elephant Group. 1998 exhibited at Inside Out: New Chinese Art (San Francisco and New York); 2003 at Venice Biennale. Lives in Guangzhou.

Liang Juting 梁巨廷 (Leung Kui-ting, b. 1945, Guangzhou). Painter, designer, print-maker, and sculptor. Studied under **Lü Shoukun** in Hong Kong. Since 1975 teacher in Hong Kong Polytechnic. 1980 with fellow artists formed Hong Kong Chingying Institute of Visual Arts. 1981 awarded Urban Council Fine Arts Award and nominated one of Ten Outstanding Young Persons of the year. Has held solo exhibitions in Hong Kong, the US, Singapore, and Canada.

Liang Meiping 梁美萍 (Liang Mee-ping, b. 1961, Hong Kong). Mixed-media artist. 1991 graduated from Ecole Nationale Supérieure des Beaux Arts, Paris. 2000 MFA from California Institute of the Arts. Received awards in Hong Kong and the US. Since 2000 she has held solo exhibitions in Hong Kong, Taiwan, and the US.

Liang Mingcheng 梁明誠 (b. 1939, Nanxiong, Guangdong province). Sculptor and oil painter. 1964 graduated from Sculpture Dept. of Guangzhou Academy. Became its president. Before 1980 did monumental realistic sculpture. 1980–82 studied in Italy, influenced by Renaissance sculpture and abstraction. Created semiabstract lyric sculpture in bronze, marble, etc.

Liang Quan 梁銓 (b. 1948, Shanghai). Painter and printmaker. Graduated from ZAFA. MA from San Francisco Art Institute. 1990 lecture in printmaking, ZAFA.

Liang Shaoji 梁紹基 (b. 1945, Shanghai). Installation artist. 1989 exhibited in China Avant-Garde, Beijing; 1998 in Jiangnan and Vancouver; 1999 Forty-sixth Venice Biennale; 2000 Shanghai Biennale; etc.

Liang Shuo 梁碩 (b. 1976, Tianjin). Sculptor. 2000 BA in sculpture from CAFA. Same year showed his figures of migrant workers in Shanghai Biennale.

Liang Xihong 梁錫鴻 (1912–82, native of Zhongshan, Guangdong province). Oil painter. Active in 1930s. 1933–35 studied in Japan. Eclectic modernist "fauve." 1934 joined Chinese Independent Art Research Institute (Zhonghua Duli Meishu Yanjiu-suo) in Tokyo, which held its first exhibition in 1935 in Guangzhou. After 1949 held post at Guangzhou Academy. In his later years worked chiefly in watercolor.

Liang Xiuzhong 梁秀中 (b. 1934, Nanjing). Ink painter. BA from NTNU; also studied in University of Illinois, Champaign. Published *Zhongxi meishushi jizhi bijiao yanjiu* 中西美術史蹟之比較研究 [Comparative Study of Chinese and Western Painting] (n.p., n.d.). 1994 living in Taipei.

Liang Yihu 梁以瑚 (Evelyna Yee Woo Liang, n.d.). Painter. Early 1970s graduated from University of British Columbia, Vancouver. Pioneer of community art in Hong Kong, where she organized "Art in the Camp" for Vietnamese boat people, supported by United Nations High Commissioner for Refugees. 1994 involved in formation of "Art in Hospital" and in conducting youth classes in Cambodia and in Qinghai, China.

Liang Yongtai 梁永泰 (1921–56, native of Huiyang, Guangdong province). Self-taught wood engraver. Active in 1930s and '40s. Worked on Guangzhou-Hankou railway, the subject of many of his woodcuts.

Liang Zhihe 梁志和 (Leung Chi Wo, b. 1968, Hong Kong). Installation artist. 1990 BA in fine arts from Chinese University of Hong Kong; 1997 MFA. Also studied in Italy and Belgium. 2000 exhibited at Shanghai Biennale. Lives in Hong Kong.

Liao Bingxiong 廖冰兄 (b. 1915, Guangzhou). Cartoonist. Childhood very poor. Studied in Guangzhou. 1936 committee member for National Comics Exhibition in Shanghai. During WWII joined Guo Moruo's cartoon propaganda team. 1945–49 in Guangzhou, Wuhan, Chongqing, Guilin, and Hong Kong doing cartoons. After 1949 edited cartoon weekly for newspaper and did some teaching, chiefly in Guangzhou. 1983 major retrospective in China Art Gallery, Beijing. Vice-chairman of Guangdong Provincial Art Society.

Liao Chi-ch'un. See Liao Jichun

Liao Dezheng 廖德政 (b. 1920, Taizhong county, Taiwan). Oil painter. 1930 went to Japan to study. 1940 enrolled in Tokyo Art School; influenced by Impressionists. 1946 returned to Taiwan. Became art teacher and formed Era Art Association to carry out research on Western art. Chiefly a landscape painter.

Liao Jichun 廖繼春 (Liao Chi-ch'un, 1902–76, b. Taiwan). Oil painter. 1922 to Tokyo Art Academy. 1927 returned to Taipei; cofounded Taiyang Art Association and Chidan Society. 1962 visited US and Europe at invitation of US State Dept. Early supporter of Fifth Moon Group (see **Liu Guosong**). Until 1973 professor in Art Dept. of NTNU. His work shows variety of influences, including that of Paul Gauguin, Raul Dufy, and Umehara Ryūzaburō.

Liao Shaozhen 廖少珍 (Jane Liu Siu, b. 1952, Macao). Printmaker. MA from University of Illinois, Chicago. Specializes in lithography and etching, often incorporating traditional Chinese ink brushwork. 1985 she won Hong Kong Urban Council Fine Arts Award in Printmaking.

Liao, Shiou-ping. See **Liao Xiuping**

Liao Xinxue 廖新學 (1901–58, native of Fumingxian, Yunnan province). Sculptor and painter, both *guohua* and oils. Studied in Paris under Henri Bouchard, Fernand Cormon, and others. Won many prizes in exhibitions in Paris, including a gold medal at Salon d'Automne in 1946. Member of Société du Salon d'Automne. Returned to China after WWII and died in Kunming.

Liao Xiuping 廖修平 (Shiou-ping Liao, b. 1936, Taipei). Watercolor artist and mixed-media printmaker. 1959 BA, NTNU. 1962–64 studied woodblock printing in Tokyo. 1965–68 studied oil painting and graphic art at Ecole Nationale Supérieure des Beaux Arts, Paris. Member of Société du Salon d'Automne. 1970 settled in US. 1972–93 returned to Taipei as visiting professor to NTNU, also lectured and demonstrated in Tokyo and Hong Kong. Teaching at NTNU for past ten years.

Liew Come Tong. See **Liu Qindong**

Lim Tsing-ai. See **Lin Qingni**

Lin Fengmian 林風眠 (1900–1991, b. Meixian, Guangdong province). Painter and art teacher. 1919 went to Shanghai, joined work-study program. December left for France. January 1920 arrived in France; studied in Ecole Nationale des Beaux Arts, Dijon, then went to Paris, where he entered the studio of Fernand Cormon at Ecole Nationale Supérieure des Beaux Arts. Spent a year in Berlin, then returned to Paris, where he married Alice Vautier, met Zhou Enlai. While in Europe he made a deep study not only of Western but also of Chinese art. 1926 returned to China to head newly established art academy in Beijing, where in 1927 he organized the groundbreaking Beiping Art Convention. 1927, driven out by warlords, he went to Ministry of Education, Nanjing, at invitation of Cai Yuanpei. 1928 Cai appointed him first director of newly established Hangzhou Academy, where he set out, in his words, to "introduce Western art, reorganize Chinese art, combine Chinese and Western art, and create an art for this epoch." During WWII he was with the academy first in Kunming, then outside Chongqing. 1946 returned with the academy to Hangzhou. 1952 ousted as director. Thereafter his life became increasingly difficult. 1955 his wife and daughter left for Brazil. Suffered severely in Cultural Revolution, when he destroyed much of his work. 1977 went to Hong Kong, where he lived in deep

seclusion, only gradually emerging to enjoy his last years of fame and recognition as a key figure in the introduction and adaptation of Western modernism into modern Chinese art. Many leading figures in modern movement were his pupils, including **Zao Wuji, Wu Guanzhong,** and **Zhu Dequn.** 2000 he was the subject of a major exhibition in Beijing. See the important commemorative volume by Pan Gongkai 潘公凱 et al., *Lin Fengmian zhi lu* 林風眠之路 [The approach of Lin Fengmian] (Beijing, 1999); see also *Han mo* 翰墨, no. 24 (1992.1).

Lin Fengsu 林豐俗 (b. 1939, Chao'an, Guangdong province). *Guohua* painter, chiefly of landscapes. Trained in Guangzhou Academy. 1950s and '60s worked in People's Art Hall in Zhaoqing area of Guangdong.

Lin Gang 林崗 (b. 1925, Shandong-Hebei border). Oil painter. Husband of **Pang Tao.** 1954–60 studied in Leningrad. Professor in CAFA, where he taught oil painting in Studio 2, previously headed by **Luo Gongliu.** 1977 painted three pictures of Zhou Enlai; the best known, depicting Zhou's funeral procession in Chang'an lu (completed with the aid of **Ge Pengren**), was exhibited on the first anniversary of Zhou's death (Jan. 8) and is now in the National Museum (formerly Museum of History). 1978 he made a painting journey tracing the route of the Red Army's Long March of 1934. Best known for his modern historical paintings. See Wen Lipeng 聞立鵬 and Shui Tian-zhong 水天中, *Lin Gang* 林崗 (Beijing, 2000). (*Photo on p. 123.*)

Lin Haizhong 林海鍾 (b. 1968, Hangzhou, Zhejiang province). Painter. 1990 graduated from *Guohua* Dept. of ZAFA. 1993 MA from ZAFA; stayed on as teacher. Became dean of Landscape Painting Teaching and Research Section of ZAFA.

Lin Hongji 林宏基 (b. 1946, Guangzhou). Oil painter. 1970 graduated from Guangzhou Academy.

Lin Jiantong 林建同 (1911–94, native of Xinhui, Guangdong province). *Guohua* and Western-style painter, sculptor, and designer. After graduating from Guangzhou Municipal College of Art, he studied in Japan. 1949 founded Hong Kong Chung Kok Chinese Art Club with **Zhao Shao'ang, Li Yanshan,** and others. Taught painting for Extramural Studies Dept. of Chinese University and elsewhere in Hong Kong. Noted for his landscapes and plum blossoms. Compiled *Dangdai Zhongguo hua ren ming lu* 當代中國畫人名錄 [Bibliography of contemporary Chinese painters] (Hong Kong, 1971).

Lin Kegong 林克恭 (Lin K'e-kung, 1901–92, b. Xiamen, Fujian province). Painter, modern school. Born to well-known Xiamen family. 1925 BA Cambridge University; graduated from Bartlett School of Architecture, University College London. 1928

exhibit at Royal Academy of Arts, London. Studied at Académie Julian in Paris and Geneva Art Academy, Switzerland. 1949 to Taiwan, where he taught and painted in College of Chinese Culture, Taipei. 1973 retired to US.

Lin K'e-kung. See **Lin Kegong**

Lin Qingni 林清霓 (Lim Tsing-ai, native of Guangzhou). *Guohua* painter. Studied art and literature at Sun Yat-sen University, Guangzhou. Later settled in US, taught at Rudolph Schaeffer School of Design, San Francisco. 1957 taught in Art Dept. of Hue University, South Vietnam. 1957 visiting art teacher at University of the Philippines, Manila.

Lin, Richard. See **Lin Shouyu**

Lin Shouyu 林壽宇 (Richard Lin, b. 1933, Taizhong, Taiwan). Sculptor and painter. 1949 to UK to study in London Polytechnic. Taught in Royal College of Art and elsewhere. 1969 moved to west Wales. Many prizes and international exhibitions.

Lin Shu 林紓 (original name Lin Qunyu 群玉, *zi* Qinnan 琴南, Hui 徽, *hao* Weilu 畏盧, 1852–1924, native of Minghou, Fujian province). Amateur *guohua* painter and calligrapher, better known as translator of Western literature.

Lin, Swallow. See **Lin Yan**

Lin Tianmiao 林天苗 (b. 1962, Taiyuan, Shanxi province). Installation and mixed-media artist. 1984 graduated from Capital Normal University, Beijing. 1988 moved to New York, where she graduated from Art Students League in 1989. Lives in Beijing. 1998 installation featured in Inside Out: New Chinese Art (San Francisco and New York). 2002 exhibited in Shanghai Biennale. With husband **Wang Gongxin** developed Loft New Media Art Space in Beijing. 2002 solo exhibition in Courtyard Gallery, Beijing. 2004 living at Art Space, working as professional artist.

Lin Tianxing 林天行 (Lam Tianxing, b. 1963, Fujian province). *Guohua* painter. After 1978 studied Western painting under Wu Guoguang, **Lin Gang**, Chen Ting, and Liu Muzhu. 1984 moved to Hong Kong, but studied *guohua* in Chinese Painting Dept. of CAFA Beijing, graduating in 1990. Has taken part in many national exhibitions and worldwide joint exhibitions and has won many awards. Combines Chinese ink and color with Western watercolor and acrylics.

Lin Wenqiang 林文強 (b. 1943, Nantou, Taiwan). Oil painter. 1967 graduated from National Institute of Fine Arts, Taipei. Gold medal in 1977. 1980 went to France to study.

Lin Wenzheng 林文錚 (1903–89, native of Guangdong province). Western-style painter. Married to Cai Yuanpei's daughter **Cai Weilian.** 1920–27 studied Western painting in Paris. 1924, with **Lin Fengmian, Li Jinfa,** and others, founded Society of Overseas Artists (Haiwai yishu yundongshe) in Paris. Returned to China; taught painting in several institutions, including Hangzhou AFA, of which he was appointed provost. During WWII was with Southwest United Universities in Kunming. After Liberation worked in Nanjing, active in art publishing.

Lin Ximing 林曦明 (b. 1926; native of Yongjia, Zhejiang province). Folk artist, like his father; also *guohua* painter and paper-cut artist. 1942 took up *guohua*. Worked for publications in Shanghai and Hangzhou. Took lessons from **Wang Xian.** Taught in Shanghai Chinese Painting Academy.

Lin Xueda 林學大 (1893–1963, b. Xiamen, Fujian province). Painter, traditional and modern schools. Trained in Fuzhou Normal School. 1937 went to Singapore. 1938 founded Nanyang Academy of Art, of which he was for many years the principal.

Lin Yan 林燕 (Swallow Lin, b. 1946, Zhejiang province). Printmaker. Became deaf as a child. 1949 to Taipei. Member of Ton Fan Group and Modern Graphic Arts Association, Taipei. Her prints, chiefly in line, are inspired by ethnic and folk-art motifs.

Lin Yan 林延 (b. 1961). Painter. Daughter of **Lin Gang** and **Pang Tao.** 1984 graduated from CAFA. 1985–86 pursued graduate studies in Paris and Pennsylvania. 1989–93 in Los Angeles. Settled with her husband, **Wei Jia,** in New York, where she works in mixed media.

Lin Yilin 林一林 (b. 1964, Guangdong province). Installation artist. 1983–87 studied in Sculpture Dept., Guangzhou Academy. Member of Southern Artists Salon, Big Tail Elephant Group. 1998 exhibited at Inside Out: New Chinese Art (San Francisco and New York) and at Taipei Biennial; 2003 at Venice Biennale.

Lin Yongkang 林永康 (b. 1959, Guangdong province). Painter. 1982 graduated from Dept. of Stagecraft of Shanghai Theatre College. Professional artist specializing in figures and portraits. 1996 exhibited at Shanghai Biennale.

Lin Yushan 林玉山 (Lin Yü-shan, 1907–2004, b. Chia-yi, Taiwan). Painter. Studied *guohua*, Chinese classics, and watercolor before he was twenty. 1926 entered Kawabata Art Academy in Tokyo to study Western painting, but an exhibition of work by **Qi Baishi, Wu Changshuo, Huang Binhong,** and others revived his interest in *guohua*. Also studied Nihonga under Okumura Gien. 1929 returned to Taiwan. 1935–36 back in Japan studying under Dōmoto Inshō. Spent the rest of his career in Taiwan. Founding member of the Chia-yi Area Painting Association.

Lin Zhiqu 林之取 (b. 1917, Taizhong county, Taiwan). Gouache painter. Sent as a child to Japan, where he studied under several noted Tokyo artists. 1941 returned to Taiwan, leaving many of his gouache-on-paper paintings in Japan. After WWII taught in Taizhong Teachers' College for more than thirty years. Also taught gouache painting in Donghai University, Taizhong.

Ling Chen, Su-hua. See **Ling Shuhua**

Ling Shuhua 凌叔華 (Su-hua Ling Chen, 1900–1990, b. Guangdong province). *Guo-hua* painter, essayist, and short-story writer. Early 1920s became well known as writer. Married Professor Chen Yuan. Mid 1930s moved to Wuhan. During WWII, moved to west China. 1947 settled in London, where Chen was Chinese representative at United Nations Educational, Scientific and Cultural Organization (UNESCO). She remained in London, apart from one year in Singapore (1956), until she returned to Beijing shortly before her death. Amateur painter in scholarly tradition and collector. See Patricia Laurence, *Lucy Briscoe's Chinese Eyes: Bloomsbury, Modernism, and China* (Columbia, S.C., 2003). (*Photo on p. 101.*)

Liu Bingheng 劉秉衡 (Lau Ping-hang, b. 1915, native of Guangzhou). *Guohua* painter. 1937 graduated from Guangzhou Municipal College of Fine Art. 1948 settled in Hong Kong, where he taught and was founding member of Hong Kong Chung Kok Chinese Art Club. Later went to Taiwan.

Liu Bingjiang 劉秉江 (b. 1937, Beijing, native of Tianjin). Painter. Studied oil painting in CAFA under **Dong Xiwen.** 1961 graduated and taught in Central Minority Institute. 1982 chief artist, with his wife **Zhou Ling,** of large mural painting, *Creativity Reaping Happiness,* for Beijing Hotel. 1983 visited Japan. Professor of CAAC. 1986 grant to study in Paris.

Liu Changchao 劉昌潮 (1907–97, Jieyangxian, Guangdong province). 1927–30 studied in Shanghai Meizhuan under **Wu Changshuo, Pan Tianshou, Huang Binhong, Liu Haisu,** and others. Returned to Guangdong, where he was attached to museums and director of Shantou Art Institute.

Liu Changhan 劉昌漢 (Charles Liu, b. 1947, Shanghai). Watercolor and mixed-media painter and critic. Educated at Escuela Superior de Bellas Artes de San Fernando, Madrid, and NTNU, Taiwan. Many prizes and solo exhibitions in Taiwan and abroad. 1995 living in Napierville, Illinois.

Liu, Charles. See **Liu Changhan**

Liu Chengyin 柳成陰 (b. 1930, native of Suzhou, Jiangsu province). 1950 graduated from Suzhou Fine Art Professional School. Joined Art Dept. of People's Literature Publishing House, where he is now art director.

Liu Chunhua 劉春華 (b. 1944, native of Heilongjiang province). Oil painter and bookbinder. Studied in LXAFA Middle School in Shenyang and CAAC. Most famous work is *Chairman Mao Goes to Anyuan* (1967), chosen as model painting by Jiang Qing during Cultural Revolution. Appointed to succeed **Cui Zifan** as director of Beijing Chinese Painting Academy (Beijing Huayuan 北京畫院), and became a *guohua* painter.

Liu Conghui 劉聰慧 (Liu Tsung-hui, b. 1954, Taiwan). Sculptor. 1985 graduated from Art Dept. of NTNU.

Liu Dahong 劉大鴻 (b. 1962, Qingdao). Oil painter. 1985 graduated from Oil Painting Dept. of ZAFA. 1993 teaching in Art Dept. of Shanghai Normal College. Active in post-1989 avant-garde movement. 1978 studied in Oil Painting Dept. of Jinan AFA, Shandong province. 1993 his elaborate iconic paintings of Mao and worshippers featured in China's New Art, Post-1989 exhibition (Hong Kong).

Liu Dan 劉丹 (b. 1953). *Guohua* and oil painter. Brought up in Nanjing, where he studied under and became assistant to **Ya Ming.** 1981 moved with his American wife, Elizabeth Wichmann, to Honolulu, where he became prominent figure in the art world. Noted for his long panoramic landscape handscrolls and his rock paintings. See Hugh Moss, *Ink: The Art of Liu Dan* (Hong Kong, 1993).

Liu Danzhai 劉旦宅 (*hao* Haiyunsheng 海雲生, b. 1931, native of Wenzhou, Zhejiang province). *Guohua* painter, illustrator, and caricaturist. As a youth, made deep study of old masters. 1951 moved to Shanghai, where he worked in art publishing house. Later appointed painter in Shanghai Chinese Painting Academy and teacher in Dept. of Fine Art, Shanghai University.

Liu Ergang 劉二剛 (b. 1947, Zhenjiang, Jiangsu province). *Guohua* painter. Studied various artistic forms. 1991 graduated from Chinese Art Institute in Chinese and Western culture. 1992–99 completed his studies in Art Research Institute. Currently painter in Nanjing Academy. See Baibuluo shuhua cang, *Liu Ergang shuhua xuanji* 劉二剛書畫選集 [Selected paintings of Liu Ergang], 2 vols. (Nanjing, 1990); Tianjin People's Art Press, *Liu Ergang huaji* 劉二剛畫集 [Collected paintings of Liu Ergang] (Tianjin, 2001).

Liu Guohui 劉國輝 (b. 1940, native of Sichuan province). *Guohua* painter and graphic artist. Graduated from ZAFA. First known for serial pictures, later for *guohua*. Visited Germany. Professor of ZAFA. Professor in *Guohua* Painting Dept. at Hangzhou Academy. Expert in figure painting.

Liu Guoshu 劉國樞 (b. 1919, Wulingxian, Sichuan province). Oil painter. 1938 began to study oil painting in Wuchang under **Tang Yihe,** then went to Chongqing. 1950 professor in Chongqing Southwest People's Art Institute and in Sichuan AFA.

Liu Guosong 劉國松 (Liu Kuo-sung, b. 1932, Yidu, Shandong province). *Guohua* and mixed-media painter. 1949, after hard upbringing, he reached Taiwan. Studied painting in NTNU under **Huang Junbi, Pu Ru,** and **Chu Dequn,** graduating in 1950. After serving in army, became art teacher. 1956, dissatisfied with conventionality of art education, he and friends formed Fifth Moon Group, in response to challenge of contemporary Western art, especially abstract expressionism. Became professor in Chungyuan College, Taiwan. 1966–67 traveled around the world, and acquired reputation as leader of modern movement in Chinese painting. 1971–73 on faculty of Chinese University of Hong Kong. Later taught in Donghai University. 1996 taught in Tainan National College of the Arts. Has had one-artist exhibitions worldwide: 1983 at China Art Gallery, Beijing, and around China for eighteen months; 1996 in National Museum of History, Taipei. 1998 exhibited in Shanghai Biennale. See Li Chunyi 李君毅, ed., *Liu Guosong yanjiu* 劉國松研究 [Liu Guosong research], and Xiao Qiongrui 蕭瓊瑞, ed., *Liu Guosong yanjiu wenxuan* 劉國松研究文選 [Collected research material on Liu Guosong], 2 vols. (Taipei, 1996). (*Photo on p. 101.*)

Liu Haiming 劉海明 (b. 1954, Shanxi province). Painter and printmaker. 1973–77 worked as coal miner. 1981 graduated from CAFA. 1986 to UK, sponsored by Scottish Arts Council as artist in residence. 1989 in Belgium. 1996 living in UK.

Liu Haisu 劉海粟 (*hao* Haiweng 海翁, 1896–1994, native of Jiangsu province). *Guohua* and oil painter. 1911 studied briefly in school set up by **Zhou Xiang** in Shanghai. At age sixteen started his own art school, which developed into Shanghai Meizhuan. He was encouraged by Cai Yuanpei, who saw his works in style of Paul Cézanne, Paul Gauguin, and Vincent van Gogh. 1919 visit to Japan strengthened his love of modern Western art. With **Jiang Xiaojian, Ding Song,** and others, founded Heavenly Horse Society (Tianma hui) to promote French salon–style exhibitions. 1920, when his students exhibited drawings of nude models, he was attacked as "art traitor," but his academy was largest and most successful in Shanghai. 1929–31 visited Europe, where he organized exhibition of contemporary Chinese art in Paris, repeated in 1933–35. 1939

went to Southeast Asia, painting in Java under assumed name. 1943 Japanese discovered his identity and flew him back to Shanghai, where he was member of Sino-Japanese Cultural Association (Zhongri wenhua xiehui). 1983 appointed director of Nanjing Academy. 1991 settled in Hong Kong. Regarding himself as "China's van Gogh," he was, with **Xu Beihong** and **Lin Fengmian,** one of key figures in modern introduction of Western art into China. See *Liu Haisu Zhongguohua xuanji* 劉海粟中國畫選集 [Selected traditional Chinese paintings by Liu Haisu] (Shanghai, 1983); *Liu Haisu youhua xuanji* 劉海粟油畫選集 [Selected oil paintings by Liu Haisu] (Shanghai, 1981); Ke Wenhui 柯文輝, ed., *Yishu dashi Liu Haisu zhuan* 藝術大師劉海粟傳 [Biography of Master Liu Haisu] (Jinan, 1986). (*Photo on p. 102.*)

Liu Hong 劉虹 (Hung Liu, b. 1948, Changchun, Jilin province). Artist. 1982 graduate student in mural painting, CAFA. 1984 left China, settled in San Diego. 1985 earned her MFA at University of California. Currently professor of art at Mills College, Oakland, CA. Known for her large-scale historical paintings in public buildings.

Liu Hongyuan 劉宏源 (b. 1976, Baoding, Hebei province). 1997–2000 studied oil painting and fresco in CAFA. 2005 first solo exhibition in Schoeni Gallery, Hong Kong. Her somewhat satirical oil and egg-tempera paintings of richly dressed women combine influences from seventeenth-century Dutch painting, Chinese court art, and the style of Giuseppe Castiglione (Lang Shining, 1688–1766).

Liu Huangzhang 劉煥章 (b. 1930, Balihan, Inner Mongolia, native of Leting, Hebei province). Sculptor. Studied sculpture in CAFA. 1954 set up his own studio. 1981 first one-man show of sculpture ever held in post-Liberation China. Works in wood, stone, marble, and clay; figures, animals, and birds. Professor in CAFA.

Liu, Hung. See **Liu Hong**

Liu Jian'an 劉建菴 (1917–71, native of Shandong province). Wood engraver. Studied painting in Shanghai. Important figure in woodcut movement. 1938 cofounder of National Anti-Japanese Association of Wood Engravers, Shanghai. After Liberation, head of Fine Art Dept., Art Bureau, Ministry of Culture.

Liu Jiang 劉江 (*zi* Hu'an 湖岸, *hao* Zhifei 知非, b. 1926, native of Wanxian, Sichuan province). Calligrapher and seal engraver. Vice-president of Xiling Seal-Carving Society. From 1961 professor at Hangzhou Academy.

Liu Jianhua 劉建華 (b. 1962, Jiangxi province). Artist and modeler. Noted for his erotic female figures in porcelain. Lives in Beijing.

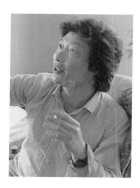 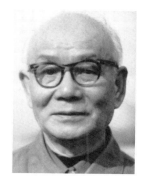 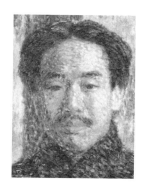

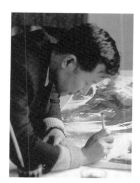 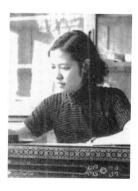 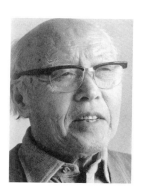

clockwise from top left
Li Huasheng. Photo by Jerome Silbergeld.
Li Keran.
Li Shutong. Self-portrait (detail), 1911.
Li Yingjie (Li Kuchan).
Ling Shuhua (Su-hua Ling Chen). Beijing, 1936.
Liu Guosong. Taipei, 1968.

clockwise from top left
Liu Haisu. Nanjing, 1980. Photo by Michael Sullivan.
Liu Kaiqu. Chengdu, 1944.
Lu Yanshao.

Liu Jincheng 劉金城 (b. 1956, Beijing). Realist oil painter. 1982 graduated from Fine Art Dept. of Beijing Normal College. Traveled and painted in Tibet and Gansu. 1989 to UK, studied at Slade School of Art, London. Exhibits widely in Europe.

Liu Jipiao 劉既漂 (1900–?). Oil painter. 1924 studied in Paris. Took part in Strasbourg Exhibition. Famous for his large painting *Yang Guifei after the Bath*. Professor of pattern design at West Lake AFA, Hangzhou. 1929 moved to Shanghai to pursue architectural design.

Liu Jixian. See **A Xian**

Liu Jixiang. See **Liu Qixiang**

Liu Junren 劉君任 (1901–61, native of Dongguan, Guangdong province). *Guohua* and Western-style painter, noted for his shrimps and chickens. Active in Guangzhou and Hong Kong.

Liu Kaiqu 劉開渠 (1904–93, b. Xiaoxiang, Anhui, native of Jiangsu province). Sculptor. 1927 graduated from NAA Beijing. 1928 studied sculpture in Paris under Henri Bauchard (1875–1960). 1934–40 taught in Hangzhou Academy. 1940–45 set up studio in Chengdu. 1946 returned to Shanghai. 1949 director of Hangzhou Academy. 1950 head of Huadong division of CAA. 1952–58 one of sculptors of Heroes' Memorial, Tiananmen Square, Beijing. 1985 president of China Art Gallery, Beijing. (*Photo on p. 102.*)

Liu Kang 劉抗 (1911–2004, b. Xiamen). Oil painter. Grew up in Malaysia. 1926–29 studied in Shanghai Meizhuan under **Liu Haisu**. 1928–33 studied in Paris. 1930 exhibited with **Zhang Liying** in Salon d'Automne. 1934–37 taught in Shanghai Meizhuan. 1937 returned to Malaysia. 1942 settled in Singapore, where after WWII he was founding member of Singapore Art Society. 1946–58 president of Society of Chinese Artists, Singapore. 1952 visited Bali with **Zhong Sibin**.

Liu Kuiling 劉奎齡 (*zi* Yaochen 耀辰, 1885–1968, native of Tianjin). Self-taught *guohua* painter. Made his living in Tianjin selling paintings. After 1949 became member of Tianjin Wenhuaguan. His style, especially of painting animals, much influenced by Lang Shining (Giuseppe Castiglione, 1688–1766).

Liu Kuo-sung. See **Liu Guosong**

Liu Lun 劉侖 (b. 1913, Guangdong province). Painter and wood engraver. Studied in Guangzhou Municipal College of Art and then in Japan. 1936 participated in woodcut

movement. 1943 teacher at Sun Yat-sen University, Guangzhou. 1983 director of Guangdong Painting Academy. Chairman of Guangzhou Art Society.

Liu Mengtian 劉蒙天 (b. 1918, native of Zhejiang province). Wood engraver, traditional-style painter, and graphic artist. Joined CCP before 1949. 1938 in Yan'an. After 1949 joined Shaanxi Art Academy in Xi'an, of which he later became director.

Liu Ming 劉鳴 (b. 1957, Nanjing). Mixed-media artist. Graduated from Oil Painting Dept. of Nanjing Academy. Member of post-1989 avant-garde movement. 1991 emigrated to Paris.

Liu Ming 劉明 (b. 1957, native of Liaoning province). Oil painter. 1983 graduated from Oil Painting Dept. of LXAFA, Shenyang, where he became dean and professor.

Liu Mu 劉牧 (b. 1947, Tongzhouxian, Beijing). Painter. After studying under Wu Jinding, he entered CAAC, Beijing, graduating in 1978. Held various posts before becoming art supervisor in Beijing Han Tang Cultural Art Co. Chiefly landscape painter in Chinese medium with rich color.

Liu Ning 劉寧 (b. 1957). Painter and art director for films. Noted for academic still lifes.

Liu Pingzhi 劉平之 (n.d.). Wood engraver. Active in 1930s and '40s. Graduated from Xinhua AFA, Shanghai. During WWII in west China. Noted for his prints of Miao people.

Liu Qifa 劉齊發 (Lau Chai Fat, b. 1957, Jiangsu province). Painter. Studied *guohua* and calligraphy under Xu Jiayang. 1966 moved to Hong Kong, where he studied under **Tao Yun** in Extramural Studies Dept., Chinese University of Hong Kong. Member of several Hong Kong painting and sketching societies.

Liu Qindong 劉欽棟 (Liew Come Tong, b. 1949, Malaysia). Artist, art teacher, and critic. 1971 graduated from Dept. of Fine Art, NTNU. Later moved to Hong Kong, where his landscapes explore both traditional Chinese ink and other media. Part-time lecturer in University of Hong Kong and Chinese University of Hong Kong. Has held solo exhibitions in Hong Kong, Singapore, Malaysia, and Taiwan.

Liu Qiwei 劉其偉 (1912–2002, Fujian province). Watercolor painter. Spent formative years in Japan, graduating from National Railway Technical College. 1945 moved to Taiwan, where he held his first exhibition in 1951. After that traveled widely in Southeast Asia. Wrote several books on art. 1990 held his eighty-year retrospective at National Museum of Art.

Liu Qixiang 劉啟祥 (1910–98, b. Tainan, Taiwan). Oil painter. 1927 graduated from Western Art Dept., Tokyo College of Culture. 1932–35 studied Impressionism and Post-Impressionism in Paris. 1935–46 back in Tokyo. 1946 returned to Taiwan. Settled in Kao-hsiung, where he painted and was active in art education.

Liu Renjie 劉仁杰 (b. 1951, native of Liaoning province). Oil painter. 1987 graduated from Oil Painting Dept. of LXAFA in Shenyang, where he became dean and professor in Oil Painting Dept.

Liu She 劉赦 (b. 1960, native of Macheng, Hubei province). Painter. 1987 graduated from Nanjing Academy, where he studied Chinese traditional painting. Became teacher in Fine Art Dept. of Nanjing Normal University.

Liu Shi 劉獅 (b. 1917, native of Wuxing, Jiangsu province). Nephew of **Liu Haisu**. After graduating from Shanghai Meizhuan, spent eight years in Japan studying Western painting and sculpture. After his return, taught in Shanghai Meizhuan. 1949 went to work in Taipei with his wife and former fellow student, Tong Jianren, a painter (chiefly of birds and flowers), poet, and calligrapher.

Liu Siu, Jane. See **Liao Shaozhen**

Liu Tianhua 劉天華 (native of Hebei province). Wood engraver. Studied in NAA Beijing. During WWII went to Xi'an, then taught in Chongqing. Organizer of Chinese Wood Engravers Research Association.

Liu Tianwei 劉天煒 (b. 1954, Shanghai). *Guohua* painter. Studied painting from his father, then painted at home during Cultural Revolution. 1982 went to study in US. Developed abstract *guohua* painting style.

Liu Tiehua 劉鐵華 (b. 1917, native of Hebei province). Wood engraver. Studied in NAA Beijing. 1932–37 imprisoned by KMT. Active in woodcut movement. During WWII teacher in Yu Ts'ai School for gifted refugee children near Chongqing. Went to Taiwan after WWII.

Liu Tsung-hui. See **Liu Conghui**

Liu Wei 劉偉 (b. 1965, Beijing). Painter. 1989 graduated from CAFA. Paints satirical and expressionist figure subjects in oils. Solo exhibitions: 1993 Greese Gallery, Philadelphia; 1999 Jack Tilton Gallery, New York. 2004 working as professional artist in Beijing.

Liu Wei 劉葦 (1901–?, native of Wuxi, Jiangsu province). *Guohua* painter. 1922 graduated from Western Art Dept. of Shanghai Meizhuan. Worked in Shanghai till WWII, when she went to Chongqing. 1943 joined CCP. 1949 went to Hangzhou, where she was put in charge, with **Ni Yide**, and taught *guohua* in what became ZAFA.

Liu Wei 劉煒 (b. 1965, Beijing). Painter. 1989 graduated from Wall Painting Dept. of CAFA. Professional painter, active in Beijing avant-garde. Major exponent of "cynical realist" style, shown, for example, in his works in China's New Art, Post-1989 exhibition (Hong Kong, 1993) and Inside Out: New Chinese Art (San Francisco and New York, 1998). Noted for the "poetic decomposition" of his portraits and landscapes.

Liu Weiji 劉偉基 (Lau Wai-ki, b. 1952, Hong Kong). Ink painter and ceramicist. Graduated from Fine Arts Dept. of Chinese University of Hong Kong. Worked for three years as technician in Chinese University. 1983 set up Creation Ceramic Studio.

Liu Wenxi 劉文西 (b. 1933, Zhengxian, Zhejiang province). *Guohua* painter. Studied in ZAFA under **Pan Tianshou**. Teacher and later president of Xi'an AFA. Well known for paintings of Shanxi peasants and serial pictures of Chairman Mao in Yan'an. Also contributed in Cultural Revolution to anonymous collaborative pictures under collective name Qin Wenmei 秦文美.

Liu Xian 劉峴 (b. 1915, Henan province). Wood engraver. 1934 studied oil painting and wood engraving in Tokyo. 1937 returned to China, taught in LXALA in Yan'an. Since 1949 engaged in art exhibition work. 1982 director of Research Dept., China Art Gallery.

Liu Xiaodong 劉小東 (b. 1963, Liaoning province). Oil painter. 1988 BA in oil painting from CAFA. 1995 MA, CAFA. "Cynical-realist." Exhibitions include Forty-seventh Venice Biennale (1997), China's New Art, Post-1989 (Hong Kong, 1993), and Shanghai Biennale (2000). Became teacher in Oil Painting Dept. of CAFA. Lives in Beijing with his wife, **Yu Hong**.

Liu Xiaomo 劉小沫 (n.d.). Graphic artist. Active in Shanghai in mid 1930s. 1934–35 regular contributor to early period of *The Ark*. Designed covers and decorative title designs in style influenced by art deco.

Liu Xiaoxian 劉晓先 (b. 1963, Beijing). Photographer and conceptual artist. Younger brother of **A Xian**. 1985 BS in optical engineering, Beijing Institue of Technology. 1987 certificate in photography, China Correspondence Institute of Photography, Beijing. 1998 BA with honors, 2002 MA, Sydney College of the Arts. Lives and works in Sydney.

Liu Xun 劉迅 (b. 1923, native of Nanjing). Oil painter. Former vice-president of Beijing Academy. Professional adviser to People's Government of Beijing Municipality. In 1990s became abstract expressionist.

Liu Yafan 柳亞藩 (b. 1920, Hunan province). Painter, modern school, and sculptor. Studied in Shanghai Academy. 1925–34 in Paris and Geneva. 1935, 1939, and 1943 again in Europe. 1946 became teacher in Hangzhou Academy.

Liu Yantao 劉延濤 (*zi* Muhuang 慕黄, b. 1908, native of Henan province). Art scholar, calligrapher, and painter, traditional school. BA Beijing University. Formerly associated with National Palace Museum as editor of *Palace Museum Weekly*. 1962 awarded golden chalice prize in Chinese painting.

Liu Yi. See **Liu Zhiping**

Liu Yisi 劉藝斯 (1907–65, native of Baxian, Sichuan province). Oil painter. As youth studied under **Xu Beihong.** Later became art teacher. After Liberation became professor in Sichuan AFA. Studied ancient Buddhist art of Tibet.

Liu Yiwen 劉依聞 (b. 1919, Hanyang, Hubei province). Oil painter. 1941 graduated from NAA Chongqing. 1946–49 taught in Wuchang. 1990s professor in Hubei AFA, Wuchang.

Liu Yong 劉永 (native of Guangdong province). Abstract expressionist painter in Chinese ink. Active in 1980s and '90s.

Liu Yuan 劉元 (b. 1913, Nanjing). Painter. 1930 graduated from Shanghai Meizhuan. During WWII taught painting in Guangxi AFA, Guilin.

Liu Zhengdan 劉正旦 (n.d.). Wood engraver. 1930s member of Eighteen Art Society, Hangzhou.

Liu Zhengxing 劉正興 (b. 1952, Chengdu, Sichuan province). Painter. Spent five years in the countryside as an "educated youth." Worked in a factory and for an art magazine. Founded the first calligraphy academy in Chengdu. Studied painting under influence of **Li Youxing.** Became entrepreneur and amateur painter.

Liu Zhide 劉志德 (b. 1939, Qindu, Huxian, Shanxi province). Huxian peasant painter. From 1960s. 2003 deputy director of Chinese Peasant Paintings Research Society (Zhongguo nongmin shuhua yanjiuhui).

Liu Zhiping 劉質平 (original name Liu Yi 劉毅, 1894–1978, b. Haining, Zhejiang province). Painter and musician. Student of **Li Shutong** in Shanghai. Traditional school. 1920 cofounder, with **Wu Mengfei** and **Feng Zikai**, of Shanghai Normal College of Art (Shanghai Yishu Zhuanmen Shifan Daxue), which survived until 1928.

Liu Zijiu 劉子久 (1891–1975, b. Tianjin). *Guohua* painter. 1920 graduated from Central School of Surveying. Active in Tianjin. 1927 joined Hu She Painting Society. After Liberation his work included realistic genre scenes of country life.

Liu Ziming 劉自鳴 (b. 1927, Kunming). Painter. 1946 studied in NAA Beijing. 1949 she went to Paris to study painting and life drawing. 1951 entered Ecole Nationale Supérieure des Beaux Arts. 1956 returned to Beijing. 1983 in Kunming, council member of Yunnan branch of CAA, and member of Yunnan Painting Academy.

Liu Zonghe 劉宗和 (b. 1928, native of Henan province). Graphic artist, also does New Year prints. 1950–53 studied in Sichuan. On staff of Guizhou Provincial Art Museum, Guiyang.

Lo Ch'ing. See **Luo Qing**

Lo Huei Ming. See **Luo Huiming**

Lo Koon-chiu. See **Luo Guanqiao**

Lo Kui Chuen. See **Lu Juchuan**

Lo Shyh-charng. See **Luo Shichang**

Lo Yuk Yin, Lucille. See **Lu Yuyan**

Long Liyou 龍力游 (b. 1958, Xiangtan, Hunan province). Oil painter. 1980–84 studied in CAFA; 1987 MA. Became teacher in Fine Art School attached to CAFA. Specializes in borderland subjects.

Long Ziduo 龍子鐸 (b. 1917, native of Panyu, Guangdong province). *Guohua* painter. 1934–37 studied in Guangzhou Municipal College of Fine Art. During WWII worked in Propaganda Bureau of PLA. 1962 settled in Hong Kong, leading a reclusive life on Castle Peak. Later emigrated to Vancouver.

Lou Shibai 婁師白 (*zi* Shaohuai 少懷, b. 1918, Beijing, native of Hunan province). *Guohua* painter. 1932 started to study painting under **Qi Baishi**. 1936–42 studied in

Furen University. 1949 joined staff of CAFA. 1958 became member of Beijing Painting Academy. Specialized in birds and flowers.

Lu Fang 陸放 (n.d.). Printmaker. 1980s on staff of ZAFA.

Lu Fusheng 盧輔聖 (b. 1949, Dongyang, Zhejiang province). *Guohua* and oil painter. 1982 graduated from Chinese Painting Dept. of ZAFA. Late 1990s editor-in-chief in Shanghai Fine Art Publishing Co. Has participated in many group exhibitions since 1984, including 2000 Shanghai Biennale.

Lu Hongji 盧鴻基 (1910–85, native of Guangzhou). Sculptor and wood engraver. Graduated from Hangzhou Academy. During WWII one of organizers of National Anti-Japanese Association of Wood Engravers and China Woodcut Research Society in Chongqing. Professor at ZAFA.

Lu Hui 陸恢 (*zi* Lianfu 廉夫, *hao* juan'an 狷盦, 1851–1920, native of Jiangsu province). *Guohua* painter. Active in Shanghai. Landscapes and flowers. Friend of Ren Bonian, **Wu Dacheng, Wu Hufan.** Very academic.

Lu Juchuan 盧巨川 (Lo Kui Chuen, *zi* Ziji 子濟, b. 1921, Xinhui, Guangdong province). Painter, printmaker and sculptor. 1938 graduated from Western Painting Dept. of Guangzhou Huaguo Art School. 1942 higher diploma at Guangxi Province Art Teachers Training College, Guilin. 1943–46 worked as designer and researcher for British Embassy Information Office in Chongqing. 1958–61 taught art in Hong Kong. Among his many appointments was that of chairman of Hong Kong Artists Society. Wrote treatise on pen drawing.

Lu Kunfeng 盧坤峰 (b. 1934, native of Shandong province). *Guohua* painter. 1964 entered ZAFA, where he later taught. Published manuals on orchid and bamboo painting.

Lu Lin 鹿林 (b. 1962, Jinan, Shandong province). 1981 taught in Arts and Crafts School of Jinan. 1991 moved to artists' colony in Yuanmingyuan. Creates semi-abstract pop images, as in Quotation Marks exhibition in Singapore, 1997.

Lu Peng 盧彭 (b. 1967, Beijing). 1987–91 earned BA in Beijing Normal College on scholarship. From 1991 teaching fine art in Beijing College of Education. 1993 formed the Three Travel-Weary Loafers Group with **Wei Dong** and Liang Changshun.

Lu Rongzhi 陸蓉之 (Victoria Lu, b. 1951, Taipei). Ink painter, critic, and curator. Studied at California State University (BA, Fullerton; MFA, Los Angeles); Royal AFA, Brus-

sels; and Chinese Culture University, Taipei. Solo exhibitions in Taiwan, Brussels, and California. Curator, Taipei Fine Arts Museum.

Lu Shaofei 魯少飛 (1903–95, b. Shanghai). Illustrator and cartoonist. Active in Shanghai in 1920s and 1930s, where he was member of Heavenly Horse Society (Tianma hui), **Xu Beihong**'s painting society. 1928–29 did vulgar covers for *Shanghai manhua* 上海漫畫. 1936 cofounded All-China Cartoonists Association. Chief editor of Beijing People's Publishing House. After Liberation active in art publishing.

Lu, Victoria. See **Lu Rongzhi**

Lu Weizhao 陸維釗 (1899–1980, native of Zhejiang province). *Guohua* painter, classical scholar, calligrapher, and seal engraver. Graduated from Zhejiang University, Hangzhou. 1960 invited by **Pan Tianshou** to be professor in ZAFA.

Lu Wu-chiu, Lucy. See **Lü Wujiu**

Lu Wuya 陸無涯 (Luk Wu-ye, 1915–84, native of Heshan, Guangdong province). Painter in Chinese and Western style. Graduated from Raffles College, Singapore. 1929 returned to China. Studied Western art and oil painting under **Chen Baoyi** in Shanghai. 1947 settled in Hong Kong, thereafter on occasion touring and painting in China and Europe. Painted panoramic landscapes in mixed Sino-Western style.

Lu Yanshao 陸儼少 (*zi* Wanruo 宛若, 1909–93, native of Jiading, Jiangsu province). *Guohua* painter. Studied in Wuxi and under **Feng Jiong** in Shanghai. After 1929, moved around Nanchang, Yichang, and Chongqing. After 1949, did comic strips and cartoons for a while. Early 1950s joined Shanghai Painting Academy. 1957 branded as Rightist and demoted to menial post. After being cleared in 1962, painted a hundred-leaf album to express his joy and joined **Pan Tianshou** in ZAFA to teach *guohua*. 1967–76 banned from painting. 1979 executive director of CAA, professor in ZAFA, and master in Zhejiang Painting Academy. Painted huge panorama of Yandangshan for Great Hall of the People, Beijing. Became famous as landscape painter and conscientious teacher, his work showing his admiration for Shitao. See *Han mo* 翰墨, no. 17 (1991.6), complete issue. (*Photo on p. 102.*)

Lu Yifei 陸抑非 (1908–97, native of Jiangsu province). *Guohua* painter, especially of flowers, and calligrapher. After Liberation, professor in ZAFA.

Lu Yushun 盧禹舜 (b. 1948, Harbin, Heilongjiang province). Painter. 1983 graduated from Art Dept. of Harbin Normal University. Stayed on as teacher. 1987 completed

study in *Guohua* Dept. of CAFA Beijing. Returned to Harbin, where he became president and professor in Art Academy of Harbin Normal University. Active in official promotion of art in Heilongjiang province. 1998 exhibited landscapes in Shanghai Biennale.

Lu Yuyan 盧玉燕 (Lo Yuk Yin, Lucille, b. 1946, Hong Kong). Painter. After graduating from Hong Kong Polytechnic, she spent time in Switzerland and France before settling in Hong Kong in early 1980s. Has participated in many exhibitions in Hong Kong and abroad. Has received a number of awards worldwide.

Lu Zhang 路璋 (b. 1939, native of Shandong province). Oil painter. 1963 graduated from Shandong Art College; completed his studies in CAFA. Silver medal at Seventh National Art Exhibition. Became professor in Shandong Art College. Chiefly a landscape painter.

Lu Zhenhuan 盧振寰 (1887–1979, native of Boluo, Guangdong province). *Guohua* painter. Cofounder of Chinese Painting Research Institute in Guangzhou and lecturer in Guangzhou Municipal College of Fine Arts. Eclectic traditionalist. Later settled in Hong Kong.

Lü Canming 呂燦銘 (Lui Chan-ming, 1892–1963, native of Heshan, Guangdong province). *Guohua* painter. Graduated from Guangdong College of Higher Education. 1949 settled in Hong Kong; became lecturer in Chinese Dept. of Chinese University of Hong Kong. Father of **Lü Shoukun.**

Lü Fengya 呂豐雅 (Eddie Lui Fung-ngar, b. 1947, Hong Kong). Painter, sculptor, and ceramicist. 1997–2002 secretary general of Asian Watercolor Confederation. 1997 appointed chairman of Hong Kong committee of Federation of Asian Artists and established Confederation of Hong Kong Visual Artists. Has participated in various cultural exchange programs and conferences. 2002 set up ceramics studio in Foshan, Guangdong province.

Lü Fengzi 呂鳳子 (1886–1959, native of Danyang, Jiangsu province). *Guohua* painter. 1909 graduated from Liangjiang College of Education under **Li Ruiqing.** Served as professor in NCU Nanjing. Principal of National College of Art, Nanjing. 1942–46 taught in Chongqing. Conservative painter chiefly of beauties and of Buddhist and Daoist figures.

Lü Shengzhong 呂勝中 (b. 1952, Shandong province). Painter and installation artist. 1978 graduated from Shandong Normal University Art Dept. MA from Folk Arts

Dept. of CAFA. 1980s representative artist of "purified language" and folk arts movements. 1990s teaching in Folk Arts Dept. of CAFA. 1989 his "Maze Walk" was a spectacular installation in Beijing Avant-Garde Exhibition.

Lü Shoukun 呂壽琨 (Lui Show Kwan, 1919–75, b. Guangzhou). *Guohua* painter. Son of **Lü Canming,** under whom he studied. Also studied economics in Guangzhou University. 1948 settled in Hong Kong, worked as inspector for Yaumatei Ferry Co. until 1966. After 1950 took up painting and, after close study of traditional painting and copying well-known masterpieces, became influential pioneer of modern movement in Hong Kong. 1956 founding member of Hong Kong Chung Kok Chinese Art Club. 1962 honorary adviser to Hong Kong Museum of Art. 1968 with his students formed In Tao Art Association. Taught ink painting in Chinese University of Hong Kong and Extramural Studies Dept., University of Hong Kong. 1971 awarded MBE (H) for distinguished contributions in the arts. See Wucius Wong et al., *Lui Shou-kwan, 1919–1975* (Hong Kong, 1979).

Lü Sibai 呂斯百 (1905–74, Jiangyinxian, Jiangsu province). Oil painter. 1921–26 studied in Fine Arts Dept. of Jiangsu Province Normal College No. 4. and in NCU. 1929 recommended by **Xu Beihong** to study in Lyon. 1931 transferred to Paris, worked in Académie Julian. 1934 graduated and returned to China, to become professor and chairman of Dept. of Fine Art in NCU. During WWII taught in Chongqing and Lanzhou, where he became professor and chairman of Art Dept. of Northwest China Teacher's College in 1950. 1957 professor and president of Nanjing Normal College. Influenced by Pierre Puvis de Chavannes, Jean-Baptiste-Siméon Chardin, and Paul Cézanne. Committed suicide owing to marital troubles.

Lü Wujiu 呂務咎 (Lucy Lu Wu-chiu, b. Danyang, Jiangsu province). Painter, embroiderer, and wood carver. Daughter and pupil of **Lü Fengzi.** Active in Taipei. 1959 moved to US. 1970 settled in Oakland, Calif. Abstract expressionist.

Lü Xiaguang 呂霞光 (1906–94, b. Anhui province). Oil painter. Went to study in Shanghai Art University at age twenty. Member of Nanguo Society. Studied oil painting under **Xu Beihong.** 1930 to Paris. 1936 taught at ZAFA. During WWII worked in Chongqing. 1948 back to Paris. 1982 returned to China for first of several visits. December 1993 major exhibition in Beijing. Accomplished painter and draughtsman in European academic tradition.

Lü Zhaowei 呂兆偉 (David Lui Siu Wai, b. 1958, Hong Kong). Mixed-media and digital artist. Studied art in New York: 1984 BFA, Parsons School of Design; 1987 MFA, Columbia University.

Lü Zhenguang 呂振光 (Lui Chun-kwong, b. 1956, Guangzhou). 1962 settled in Hong Kong. 1974–76 attended art courses at Extramural Studies Dept., University of Hong Kong, and at Chinese University of Hong Kong. 1980 BA, NTNU, then studied in Dept. of Fine Art there. 1994 MA from Goldsmiths College, University of London. 1978 awarded gold medal in Western painting in Forty-first Taiyang Art Exhibition, Taipei. 1980 won first prize in watercolor in Ninth Taiwan Exhibition, Taipei. Now associate professor of Dept. of Fine Arts, Chinese University of Hong Kong, and member of Hong Kong Visual Arts Society.

Lui Chan-ming. See **Lü Canming**

Lui Chun-kwong. See **Lü Zhengguang**

Lui Fung Ngar, Eddie. See **Lü Fengya**

Lui Long-luk. See **Lei Langliu**

Lui Show Kwan. See **Lü Shoukun**

Lui Siu Wai, David. See **Lü Zhaowei**

Luk Wu-ye. See **Lu Wuya**

Luo Erchun 羅爾純 (b. 1929, Xiangxiang *xian*, Hunan province). Oil painter. 1951 graduated from Suzhou Academy, one of **Yan Wenliang**'s last pupils. Worked in People's Fine Art Publishing House. Later became professor in CAFA.

Luo Fahui 羅發輝 (b. 1961, Chongqing, Sichuan province). Painter. 1981 graduated from middle school attached to Sichuan AFA, Chongqing. 1985 graduated from Oil Painting Dept., became teacher in Dept. of Fine Art, Sichuan Teachers' Training College. 1996 his landscapes featured in Shanghai Biennale.

Luo Fang 羅芳 (b. 1937, Hunan province). Painter. Wife of **Huang Junbi**. 1961 graduated from NTNU Art Dept.; 1971 became associate professor there. 1981 founding member of Taipei Art Club.

Luo Gongliu 羅工柳 (1916–2004, Kaipingxian, Guangdong province). Oil painter and wood engraver. Joined CCP before 1949. 1936 studied in Hangzhou Academy. 1938 worked in Wuhan in political bureau of military commission of KMT government, where he promoted wood engraving. That summer he went to Yan'an, took active part in anti-Japanese propaganda. After 1949 taught at CAFA. 1955–58 studied European oil painting in Leningrad. Established Studio 2 in CAFA dedicated to Soviet-style

realistic oil painting. 1961 head of history painting project for museums throughout China. 1990 vice-president and head of CCP in CAFA.

Luo Guanqiao 羅冠樵 (Lo Koon-chiu, b. 1919, native of Guangdong province). *Guohua* painter specializing in genre and folk themes. 1938 graduated from Guangzhou Municipal College of Fine Art. During WWII joined anti-Japanese campaign. 1947 settled in Hong Kong. 1960–70 taught in various schools and colleges in Malaysia.

Luo Huiming 羅慧明 (Lo Huei Ming, b. 1932, Zhejiang province). Oil and watercolor painter and sculptor in stainless steel. BA NTNU. Lives and works in Taipei.

Luo Ming 羅銘 (b. 1912, native of Guangdong province). *Guohua* painter. 1953–54, while on staff of CAFA, he, **Li Keran,** and **Zhang Ding** toured China painting landscapes and scenes of everyday life in modified *guohua* techniques to show that they could be used effectively for representational purposes. Also taught in the Xi'an AFA.

Luo Qing 羅青 (Lo Ch'ing, original name Luo Qingzhe, b. 1948, Qingdao). Poet, painter, critic, and essayist in Taiwan. 1974 MA, University of Washington, Seattle, where he was Fulbright scholar in residence. Later became professor at Furen University and NTNU. (*Photo on p. 123.*)

Luo Qingzhen 羅清楨 (1905–42, native of Xiangning, Guangdong province). Wood engraver. Graduated from Xinhua AFA, Shanghai. Before 1939 taught in Meixiang, Guangdong. Associated with Lu Xun in woodcut movement.

Luo Shichang 羅世長 (Lo Shyh-charng, b. 1945, Nagano, Japan). Oil and watercolor painter and printmaker. BA NTNU. MA University of British Columbia, Vancouver. Master of Media Studies, University of Toronto. Solo exhibitions in Taiwan and Canada. 1995 living in Vancouver.

Luo Zhongli 羅中立 (b. 1948, Chongqing, Sichuan province). Oil painter. 1968–77 worked in Daba Mountain area. 1978 entered Sichuan AFA. Cofounder of the Grasses. 1980 his *Father*—in hyperrealist style influenced by Chuck Close—won first prize at Second National Youth Art Exhibition. 1983–86 studied in Royal AFA, Antwerp. Became professor in Sichuan AFA, Chongqing. His later affectionately satirical studies of peasant life show here and there the influence of Vincent van Gogh and Paul Gauguin, but are highly individualistic.

Ma Baishui 馬白水 (b. 1911–2002, native of Liaoning province). Watercolor painter. Graduated from LXAFA, Shenyang. Active in art education for more than forty years. Since 1949 teaching at NTNU and College of Chinese Culture, Taipei.

Ma Da 馬達 (1903–78, native of Guangxi province). Woodcut artist. 1930s participated in woodcut movement. 1938 in Yan'an, taught at LXALA. After Liberation active in Tianjin.

Ma Desheng 馬德升 (b. 1952, Beijing). Expressionist painter in Chinese ink. Denied entry to art school on account of disability. Self-taught. Became industrial draughtsman. 1979 and 1980 among chief organizers of Stars exhibitions. 1985 moved to Switzerland. 1986 settled in Paris.

Ma Gang 馬剛 (b. 1956). Graphic artist. Graduated from Graphic Art Dept. of CAFA, where in 1986 he became a teacher. Noted for his woodcuts of peasant life.

Ma Gongyu 馬公愚 (1893–1969, b. Zhejiang province). *Guohua* painter (literary school) and calligrapher. At one time teacher in Shanghai Academy and other institutions in Shanghai. 1919 he and his brother founded China Art College. 1915 founded Tung-ou Art Society.

Ma Hao 馬浩 (b. 1935, Guangdong province). Ceramicist and painter. 1958 graduated from NTNU. Participated in Fifth Moon Group. In 1960s and '70s she worked in pottery. Lived for some years in Ann Arbor, Michigan. 1987 moved to Yonkers, New York, to devote herself to painting.

Ma Huixian 馬慧嫻 (Luisa Ma Hwei-hsien, b. 1930, Anhui province). Painter. 1953 graduated from NTNU. 1955 went to Madrid to study art. Since then she has worked chiefly in Spain and exhibited frequently there and in Taiwan.

Ma Hwei-hsien, Luisa. See **Ma Huixian**

Ma Jiabao 馬家寶 (1927–85, native of Haifeng, Guangdong province). Oil painter. As a youth was influenced by **Gao Lun**. 1947 moved to Hong Kong. Studied Western painting with **Li Tiefu**. 1958 established Art Division of Chinese Reform Club and held other teaching appointments. In 1987–88 his academic oil paintings were shown in memorial exhibition in Hong Kong City Hall.

Ma Jin 馬晉 (*zi* Boyin 伯逸, *hao* Chushi 楚石, Yunhu 雲湖, Zhanru 湛如, 1899–1970, native of Beijing). *Gongbi* painter, chiefly of horses, dogs, birds, and flowers. 1920 joined Chinese Painting Research Society. 1922 began to paint horses, his style influenced by Lang Shining (Giuseppe Castiglione, 1688–1766). Remained professional artist in Beijing during and after WWII. After Liberation active in *guohua* and teaching. Member of Beijing Painting Academy.

Ma Liuming 馬六明 (b. 1969, Hubei province). Performance artist, concerned with issues of bisexuality. 1991 graduated from Hubei AFA. 1997 staged performance in Breda, Netherlands. Has performed in twelve cities around the world and on the Great Wall. 1999 performed at Venice Biennale. Lives and works in Beijing.

Ma, Luisa Hwei-hsien. See Ma Huixian

Ma Shouhua 馬壽華 (*hao* Muxuan 木軒, 1892–1977, native of Woyang, Anhui province). 1911 graduated from Henan Provincial College of Law and Administration. Moved to Taiwan. From 1955 taught part-time at Tung-wu University.

Ma Xiguang 馬西光 (b. 1932, Linqi county, Shanxi province). 1952 cultural worker in PLA in Qinghai.

Ma Xingchi 馬星馳 (b. early 20th century, native of Shandong province). Cartoonist. Did cartoons in *Shenzhou manhua*. 1912 worked for *Xinwen bao*.

Ma Wanli 馬萬里 (Ma Yunfu 允甫, *zi* Ruitu 瑞圖, 1904–79, native of Changzhou, Jiangsu province). *Guohua* painter. 1922 entered Nanjing Academy; after graduation joined staff. 1934 taught in Shanghai. During WWII in Guilin. 1950s in Beijing. 1960s director of Guangxi Cultural Research Bureau, Nanning. Collaborations include *Three Friends in Winter,* with **Zhang Daqian** and **Xu Beihong.** Member of Bee Society.

Ma Zelin 馬澤霖 (b. 1960, Guangzhou). Painter. 1983 BA from CAAC, Beijing, then worked in Huacheng Publishing House, Guangzhou. 1986–90 studied in College of Decorative Arts, Paris. 1991 graduated from Modern Art Theory Dept. of Paris First University. 1998 exhibited mixed-media composition in Shanghai Biennale.

Ma Zhenrong 馬貞榮 (n.d.). Batik designer. 1980s trained and worked in CAAC.

Mai Xianyang 麥顯揚 (Antonio Hinyeung Mak, 1951–94). Sculptor. Went to Hong Kong as a baby. 1971–75 studied painting at Goldsmith's College, London. Winner of Delegacy Prize, UK. Studied sculpture at Slade School of Art and Royal College of Art, London. 1975–1995 held seven exhibitions in Hong Kong.

Mak Hinyeung, Antonio. See Mai Xianyang

Man, Changbai. See Li Mingjiu

Mao Benhua 毛本華 (b. 1942, Zhejiang province). Oil painter. 1964 graduated from Oil Painting Dept. of CAFA. 1989 awarded bronze medal for his *Desert Wind* in Seventh National Art Exhibition.

Mao Lizi 毛栗子 (original name Zhang Zhunli 張准立, b. 1950, Xianyang, Shaanxi province). Trompe l'oeil oil painter. Grew up in Beijing. Self-taught. 1970s member of PLA Drama and Art Workers Troupe. 1970–80 member of Stars. 1981 prize winner in National Youth Art Exhibition. 1990 emigrated to Paris. Has exhibited widely in East Asia, Europe, and US.

Mao Xuhui 毛旭輝 (b. 1956, Chongqing, Sichuan province). Painter. 1982 graduated in oil painting from Yunnan AFA, Kunming. Member of avant-garde movement. 1992 art director of Kunming Film Society. Teaches in Oil Painting Dept., Yunnan AFA. Symbolic expressionist oil painter.

Mao Yan 毛焰 (b. 1968, Xiangtan, Hunan province). Oil painter. 1991 graduated from Oil Painting Dept. of CAFA; appointed teacher in Fine Art Dept. of Nanjing Art College. 1992 figures and portraits exhibited in First Biennale Art Exhibition, Guangzhou. 1996 exhibited in Shanghai Biennale.

Mei Chuangji 梅創基 (Mui Chong-ki, b. 1940, Taishan, Guangdong province). Painter and printmaker. Studied printmaking in Guangzhou College of Art. 1963 settled in Hong Kong, where he teaches in several institutions. Has published books on printmaking and held solo exhibitions in Hong Kong, Malaysia, Singapore, Beijing, Macau, and US.

Meng Luding 孟祿丁 (b. 1962, Hebei province). Oil painter. 1987 graduated from CAFA. 1987–90 instructor in Studio 4, CAFA. 1989 went to West Germany. 1990 to US. Since painting his well-known *Adam and Eve* (1985) and other realistic and surrealistic works, he has turned to abstraction.

Mi Gu 米谷 (Mi Ke, original name Zhu Wushi 朱吾石, 1918–86, native of Zhejiang province). Cartoonist. Studied in Hangzhou and Shanghai academies. 1938 went to Yan'an; graduated from LXALA. 1950s active with **Hua Junwu** in campaign against the deviant writer and critic Hu Feng. 1961 wrote eloquent defense of the art of **Lin Fengmian**. Later in life became editor of *Manhua* 漫畫, section head of Research Division of CAA.

Mi Ke. See **Mi Gu**

Miao Huixin 繆惠新 (b. 1956, Jiaxingxian, Zhejiang province). Peasant artist. Active in 1980s and '90s.

Miao Jiahui 繆嘉蕙 (1841–1918, Kunming). Painter, especially of flowers. She also served as tutor and ghost painter to Empress Dowager Ci Xi in Beijing.

Miao Pengfei 繆鵬飛 (b. 1936, native of Jiangsu province). Mixed-media and oil painter. Graduated from Art Dept. of Fujian Normal College. Became professor in Advanced Art School of Macao University of Science and Engineering. Guest professor in Art College of Shanghai University and Nanjing Academy. Abstract expressionist.

Min Xiwen 閔希文 (b. 1918, Changshu, Jiangsu province). Oil painter. In high school saw Chun Yang Exhibition, organized by **Pang Xunqin** and others. 1934 studied printmaking in Suzhou Academy. 1935 entered Hangzhou Academy. Classmate with **Wu Guanzhong, Zhao Wuji, Zhu Dequn,** Zhu Ying, and **Luo Gongliu.** Studied Japanese, intending to go to Japan. Became a communist. 1957, after being branded a Rightist, sent by CCP to work in a library for twenty years. 1979 appointed to Shanghai Drama School to teach painting.

Ming Jing 明鏡 (b. 1960, native of Hebei province, of Manchu nationality). Oil painter. 1983 graduated from Decorative Art Dept. of Tianjin Academy. Became associate professor in Hebei Arts and Crafts College. Paints semi–abstract expressionist subjects.

Mo Pu 莫朴 (1915–96, Nanjing). Oil painter, graphic artist, and wood engraver. Member of CCP before 1949. Studied under **Yan Wenliang** in Suzhou, under **Xu Beihong** in Nanjing, and under **Liu Haisu** in Shanghai Academy. 1940 joined Communist New Fourth Army. 1942–49 taught in LXALA in Yan'an, North China United University, and Art College of North China University. After 1949 vice-president, Party secretary, and later president of ZAFA. In 1957 purged as Rightist. 1986 his most famous painting, *Settling Accounts* (1946), shown in Paris Salon.

Mo Yixin 莫一新 (Mok Yat Sun, b. 1968, China). Sculptor. 1993 graduated from Fine Art Dept. of Chinese University of Hong Kong. Did postgraduate study in Sculpture Dept. of Guangzhou Academy. Vice-chairman of Hong Kong Visual Arts Society. Public commissions in various sites around Hong Kong.

Mok Yat Sun. See **Mo Yixin**

Mu Chen 慕辰 (b. 1970, Dandong, Liaoning province). Photographer. 1986 graduate from News Photography Dept. of Chinese People's University, Beijing. Collaborates with **Shao Yinong** on many exhibitions in China, Europe, and US, including 2004 Shanghai Biennale.

Mui Chong-ki. See **Mei Chuangji**

Nasierding, Kelimu 納斯爾丁克里木 (b. 1947, of Uighur nationality). Oil painter. 1967 graduated from Fine Arts Dept. of Central Academy of Nationalities. 1981

graduated from postgraduate class in oil painting at CAFA. Vice-president of Xin-jiang Art Academy.

Ng Ku-hung. See Wu Guhong

Ng, Pansy. See Wu Puhui

Ng Po-wan. See Wu Buyun

Ng Yiu-chung. See Wu Yaozhong

Ng Yuen-wa. See Wu Xuanhua

Ni Haifeng 倪海峰 (b. 1964, Zhoushan, Zhejiang province). Painter and installation artist. 1986 graduated from ZAFA. Teaches in Zhoushan Normal College; member of avant-garde movement. 1984 started out painting abstract works. 1985 joined seven other artists to produced the series of works entitled *70% Red, 25% Black, 5% White,* which were informed by "a rational critique of the Chinese national consciousness." 1993 exhibited in China's New Art, Post-1989 exhibition (Hong Kong). Since 1994 has lived and worked in Amsterdam.

Ni Tian 倪田 (*zi* Baotian 寶田, Mogeng 墨畊, 1855–1919, native of Yangzhou, Jiangsu). *Guohua* painter. Studied figure painting under Wang Su; influenced by Ren Bonian. Landscapes, flowers, and horses. Lived in Shanghai in his later years.

Ni Yide 倪貽德 (1901–70, b. Hangzhou). Oil painter and writer on art theory and criticism. 1919 studied in Shanghai Meizhuan. 1922 graduated and taught there. 1923 member of Creation Society. 1927 studied in Japan at Kawabata Art Academy. 1928 returned to China. 1931 professor in Shanghai Meizhuan, chief editor of *Yishu xunkan* 藝術旬刊. 1931 founding member of Storm Society with **Pang Xunqin** and **Wang Daoyuan.** 1941 set up Nitian Studio in Chongqing. 1944 professor in NAA Chongqing. 1949 professor and vice-president of ZAFA. 1953 transferred to teaching post in CAFA. 1955 director of Editing Dept. of *Meishu* 美術. 1961 set up studio in ZAFA, Hangzhou. Is said to have died as result of torture suffered during Cultural Revolution.

Nie Ou 聶鷗 (b. 1948, Shenyang, Liaoning province). *Guohua* and oil painter. 1954 moved with her parents to Beijing. Spent many years of her youth in the countryside. 1981 graduated from postgraduate class of Chinese painting in CAFA. 1981 became professional artist in Beijing Painting Academy. Married to **Sun Weimin.** 1982 exhibited in Spring of Beijing exhibition and joint exhibition of CAFA and Japanese

South Academy. Solo exhibitions in Singapore (1987), Taipei (1988), Hong Kong (1991). Noted for her genre scenes, chiefly country people in landscape settings.

Niu Wen 牛文 (b. 1922, native of Shanxi province). Graphic artist and wood engraver. 1938 joined CCP. 1942 joined LXALA in Yan'an. 1951–52 with PLA in occupation of Tibet. In his later years based in Sichuan.

Ou Dawei 歐大為 (b. 1947, native of Guangdong province). Painter, seal carver, and calligrapher. Tutored in several Hong Kong institutions. Won Hong Kong Urban Council Fine Arts Award and Hong Kong Development Council Award for artistic development. Books on his painting and seal carving have been published.

Ou Haonian 歐豪年 (Au Ho-nien, b. 1935, Maoming *xian*, Guangdong province). *Guohua* painter. Pupil of **Zhao Shao'ang.** Settled in Hong Kong and later in Taiwan, where he became chairman of Fine Arts Dept. of Chinese Culture University. Has held many solo exhibitions in Hong Kong, Taiwan, Japan, and the West.

Ouyang Wenyuan 歐陽文苑 (b. 1929, Jiangxi province). Oil painter. Abstract expressionist. Member of avant-garde Ton Fan Group and Modern Graphic Arts Association, Taiwan.

Pan Dehai 潘德海 (b. 1956, Jilin province). Painter. Graduated from Dongbei Normal University. Later taught in Yunnan. Member of avant-garde movement.

Pan Jiezi 潘絜兹 (b. 1915, Wuyi, Zhejiang province). *Guohua* painter. Expert at *gong-bi*, "heavy color," and figure painting. Studied in middle school under **Wang Daoyuan.** 1936 graduated from Qinghua Art Academy, Beijing. 1945 went to assist **Chang Shuhong** at Dunhuang. Painted minorities in northwest China. 1950 cofounded Shanghai New Chinese Painting Research Society. 1965 worked in Beijing Art Institute, later Beijing Chinese Painting Academy. Decorative style, especially of flower painting.

Pan Ren 潘仁 (b. Lishui, Zhejiang province). Wood engraver. 1920s and '30s prominent figure in early history of woodcut movement.

Pan Sitong 潘思同 (1904–80, b. Shanghai, native of Guangdong province). Watercolor painter. 1922 entered Shanghai Meizhuan to study Western art. 1925 graduated, went into business, and studied watercolor painting in his spare time. 1928 joined the White Goose Painting Research Society with **Chen Qiucao** and others. Taught in Shanghai Meizhuan and worked for Art Dept. of Shanghai Commercial Press. 1956 became professor in Hangzhou Academy. Wrote a number of books, chiefly on watercolor painting.

Pan Tianshou 潘天壽 (original name Tianshou 天授, *zi* 大頤, *hao* A Shou 阿壽, Landaoren 懶道人, Xin A Lanruo Zhuchi 心阿蘭若主持, Dongyue Yizhe 東越頤者, Yiweng 頤翁, Leipo Toufeng Shouzhe 雷婆頭峰壽者, etc.; 1897–1971, native of Ninghai, Zhejiang province). *Guohua* painter, calligrapher, seal engraver, and connoisseur. 1915 entered First Normal School in Hangzhou, where in 1919 he took part in May Fourth Movement. 1919 graduated and became school teacher. 1923 moved to teaching posts in Shanghai Women's Craft School and then Shanghai Meizhuan. Encouraged by **Wu Changshuo, Wang Zhen,** and **Huang Binhong.** Wu Changshuo's style influenced his early landscapes. By mid 1920s he had developed his own powerful style, which he maintained all his life. 1924–27 on staff of Shanghai Meizhuan. 1927 briefly joined newly established Xinhua AFA, Shanghai, before moving in the same year to Hangzhou Academy, with which he was connected from then on. 1929 went on study tour to Japan. During WWII went with Hangzhou Academy to Kunming and then Bishan near Chongqing. 1944–47 president of Hangzhou Academy. 1947 ousted when KMT government installed Wang Yuezhang. 1958 elected honorable fellow of Academy of Arts and Science, USSR. 1959 reinstalled as president and professor of Hangzhou Academy. 1966 ousted again at beginning of Cultural Revolution. An opponent of socialist realism, he was attacked posthumously in Cultural Revolution and again in the notorious "Black Painting" Exhibition of 1974; not rehabilitated until 1979. Wrote widely on Chinese painting and calligraphy. Revered as powerful artist and dedicated teacher. See Pan Tianshou Memorial Hall, ed., *Pan Tianshou yanjiu* 潘天壽研究 [Pan Tianshou: Life and work] (Hangzhou, 1989), and Pan Gongkai 潘公凱, ed., *Pan Tianshou huaji* 潘天壽畫集 [Collected paintings of Pan Tianshou], 2 vols. (Hangzhou, 1996).

Pan Ye 潘業 (n.d.). Wood engraver. Active in Guangzhou in 1930s and '40s.

Pan Ying 潘纓 (b. 1962, Beijing). Painter. Trained in art college of PLA and CAFA, she works in Fine Art Dept. of Beijing Minorities Art Institute.

Pan Yuliang 潘玉良 (original name Zhang Yuliang 張玉良, 1895–1977, native of Yangzhou, Jiangsu province). Oil painter and sculptor. Left an orphan, she was sold into a brothel, where she was rescued by an official, Pan Zhanhua, whose surname she took and who arranged for her to study painting in Shanghai Meizhuan under **Liu Haisu.** 1921–28 studied in Lyon, Paris, and Rome. 1928–35 taught in NCU Nanjing under **Xu Beihong,** becoming well known in Shanghai art circles. 1937 settled permanently in Paris. Member of Salon d'Automne, Salon des Indépendants, and Salon du Printemps. Her best work was done in the 1930s and '40s, after which it became increasingly sentimental. (*Self-portrait on p. 123.*)

Pan Yun 潘韻 (1906–85, native of Changxing, Jiangsu province). Wood engraver and painter. 1957 professor in ZAFA. Painted realistic subjects in *guohua* technique.

Pan Zhenhua 潘振華 (Poon Chun Wah, b. 1936, Guangdong province). Landscape painter. After receiving BA in architecture, moved to Hong Kong, where he became a student of **Lü Shoukun.** 1985 received Hong Kong Urban Council Fine Arts Award.

Pang Chap-ming. See **Peng Ximing**

Pang Jen. See **Peng Zhen**

Pang Jun 龐均 (b. 1936, Shanghai). Oil painter. Son of **Pang Xunqin.** 1949–53 studied in ZAFA. 1979 taught in Central Academy of Drama. 1980 settled in Hong Kong, where he worked as professional artist. 1995 appointed associate professor in Taipei Academy of Art.

Pang Tao 龐濤 (b. 1934, Shanghai, native of Jiangsu province). Oil painter. Daughter of **Pang Xunqin** and wife of **Lin Gang.** 1949–51 studied in Hangzhou Academy. 1953 graduated from CAFA, where she studied under **Dong Xiwen.** 1955 became a teacher. 1984, after a year's study in Paris, appointed professor of oil painting in Studio 4, CAFA. 1990 visited US. 2001 visited UK and Paris. 1994 published *Huihua cailiao yanjiu* [Studies of artists' materials] (Beijing, 1995). (*Photo on p. 123.*)

Pang Xunqin 龐薰琹 (1906–85, native of Changshuxian, Jiangsu province). Oil and *guohua* painter and designer. 1925 studied oil painting in Shanghai under a Russian teacher. 1925–30 studied in France. 1930 returned to Shanghai and joined Taimeng Painting Society. 1931 founding member, with **Ni Yide,** of Storm Society dedicated to promoting a Parisian-style art world in Shanghai. 1936 taught in NAA Beijing. 1939–40 worked for Central Museum in Kunming and collected decorative textiles and patterns of Southwestern minorities. 1940 taught in Sichuan Provincial Academy of Art in Chengdu. 1947 taught in Guangzhou. 1949 taught in East China Division of Hangzhou Academy. 1953 taught in CAFA, prepared for founding of CAAC. 1956–85 vice-president and professor of CAAC. 1959 condemnation during Anti-Rightist campaign contributed directly to death of his wife, the painter **Qiu Ti,** from heart attack. Key figure in revival of decorative arts based on ancient folk art elements, which he promoted through CAAC with active encouragement from Premier Zhou Enlai. See Chang Renxia 常任俠, Shao Dazhen 邵大箴, and Michael Sullivan, *Pang Xunqin huaji* 龐薰琹畫集 [Collected paintings of Pang Xunqin], (Beijing, 1998); Pang Xunqin 龐薰琹, *Gongyi meishu sheji* 工藝美術設計 [Decorative art designs] (Beijing, 1999); Pang Tao, ed., *The Storm Society and Post-Storm Art Phenomenon* (Taipei, 1997). (*Photo on p. 123.*)

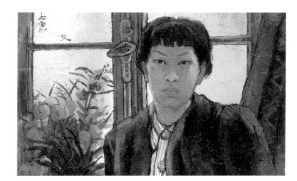
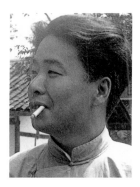

clockwise from top left
Luo Qing (Lo Ch'ing).
Pan Yuliang. Self-portrait (detail), Paris, c. 1944.
Pang Tao and Lin Gang. Beijing, 2004.
Pang Xunqin. Chengdu, 1945. Photo by Michael Sullivan.

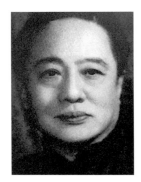

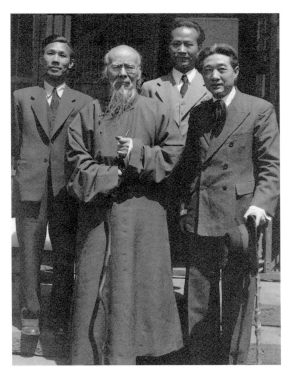

clockwise from top left
Pu Ru (Pu Xinyu).
Qi Baishi with Li Hua (left), Wu Zuoren and Xu Beihong (right). Beijing, 1948.
 Photo by Geoffrey Hedley.
Qian Songyan.

Pao, Cissy. See Bao Peili

Pau, Ellen. See Bao Ailun

Pau Shiu-yau. See Bao Shaoyou

Peng Bin 彭彬 (b. 1927, native of Jiangsu province). Oil painter with Chinese Military Museum.

Peng Peiquan 彭培泉 (b. 1941, native of Beijing). *Guohua* painter in CAFA. Known for her decorative style.

Peng Wanchi 彭萬墀 (Peng Wants, b. 1939, Sichuan). Painter. Trained in Dept. of Fine Arts, NTNU. Worked in Hong Kong. Since 1965 has lived in Paris.

Peng Wants. See Peng Wanchi

Peng Ximing 彭襲明 (Pang Chap-ming, b. 1908, native of Xunyang, Jiangsu province). *Guohua* painter. Graduated from Shanghai Meizhuan. During WWII in Sichuan, where he knew **Zhang Daqian.** 1950 moved to Hong Kong, where he taught in Dept. of Fine Art, Chinese College, and Dept. of Fine Art, New Asia College. Eccentric landscapist inspired by Qing dynasty masters Shitao and Shiqi.

Peng Zhen 彭貞 (Pang Jen, b. 1928, Jiangnan). Oil painter. Studied and worked for some years in Hong Kong and in Paris under Jean de Botton. Lives and works in US.

Poon Chun Wah. See Pan Zhenhua

Pu Guochang 蒲國昌 (b. 1937). 1958 graduated from Printmaking Dept. of CAFA. 1986 teaching in Guizhou Province Art Academy, Guiyang. Makes woodcuts, carved and painted woodblocks, and wall hangings inspired by minority themes.

Pu Hua 蒲華 (*zi* Zuoying 作英, Zhuying 竹英, 1834–1911, native of Xiushui, Zhejiang province). *Guohua* painter and calligrapher. Active in Shanghai. Friend of **Wu Changshuo.** Visited Japan, where his ink landscapes and bamboo were much admired. Died in Shanghai.

Pu Jin 溥伒 (*zi* Xuezhai 雪齋, *hao* Xuedaoren 雪道人, 1893–1966, b. Beijing, of Manchu descent). *Guohua* painter. Member of Manchu imperial family. Eldest brother of **Pu Xian, Pu Quan,** and **Pu Zuo.** Until 1949 dean of College of Art, Furen University, Beijing. Member of Beijing Chinese Painting Academy and, from 1949, of Wenhuayuan. An orthodox traditional landscape painter who made great efforts to adapt content, if

not style, of his landscapes to requirements of Communist society. Died as result of persecution at outset of Cultural Revolution.

Pu Quan 溥佺 (*hao* Pu Songchuang 溥松窗, 1913–91, of Manchu descent). *Guohua* painter. Member of Manchu imperial family. Younger brother of **Pu Jin.** 1920s and '30s member of Hu She Painting Society, founded by **Jin Cheng.** From 1936 taught in Furen University Art Dept., where his students included **Zeng Youhe** (Betty Ecke). After 1949 with Beijing Painting Academy. Specialized in painting horses, flowers, birds, and landscapes. 1994 solo exhibition at Ashomolean Museum, Oxford. See Shelagh Vainker and James C. S. Lin, *Pu Quan and His Generation: Imperial Painters of Twentieth Century China* (Oxford, 2004). Works in this exhibition came chiefly from the collection of Kati Talati, who had been his student in Beijing.

Pu Ru 溥儒 (*hao* Pu Xinyu 心畬, Xishan Yishi 西山逸士, 1896–1963, native of Wanping, Beijing, of Manchu descent). *Guohua* painter. Member of Manchu imperial family. Cousin of **Pu Jin.** 1915 graduated from University of Law and Politics. Later pursued advanced study in Germany and, it is said, obtained two doctoral degrees. After 1911 devoted himself to painting; taught at Kyoto Imperial University and in National Beijing College of Art. 1950 went to Taiwan, joined NTNU, and did a good deal of private teaching. Eclectic academic artist. See Zhang Qianyu (Chiang-yu Jan) 詹前裕, ed., *Pu Xinyu huihua yishu zhi yanjiu* [Research on the paintings of Pu Xinyu] (Taipei, 1992). (*Photo on p. 124.*)

Pu Songchuang. See **Pu Quan**

Pu Xian 溥僩 (*zi* Yizhai 毅齋, 1901–66, native of Beijing, of Manchu descent). *Guohua* painter. Member of Manchu imperial family. Younger brother of **Pu Jin.** Before 1949 sold paintings for a living. After 1949 joined Beijing Chinese Painting Academy. Painted chiefly horses, birds, and flowers.

Pu Xinyu. See **Pu Ru**

Pu Zuo 溥佐 (1918–2001, b. Beijing, of Manchu descent). *Guohua* painter, chiefly of horses. Member of Manchu imperial family. Youngest brother of **Pu Jin.** 1952 joined Chinese Painting Research Society with **Qi Baishi** and the actor Mei Lanfang, with official approval of Zhou Enlai. Worked and taught chiefly in Tianjin Academy.

Qi Baishi 齊白石 (original name Qi Huang 齊璜, *zi* Weiqing 渭青, *hao* Baishi 白石, Lanting 蘭亭, Kemu laoren 刻木老人, etc., 1864–1957, native of Xiangtanxian, Hunan province). *Guohua* painter, calligrapher, and seal engraver. Of poor peasant

family. 1877 apprenticed to carpenter, in 1878 to wood carver. Studied painting, calligraphy, and seal engraving under local painters. 1889 became professional painter. 1902–10 traveled around China. 1919 settled in Beijing. Patronized and encouraged by **Chen Hengke** and influenced by **Wu Changshuo,** he attained a leading position, in spite of his lack of education, in traditional art world of Beijing. Although he painted striking landscapes, he is chiefly known for his birds and flowers, fishes, shrimps, and crabs, of which he painted many hundreds of pictures, partly as a means of support. 1926–37 taught in NAA Beijing. Lived in Beijing during WWII. After 1949 honorary professor in CAFA. 1953 named Outstanding Artist of the Chinese People by Ministry of Culture. 1955 awarded International Peace Prize by World Peace Council. See Hu Shih 胡適 et al., *Qi Baishi nianpu* 齊白石年譜 [Biographical chronology of Qi Baishi] (Shanghai, 1949); Qi Baishi 齊白石, *Baishi laoren zizhuan* 白石老人自傳 [The autobiography of Qi Baishi] (Beijing, 1962); Huang Guangnan 黃光南 et al., *Qi Baishi huaji* 齊白石畫集 [Collected paintings of Qi Baishi] (Taipei, 1996); Lang Shaojun 郎紹君 and Guo Tianmin 郭天民, *Qi Baishi quanji* 齊白石全集 [Collected works of Qi Baishi], 10 vols. (Changsha, 1996); and *Han mo* 翰墨, no. 14 (1991.3), complete issue. (*Photo on p. 124.*)

Qi Gong 啟功 (*zi* Yuanbo 元伯, 1912–2005, Beijing). *Guohua* painter, calligrapher, and scholar. Member of Manchu imperial family. As a boy was a monk for nine or ten years in Yonghegong Monastery, Beijing. From age 21 studied in Furen University, where he became professor of Chinese literature and painting. After 1949 he was professor in Beijing Normal College. 1957 condemned as Rightist, but was later able to resume his teaching. Chairman of Chinese Calligraphy Association. Important influence on **Zeng Youhe.**

Qi Haiping 祈海平 (b. 1957, native of Shanxi province). Oil painter. 1982 graduated from Guangxi Provincial Art Academy. 1991 completed training in CAFA. Associate professor in TianjinAcademy.

Qi Huang. See **Qi Baishi**

Qi Zhilong 祁志龍 (b. 1962, Hohhot, Inner Mongolia). Oil painter and pop artist. 1987 graduated from CAFA. 1992 settled in Beijing as independent artist. Has held solo exhibitions in Hong Kong and Australia, participated in group shows worldwide.

Qian Binghe 錢病鶴 (1879–1944, native of Wuxing, Zhejiang province). Figure painter and later professional cartoonist in Shanghai.

Qian Juntao 錢君匋 (*zi* Juntao 君匋, Yutang 豫堂, 1906–98, native of Tongxiang, Zhejiang province). *Guohua* painter, graphic designer, calligrapher, and seal engraver.

Late 1920s studied in Hangzhou Academy, then worked for Kaiming Bookstore in Shanghai. Deputy editor-in-chief of Shanghai Music Publishing Co. See *Qian Juntao zuopin ji* 錢君匋作品集 [Collected works of Qian Juntao] (Changsha: 1982).

Qian Shaowu 錢紹武 (b. 1928, native of Jiangsu province). Sculptor and graphic artist. 1953–55 studied sculpture in Leningrad. Teacher and later professor in Dept. of Sculpture, CAFA.

Qian Shoutie. See **Qian Ya**

Qian Songyan 錢松喦 (1899–1985, native of Yixingxian, Jiangsu province). *Guohua* landscape painter. 1918–23 studied in Third College of Education of Jiangsu. From 1923 taught in art schools in Suzhou and Wuxi. During WWII lived by selling paintings. 1945 resumed teaching. 1957 taught in Jiangsu Chinese Painting Academy, Nanjing, where he succeeded **Fu Baoshi** as director. Vice-chairman of Jiangsu branch of CAA. Close friend of **Liu Haisu.** (*Photo on p. 124.*)

Qian Xindao 錢辛稻 (b. 1912). Painter, modern school. Active in Shanghai. Professor and head of Fine Art Dept. at Beijing Central Drama Academy.

Qian Ya 錢厓 (*zi* Shuya 叔崖, *hao* Shoutie 瘦鐵, 1896–1967, b. Wuxi, Jiangsu province). *Guohua* painter. Began his career as apprentice in seal-carving workshop. Came to know **Wu Changshuo.** Taught in Shanghai Meizhuan. 1935–42 worked in Japan. After 1949 became painter in Shanghai Academy. Founding member of Bees Society.

Qin Long 秦龍 (b. 1939). Expert at *gongbi,* "heavy color," and figure painting. Painter and book illustrator active in Beijing after 1979. Art editor of Beijing People's Literature Publishing House.

Qin Song 秦松 (b. 1933, Xuyi, Anhui province). Painter, poet, and graphic artist. 1948 began painting in Nanjing. 1949 went to Taiwan with KMT army. 1957 founded Modern Graphic Arts Association, Taipei. 1966 founded *Avant-Garde Monthly.* Developed abstract style. 1969 went to US, where he stayed for 24 years.

Qin Wenmei 秦文美. Not a single painter, but a name used on collaborative works in Xi'an during Cultural Revolution by a group of artists who included **Liu Wenxi.**

Qin Xuanfu 秦宣夫 (1906–98, Guilin, Guangxi province). Oil painter and art historian. 1929 graduated from Dept. of Foreign Languages at Qinghua University. 1930–34 studied in Ecole Nationale Supérieure des Beaux Arts in Paris; also visited England, Germany, and Spain. Returning to China, he taught successively in Beijing Academy,

Qinghua University, Dept. of Art in NCU Nanjing, and Nanjing Normal College, where he was professor and department head.

Qin Zheng 秦征 (b. 1924, Xingtangxian, Hebei province). Oil painter. At age of 14 joined Communist revolutionary army, active in culture and propaganda. 1943 joined CCP. 1950–52, 1955, and 1957 studied painting at CAFA under Konstantin Maksimov. 1957 victimized as supporter of **Jiang Feng;** barred from exhibiting officially till 1962. Later became professor and chairman of Tianjin Academy and vice-chairman of CAA. Socialist-realist.

Qin Zhongwen 秦仲文 (1896–1974, native of Zunhuaxian, Hebei province). *Guohua* painter. 1915 entered Law Dept. of Beijing University and joined Painting Methods Research Society, organized by Cai Yuanpei and directed by **Chen Hengke.** 1920 researcher in Chinese Painting Research Society. Before 1937 lecturer in NAA Beijing. 1937–45 studied calligraphy and painting at home. 1945 professor of Chinese painting history in Beijing University. After 1957 member of Beijing Chinese Painting Academy. Chiefly a landscape painter.

Qiu Anxiong 丘黯雄 (b. 1972, Chengdu, Sichuan province). Oil painter. 1994 graduated from Printmaking Dept. of Sichuan AFA, Chongqing. 1998 studied at Kassel University, Germany. 2001 exhibited in Chengdu Biennale.

Qiu Deshu 仇德樹 (b. 1948, Shanghai). Painter. Without formal training, he was one of the organizers of Grasses (Caocao) independent art movement of 1979–80. 1982 exhibited abstract paintings suggestive of calligraphy and seals; conceived "fissuring" texture that became characteristic of his art thereafter. 1985 artist in residence, Tufts University, holding exhibitions there and at Harvard University. 1986 returned to China to establish himself as professional painter in Shanghai. Has since participated in many exhibitions at home and abroad, including 1994 Shanghai Art Museum and 1998 Shanghai Biennale. See Asian Art Museum (Seoul), *Qiu Deshu: Beginning of the World and Heaven, Earth and Human* (Seoul, 2000).

Qiu Ruimin 邱瑞敏 (b. 1944, Longyan, Fujian province). Painter. 1965 graduated from Oil Painting Dept. of Shanghai College of Art. 1986–87 visiting scholar at Pratt Institute, New York. 1988 second visit to US. Director of China Oil Painting Society. 1996 his landscapes exhibited in Shanghai Biennale.

Qiu Shihua 邱世華 (b. 1940, Sichuan province). Painter. 1962 graduated from Xi'an AFA. Lived for 22 years on yellow loess plains of northwest China, surviving Cultural Revolution as sign painter for a cinema. 1984 moved to south China. His subtle, apparently featureless canvases reflect his Daoist absorption in the Void. 1996, one-

artist show at Twenty-third International Biennale, São Paulo, Brazil. 1993 works included in China's New Art, Post-1989 exhibition (Hong Kong); 1996–97 shown in Germany and US.

Qiu Ti 丘堤 (1906–58, b. Fujian province). Oil painter. Wife of **Pang Xunqin** and mother of **Pang Tao** and **Pang Jun**. After graduating in Western art from Shanghai Academy, she studied in Tokyo from 1928–31. 1931 returned to China and became researcher in Shanghai Academy. Only woman painter in Storm Society. During WWII in southwestern China. After 1949 member of National Art Workers Association. 1956 senior researcher in CAAC. Died of heart attack in hospital on hearing that her husband had been branded a Rightist. (*Portrait on p. 131*.)

Qiu Yacai 丘亞才 (Ch'iu Ya-ts'ai, b. 1949, Yilan, Taiwan). Self-taught oil painter, especially of figures, and poet. Influenced by European expressionism. Lives and works in Taipei.

Qiu Zhijie 邱志傑 (b. 1969, Fujian province). Printmaker, mixed-media artist, video artist. 1992 graduated from Printmaking Dept. of ZAFA. Member of post-1989 avant-garde movement. 2002 exhibited in Kwangju Biennale, São Paulo Biennale, Guangzhou Triennial. 2005 exhibited at Cantor Center for Visual Arts, Stanford University. Lives and works in Beijing and Hangzhou, where he is involved in New Media Art Center of ZAFA.

Qu Fengguo 曲豐國 (b. 1966, Liaoning province). Painter and mixed-media artist. 1988 graduated from Shanghai Theater Academy. Lives and works in Shanghai. 2000 exhibited in Shanghai Biennale.

Qu Leilei 曲磊磊 (b. 1951, Heilongjiang province). *Guohua* and mixed-media painter and calligrapher. Born into intellectual family, but grew up as ardent revolutionary. 1967 sent to mountains of Northeast to work as peasant and barefoot doctor. 1969 enrolled in PLA. Later worked as designer, electrician, and artist. 1973 first encountered Western art. 1979 became leading member of dissident Stars and took part in their 1979 and 1980 exhibitions. After Wei Jingshen's trial in 1979, which he secretly recorded, he left China and settled in London; became prominent in international movement of contemporary Chinese art. President of Chinese Ink Painters Society of the UK. March–July 2005 solo exhibition at Ashmolean Museum, Oxford. (*Photo on p. 132*.)

Quan Shanshi 全山石 (b. 1930, Ningbo, Zhejiang province). Oil painter. 1954–60 studied in Leningrad; on his return worked with Konstantin Maksimov in CAFA and collaborated with **Luo Gongliu** on history pictures. After Cultural Revolution visited Xinjiang eight times; also visited US, Japan, France, and Spain. Dean of ZAFA.

Qiu Ti. Portrait by Pang Xunqin, c. 1936.

clockwise from top left
Qu Leilei. Photo by his wife, Caroline Deane, 2003.
Shao Fei.
Shi Lu.

Quan Xianguang 全顯光 (b. 1931, Kunming). Ink painter and printmaker. 1955 graduated from Painting Dept. of LXAFA in Shenyang. 1955–61 studied in Leipzig AFA, East Germany. 1961–91 professor of drawing and printmaking in LXAFA. 1979 opened his own studio in Shenyang, which was so popular with his students that jealous rivals forced it to close down after a few years. More recently has devoted himself to ink painting.

Quan Zhenghuan 權正環 (b. 1932 or 1933, Beijing). Oil painter. Graduated from CAFA, where she stayed on to teach. 1959 married **Li Huaji,** with whom she visited Dunhuang and Tibet. Executed murals for Beijing Airport; Yanjing Hotel, Beijing; and Chinese Cultural Center, New York.

Ran In-ting. See **Lan Yinding**

Rao Zongyi 饒宗頤 (Jao Tsung-i, b. 1917, native of Chaozhou, Guangdong province). *Guohua* painter, calligrapher, and scholar. Has held teaching appointments in National University of Singapore (1952–73), University of Hong Kong, and Chinese University of Hong Kong, where he was professor of Chinese. Also served as visiting professor at Yale University and in France and Japan. 1962 received Prize Stanislas Julian. 1993 received Art and Letters Official Medal from French Ministry of Culture.

Ren Chuanwen 任傳文 (b. 1963, Jiangxi province). Painter. 1990 graduated from Jilin AFA, became teacher in Jilin Art Institute. 2000 his figures in landscapes were exhibited in Shanghai Biennale.

Ren Heping 任和平 (b. 1934, Shuluxian, Hebei province). Painter. 1953 graduated from Drawing Dept. of CAFA. 1955–57 studied oil painting under Konstantin Maksimov. Became professor in LXAFA in Shenyang. Socialist realist.

Ren Jian 任戩 (b. 1955, Liaoning province). Painter. 1987 MA from LXAFA in Shenyang. Leading figure in 1980s avant-garde movement. Early 1990s teaching in Wuhan University Architecture Dept.

Ren Ruiyao 任瑞堯 (native of Guangzhou). Oil painter. Trained in Japan. 1921 returned to China, set up Chishe Fine Art Research Society in Guangzhou.

Ren Zhenhan 任真漢 (1907–91, native of Huaxian, Guangdong province). *Guohua* and oil painter. 1913 moved to Taiwan. 1925 returned to Guangzhou, studied in Chishe Fine Art Research Society. 1927 to Kyoto to study oil painting. After his return to China, taught oil painting at Chishe Research Society. 1937 settled in Hong Kong.

Held position of chairman of Hong Kong Painters' League and other posts. In his later years he abandoned oil painting for *guohua*.

Rong Ge 戎戈 (b. 1923, Ningbo, Zhejiang province). Wood engraver. Active in Shanghai before WWII.

Rong Rong 榮榮 (b. 1968, Fujian province). Photographer. Studied painting at Fujian Industrial Art Institute. 1992 entered Central Industrial Art Institute, Beijing. 1993–95 documented growing art movement in East Village artists' community. Cofounder, with Liu Zheng, of *New Photo* magazine. 2002 exhibited at Guangzhou Triennial. Numerous photography exhibitions.

Rou Shi 柔石 (original name Zhao Pingfu 趙平福 [甫], 1902–31, *xiang* Ninghai, Zhejiang province). Wood engraver and writer. Studied in Beijing University before becoming a teacher in Ninghai. Member of radical Eighteen Art Society in Shanghai. Executed by KMT. Close friend and protégé of Lu Xun, who wrote a moving elegy for him.

Seeto Ki. See **Situ Qi**

Sha Menghai 沙孟海 (*zi* Shihuang 石荒, 1900–1992, native of Zhejiang province). Calligrapher and *guohua* painter. Pupil of vice-president of Chinese Calligraphy Association; honorary professor in ZAFA. President of Xiling Seal-Carving Society. His calligraphy is much admired in Japan.

Sha Qi 沙耆 (1914–99, Zhejiang province). Oil painter. Began to study painting in Shanghai. Arrested by KMT. After his release, studied in Hangzhou and Nanjing under **Xu Beihong**. 1937 to Belgium, where he stayed for ten years. Returning to China he developed schizophrenia and retired to the country but, with support of Zhou Enlai, continued to paint. Spent his late years in hospital in Shanghai, holding a solo exhibition there in 1984. Subject of two conferences. Regarded as "China's van Gogh."

Shang Ding 尚丁 (b. 1954, Kunming, Yunnan province). Oil painter. Soldier. Active in early 1970s. Professor in PLA Art Academy.

Shang Wenbin 尚文彬 (b. 1932, Jiangsu province). Oil painter. 1955 graduated from Fine Arts Dept. of NTNU. Later studied architecture in Belgium. Realist.

Shang Yang 尚揚 (b. 1942, Kaixian, Sichuan province). Oil painter. 1965 graduated from Fine Arts Dept. of Hubei Art College. 1981 MA. 1989 associate president. 1993 professor and officer-in-charge of fine arts, Research Institute of South China Nor-

mal University and vice-president of Chinese Art Painting Society. Participated in many exhibitions in China and abroad, including Shanghai Biennale 1996. Lives in Beijing.

Shao Fei 邵飛 (b. 1954, Beijing). Painter. Studied *guohua* with her mother, **Shao Jingkun.** 1970–76 served in PLA. 1976 joined Beijing Painting Academy. 1979 and 1980 member of Stars. Early 1990s emigrated to US with her husband, the dissident poet Bei Dao, who took a teaching appointment at University of California, Davis. They later separated, and Shao Fei returned to Beijing. Noted for her decorative fantasy paintings, chiefly of children, and more recently for her paintings inspired by creatures described in the *Shanhaijing* 山海經 [Classic of hills and seas] and garden scenes inspired by a late Ming collection of woodcut illustrations. See L'Atelier Productions, ed., *A World of Fantasy: Shao Fei* (Singapore, 1992), and Wang Fei 王非, ed., *Shao Fei* 邵飛 [Shao Fei] (Beijing, 2001). (*Photo on p. 132.*)

Shao Jingkun 邵晶坤 (b. 1932, Heilongjiang province). Oil painter. Mother of **Shao Fei.** Studied in Beijing under **Xu Beihong, Dong Xiwen,** and others. Active as oil painter and teacher for many years, specializing in flowers and portraits. 1962 went on painting tour of Tibet with Dong Xiwen and **Wu Guanzhong.**

Shao Keping 邵克萍 (b. 1916, native of Zhejiang province). Wood engraver. Studied in Shanghai. During war with Japan served as editor of *Minzu Ribao* in Zhejiang and began to study woodcuts. After 1949 with Cultural Bureau in Shanghai and Shanghai Art Press.

Shao Yinong 邵逸農 (b. 1961, Qinghai province). Oil painter and photographer. 1982 graduated from Qinghai Normal University. 1987 assistant instructor in Oil Painting Dept. of CAFA. Lives and works in Beijing. Collaborates with **Mu Chen.** Many exhibitions in China, Europe, and US, including 2004 Shanghai Biennale.

Shao Yiping 邵一萍 (1910–63, native of Zhejiang province). *Guohua* painter, chiefly of birds and flowers. Studied painting with her cousin. During war with Japan traveled in Fujian, Jiangxi, Guangdong, Guangxi, and Sichuan. After Liberation, studied with **Huang Junbi** and **Zhao Shao'ang** in Changsha. Taught at Hunan Provincial Handicraft Academy and elsewhere.

Shao Yixuan 邵逸軒 (1886–1954). *Guohua* painter. Active in Beijing, where he was a friend of many leading *guohua* artists, including **Huang Binhong, Qi Baishi, Chen Nian,** and **Pu Ru.** Influenced **Fu Baoshi.** Among his pupils was noted actor Mei Lanfang. Highly versatile artist with wide range of styles and subjects. Lived and worked primarily as a journalist in Beijing.

Shao Yu 邵宇 (b. 1919, Dandong, Liaoning province). Painter, graphic artist, and wood engraver. 1934 studied in art college in Shenyang. 1935 studied Western art in NAA Beijing. Late 1930s to 1949 active in left-wing propaganda art. After 1949 leading figure in People's Art Press and in Artists Association. Published several albums of paintings and serial pictures.

Shen Bochen 沈泊塵 (1889–1920, native of Tongxiang, Zhejiang province). Cartoonist. Active in Shanghai after 1911 revolution. Contributor to *Shanghai Puck*.

Shen Fuwen 沈福文 (b. 1906, Fujian province). Oil painter, lacquer craftsman, and wood engraver. 1924 studied in Xiamen College of Art. 1929 went to Hangzhou to study painting and woodcut; joined the Eighteen Art Society. 1932 taught oil painting in art school of Beijing University. 1933 professor at NAA Beijing. 1935–37 studied lacquerware in Tokyo. 1939 involved in woodcut movement in Chongqing. 1946 went to Dunhuang to copy frescoes. 1950 taught in Chengdu. Later became professor and director of Sichuan AFA, Chongqing.

Shen Houshao 沈厚韶 (b. 1914, Panyu, Guangdong province). *Guohua* painter. Settled in Panyu, Guangdong. Daughter of **Shen Zhongqiang**. Head teacher in a high school in Guangzhou and member of Guangzhou Chinese Painting Research Society. 1981 settled in US. Specialized in landscapes and chrysanthemums.

Shen Jiawei 沈加蔚 (b. 1949, Jiaxing, Zhejiang province). Oil painter. 1970 assigned to farm work. 1976 joined cultural troupe of Shenyang Military Area of PLA as décor designer. 1981–82 studied in Liaoning AFA. 1982–84 in CAFA. Joined Liaoning Academy of Painting. His work in China was socialist realist in style and content, best known being his *Standing Guard for our Great Motherland* (1974). 1989 emigrated to Australia, where he concentrated on portraits and figure subjects with symbolic content. Lives and works in Sydney.

Shen Ling 申玲 (b. 1965, native of Liaoning province). Oil painter. 1989 graduated from Oil Painting Dept. of CAFA. 1994–95 did post-graduate study there. Taught in Fine Arts Middle School attached to CAFA. Silver award at Third China Oil Painting Exhibition. Her work has shown in many exhibitions in China and around the world, including Venice Biennale 1997.

Shen Qin 沈勤 (b. 1958, Jiangsu province). Painter. 1982 graduated from Jiangsu Chinese Painting Academy, where he became artist in residence. Member of post-1989 avant-garde movement.

Shen Roujian 沈柔堅 (1919–98, Fujian province). Painter, woodcut artist, and critic. Graduated from Fujian Normal College. 1930s took up wood engraving. Joined New Fourth Army. 1939 joined CCP. Active in propaganda art before and after Liberation. 1973 visited Italy with delegation of Chinese artists. 1980s in charge of Shanghai branch of CAA.

Shen Xiaotong 沈曉彤 (b. 1968, Chengdu, Sichuan province). Painter. 1989 graduated from Sichuan AFA. Professional painter and member of avant-garde movement. Noted for his portraits of family and friends.

Shen Yaochu 沈耀初 (1908–90, b. Fujian province). *Guohua* painter. Studied in Xiamen and Shantou colleges of art. Schoolteacher for thirty years. 1948 settled in Taipei. Expressionist in tradition of Zhu Da. 1987 chosen as one of Taiwan's ten great painters. See Yeh Cultural Foundation, *Shen Yaochu huaji* 沈耀初畫集 [Shen Yaochu's masterpieces] (Taichung, 1976).

Shen Yiqian 沈逸千 (1908–44, b. Shanghai). Ink and wash painter. 1932, after graduating from Shanghai Meizhuan, became involved in workers' art movement and patriotic propaganda. During WWII in west and northwest China, where he painted many pictures of peasant life. 1944 went missing in Chongqing, possibly on account of his leftist sympathies.

Shen Yuan 沈遠 (b. 1959, Xianyou, Fujian province). Installation artist. Living in Paris since 1990. 2002 exhibited at São Paulo Biennale.

Shen Zhongqiang 沈仲強 (1894–1974, native of Panyu, Guangdong province). *Guohua* painter. Father of **Shen Houshao.** In Guangzhou founded Guihai Painting Cooperative with Pan Zhizhong, **Deng Fen,** and others. Later settled in Hong Kong. Famous for his paintings of chrysanthemums.

Sheng Song. See **Te Wei**

Shi Banghe 施邦鶴 (b. 1951, Nanjing). *Guohua* painter. 2004 painting master in Nanjing Academy Specializes in landscapes and cityscapes painted in fine ink line without color. See *Shi Banghe baimiao ji* 施邦鶴白描集 [Shi Banghe's *baimiao* paintings] (Nanjing, 1999).

Shi Chong 石沖 (b. 1963, Huangshi, Hubei province). Oil painter and mixed-media artist. 1987 graduated from Oil Painting Dept. of Hubei AFA, where he was later taken on as associate professor. Has participated in many exhibitions at home and

abroad, including Quotation Marks (Bonn and Singapore, 1997) and Shanghai Biennale 2000. Hyperrealist.

Shi Chujian 師礎堅 (1892–1963, b. Guilin, Guangxi province). Painter. 1919 entered Shanghai Meizhuan to study Western art. Later returned to Guangxi, where he was active as painter and teacher. Painted large portrait of Sun Yat-sen for memorial hall in park in Guilin.

Shi Hu 石虎 (b. 1942, native of Xushui, Hebei province). *Guohua* painter. Graduated from CAAC and ZAFA. Member of Research Society of Chinese Folk Arts. His recent work has become increasingly abstract.

Shi Hui 施慧 (b. 1955, native of Ningbo, Zhejiang). Tapestry and installation artist. Pupil of Maryn Varbanov in ZAFA, where she became a teacher. Has participated in many exhibits in China, Australia, and Europe, including Shanghai Biennale 2000.

Shi Jiahao 石家豪 (Wilson Shieh, b. 1970, Hong Kong). *Guohua* painter. 1994 BA (fine art) and 2001 MFA from Chinese University of Hong Kong. Noted for his Chinese-style figure painting. Has participated in many exhibitions in Hong Kong and overseas, including 1999 Third Asia-Pacific Triennial of Contemporary Art, Queensland Art Gallery, Brisbane, Australia. 2003 won Asian artists fellowship, Freeman Foundation (Vermont Studio Center), and fine arts award at Hong Kong Art Biennial.

Shi Jihong 史濟鴻 (n.d.). Printmaker. 1980s teaching in Graphic Arts Dept. of CAFA.

Shi Lu 石魯 (original name Feng Yaheng 馮亞珩, 1919–82, native of Renshouxian, Sichuan province). Painter and wood engraver. Took his name from Shitao and Lu Xun. Son of wealthy landlord. 1934 studied *guohua* painting in Dongfang Art College, Chengdu. 1938 enrolled in West China Union University in Chengdu. 1940 went to Yan'an, where he took up propaganda work as head of arts section of Northwest Cultural Working Group. From 1942 did cartoons, woodcuts, new year pictures. After 1949 editor-in-chief of the magazine *Qunzhong huabao* 群眾畫報. His early work after Liberation was politically and stylistically orthodox, later landscapes and calligraphy very free in style. Visited India and Egypt in 1955–56. Imprisoned during Cultural Revolution and came under severe emotional and psychological pressure, leading to mental breakdown. His style changed, becoming more and more wild and expressionistic. See Wang Chaowen 王朝聞, Li Jiantong 李建彤, Wu Guanzhong 吳冠中, et al., *Shi Lu shuhua ji* 石魯書畫集 [Shi Lu's painting and calligraphy], with text in Chinese and English (Beijing, 1990). See also *Han mo* 翰墨, no. 47 (1993.1). (*Photo on p. 132.*)

Shi Qi 石齊 (b. 1939, native of Fujian province). *Guohua* painter trained in Fujian. Specializes in figure subjects. Member of Beijing Academy.

Shiau Jon Jen. See Xiao Zhangzheng

Shieh Hung Juin. See Xie Hongjun

Shieh, Wilson. See Shi Jiahao

Shiu, Margaret. See Xiao Lihong

Shiy De Jin. See Xi Dejin

Shu Chuanxi 舒傳熹 (b. 1932, native of Nanjing, Jiangsu province). Painter and wood engraver. Studied in Huadong Art Academy. 1955–56 studied in Hochschule für Grafik und Buchkunst, Leipzig, East Germany. 1961 graduated with honors, exhibited in Germany. 1962 returned to teach in Hangzhou Academy. First exhibition. Earlier work very German; later painted ink abstractions. 1986 solo exhibition at National Gallery of Victoria, Melbourne, Australia. Exhibitions in Germany and at British Museum (1994). 1998 exhibited in A Century in Crisis: Modernity and Tradition in the Art of Twentieth-Century China, Guggenheim Museum, New York.

Shu Tao 蜀濤 (original name Yi Zhongqian 易忠錢, b. China). Mixed-media artist. Educated at Royal AFA, Brussels; Chinese Culture University, Taipei; National AFA, Taipei. She has held many solo exhibitions in Taipei and in the West, and received a number of awards. Lives in Brussels.

Shu Tianxi 舒天錫 (b. 1922, native of Guangdong province). Oil painter. Studied in Hangzhou Academy. Professor and head of Dept. of Fine Arts, Nanjing Academy.

Shyu, Onion. See Xu Yangcong

Si Zijie 司子傑 (b. 1956, Shandong province). Oil painter. 1982 graduated from Stage Design Dept. of Central Academy of Drama. Academic realist.

Siao Ling-cho/Ling-tcho. See Xiao Lingzhuo

Situ Qi 司徒奇 (Seeto Ki, 1906–after 1995, native of Kaiping, Guangdong province). *Guohua* painter. After studying Western painting in Shanghai and Guangzhou, became student of **Gao Lun** and painted in style of Lingnan school. Settled in Vancouver.

Situ Qiang 司徒強 (Szeto Keung, b. 1948, Guangzhou). Hyperrealist painter in oils and acrylics. 1979 trained at Pratt Institute in Brooklyn. 1983 at NTNU. Works in New York. Has held solo exhibitions in US, Hong Kong, and Taipei.

Situ Qiao 司徒喬 (1902–58, native of Kaipingxian, Guangdong province). Oil painter and graphic artist. 1928 noticed by Lu Xun at his exhibition in Shanghai. 1928–30 studied in Paris and New York, supporting himself by painting pictures on restaurant walls. Returning to China, taught in Lingnan University, Guangzhou. Close friend of Lu Xun, of whom he made three quick sketches just after Lu Xun died. 1934–36 chief of art section of *Dagongbao* newspaper. During WWII in west China. After WWII was again in US. 1950 returned to Beijing, where he worked on setting up Museum of the Revolution and painted modern historical pictures. His best-known work is *Put Down Your Whip* (1940).

Siu Lap-sing. See **Xiao Lisheng**

Song Dayong 宋大勇 (Michael Ta Yung Soone, b. 1954, Taipei). Ink painter. BA California State University, Fresno. MBA West Coast University, Los Angeles. Lives in Hacienda Heights, California.

Song Dong 宋冬 (b. 1966, Beijing). Video artist. Studied at Capital Normal University, Beijing. 1998 exhibited at Inside Out: New Chinese Art (San Francisco and New York); 2000 at Global Conceptualism: Points of Origin, 1950s–1980s, 2002 Guangzhou Triennial, etc. Lives in Beijing.

Song Haidong 宋海東 (b. 1958, Yangzhou, Jiangsu province). Painter and installation artist. 1985 graduated from ZAFA Sculpture Dept. Teaches in Shanghai. Member of avant-garde movement.

Song Huimin 宋惠民 (b. 1937, Jilin). Oil painter. 1962 graduated from LXAFA in Shenyang, where he later became professor, director, and finally honorary president. Best known for his realistic panorama of *The Battle of the Red Cliff* (a scene from the third century), and *The Taking of Jiuzhou during the Civil War of 1947–49,* both now in the National (formerly Historical) Museum, Beijing.

Song Kejun 宋克君 (b. 1922, native of Guilin, a Muslim). Cartoonist and woodcut artist. 1940s in Sichuan. Later active in Chongqing.

Song Wenzhi 宋文治 (1919–99, Taichongxian, Jiangsu province). *Guohua* painter of landscapes. Father of Song Yulin. 1937 studied art in Suzhou Academy and under **Wu Hufan** and **Lu Yanshao**, then taught at primary school. 1957 taught at Nanjing Academy.

1960 toured with **Fu Baoshi** and other Jiangsu painters. 1982 deputy director, later director, of Nanjing Academy.

Song Yinke 宋吟克 (b. 1902, Nanjing). Painter. Started work in art section of Commercial Press; taught himself painting in his spare time. 1930s moved to Hong Kong. 1940s settled in Guiyang, Guizhou. After 1949 head of fine art section of Guizhou People's Publishing House. 1950s professor of Chinese painting in Southwest Nationalities College and Art Dept. of Guizhou University.

Song Yonghong 宋永紅 (b. 1966, Hebei province). Painter and printmaker. 1988 graduated from Print Dept., ZAFA. Member of avant-garde movement. 1993 exhibited at China's New Art, Post-1989 (Hong Kong); 1998 at Inside Out: New Chinese Art (San Francisco and New York). Member of avant-garde movement. Lives in Beijing.

Song Yuanwen 宋源文 (b. 1933, Liaoning province). Printmaker of Beidahuang school. 1961 graduated from CAFA Beijing, where he has taught for more than thirty years. 1980s and '90s active in northeast China. His *shuiyin* prints have been shown widely in the West. Most famous for his *White Mountain, Blackwater* (1981).

Song Yugui 宋雨桂 (b. 1940, Linyixian, Shandong province). 1960 entered Painting Dept. of LXAFA in Shenyang. 1968 entered cultural sector of PLA, where he did propaganda paintings and photography. 1979 transferred as professional artist to Liaoning AFA, of which he later became director. 1998 solo exhibitions in Shenyang and Singapore. Noted chiefly for his flower paintings and poetic ink landscapes evoking character of "Northern Waste" (*Beidahuang*). See Chua Soo Bin 蔡斯民, ed., *Song Yugui huaji* 宋雨桂畫集 [Song Yugui: Images of benevolence] (Singapore, 1998).

Song Yulin 宋玉麟 (b. 1947, Taihexian, Jiangsu province). *Guohua* painter. Son of **Song Wenzhi**. 1969 graduated from Theater Design Dept., Shanghai Institute of Dramatic Art. After working for some years as stage designer, he took up landscape painting. 1988 visited West Germany. Honorary curator of Song Wenzhi Museum of Art; deputy director of Jiangsu Chinese Painting Academy. 2004 director of Jiangsu Provincial Art Museum. See *Song Yulin shanshui huaji* 宋玉麟山水畫集 [Collected landscapes of Song Yulin] (Hong Kong, 1991).

Sonteperkswong, Tchai or **Thongchai.** See **Ye Meisong**

Soone, Michael Ta Yung. See **Song Dayong**

Su Baozhen 蘇葆楨 (b. 1916, native of Suqian, Jiangsu province). *Guohua* painter. 1939–44 studied under **Xu Beihong** in Art Dept., NCU Chongqing. Chiefly active in Sichuan. Specialized in bird and flower painting.

Su Guang 蘇光 (b. 1919, native of Shanxi province). Cartoonist and woodcut artist. 1940 studied at LXALA in Yan'an. Active in Shanxi.

Su Hui 蘇暉 (n.d.). Wood engraver. Active in Yan'an during WWII.

Su Manshu 蘇曼殊 (*zi* Xuanying 玄瑛, Zigu 子穀, *hao* Xuedie 雪蝶, 1884–1916, b. Yokohama, Japan, of a Japanese mother, native of Zhongshan, Guangdong province). Poet, translator, and *guohua* painter.

Su Tianci 蘇天賜 (b. 1922, Guangdong province). Oil painter. 1946 graduated from Art Dept., NCU Chongqing. Returned to Guangzhou to teach, then joined ZAFA in Hangzhou, where he became a friend and assistant to **Lin Fengmian,** who strongly influenced his style.

Su Xiaobai 蘇笑柏 (b. 1949, native of Hebei province). Oil painter. Graduated from Wuhan School of Arts and Crafts. 1987 completed his training in Oil Painting Dept. of CAFA. 1992 graduated from Düsseldorf National Art College. Settled in Germany.

Su Xinping 蘇新平 (b. 1960, Jining, Inner Mongolia). Oil painter and print artist: China's leading lithographer. 1989 MA from CAFA. Taught in Inner Mongolia Normal University before becoming head of CAFA Printmaking Dept. Awarded grand prize in Taipei exhibitions of young printers from the Mainland. 1998 exhibited at Inside Out: New Chinese Art (San Francisco and New York).

Sui Jianguo 隨建國 (b. 1956, Qingdao, Shandong province). Sculptor and avant-garde artist. 1984 BA Shandong AFA. 1989 MA CAFA. Appointed associate professor in CAFA. Solo exhibitions in Beijing (1994), New Delhi (1995), Hong Kong (1996), Melbourne (1997), etc. Group exhibitions include Shanghai Biennale (2000). Known for nude and clothed figures, such as his Mao jackets in fiberglass and aluminium. 2004 director and professor in Dept. of Sculpture, CAFA. 2005 solo exhibition at Asian Art Museum, San Francisco. (*Photo on p. 149.*)

Sun Duoci 孫多慈 (1912–75, Shouxian, Anhui province). Painter. Studied in Art Dept. of NCU Nanjing; favorite student of **Xu Beihong.** After WWII moved to Taiwan, where she taught in Art Dept. of NTNU.

Sun Fuxi 孫福熙 (*zi* Chuntai 春苔, 1898–1962, native of Shaoxing, Zhejiang province). Watercolor painter. 1918 Lu Xun recommended him to Beijing University library. 1920 Cai Yuanpei sent him to France on work-study program. Secretary of Franco-Chinese Institute, then studied painting and sculpture in Lyon. 1925 back to China, engaged in writing. 1928 cofounder of Hangzhou Academy with **Lin Fengmian** and **Pan Tianshou**. 1930–31 studied literature and art theory in France. 1931 professor in Hangzhou Academy and chief editor of *Yifeng* 藝風. 1937 went to Wuhan, joined All-China Federation of Anti-Japanese Artists. 1938 returned to Shaoxing. 1945 went to Shanghai. 1949 schoolmaster in Shanghai Middle School. 1951 to Beijing to work in People's Educational Publishing House.

Sun Gang 孫綱 (b. 1959, native of Hubei province). Oil painter. 1985 graduated from Fine Art Dept. of Hebei Normal University. 1986–87 studied printmaking in Guangzhou Academy. 1991 MFA from Oil Painting Dept. of CAFA. Associate professor in Hebei Normal University. Primarily a landscape painter.

Sun Jianping 孫建平 (b. 1948, native of Tianjin). Oil painter. 1981 graduated from Tianjin Academy. 1987 MA, became dean and professor in Tianjin Academy. Paints figure subjects, portraits, and landscapes in expressionist manner.

Sun Jingbo 孫景波 (b. 1945, native of Shandong province). Oil painter. 1980 graduated from CAFA as postgraduate student. Became professor in CAFA and dean of Mural Painting Dept. 1987 solo exhibition in Paris. Paints chiefly historical and Tibetan subjects.

Sun Kegang 孫克綱 (b. 1923, Tianjin). *Guohua* painter, chiefly of landscapes. Active in Tianjin. Member of Tianjin Painting Academy.

Sun Mide 孫密德 (b. 1947, Taiwan). Graphic designer and landscapist. 1967 BA from Fine Art Dept. of NTNU. 1970 illustrator for *China Times*. 1977 studied painting in US. 1981 founding member of Taipei Art Club.

Sun Weimin 孫為民 (b. 1946, Hulinxian, Heilongjiang province). Oil painter. Studied in middle school affiliated with CAFA. 1982 married painter **Nie Ou**. 1984 postgraduate in CAFA, won gold medal in Sixth National Art Exhibition. Vice-president and professor in CAFA. Noted for his borderland themes and figures in landscapes in dappled sunlight.

Sun Xiangyang 孫向陽 (b. 1956, Jinan, Shandong province). Oil painter. 1983 graduated from PLA Art Academy, where he became a teacher. Known for his paintings of Shaanxi peasant life.

Sun Xiaoyun 孫曉雲 (b. 1955, Nanjing). Calligrapher and painter. After graduation from middle school he was sent to work for five years in the countryside, then assigned to the Air Force. 1985 joined Nanjing Institute of Calligraphy and Painting. Has exhibited his calligraphy widely in East Asia. Member of executive council of Chinese Calligraphers Association.

Sun Xingge 孫星閣 (*hao* Shiwan Shanren 十萬山人, 1897–1996, native of Jieyang, Guangdong province). *Guohua* painter. Studied in Dept. of Literature in Nanfang University, Guangzhou. Aged 23 moved to Shanghai. Later cofounded Arts and Painting Society with Yu Youren and Tan Yankai. After WWII settled in Hong Kong. Painted landscapes, bamboo, shrimps, and crabs in vigorous ink manner. See Lin Shuji 林樹基, ed., *Shiwan Shanren Sun Xingge sheshuhua xuanji* 十萬山人孫星閣選集 [Selected poetry, calligraphy, and paintings by Shiwan Shanren Sun Xingge] (Hong Kong, 1972).

Sun Ying 孫瑛 (*zi* Dashi 大石, b. 1919, native of Zhongshan, Guangdong province). *Guohua* painter. Self-taught. During WWII served in army. 1945 met **Feng Zikai** in Wuhan. 1949 to Taipei. 1974–82 in San Francisco. After his return, active in promoting *guohua* in Taipei, founding several painting societies.

Sun Zongwei 孫宗慰 (1912–79, b. Jiangsu province). Painter in both *guohua* and Western style. 1934–37 studied Western painting under **Xu Beihong** in NCU Nanjing. During WWII went to front to sketch war scenes. 1940 to Dunhuang and Qinghai, painting life of Tibetans and Mongolians. 1942 research fellow in Chinese Art Research Institute, Chongqing. 1946 taught in NAA Beijing. 1956 appointed professor in Central Drama Institute. 1980 visited Japan with **Ya Ming**.

Szeto Keung. See **Situ Qiang**

Tam, Lawrence. See **Tan Zhicheng**

Tan Duan 譚端 (Tan Manyu 譚曼于, b. 1908, Changsha, Hunan province). *Guohua* painter. Educated in Shanghai. 1950 settled in Hong Kong, where she studied painting under **Zhao Shao'ang** and **Lü Shoukun**. 1960s participated with other students of Lü Shoukun in In Tao exhibitions.

Tan Manyu. See **Tan Duan**

Tan Ping 譚平 (b. 1960, Chengde, Hebei province). Printmaker. 1980–84 studied in Printmaking Dept. of CAFA. 1985–89 taught printmaking at CAFA. 1989–94 worked in Independent Artists Dept. of Berlin Art College. 1995–2003 professor and director

of Design Dept. of CAFA. From 2003 deputy director of CAFA. Has held many solo exhibitions in China and Germany.

Tan Shaoyun 譚少雲 (1901–88, b. Haianxian, Jiangsu province). *Guohua* painter. 1920 studied painting in Shanghai under **Wu Changshuo**. 1930 joined family business selling paintings. 1935 taught painting in Fudan University with **Feng Zikai**. 1960s and '70s traveled widely in China. 1978 joined staff of Shanghai Wenshiguan. Painted wide variety of traditional subjects.

Tan Zhicheng 譚志成 (Lawrence Tam, b. 1933, Guangzhou). Oil painter. 1947 settled in Hong Kong. Educated in Hong Kong, Edinburgh, and London. 1968 president of In Tao Art Association, Hong Kong, where he had studied for two years under **Lü Shoukun**. 1970 MA in history of Chinese painting, University of Hong Kong; taught in Extramural Studies Dept. 1992 chief curator, Hong Kong Museum of Art. On retirement settled in Toronto.

Tang Di 湯滌 (*zi* Dingzhi 定之, *hao* Shuangyu daoren 雙于道人, Lesun 樂孫, 1878–1948, native of Wujin, Jiangsu province). *Guohua* painter and calligrapher. Great-grandson of the painter Tang Yifen (1778–1853). Active in Beijing and Shanghai. Chiefly noted for his landscapes influenced by Li Liufang (1575–1629).

Tang Haiwen 唐海文 (1927–91, b. Xiamen, Fujian province). Painter. 1937 went with his family to Vietnam. 1948 arrived in France. After earning degree from University of Paris, he studied painting in La Grande Chaumière. Settled in Paris. Worked some years in Western media, then began to experiment with Chinese ink and wash techniques, creating semiabstract and abstract compositions.

Tang Hong 唐鴻 (original name Tatala 他塔拉, *zi* Sanchuan 三川, *hao* Chunzhi 淳之, b. 1926, Beijing, of Manchu origin). Painter. Studied bird and flower painting under **Yu Fei'an** and in Palace Museum, Beijing (1941), and NAA Chongqing (1944). 1949 moved to Taiwan; taught painting in Taichung Normal University. From 1954 taught in Fine Arts Dept. of Tunghai University. 1961 moved to Hong Kong, where he combined his careers as painter and teacher.

Tang Hui 唐暉 (b. 1968, Wuhan). Painter. 1991 graduated from Mural Painting Dept. of CAFA. 1995 produced major work, *The Time Machine* (five panels).

Tang Jiawei 唐家偉 (Wesley Tongson, b. 1957, Hong Kong, native of Guangdong province). Aged 20 settled in Toronto, where he studied under **Gu Qingyao**, teacher of **Huang Zhongfang**. Returned to Hong Kong as Huang Zhongfang's protégé. Eclectic style influenced by **Zhang Daqian**.

Tang Jingsen 唐景森 (Tong Kim-sum, b. 1940, Hong Kong). Sculptor. Since 1982 instructor in Hong Kong Sculpture Association. Works chiefly in stone.

Tang Jixiang 湯集祥 (b. 1939, native of Guangdong province). Primarily woodcut artist. 1962 graduated from Guangdong AFA. Mentor of Guangdong Painting Academy.

Tang Muli 湯沐黎 (b. 1947, Shanghai). Oil painter. 1979–81 postgraduate in CAFA, then worked in Shanghai University Art Dept. 1981–84 studied in Royal College of Art, London; received MA. Later settled in Montreal.

Tang Song 唐宋 (b. 1962, Hangzhou, Zhejiang province). Installation artist. Studied at ZAFA. Created installation piece *Dialogue*, which **Xiao Lu** fired on in 1989 China/Avant-Garde, prematurely closing the exhibition. Afterward he went to Hong Kong, where he was held in refugee camp until 1991. Made his way to Sydney, where he was again detained but released in November 1991. Since then has lived with Xiao Lu in Sydney, Hangzhou, and Beijing.

Tang Wing Chi. See **Deng Rongzhi**

Tang Xiaoming 湯小銘 (b. 1939, Guilin, Guangxi province). Oil painter. 1964 graduated from Oil Painting Dept. of Guangzhou Academy. Member of Guangdong Painting Academy. Studied at CAFA under Konstantin Maksimov. Early work in socialist realist style; later turned increasingly to portraiture.

Tang Yihe 唐一禾 (1905–44, native of Wuchang, Hubei province). Oil painter. 1919 studied art in Wuchang. 1924 studied Western painting in Beijing Art College. 1930–34 in Paris. Returned to become dean of Western Art Division of Wuchang Art College. Went with art college to west China in WWII; active in propaganda art. Drowned trying to save his brother when their boat foundered in the Yangzi on the way to Chongqing.

Tang Ying Chi, Stella. See **Deng Ningzi**

Tang Yingwei 唐英偉 (b. 1915, native of Chao'an, Guangdong province). Woodcut artist and *guohua* painter. Studied Chinese painting at Guangzhou Academy. 1932 joined woodcut movement. 1934 active with **Li Hua** and others in Guangzhou Modern Woodcut Society. Summer 1946 passed through Guangzhou on his way to Hong Kong. Most famous painting was his unfinished *Call to Arms* of 1940.

Tang Yun 唐雲 (*hao* Laichen 俠塵, Yaoweng 藥翁, Dashi Jushi 大石居士, 1910–93, b. Hangzhou). *Guohua* painter and connoisseur. Became art teacher in Hangzhou mid-

dle school. 1938 went to Shanghai. 1939–41 taught at Xinhua AFA. After 1949 joined Shanghai Institute of Painting. Head of Dept. of Chinese Painting, Shanghai College of Art. Later member of Shanghai Chinese Painting Academy, art administrator, and member of Shanghai Museum Authentication Board. Specialized in painting birds and flowers.

Tang Zhigang 唐志岗 (b. 1959, Kunming, Yunnan province). Painter. 1976 joined PLA after leaving high school. 1989 graduated from the Painting Dept. of PLA Art Institute. Since 1996 teaching at Yunnan Art Academy in Kunming. His early work depicted army life. Later his paintings, some of which depict small boys in army uniforms aping their elders, became increasingly satirical.

Tao Lengyue 陶冷月 (1895–1985, b. Suzhou). *Guohua* painter. Held successive teaching posts in Jinan, Henan, and Sichuan universities. 1958 branded Rightist. 1962 rehabilitated. Was for some time a professional artist in Shanghai, where his paintings showing Western influence fetched high prices. (*Photo on p. 149.*)

Tao Yiqing 陶一清 (1914–86, Beijing, native of Shanghai). *Guohua* painter. 1934 graduated from Jinghua College of Fine Arts, then taught in Kaifeng. 1936–49 taught in middle schools and teachers' colleges in Beijing. 1961 joined staff of CAFA. Accomplished landscape painter.

Tao Yuanqing 陶元慶 (1893–1929, native of Shaoxing, Zhejiang province). Painter. 1920s took up Western painting. 1925 held exhibition in Beijing; Lu Xun wrote preface to his catalogue. Vice-president of Chinese Painting Research Society, Beijing. 1928 professor of design in Hangzhou Academy.

Tao Yun 陶濚 (Tao Wan 陶濚, b. 1915, native of Panyu, Guangdong province). *Guohua* painter. Graduated from Sun Yat-sen University, Guangzhou. Before WWII member of Chinese Painting Research Society and Qingyou Society. Later moved to Hong Kong, where he was deputy chairman of Hong Kong Chung Kok Chinese Art Club and professor of fine art in Lianda College. Specializes in ink landscapes.

Tao Wan. See **Tao Yun**

Te Wei 特偉 (Sheng Song 盛松, b. 1915, Shanghai, native of Zhongshanxian, Guangdong province). Cartoonist. 1930s and '40s active in Shanghai and Guilin. Influenced by English cartoonist David Low. Later lived in Shanghai.

Teng Baiye. See **Teng Gui**

Teng Gui 滕圭 (*hao* Teng Baiye 白也, 1900–1980, b. Shanghai, native of Fengxian, Jiangsu province). Sculptor and *guohua* painter. From 1923 studied sculpture and painting in Seattle, where he met Mark Tobey. 1928 returned to China; worked chiefly in Shanghai, where Tobey studied under him in 1934. Sculpted monument to Chiang Kai-shek in Nanjing before WWII, which he spent in west China. His career as an artist ended with Liberation. (*Photo on p. 149.*)

Tian Huan 田桓 (1893–1982, native of Hubei province). Painter and calligrapher. Before 1911 Revolution joined Tongwenhui, was close associate of Sun Yat-sen in revolutionary KMT. 1912–19 studied in Japan. Returned to Shanghai, then Nanjing. Spent later years chiefly in Shanghai, becoming official in Shanghai municipal government.

Tian Liming 田黎明 (b. 1955, Beijing). *Guohua* painter. 1984 completed study in advanced class in Chinese painting at CAFA; became lecturer there. 1991 MA in Dept. of Chinese Painting in CAFA, where he was later appointed dean. Noted for his experimental technique with ink and color wash. 2000 exhibited at Shanghai Biennale.

Tian Shiguang 田世光 (*zi* Gongwei 公煒, b. 1916, native of Beijing). *Guohua* painter, chiefly of birds and flowers. 1933 enrolled in Chinese Painting Dept. of Jinghua Art Institute, Beijing. 1937 worked as researcher in Beijing Antiquities Bureau. From 1949 taught in both CAFA and CAAC. Member of Beijing Chinese Painting Research Institute.

Tian Yugao 田宇高 (b. 1923, Xushuixian, Hubei province). Watercolor painter. Until 1944 worked in Beijing. 1944 went to Xi'an to teach. After WWII went to Shanghai, then Guizhou, where he worked for provincial administration.

Ting Chih Jen. See **Ding Zhiren**

Ting Shao Kuang. See **Ding Shaoguang**

Ting, Walasse. See **Ding Xiongquan**

Ting Yen-yung. See **Ding Yanyong**

Tomos (Tuo Musi 妥木斯, b. 1934, Inner Mongolia, of Mongol nationality). Painter. 1958 MFA in oil painting from CAFA, where he studied under Luo Gongliu as first Mongol in the academy. Later became professor and dean of the Fine Art Dept., Normal University of Inner Mongolia.

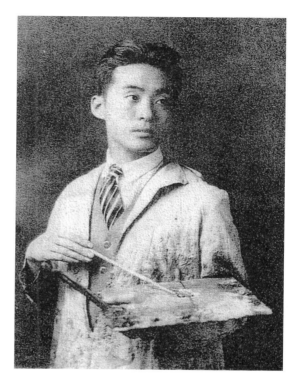

clockwise from top left
Sui Jianguo.
Teng Gui (Teng Baiye).
Tao Lengyue.

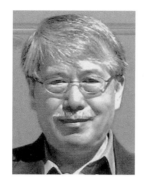

clockwise from top left
Wan Qingli. Photo by Zheng Jie, 2003.
Wang Henei.
Wang Huaiqing. Beijing. Photo by Xu Qinghui.
Wang Jia'nan.
Wang Keping.
Wang Linyi.

Tong, Grace Tang Tse. See Dong Yangzi

Tong Jun 童寯 (T'ung Chün, b. 1900, Shenyang, Liaoning province). Watercolor painter. Graduated in architecture from Qinghua University. 1925–28 traveled to US and Europe. 1930 retired to China to teach architecture in Shenyang. After a stay in Shanghai, taught at NCU Chongqing during WWII, then worked in Nanjing. Noted for his watercolors showing influence of his teachers G. W. Dawson and John Singer Sargent.

Tong Kim-sum. See Tang Jingsen

Tongson, Wesley. See Tang Jiawei

Ts'ai Intang. See Cai Yintang

Ts'ai Wen-ying. See Cai Wenying

Tsao Ya. See Cao Ya

Tsay Shoe-lin. See Cai Shuilin

Tseng Yu-ho. See Zeng Youhe

Ts'o, Beatrice. See Zhang Jiahui

Tsui, Joseph Chee Kui. See Xu Zhiju

Tsung Pu. See Zhuang Pu

Tu Guowei 屠國威 (Tu Kuo-wei, b. 1947, Taiwan). Sculptor. 1970 completed studies in National AFA, Taipei. 1975 completed studies in the National AFA, Rome. 1981–85 exhibitions in Europe. 1987–88 exhibition in New York and Italy. Important public works in Taiwan. 1997 professor of sculpture in Tainan National College of Art. His abstract works in stone have been widely shown in Taiwan, Germany, and US.

Tung Hing Yee. See Dong Qingyi

Ung Kim Leng. See Huang Jinlong

Van I-pong. See Wan Yipeng

Van Lau. See Wen Lou

Wan Qingli 萬青力 (b. 1945, Beijing). Painter, teacher, and art historian. 1963–68 studied in Art History Dept. of CAFA. 1967–68 detained in "cowshed" (*niupeng*), where he met **Li Yingjie, Li Keran, Wu Zuoren,** and **Huang Yongyu.** 1968–73 worked as farm laborer in Xuanhua, Hebei province. Later studied in Beijing under Li Keran and Liang Shunian at CAFA. Member of Beijing Chinese Painting Academy. 1991 PhD from University of Kansas. Appointed lecturer in art history in University of Hong Kong; 2000 promoted to reader; 2001 given title of professor. 2005 appointed professor at Baptist University, Hong Kong. Among his many valuable writings on nineteenth- and twentieth-century Chinese art, his works on Li Keran and nineteenth-century Shanghai school are definitive. 2003 solo exhibition in CAFA gallery, Beijing. See Xue Yongnian 薛永年 and Yeung Chon-tong 楊春棠, eds., *Wan Qingli shu hua* 萬青力書畫 [The calligraphy and painting of Wan Qingli] (Hong Kong, 1996); and Xiao Fenqi 蕭芬琪, ed., *Wan Qingli huazhan* 萬青力畫展 [Exhibition of paintings by Wan Qingli] (Beijing, 2003). (*Photo on p. 150.*)

Wan Yipeng 萬一鵬 (Van I-pong, b. 1917, native of Jiading, Jiangsu province). *Guohua* painter. Born into literati family. Studied painting under Zhao Mengsu. 1949 settled in Hong Kong. 1973–76 lecturer in Fine Arts Dept., Chinese University of Hong Kong. 1985 emigrated to Canada.

Wang Biwu 王碧梧 (b. 1916, Shanghai, native of Wuxing, Zhejiang province). Painter. 1933–36 she studied under **Yan Wenliang** in Suzhou Academy. Worked as illustrator in Suzhou. 1938 went to Shanghai. 1947–49 in Kao-hsiung, Taiwan, then returned to teach in Shanghai and elsewhere. Specialized in watercolor painting.

Wang, C. C. See **Wang Jiqian**

Wang Chaowen 王朝聞 (1909–2003, native of Hejian *xian*, Sichuan province). Sculptor, aesthetician, and critic. Early 1930s studied in Hangzhou Academy. 1937 joined anti-Japanese propaganda team. 1940 went to Yan'an, taught in LXALA. After 1949 professor at CAFA. General editor of *Meishu* 美術, vice-president of CAA. Has written widely on art and drama.

Wang Cheng 王成 (b. 1965, Wuhu, Anhui province). 1991 graduated from Jiangsu Normal College, Nanjing. 1997 mixed-media collages exhibited in Quotation Marks exhibition, Singapore. Works in Nanjing.

Wang Chuan 王川 (b. 1953, Chengdu, Sichuan province). Painter. 1982 graduated from Sichuan AFA. 1984 moved to Shenzhen, where he helped to organize independent artists. 1987 became full-time artist. Developed as abstract expressionist and installation artist. 1991 returned to Chengdu.

Wang Chunjie 王純杰 (b. 1953, Shanghai). Installation artist. 1982 graduated from Stage Design Dept. in Shanghai Drama Institute. Many solo and group exhibitions at home and abroad, including Shanghai Biennale 2000.

Wang Daizhi 王代之 (n.d.). Oil painter. 1924, while studying in France, cofounded Phoebus Society (Association des artistes chinois en France) with **Lin Fengmian, Lin Wenzheng, Liu Jipiao,** and **Li Jinfa,** with support from Cai Yuanpei. Wang returned to Shanghai later that year.

Wang Daoyuan 王道遠 (1892–1965, native of Zhaoyuan, Shandong province). *Guohua* painter. Taught in Shandong Licheng Normal College. Member of Beijing Academy.

Wang Daoyuan 王道源 (n.d.). Graduated from Tokyo Academy of Art. 1930 headed Yishu Zhuanke Xuexiao, a small school in Shanghai dedicated to development of oil painting, with **Ni Yide.** 1931 he, **Ni Yide,** and others founded Storm Society. 1932 fighting in Shanghai destroyed their school.

Wang Datong 王大同 (b. 1937, Anlong, Guizhou province). Painter. Studied in Sichuan AFA, then remained to teach there. Developed from realist to postimpressionist and expressionist style.

Wang Dawen 王大文 (b. 1942, Shanghai). *Guohua* painter. Studied under **Cheng Shifa.** 1984 moved to New York.

Wang Dewei 王德威 (1927–84, Shanghai). Oil painter. During WWII active in anti-Japanese propaganda in liberated areas and in publishing *Children's Pictorial* 兒童畫報, then as art worker with PLA. After WWI active in art publishing for young people. 1955–57, after a period in ZAFA, studied in CAFA under Konstantin Maksimov. Then appointed professor and chairman of the Oil Painting Dept. of ZAFA. Dedicated socialist realist. Attacked during Cultural Revolution for having painted a picture of Liu Shaoqi talking to lumberjacks.

Wang Dongling 王冬齡 (b. 1945, Rudong, Jiangsu province). 1961–66 studied fine art at Nanjing Normal College. After Cultural Revolution studied calligraphy in ZAFA under **Sha Menghai,** graduating in 1981. Since then has taught in several institutions, including ZAFA. His quasi-abstract calligraphy has been featured in exhibitions at British Museum and at Michael Goedhuis galleries, London and New York.

Wang Du 王度 (b. 1956, Hubei province). Sculptor and installation artist. Studied at Guangzhou Academy. 1989 arrested for participation in pro-democracy movement.

1990 moved to Paris. Focuses on role of media in creating "information." Exhibited at Venice Biennale (1999); Taipei Biennial (2000); Cantor Center for Visual Arts, Stanford University (2005).

Wang Duan 王端 (*zi* Yichang 辰昌, Zhiduan 之端, Xiaoshan 孝善, *hao* Wushi Caotangzhu 五十草堂主, 1908–?, native of Shaoxing, Zhejiang province). Calligrapher and *guohua* painter. Studied under **Zheng Chang.** Active chiefly in Shanghai and Hangzhou. Member of Wave Society and Xiling Seal-Carving Society. Compiled *Meishu nianjian* [Fine arts yearbook] (n.p., 1947).

Wang Fangyu 王方宇 (1913–97, Beijing). Calligrapher, *guohua* painter, and art historian. 1936 BA, Furen University, Beijing. 1946 MA, Columbia University, New York. Taught Chinese for more than thirty years at Yale and Seton Hall universities. Author of numerous textbooks, dictionaries, and studies of Chinese art, the most notable of which is his *Master of the Lotus Garden: Life and Art of Bada Shanren*, with Richard Barnhart (New Haven, Conn., 1990).

Wang Geyi. See **Wang Xian**

Wang Gongxin 王功新 (b. 1960, Beijing). Video and installation artist. 1982 graduated from Beijing Normal University. 1987 visiting scholar, State University of New York at Cortland and at Albany. Has since participated in many shows in US and in Europe, Australia, and Singapore. Lives and works in Beijing.

Wang Gongyi 王公懿 (b. 1946, Liaoning province). Print artist. 1962–66 studied in middle school attached to CAFA. 1973–78 art editor of Tianjin People's Publishing House. 1980 graduated from ZAFA. 1990s mostly in Paris. Now works in Tianjin.

Wang Guangyi 王廣義 (b. 1957, Harbin, Heilongjiang province). Painter. 1984 graduated from Oil Painting Dept. of ZAFA. 1985 teacher in Harbin Middle School. 1990 lecturer in Oil Painting Institute of Art and Technology, Wuhan. 1980s and '90s active in avant-garde movement. Exhibitions include China Avant-Garde (1989), and Inside Out: New Chinese Art (1993), where he showed "political pop" oil paintings. Lives in Beijing. His *Great Criticism* series combined Maoist poster art with the logos of modern consumerism.

Wang Guanyi 王官乙 (b. 1935, Changshou, Sichuan province). Sculptor. Trained in Sichuan AFA, Chongqing, where he became a teacher. 1965 on team of sculptors and artisans who created *The Rent Collection Courtyard.*

Wang Hai 王亥 (b. 1955, Sichuan province, native of Chongqing). Oil painter, formerly printmaker as well. His *Spring* (1979) was symbolic of China's reawakening after Cultural Revolution. 1982 BA from Sichuan AFA, Chongqing. 1982–87 teacher in Sichuan AFA. Gave up painting for academic study and writing novels. 1988 moved to Hong Kong. Took up painting again; executed series of paintings inspired by nineteenth-century photographs of Chinese (*Icons*) and Hong Kong (*Cultural Relics, Hong Kong History Series*).

Wang Hao 王浩 (b. 1963, Nanjing). 1987 graduated from CAFA. Photorealist oil painter. Husband of **Wei Rong**. Works in Beijing.

Wang Henei 王合内 (b. 1912, Paris). Sculptor. 1933 studied sculpture in Paris. 1937 married **Wang Linyi**; returned with him to China. 1937–48 made small sculptures at home. 1948 taught in Arts and Crafts Dept. of Beijing Normal College. 1955 became Chinese citizen. 1956 joined CAA. 1958 engaged in relief sculpture of minorities in Hall of Nationality Palace. 1985 associate professor in CAFA. (*Photo on p. 150.*)

Wang Honghui 王弘輝 (Wong Wangfai, b. 1940, Hong Kong). Studied painting under **Lü Shoukun**. Member of In Tao Art Association. 1970s active in Hong Kong.

Wang Huaiqing 王懷慶 (b. 1944, Beijing). Oil painter. Army stage designer for song-and-dance group. 1979 enrolled as postgraduate student in Wall-Painting Dept. of CAAC; studied in **Wu Guanzhong**'s studio. Joined staff of CAAC. 1980 member of Contemporaries (Tongdai Ren), one of the first independent groups in post-Mao period. After 1985 he went from painting figures to house interiors, then traditional furniture. Later developed as a quasi-abstract painter. 1991 gold medal at Exhibition of Chinese Oil Painting in Beijing and Hong Kong. 1982 exhibited at Paris Salon; 1983 in Italy; 1998 in exhibition China: 5,000 Years at Guggenheim Museum, New York. Also exhibited in Taipei and at Shanghai Biennale (2000). Husband of **Xu Qinghui**. Works in Beijing. See *Wang Huaiqing* 王懷慶 (Beijing, n.d.). (*Photo on p. 150.*)

Wang Huanan 王華南 (b. 1917, native of Fushanxian, Shandong province). *Guohua* painter. Takes famous sacred mountains as his subjects. Member of Beijing Academy of Painting.

Wang Huaxiang 王華祥 (b. 1962, Dajiagou, Guizhou province, of Yi nationality). Print artist and oil painter. Graduated from Guizhou Provincial Art School and CAFA, where he became lecturer in Printmaking Dept. 1989 awarded gold medal at National Print Exhibition. For some time he was a "cynical realist," but his recent work has become more lyrical.

Wang Huimin 王惠敏 (b. 1962, Beijing). Performance artist. 1985 graduated from Guangzhou Academy. 1997 working in Guangzhou Huashi Publishing House. 1997 exhibited "site-related happenings" at Quotation Marks exhibition, Singapore.

Wang Jia'nan 王佳楠 (b. 1955, Harbin). Painter. During Cultural Revolution worked in countryside and in factories. After working as a journalist in Heilongjiang province, he entered the reestablished CAFA. 1982 graduated and then taught at CAFA. Worked on ambitious mural projects for public buildings. 1983 set up first independent professional studio. 1987 settled in London, where he lives with his wife, the painter **Cai Xiaoli**. They also have homes in Beijing and France. See Zhang Daping, ed., *Wang Jianan and Cai Xiaoli* (Nanning, 2004). (*Photo on p. 150.*)

Wang Jianwei 王建偉 (b. 1958, Sichuan province). Painter and installation artist, curator, art editor, video artist, and filmmaker. Studied in Chengdu. 1987 MFA in oil painting from ZAFA. Became full-time professional painter in Beijing Painting Academy. Expressionist member of avant-garde movement. Gold medal in Sixth National Art Exhibition. 2000 exhibited in Shanghai Biennale. Has participated in many important exhibitions in China, Japan, Australia, US, and Europe.

Wang Jida 王濟達 (b. 1935, Beijing). Sculptor. 1962 graduated from Sculpture Dept. of CAFA. 1966 moved to Mongolia, where he specialized in herdsmen and horses. 1977 made statue of Mao in front hall of Mao's Memorial Hall in Beijing. 1984 went with his artist wife **Jin Gao** to New York, where, among other things, he worked on a scaled-down mural of the Statue of Liberty.

Wang Jieyin 王劫音 (b. 1941, Shanghai). Print artist. 1956 entered middle school attached to CAFA. 1966 graduated from Shanghai College of Art. 1994 gold medal in National Print Exhibition. His work influenced by New Year prints, traditional book illustration, and ink painting. Now an independent artist working in Shanghai.

Wang Jin 王晉 (b. 1962, Datong, Shanxi province). Installation artist. Lives in Beijing. Studied painting at ZAFA. Exhibited at Inside Out: New Chinese Art (San Francisco and New York, 1998), Venice Biennale (1999), Global Conceptualism: Points of Origin, 1950s–1980s (New York, 1999).

Wang Jingguo 王景國 (b. 1957, Harbin). Studied in Theater Design Dept. of Shanghai Academy of Drama. Stage designer and member of avant-garde movement of 1980s in Shanghai and Beijing.

Wang Jingsheng 王勁生 (b. 1928, native of Dongguan, Guangdong province). Studied Western painting in studio of Wang Xiaotian. From 1968 studied under **Lü Shoukun**

in Hong Kong. 1970 cofounded of One Art Club, Hong Kong. 1984 organized Joining Stream Art Club. From 1988, member of Hong Kong Artists' Guild. Chiefly noted for his landscapes in Chinese ink.

Wang Jinsong 王劲松 (b. 1963, Heilongjiang province). Painter. 1987 graduated from *Guohua* Dept. of ZAFA. Early 1990s teaching in Fine Art Dept. of Beijing Normal University. "Cynical realist" and member of avant-garde movement whose work in various media featured in Inside Out: New Chinese Art (San Francisco and New York, 1998) and China's New Art, Post-1989 (Hong Kong, 1993).

Wang Jiqian 王己千 / 王季遷 (C. C. Wang, 1907–2003, b. Suzhou). *Guohua* painter, connoisseur, collector, and art dealer. Qualified in law in Suzhou. 1925 moved to Shanghai, where he studied painting under **Gu Linshi** and **Wu Hufan.** Developed a close relationship with Wu Hufan and gained access to collection of Pang Yuanqi (1865–1949). 1935 advised Chinese government on selection of paintings for Chinese Exhibition at Burlington House, London, and began to collaborate with Victoria Contag on compiling encyclopedia of seals on Chinese paintings. 1947 moved to New York, where he studied Western painting at Art Students' League, supporting himself by dealing in real estate. 1954 helped Chou Fulai establish Mi Chou Gallery, first in New York to deal in Chinese paintings. Encouraged by **Zhang Daqian** and partly under stimulus of Western art, he began to develop the unique landscape style for which he became famous. 1962–64 head of Art Dept. of New Asia College, Chinese University of Hong Kong. Adviser on Chinese painting to Metropolitan Museum of Art, New York. For studies of his life and work, see Meredith Weatherby, ed., *Mountains of the Mind: The Landscape Paintings of Wang Chi-ch'ien* (New York, 1970); James Cahill, *C. C. Wang: Landscape Paintings* (Seattle, 1986); and Jerome Silbergeld, *Mind Landscapes: The Paintings of C. C. Wang* (Seattle, 1987).

Wang Jiyuan 王濟遠 (1895–1974). *Guohua* and *xihua* painter. Studied under **Liu Haisu** in Shanghai., 1926–31 in France and Japan. After returning to China, head of Western Painting Dept. at Shanghai Meizhuan. 1931–34 member of Storm Society. 1941 taught in New York and established school of Chinese brushwork. 1971 held joint exhibition with **Zhang Daqian** in Smithsonian Institution, Washington, D.C.

Wang Junchu 王鈞初 (b. 1905, Henan province). Oil painter. Trained in Shanghai Meizhuan. 1925 studied in Beijing Art Institute, where he and other leftist art students organized Anti-Feudalist, Anti-Imperialist Art Exhibition. 1929 taught in NAA Beijing. 1930, when he was fired, he and five others organized Society of Proletarian Painters. 1931 they were arrested and the society broke up. 1939 taught in NAA Beijing. 1932 founded Beiping League of Left-Wing Artists. 1933 edited secret left-wing art magazine. 1936 visited Moscow. 1939 taught in LXALA in Yan'an.

Wang Keping 王克平 (b. 1949, Beijing). Sculptor. Self-taught. In post-Mao years, was prominent activist in Beijing. 1979–81 leader of the Stars, with **Ma Desheng, Huang Rui,** and others. His works *Idol* (1978) and *Silence* (1979) were provocative satires in the political climate of the day. 1984 settled in Paris with his French wife, Catherine. 1997 artist in residence in Hong Kong University of Science and Technology. Working almost exclusively in wood, his figures, less satirical than his early work, are notable for their boisterous, powerful sense of form. He has exhibited widely in East Asia, Europe, and North America. See Jacques Barrière, *Les Voies de la sculpture: Wang Keping* (Paris, 1999); Michael Sullivan and Paul Serfaty, *Wang Keping* (Hong Kong, 2001). (*Photo on p. 150.*)

Wang Lan 王籃 (b. 1922, Tianjin). Watercolor painter and novelist. After studying painting, he joined the KMT army in 1937, wrote about his experiences, and became a successful novelist. 1957 took up painting again in Taiwan. 1964 State Department invited him to visit US. 1971–72 scholar in residence, University of Hawaii. 1979 visiting professor of art, Ohio State University. Returned to Taiwan, where he was founding member of Taipei Art Club. 1990s living in California.

Wang Lanruo 王蘭若 (b. 1911, native of Guangdong province). Painter. 1935 graduated from Chinese Painting Division of Shanghai Meizhuan. 1947 in Indonesia, where he exhibited with **Guan Shanyue.** 1948 returned to China. Active chiefly in Shantou, Guangdong province.

Wang Li 王里 (b. 1925, native of Henan province). *Guohua* painter. 1947 graduated from Wuchang Art College. Working in Shanghai.

Wang Lifeng 王利豐 (b. 1962, Inner Mongolia). Oil painter and sculptor. 1986 graduated in stage design, Central Academy of Theater, Beijing; became stage designer at Beijing People's Theater of the Arts. Many solo exhibitions, including Great Tang Series, Yi Bo Gallery, Shanghai (2002) and Great Han Series, Red Gate Gallery, Beijing, and J Gallery, Hong Kong (2003). (*Photo on p. 159.*)

Wang Linyi 王臨已 (1908–97, native of Shanghai). Sculptor. 1927–28 studied painting under **Xu Beihong** in NCU Nanjing. 1928–35 studied in Lyon and Paris, where he married the French sculptor **Wang Henei.** 1937 they returned to China, teaching sculpture in NAA Beijing. During WWII professor and head of Sculpture Dept., NAA Chongqing, where he made a bronze statue of President Lin Sen. 1946 joined Xu Beihong in NAA Beijing. From 1949 professor and head of Sculpture Dept. of CAFA. 1952–58 leading member of team that created reliefs for Heroes' Memorial, Tiananmen, Beijing. (*Photo on p. 150.*)

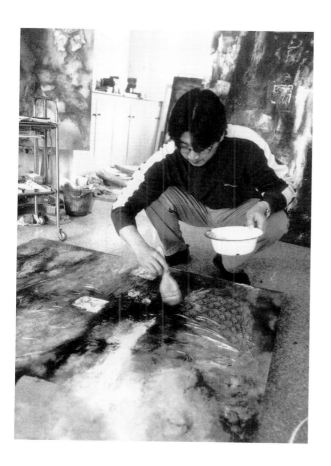

Wang Lifeng.

clockwise from top left
Wang Wuxie (Wucius Wong). Hong Kong, 1997. Photo by Josiah Leung.
Wei Tianlin. Self-portrait.
Wang Zhen (Wang Yiting).

Wang Lu 王路 (b. 1936, Huoqiuxian, Anhui province). 1955–61 studied oil painting in CAFA under **Dong Xiwen**. Assigned to work as painter in Beijing Fine Art Co. Later became director of studies in oil painting, woodcut and sculpture, Beijing Academy of Painting. Chiefly a landscape painter, much influenced by Soviet art.

Wang Maigan 王麥桿 (1921–2002, *xiang* Shandong province). Wood engraver. Settled in Shanghai. 1940 began making woodcuts. After WWII was friends with Geoffrey Hedley of the British Council in Shanghai; visited Taiwan.

Wang Meng 王夢 (n.d.). Oil painter. Active from 1920s until 1949. Studied under **Li Yishi** and **Wu Fading**. Graduated from NAA Beijing, where he also studied under Vojtech Chytil, secretary in Czech Legation, who arranged for him to study in Prague AFA. 1938 returned to China. 1948 exhibition of oil portraits and still lifes in Shanghai.

Wang Mengbai. See **Wang Yun**

Wang Panyuan 王攀元 (b. 1911, Jiangsu province). Painter. 1936 graduated from Shanghai Academy, where he studied under **Liu Haisu, Pan Yuliang,** and **Pan Tianshou.** 1949 moved to Taiwan; became art teacher and professional painter.

Wang Peng 王蓬 (b. 1964, Jinan, Shandong province). Performance and mixed-media artist. 1988 graduated from CAFA. Spent time in New York; now lives in Beijing. 1998 exhibited at Inside Out: New Chinese Art (San Francisco and New York).

Wang Ping 王平 (b. 1950s). Sculptor and ceramicist. Worked as editor for the Guizhou Publishing House in Guiyang before becoming professional artist and potter. 1989 held solo exhibition in National Art Gallery, Beijing. Her work in ceramics, bronze, and iron is influenced by the art and life of the Dong people of Guizhou and other elements of folk art.

Wang Qi 王琦 (b. 1918, Chongqing, Sichuan province). Wood engraver and watercolorist. 1937 graduated from Shanghai Meizhuan. 1938 studied in Art Dept. of LXALA in Yan'an. 1942 founded Chinese Wood Engravers' Research Association. After 1946 joined anti-KMT, anti-imperialist movements. 1948 joined Renjian Huahui in Hong Kong. 1950 taught in art school founded by Tao Xingzhi in Shanghai. 1952 taught in CAFA, engaged in design work for reliefs for Heroes' Memorial, Tiananmen, Beijing. In 1950s and '60s instructor in Print Dept. of CAFA.

Wang Qiang 王強 (b. 1957, Hangzhou). Painter, sculptor, and installation artist. 1985 graduated from ZAFA, became lecturer there in Sculpture Dept. 1986 active in Chishe (Purple Society). 1988–89 studied in University of Minnesota. Solo and

group exhibitions at home and abroad. 2000 exhibited installations in Shanghai Biennale.

Wang Qingfang 王青芳 (1900–1956, native of Xiaoxian, Anhui province). *Guohua* painter, especially of birds, flowers, fish, and horses. Younger brother of **Wang Ziyun.** 1923 graduated from Nanjing Teachers' College. 1924–25 studied in NAA Beijing under **Qi Baishi;** also influenced by **Xu Beihong.** After 1926 art teacher in Beijing middle school. 1942 part-time lecturer in NAA Beijing. After 1949 lecturer in CAFA. Close friend of Qi Baishi and **Li Kuchan.**

Wang Qingsheng 王慶昇 (b. 1932, native of Cunhua, Hebei province). *Guohua* painter. 1961 entered Bird and Flower Dept. of CAFA. Studied especially Song painting and art of Lü Ji and Chen Hongshou. Member of Beijing Academy of Painting.

Wang Qingsong 王慶松 (b. 1966, Shashi, Hubei province). Painter, installation artist, and photographer. Graduated from Sichuan AFA, Chongqing. Noted for his satirical panoramic photographic tableaux. Solo exhibitions in Beijing (2000), Macao and Milan (2002), Montreal (2003).

Wang Rizhang 汪日章 (1905–92, Fenghuaxian, Zhejiang province). Oil painter. 1926–29 studied oil painting in Paris. 1929 head of Western Art Dept. of Xinhua AFA and Changming Art College, Shanghai. With **Pang Xunqin** founded Taimeng Art Society in Shanghai. 1937 chairman of All-China Federation of Anti-Japanese Artists. 1947 director of Hangzhou Academy. 1949 quit as Communists approached Hangzhou.

Wang Rong 汪溶 (*zi* Shensheng 慎生, *hao* Manzhou cunren 滿州村人, 1896–1972, native of Xixian, Anhui province). *Guohua* painter, specializing in birds and flowers. Taught in NAA and other institutions in Beijing. Member of Beijing Academy of Painting.

Wang Senran 王森然 (1895–1984, b. Dingxian, Hebei province). *Guohua* painter, scholar, and critic. 1920s close friend of **Qi Baishi** in Beijing. 1930 graduated in Chinese literature from Beiping Normal College. 1948 **Xu Beihong** introduced him to NAA Beijing, where he became a teacher in 1951. Author of several books on Chinese painting. Coined the term *houwenrenhua* for scholarly modern traditional painters. Paid several visits to Japan, where his work is much admired.

Wang Shaoling 王少陵 (Wong Siu-ling, 1909–89, native of Taishan, Guangdong province). Oil and watercolor painter. 1913 moved with his family to Hong Kong. 1928 joined KMT political propaganda teams in China. 1935 with Du Geling, Mu Shiying, and **Chen Fushan** founded Literature and Art Association in Hong Kong. 1938–43 studied art in San Francisco and Columbia University, New York. Later held ap-

pointment in Fine Arts Dept. of Columbia University. Exhibited widely, chiefly in US and Hong Kong.

Wang Shikuo 王式廓 (1911–73, native of Yexian, Shandong province). Oil painter. 1932 studied Western painting in NAA Beijing. 1933–35 in Hangzhou Academy and Shanghai Meizhuan. 1935–37 studied in Japan. Returned to China; worked in art section of military commission of Nationalist Government. 1938 walked to Yan'an; taught in LXALA. After 1949 taught in CAFA. Active in history painting project of 1958–59, for which he prepared his *Bloody Clothes* illustrating denunciation of a wicked landlord. 1959 exhibited huge charcoal drawing for opening of historical museums, but final version in oils was unfinished at the time of his death, it is said, of overwork. See Zhu Dan 朱丹, ed., *Wang Shikuo huaji* 王式廓畫集 [Collected paintings of Wang Shikuo] (Beijing, 1982).

Wang Shou-hsiun. See **Wang Shouxuan**

Wang Shouqing 王守清 (Wong Sau Ching, b. 1954, Fujian province). Ink painter. 1973–78 worked on farm. 1978 moved to Hong Kong. 1987 studied at Central School of Arts and Crafts, London. 1992 BA (Hons) in fine art from Wimbledon School of Art, London. 1992 held first one-artist show at Morden College, London. Since returning to Hong Kong has worked in art and dance education projects. 1993–2000 held solo exhibitions in many cities throughout the world. 1997 won Hong Kong Arts Development Council Visual Arts Fellowship. Chairman of Artist Commune in Hong Kong.

Wang Shouxuan 王壽護 (Wang Shou-hsiun, b. 1924, native of Liaoning province). *Guohua* painter. Went to Taiwan, where she studied under **Zhang Gunian.** Popular, eclectic, and well-connected painter in Taiwan. See Kuo Tai-chun 郭太君, ed., *Wang Shouxuan de shuimo yishu* 王壽護的水墨藝術 [The ink-wash art of Wang Shouxuan] (Taipei, 1997).

Wang Shuhui 王叔暉 (1912–85, b. Beijing, native of Shaoxing, Zhejiang province). *Guohua* painter. Studied in Beijing under **Xu Yansun** and **Chen Shaomei.** Chiefly a figure painter. After 1949 she worked on New Year pictures and serial pictures for People's Art Publishing House.

Wang Songyu 王松峪 (n.d., native of Beijing). *Guohua* painter of birds, flowers, and landscapes. Member of Hu She Painting Society.

Wang Songyu 王頌余 (*zi* Bochuan 伯川, b. 1910, native of Tianjin). *Guohua* painter and calligrapher. While working in a bank, started to study painting, eventually becoming full-time painter. Member of Tianjin Painting Academy.

Wang Tiande 王天德 (b. 1960, Shanghai). Painter and installation artist. 1981 graduated from Shanghai Academy. 1988 graduated from ZAFA. 1990s associate professor in Art Education Center, Fudan University, Shanghai. Experimental ink painter. 1998 exhibited in Inside Out: New Chinese Art (San Francisco and New York) and in Shanghai Biennale.

Wang Tong 汪彤 (b. 1955, Hangzhou). Oil painter. 1982 graduated from ZAFA. 1983 went to study at Rhode Island School of Design. Settled in US.

Wang Wei 王偉 (*zi* Shimei 師梅, *hao* Shizi 師子, 1883–1950, native of Quyang, Jiangsu province). *Guohua* painter of landscapes, birds and flowers, fish, and insects. Trained in Japan, then taught in Shanghai Meizhuan and in Fujian. Member of Bees Society.

Wang Weibao 王維寶 (b. 1942, native of Jinjiangxian, Fujian province). *Guohua* painter and graphic artist. 1959 studied in middle school affiliated with Guangzhou AFA. 1963 entered Guangzhou Painting Academy.

Wang Weixin 王維新 (b. 1938, Zhejiang province). Painter and etcher. 1963 graduated from ZAFA. 1978–80 researcher at CAFA, then teacher in Graphic Arts Dept there. Did many etchings of Beijing scenes.

Wang Wenfang 王文芳 (b. 1938, native of Caoyuan, Shandong province). *Guohua* painter. Graduated from CAFA. Paints landscapes in the manner of **Li Keran**. Member of Beijing Academy of Painting.

Wang Wuxie 王無邪 (Wucius Wong, b. 1936, Tongguanxian, Guangdong province). Painter. Moved to Hong Kong, where he joined Hong Kong Chung Kok Chinese Art Club and, in 1956, Modern Literature and Art Association. Studied painting first under **Lü Shoukun**. 1961–65 earned BFA and MFA from Maryland Institute College of Art. 1970 received John D. Rockefeller III grant. Became assistant curator in Hong Kong City Hall Museum and Art Gallery. 1984, after prominent career as landscape painter in Hong Kong, moved to US. 1997 returned to establish permanent home in Hong Kong. See Stephen McGuinness et al., *Wucius Wong: Visions of a Wanderer* (Hong Kong, 1997); Wucius Wong, *The Tao of Chinese Landscape Painting* (New York, 1991). (*Photo on p. 160.*)

Wang Xian 王賢 (*zi* Qizhi 啟之, *hao* Geyi 個簃, 1897–1988, native of Haimen, Jiangsu province). *Guohua* painter, calligrapher, and seal engraver. 1920 studied under **Wu Changshuo** in Shanghai. 1921 visited Japan with art delegation led by **Wang Zhen**. 1928 visited Japan with **Zhang Daqian**. Professor in Xinhua AFA, Shanghai. 1929 professor

in Zhonghua Art University. 1930 head of Chinese Painting Dept. of Chongqing Art College. 1935 professor in Shanghai College of Art. 1956 founding member of Shanghai Chinese Painting Academy; later vice-president of Xiling Seal-Carving Society.

Wang Xin 王新 (b. 1957, Beijing). Oil painter. 1982 graduated from CAFA. Salon-style figure and landscape painter. Became teacher in Architecture Dept. of Qinghua University and in Art Division of School of Drama, Beijing.

Wang Xingwei 王興偉 (b. 1969, Shenyang, Liaoning province). Oil painter. 1988–90 studied in Art Dept. of Educational Institute of Shenyang University. Since 1991 has lived and worked as independent artist in Liaoning and Shanghai. Exhibited at Venice Biennale (1999), Chengdu Biennale (2001).

Wang Xuetao 王雪濤 (*zi* Chiyuan 遲園, Aoxue jushi 傲雪居士; 1903–82; native of Cheng'an, Hebei province). *Guohua* painter. 1919 entered Beijing Higher Normal College. 1922–26 studied Chinese painting at NAA Beijing under **Chen Hengke, Wang Yun,** and **Qi Baishi.** 1926 taught there. 1954 director of Chinese Painting Research Society, research fellow of Research Institute of Ethnic Arts in CAFA. 1980 head of Beijing Chinese Painting Academy. See Zhang Xuanjian 張宣健, *Wang Xuetao huaji* 王雪濤畫集 [Collected paintings of Wang Xuetao] (Beijing, 1983).

Wang Xuyang 王緒陽 (b. 1932, native of Zhanghe, Liaoning province). *Guohua* painter. 1950s and '60s with LXAFA in Shenyang. Did some collaborative works with other artists.

Wang Yachen 汪亞塵 (1894–1983, native of Hangxian, Zhejiang province). *Guohua* painter. 1915–20 studied Western painting in Tokyo. 1920 taught in Shanghai Meizhuan. 1928–31 in Europe. 1931 director of Xinhua AFA, Shanghai; founded Xinhua Art Teachers' College. 1937 sent by Ministry of Education to study crafts in Japan. 1948 studied in US, organized exhibition of modern Chinese painting. 1980 returned to China, died in Shanghai. Noted for his goldfish.

Wang Yan 王岩 (b. 1956, native of Liaoning province). Oil painter. 1982 graduated from LXAFA, Shenyang, where he became associate professor in Studio 2. Specializes in figure subjects.

Wang Yanping 王彥萍 (b. 1956, Beijing). Artist. 1982 graduated from Chinese Painting Dept. of CAFA; 1987 MA. Appointed associate professor in Beijing Technical University. 2000 she visited New York; solo exhibition in Sweden. Paints chiefly figure subjects in rich color.

Wang Yanzhang 王岩章 (b. 1951, Jiyuanxian, Henan province). *Guohua* painter. After working as farmer, taught himself to paint, encouraged by **He Haixia** and **Li Keran.** Traveled widely in China. 1987 lectured and exhibited in US. 1988 held solo exhibition in China Art Gallery. See Zhang Jinxian 張進賢 and Tao Xiulian 陶秀蓮, *Wang Yanzhang huaji* 王岩章畫集 [Collected paintings of Wang Yanzhang] (Beijing, 1988).

Wang Yidong 王沂東 (b. 1955, native of Linyixian, Shandong province). Oil painter. Studied in Shandong Art Institute. 1982 graduated in oil painting from CAFA, became teacher there. Admired Johannes Vermeer, Jean-François Millet, and Georges de La Tour. Noted for his portraits and figure studies, especially of people of his native region. See Wang Hongjian 王宏建, ed., *Wang Yidong youhua* 王沂東油畫 [Oil paintings of Wang Yidong] (Changsha, 1991).

Wang Yingchun 王英春 (b. 1942, Taiyuan, Shanxi province). Painter. 1966 graduated from Chinese Painting Dept. of Xi'an AFA. 1978 she attended Chinese painting graduate program in CAFA; later became member of Beijing Academy.

Wang Yiting. See **Wang Zhen**

Wang Yongqiang 王永強 (b. 1945, Shanghai). Oil painter. member of Shanghai Oil Painting and Sculpture Institute. 1980s specialized in realistic paintings on military themes.

Wang Youshen 王友身 (b. 1964, Beijing). Painter, installation artist, photographer, curator, and editor of *Beijing Youth Daily*. 1988 graduated from CAFA. Member of post-1989 avant-garde movement. 1989 artist-in-residence at Tasmania School of Art, University of Tasmania. 1998 solo exhibition at Art Gallery of New South Wales, Sydney. Has organized many visionary exhibitions using a variety of media, including postcards, books, and pages of *Beijing Youth Daily* newspaper. 2004 participated in Shanghai Biennale.

Wang Yuezhi 王悅之 (*zi* Yuezhi 月芝, Liu Jintang 劉錦堂, 1894–1937, b. Taichung, Taiwan). Oil painter. 1915 to Japan; entered Kawabata Academy. 1921 graduated from Tokyo Academy; went to Shanghai. 1922, with **Li Yishi, Wang Ziyun,** and **Wu Fading,** cofounded Apollo Art Research Institute for promotion of Western art. 1924 cofounded Beijing College of Art. 1930–34 principal of Beijing Professional Art School; also taught in other art schools in Beijing and Hangzhou. Sought to make his painting more "Chinese" by sometimes painting in oils on silk and mounting the picture as a hanging scroll.

Wang Yu-jen. See **Wang Yuren**

Wang Yun 王雲 (*zi* Zhuren 竹人, Wang Mengbai 王夢白, 1888–1934, native of Xin-feng, Jiangxi province). *Guohua* painter and Shanghai businessman. Studied painting under **Wu Changshuo.** Later taught in NAA Beijing, where famous actors, including Mei Lanfang, were among his students. He quarreled with many people, including **Qi Baishi.**

Wang Yuping 王玉平 (b. 1962, Beijing). Oil painter. 1989 graduated from CAFA, where he became instructor in Studio 4. Many solo and group exhibitions in China and abroad, including Shanghai Biennale 2000. Expressionist.

Wang Yuqi 王玉琦 (b. 1958, native of Hebei province). Oil painter. Active 1980s and '90s. Trained in CAFA.

Wang Yuren 王昱仁 (Wang Yu-jen, b. 1960, Taiwan). Sculptor. Graduated from Dept. of Sculpture, National Taiwan Academy of Arts.

Wang Zan 王贊 (b. 1957). Oil painter. Active in Shanghai. Best noted for his portraits of **Lin Fengmian,** *Spring from the Valley,* and Cai Yuanpei, *Reaching for the Sky*, in col-lection of Shanghai Art Museum.

Wang Zhen 王震 (*zi* Yiting 一亭, *hao* Bailong Shanren 白龍山人, 1867–1938, native of Wuxing, Zhejiang). *Guohua* painter. Apprenticed to picture-mounting shop in Shanghai, where he met and was greatly influenced by Ren Bonian. After working for several banks in Shanghai, became wealthy merchant with strong connections in Japan. 1911 met **Wu Changshuo,** who became his mentor and close friend. 1930 founded Sino-Japanese Art Lovers' Association. 1931 led art delegation to Japan that included **Zhang Daqian, Wang Xian, QianYa,** and Wang Jimei. Member of Haishang Tijingquan, Bees Society, and many other *guohua* societies. 1937 severed his business connections with Japan and moved to Hong Kong. Continued to paint all his life and even did some oil paintings. (*Photo on p. 160.*)

Wang Zhenghua 王征驊 (b. 1937, Henan province). Oil painter. 1956–61 student of **Wu Zuoren** in CAFA. Later studied in Biera, Italy, and in France and England. 1980s associate professor in CAFA. His early works were socialist realist, later works more abstract. 1990s living in New York.

Wang Zhijiang 王之江 (b. 1917, native of Heilongjiang province). Sculptor. 1930s studied in Japan. Close friend of **Qi Baishi,** of whom he made a bust in stone in 1954. Also worked in ceramics.

Wang Zhiyuan 王智遠 (b. 1958, Tianjin). Printmaker and installation artist. 1975–78 studied in Tianjin Craft High School. 1984 graduated from Printmaking Dept. of

CAFA. 1982 won gold medal from CAFA for his print *Wildflower*. Taught for several years in middle school attached to CAFA. 1989 went to Sydney as English-language student. Settled in Sydney as professional artist, making return visits to China in 1997 and 1998, since then he has divided his time between Sydney, Beijing, and Tianjin.

Wang Ziwei 王子衛 (b. 1963, Shanghai). Painter. 1983 graduated from Shanghai Institute of Technology. Worked for advertising agency until 1992, when he became full-time painter. Noted for his "political pop" paintings, as featured in China's New Art, Post-1989 exhibition (Hong Kong, 1993). 1987 began to paint the Mao series of portraits. Lives in Shanghai.

Wang Ziwu 王子武 (b. 1936, Xi'an). *Guohua* painter. 1963 graduated from Xi'an AFA. Active in affairs of CAA.

Wang Ziyun 王子雲 (1897–1974, native of Xiaoxian, Anhui province). Oil painter and sculptor. 1915 studied in Shanghai Meizhuan. 1920 entered NAA Beijing. 1922 taught in Beijing; cofounder of Apollo Art Research Institute with **Li Yishi, Wang Yuezhi,** and **Wu Fading.** 1924 with Wang Yuezhi cofounded Beijing College of Art. 1928 taught in Hangzhou Academy. 1931 studied sculpture in Paris. 1936 visited England, Belgium, Germany, Italy, and Greece. 1937 returned to China; professor in Sculpture Dept., Hangzhou Academy. 1949 professor of art history, Chengdu Art Academy. 1952 professor in Northwest Art Academy and Xi'an AFA.

Way, John. See **Wei Letang**

Wee Beng-chong. See **Huang Mingzong**

Wei Chuanyi 魏傳義 (b. 1928, Daxian, Sichuan province). *Guohua* and oil painter. Studied in Sichuan AFA and CAFA, and under **Zhang Daqian.** Later taught in Sichuan AFA. 1980s became president of the Fujian Academy (South Fujian Branch) in Xiamen.

Wei Dong 魏東 (b. 1968, Chifeng, Inner Mongolia). Painter. 1991 BFA, Beijing Normal College. 1995 solo exhibition Ancient Stage—Modern Players (Plum Blossoms Gallery, Hong Kong and Singapore). 1996 exhibited scrolls with costumed figures in classical landscapes in *Reckoning with the Past* (Fruit Market Gallery, Edinburgh) and *The New Investiture of the Gods* (Paris).

Wei Ershen 韋爾申 (b. 1956, native of Heilongjiang province). Oil painter. 1981 graduated from LXAFA in Shenyang; 1985 MA; 1988 research associate. Became

president and professor in LXAFA and chairman of Liaoning Provincial Artists Association. Noted for his monumental figure subjects influenced by Italian early Renaissance painting and Grant Wood.

Wei Guangqing 魏光慶 (b. 1962, Huangshi, Hubei province). Painter and performance artist. 1985 graduated from Oil Painting Dept. of ZAFA. Teaches in Hubei AFA. 1989 participated in China/Avant-Garde exhibition, Beijing.

Wei Jia 韋加 (b. 1957, Beijing). Painter and calligrapher. Husband of **Lin Yan** 林延. 1984 BA, CAFA, Beijing. 1987 MA in studio arts, Bloomsburg University, Pennsylvania. Since then has practiced as professional artist in US, noted for his Calligrapher series. Has held solo exhibitions in Schmidt/Dean Gallery, Philadelphia (1997, 1998, 2002, and 2004) and China Two Thousand Art, New York (2004).

Wei Jingshan 魏景山 (b. 1943, native of Ningbo, Zhejiang province). Oil painter and wall painter. Active in Shanghai. 1974 declared a "black painter" for his interest in modern Western art; assigned to factory work till 1977, when he assisted **Chen Yifei** on major painting, *Overturning the Dynasty of Chiang Kai-shek.*

Wei Letang 魏樂唐 (John Way, b. 1921, Shanghai). Painter. 1935–49 studied Chinese calligraphy and painting with **Li Jian.** 1949–56 in Hong Kong. 1956 immigrated to US, settled in Boston, studied architecture at MIT. 1973 moved to Los Altos, California. 1999 settled in San Francisco. His calligraphy and Abstract Expressionist paintings have been widely exhibited in the US and abroad. 2001 solo exhibition in Shanghai Art Museum.

Wei Qimei 韋啟美 (b. 1923, Anqing, Anhui province). Oil painter. Studied in NCU Chongqing during WWII. Has taught for many years in CAFA. Admirer of Edward Hopper and Piet Mondrian.

Wei Rong 韋蓉 (b. 1963, Beijing). Photorealist oil painter. Wife of **Wang Hao.** 1984 graduated from CAFA, where she became a lecturer.

Wei Tianlin 衛天霖 (1898–1977, b. Yangxian, Shanxi province). Oil painter. 1920–28 studied oil painting in Tokyo under Fujishima Takeji. Returned to China to become professor of Western Painting in Sino-French Institute, Shanghai. During WWII taught in National Beijing Academy of Painting, a Japanese-sponsored institution. Later taught in Beijing, became professor in CAFA and, in 1964, in CAAC. Much of his work was destroyed in Cultural Revolution. Impressionist, admired by **Wu Guanzhong.** (*Self-portrait on p. 160.*)

Wei Yinru 魏隱儒 (b. 1916, native of Hebei province). *Guohua* painter and calligrapher. Active in Beijing. Studied in NAA Beijing. Pupil and close associate of **Li Kuchan**. Member of many painting and calligraphy societies.

Wei Zixi 魏子熙 (1915–2002, native of Suiping, Henan province). *Guohua* painter. Member of Jiangsu Chinese Painting Academy, Nanjing. Landscapes and figures. 1990s his landscapes became more classical in style. See *Han mo* 翰墨, no. A16 (1996).

Wen Lipeng 聞立鵬 (b. 1931, Xihuixian, Hubei province). Oil painter. Son of **Wen Yiduo**. 1958 graduated from CAFA, where he studied under **Wang Shikuo** and **Luo Gongliu**. Former professor in Studio 4, CAFA. 1989 one-man show in Paris.

Wen Lou 文樓 (Van Lau. b. 1933, Vietnam). Sculptor and watercolorist. 1959 graduated from Fine Art Dept., NTNU. 1960 settled in Hong Kong. 1982 became chairman of Hong Kong Artists' Association and president of Hong Kong Sculptors Association. 1965 visited US on a grant. 1970 awarded Samuel Finley Breese Morse medal at 145th Annual Exhibition of National Academy of Design, New York. 1984 organized first Hong Kong Open Air Sculpture Exhibition. Major exhibitions of his sculpture have been held in Hong Kong (1987), Taipei (1992), and Sichuan (1992). Has executed many commissions, chiefly in metal, for public buildings in Hong Kong, Europe, North America, and Asia.

Wen Yiduo 聞一多 (1899–1946, native of Xishui, Hubei province). Painter and writer. Studied classical literature at Qinghua University. 1922 entered Art Institute of Chicago; immersed himself in English poetry while studying art. 1923 transferred to Colorado College, then Art Students League, New York. 1925 returned to China, gradually giving up painting for literature and poetry, although he made sketches on long overland journey to Yunnan during WWII. Assassinated by KMT agents in Kunming. (*Portrait on p. 171.*)

Weng Chenghao 翁承豪 (b. 1951, native of Jiangsu province). Printmaker. Active in Nanjing in 1980s and '90s.

Weng Tianchi 翁天池 (Weng Tien Chi, b. 1949). *Guohua* painter. Great-nephew of noted modern Chinese artist **Wu Hufan**. 1965 studied Chinese painting with **Pan Tianshou**. 1981 moved to Hong Kong. 1986 studied Western painting in France. 1996 awarded Urban Council Fine Arts Award in painting–Chinese media.

Weng Tonghe 翁同龢 (*zi* Shuping 叔平, Shengfu 聲甫, *hao* Songchan 松禪, Pingsheng 瓶生, Pinglu 瓶盧. 1830–1904, native of Changshu, Jiangsu province). Amateur

Wen Yiduo. Woodcut by Xia Ziyi.

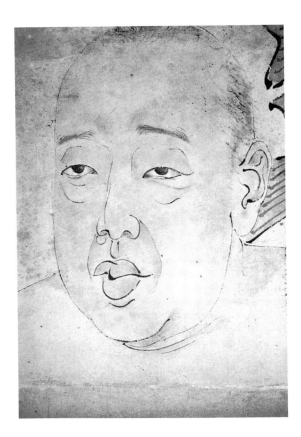

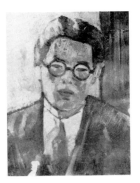

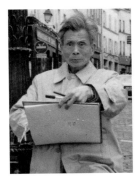

clockwise from left
Wu Changshuo at age sixty-one. Portrait by Ren Bonian.
Wu Dayu. Self-portrait.
Wu Guanzhong. Paris, 1989. Photo © Jeff Hargrove.

guohua painter and calligrapher. Reformist, high court official, and from 1875–97 tutor to Guangxu emperor (r. 1875–1908). Dismissed after failure of 1890 Reform Movement. A landscape of 1901, in the reflections, hints at Western influence.

Wo Yue Kee, Henry. See Hu Yuji

Wo Zha 沃渣 (1905–74, native of Zhejiang province). Woodcut artist. Studied in Shanghai. Joined woodcut movement. 1938 at LXALA in Yan'an. After 1950 in Beijing in charge of People's Art Press. His work studio produced *Nianhua*. Also associated with Rongbaozhai art publishing house.

Wong, Harold. See Huang Zhongfang

Wong Hau-kwei. See Huang Xiaokui

Wong, Kwan S. See Huang Junshi

Wong Lo. See Huang Lu

Wong Lui-sang. See Huang Leisheng

Wong Po Yeh. See Huang Banruo

Wong Sau Ching. See Wang Shouqing

Wong Siu-ling. See Wang Shaoling

Wong Wangfai. See Wang Honghui

Wong, Wucius. See Wang Wuxie

Woo, Nancy Chu. See Zhu Chuzhu

Wu Biduan 伍必端 (b. 1926, Nanjing). Printmaker. 1946 graduated from North China Joint University 1956 studied printmaking in Republic Institute, Leningrad. From 1981 director of Graphic Arts Dept. of CAFA.

Wu Buyun 伍步雲 (Ng Po-wan, b. 1904, native of Guangdong province). Oil painter. 1931 graduated from School of Fine Arts, University of Philippines. 1934 moved to Hong Kong. 1946 art teacher in Ying Wah College. 1960 founded his own studio. 1975 moved to Canada; instructor in Calgary. 1979, on invitation of Chinese Ministry of Culture, visiting professor of oil painting in CAFA. Paints in realistic colorful

style. See Ping Ye 平野, ed., *Wu Buyun huaji* 伍步雲畫集 [Collected paintings of Wu Buyun] (Beijing, 1983).

Wu Changjiang 吳長江 (b. 1954, native of Tianjin). Wood engraver. Active in 1980s and '90s.

Wu Changshuo 吳昌碩 (*zi* Junqing 俊卿, Foulu 缶盧, 1844–1927, native of Anji-xian, Zhejiang province). *Guohua* painter, seal engraver, calligrapher, and poet. 1865 passed civil service examinations, practiced seal engraving. 1877 started to learn painting and to study stone inscriptions, which were greatly to influence his later revival of antique styles of calligraphy, under Zhang Xiong (1803–86) in Shanghai. 1896 magistrate of Andong district for one month. 1903 chairman of Xiling Seal-Carving Society. Dominant figure in Shanghai school; also worked in Suzhou and Hangzhou. Close friend of **Wang Xian** and **Wang Zhen.** See *Han mo* 翰墨, nos. 37, 38, 39 (1993.2,3,4). (*Portrait on p. 172.*)

Wu Chengyan 吳承硯 (Wu Ch'eng-yen, 1921–99, b. Jiangyinxian, Jiangsu province). Oil and watercolor painter. Studied under **Xu Beihong** and **Lü Sibai** in NCU Nanjing. Around 1949 moved to Taiwan. From 1963 professor in University of Chinese Culture, Taipei. Many of his oil paintings of historical figures and sages and those of his wife, Shan Shuzi 單淑子, are housed in Huagang Museum, Taipei.

Wu Ch'eng-yen. See **Wu Chengyan**

Wu Dacheng 吳大澂 (1835–1902). Amateur *guohua* painter, calligrapher, archaeolo-gist, and collector. Qing official. Grandfather of **Wu Hufan.**

Wu Dayu 吳大羽 (1903–88, b. Yixingxian, Jiangsu province). Oil painter. 1922–27 studied in Paris under Emile-Antoine Bourdelle. On his return to China, taught at Hangzhou Academy, then deputy director of Shanghai College of Art. Spent WWII in Shanghai, making a small living as professional painter. After WWII rejoined Hangzhou Academy. 1950 went to Shanghai to illustrate picture books and did some teaching. Spent last years in retirement in Shanghai. A semi–abstract expressionist. Most of his work was destroyed in Cultural Revolution. (*Self-portrait on p. 172.*)

Wu Deyi 伍德彝 (1854–1920, native of Fanyu, Guangdong province). *Guohua* painter. Student of Ju Lian, Guangzhou.

Wu Dongcai 吳棟材 (1910–81, b. Taipei). Oil painter. Pupil of **Li Shiqiao.** Lived and worked in Taipei.

Wu Fading 吳法鼎 (1883–1924; native of Xinhui, Guangdong province). Painter. 1911 went to Europe to study law, but abandoned it for painting. One of first Chinese painters trained in France. 1919 returned to China. After 1920 taught at Shanghai Meizhuan. 1922 cofounder—with **Li Yishi, Wang Yuezhi,** and **Wang Ziyun**—of Apollo Art Research Institute for promotion of Western art in Beijing. 1924 joined Painting Methods Research Society, Beijing. Helped to establish NAA Beijing.

Wu Fan 吳凡 (b. 1924, Chongqing, Sichuan province). Painter and graphic artist. 1944 entered NAA Chongqing to study *guohua* under **Pan Tianshou** and **Li Keran**. 1946 moved to Hangzhou, studied oil painting under **Ni Yide**. 1948 graduated, returned to Chongqing. 1949 worked in fine art section of Chongqing Municipal Culture Association. From 1950 did illustrations, cartoons, and graphic work.

Wu Fuzhi 吳茀之 (1900–1977, b. Pujianxian, Zhejiang province). *Guohua* painter. Before WWII taught in Shanghai. After 1945 became professor in ZAFA and head of Chinese Painting Dept.

Wu Guandai 吳觀岱 (1862–1929, *zi* Niankang 念康, *hao* Jieweng 潔翁, Jiangnan buyi 江南布衣, native of Wuxi, Zhejiang province). *Guohua* painter, poet, and calligrapher. Influenced by Xu Wei (1521–93), Yun Shouping (1633–90), Shitao (1642–1707), and Hua Yan (1682–c. 1755). Lived principally in Beijing.

Wu Guanzhong 吳冠中 (b. 1919, Yixing, Jiangsu province). *Guohua* and oil painter. 1937–42 studied in Hangzhou Academy under **Pan Tianshou** and **Lin Fengmian;** went to Yunnan and Sichuan with NAA. 1942–46 taught in Art Dept. of Qinghua University. 1946–50 studied oil painting in Paris at Ecole Nationale Supérieure des Beaux Arts. 1950 taught in CAFA. 1955–64 taught oil painting in Beijing Fine Art Normal College. 1964–74 taught at CAAC. Currently professor in CAFA. Since 1980 his paintings have been widely exhibited in various countries. 1992 one-artist exhibition at British Museum, London. 1999 major retrospective in National Art Gallery, Beijing. Thoughtful and articulate writer on modern Chinese art. For studies of his work, see Lucy Lim, ed., *Wu Guanzhong: A Contemporary Chinese Artist* (San Francisco, 1989); *Wu Guanzhong huaji* 吳冠中畫集 [Collected paintings of Wu Guanzhong] (Beijing and Tianjin, 1987); *Wu Guanzhong guohua xuan* 吳冠中國畫選 [Selected *guohua* paintings of Wu Guanzhong], 4 vols. (Chengdu, 1982, 1984, 1986, 1987); Anne Farrer, ed., *Wu Guanzhong: A Twentieth-Century Chinese Painter* (London, 1992); *Han mo* 翰墨, nos. 22 (1991.12) and A21, A22 (1996); Fong Yuk Yan (preface), *Wu Guanzhong: Connoisseur's Choice*, 2 vols. (Beijing, 2003). (*Photo on p. 172.*)

Wu Guhong 吳孤鴻 (Ng Ku-hung, b. 1918, native of Dongguan, Guangdong province). *Guohua* and watercolor painter. 1926 settled in Hong Kong, devoted himself to business. 1963 began his artistic career and accepted students. For a time he taught watercolor in Dept. of Extramural Studies, Chinese University of Hong Kong. Specializes in topographical and scenic landscapes.

Wu Guxiang 吳榖祥 (*zi* Qiunong 秋農, 1848–1903, native of Jiaxing, Zhejiang province). *Guohua* painter, chiefly of landscapes in manner of Wen Zhengming (1470–1559) and Shen Zhou (1427–1509). Worked chiefly in Beijing and Shanghai.

Wu Hao 吳昊 (b. 1931, Nanjing). Oil painter and printmaker. Abstract expressionist. Trained in Nanjing. 1947 moved to Taiwan. 1956 founder of Ton Fan Group. From 1963 began printmaking, for which he received many awards.

Wu Hengqin 吳恒勤 (n.d.). Oil painter. Studied in Shanghai Meizhuan. At age of twenty-five went to Paris; there he copied many masterpieces in oils. 1930 returned to Shanghai with his copies, which were kept in Xinhua AFA, Shanghai, until they were destroyed by fire in August 1937. During WWII he was first in Nanjing with **Ye Qianyu**, then Wuhan, Changsha, Guilin, and Chongqing. After Liberation worked in Nanjing and Shanghai.

Wu Hufan 吳湖帆 (*hao* Qian'an 倩庵, 1894–1968, native of Suzhou, Jiangsu province). *Guohua* painter, calligrapher, and connoisseur. Grandson of **Wu Dacheng**, whose important family art collection he inherited. 1922 settled in Shanghai. Founder of Zhengshe Calligraphy and Painting Society; students included **Xu Bangda**. During WWII remained in Shanghai, joined Sino-Japanese Cultural Association. 1956 member of Shanghai Chinese Painting Academy. Leading member of Shanghai circle of traditional painters and connoisseurs. Is said to have committed suicide in hospital during Cultural Revolution. (*Portrait on p. 187.*)

Wu Jian 吳健 (b. 1942, Hangzhou). Oil painter. Studied in Shanghai Academy. Taught in Shanghai until 1986, when he moved to US. Studied first in San Francisco Academy of Art, later at Art Students League in New York.

Wu Jingding 吳鏡汀 (1904–72, native of Beijing). Orthodox *guohua* painter. Self-taught when young in *guohua*. Later joined Chinese Painting Research Society. Held various posts, including membership of Beijing Chinese Painting Academy, founded in 1957.

Wu Junfa 吳俊發 (original name Weng Yuanfa 翁元法, b. 1927, Guangfengxian, Jiangxi province). Printmaker, graphic artist, and art critic. Early 1940s took correspon-

dence course of All-China Woodcut Association. After 1943 started to make prints. 1946 joined China National Wood Engravers Association and entered Zhengze Art College, Jiangsu; studied under **Lü Fengzi**. After 1949 worked for art section in PLA. After 1977 deputy director of Jiangsu Provincial Art Gallery.

Wu Mali 吳瑪悧 (b. 1957, Taipei). Installation artist. Lives in Taipei. 1979 undergraduate degree from Tamkang University, Taipei. 1986 graduate degree from Staatliche Kunstakademie, Düsseldorf. Exhibited at Venice Biennale (1995), Taipei Biennial (1998), Inside Out: New Chinese Art (San Francisco and New York, 1998), etc.

Wu Mengfei 吳夢非 (1893–1979). *Guohua* painter. 1915 graduated from Zhejiang Junior and Senior Normal School, where he then taught painting and music. 1920 cofounded Shanghai Normal College of Art with **Liu Zhiping** and **Feng Zikai,** which, after several changes of name, closed in 1928.

Wu Puhui 吳璞輝 (Pansy Ng, b. 1937, Hong Kong). Painter. Studied under **Lü Shoukun.** Since 1961 in Columbus, Ohio.

Wu Qiangnian 吳強年 (b. 1937, native of Guangdong province). Woodcut artist. 1958 graduate of CAFA. Now active in Sichuan.

Wu Shanming 吳山明 (b. 1941, native of Zhejiang province). *Guohua* painter, chiefly of figures. Studied in ZAFA middle school and ZAFA, where he became professor of *guohua.*

Wu Shanzhuan 吳山專 (b. 1960, Zhoushan, Zhejiang province). Painter and installation artist. 1984 graduated from ZAFA. Member of avant-garde movement specializing in satirical conceptual art. His work featured in China's New Art, Post-1989 exhibition (Hong Kong, 1993) and Inside Out: New Chinese Art (San Francisco and New York, 1998). Lives and works in Germany.

Wu Shi 武石 (original name Feng Yushu 馮予樹, b. 1915, native of Xiangtan, Hunan). Painter and wood engraver. 1931 graduated from Changsha Huazhong Art School. Went to Shanghai Meizhuan. Started art group in girls' middle school; active in other groups. 1938 she joined left wing of United Front Against Japan and took up wood engraving. Active as art official in a number of places after Liberation, including Wuhan.

Wu Shiguang 鄔始光 (n.d.). Painter and graphic artist. Active until early 1920s. Studied under **Zhou Xiang** in Shanghai. 1914, with **Wang Yachen** and others, founded East Art Society (Dongfang huahui). 1916 studied in Tokyo. Established pioneer studio in Shanghai dedicated to Western methods of drawing and painting.

Wu Shixian 吳石僊 (?–1916, native of Changnong, Jiangsu province). *Guohua* painter. Active in Shanghai. Noted for his use of Western watercolor techniques to achieve atmospheric effect of rain and mist.

Wu Shuyang 吳叔養 (1901–66, b. Hangzhou). *Guohua* painter. Studied in Japan. After 1949 became professor in LXAFA in Shenyang.

Wu Tianzhang 吳天章 (b. 1956, Taiwan). Painter. 1980 graduated from Fine Art Dept. of Cultural University, Taiwan. 1982 cofounder of Contemporary Art Group. 1996 showed satirical photorealist works in Reckoning with the Past exhibit at Edinburgh International Festival.

Wu Xiaochang 吳小唱 (b. 1940, Shouguangxian, Shandong province). Oil painter. 1964 graduated from Oil Painting Dept. in CAFA. 1986 lecturer, then professor and director of postgraduate studies in CAFA.

Wu Xiu 吳休 (b. 1932, Chengdu, Sichuan province). *Guohua* painter and calligrapher. 1949 graduated from Sichuan College of Art. 1961 graduated from *Guohua* Dept. of CAFA. 1964 graduated from Beijing Painting Academy Advanced Studies Dept. Has held teaching appointments in US and exhibited worldwide. Deputy director of Beijing Painting Academy, specializing in landscape painting.

Wu Xuanhua 吳炫樺 (Ng Yuen-wa, b. 1970, Guangdong, Guangzhou province). Artist and printmaker. 1992 graduated from Printmaking Dept. of Guangzhou Academy, specializing in lithography. She has participated in numerous solo and group exhibitions. 1994 third prize in Fifth Chinese Ex Libris Exhibition, Beijing. 1998 first prize, Olympic Art and Sports. 1999 the printmaking prize in Chinese National Art Exhibition. 2000 prize from Ninth Chinese Fine Art Exhibition.

Wu Xuansan 吳炫三 (b. 1942, Yilan, Taiwan). Oil painter. 1968 graduated from Art Dept. of NTNU. 1973 graduated from Escuela Superior de San Fernando, Madrid. Has lived, worked, and exhibited in Europe, Africa, and US. Abstract expressionist.

Wu Xuerang 吳學讓 (b. 1923, Sichuan province). Painter, calligrapher, and seal engraver. 1948 graduated from Hangzhou Academy. Moved to Taiwan, where he taught in Taipei Municipal College for Women.

Wu Yaozhong 吳耀忠 (Ng Yiu-chung, b. 1935, Hong Kong, native of Guangzhou). Painter. Studied in Chinese University of Hong Kong. 1968 studied under **Lü Shoukun**. One of founders of In TaoArt Association.

Wu Yiming 烏一名 (b. 1966, Shanghai). Painter. 1986 graduated from Shanghai Arts and Crafts Institute. 1992 graduated from Fine Arts Dept. of East China Normal University. 1997 first solo exhibit in Shanghai. 1999 was in Maya Biennale, Portugal.

Wu Yongxiang 吳詠香 (1913–70, native of Minhou, Fujian province). *Guohua* painter. Studied under **Qi Baishi** and, after settling in Taipei, under **Pu Ru.** 1954 succeeded Pu Ru in teaching post at NTNU.

Wu Youru 吳友如 (1850–93). Graphic artist working in Shanghai. From 1884 edited and illustrated the popular periodical *Dianshizhai huabao.*

Wu Zaiyan 吳在炎 (1911–2001, native of Nan'an, Fujian province). Painter, traditional school. Spent his childhood in Indonesia and Singapore. 1931–34 studied in Xinhua AFA, Shanghai. 1938 settled in Singapore, where he taught in Nanyang Academy. Worked chiefly in Singapore and Hong Kong. Specialized in finger painting.

Wu Zheng 吳徵 (1878–1949, native of Tongxiang, Zhejiang province). *Guohua* painter. Active chiefly in Shanghai. Noted for his vigorous landscapes, and flowers in the manner of **Wu Changshuo.**

Wu Zhufeng 吳竹風 (b. 1918, Jiangsu province). Painter and designer, in both *guohua* and Western styles. Trained at Hangzhou Academy. 1943 exhibited in exhibition in Chongqing, was labeled "the Matisse of the East." 1946 returned to Shanghai.

Wu Zuoren 吳作人 (1908–97, Jiangyin, Jiangsu province, native of Jinxian, Anhui province). *Guohua* and oil painter. 1927 entered Shanghai University of Arts. 1928 transferred to Nanguo Academy under **Xu Beihong.** Later joined Nanguo Society organized by writer Tian Han. 1928 studied under Xu Beihong in NCU Nanjing. 1929–30 studied in France, then in Royal AFA, Brussels. 1931 awarded gold medal from Brussels Academy. 1935 returned to China; lecturer in Dept. of Fine Arts, NCU Nanjing. Married the flower painter Xiao Shufang. During WWII moved to Chongqing, toured Qinghai and Tibet. 1946 back to Shanghai, organized Shanghai Artists Association; joined Xu Beihong as professor and provost of NAA Beijing. After 1949 held various leading posts at CAFA; acting president of CAA. See Xiao Man 蕭曼 and Huo Dashou 霍大壽, *Wu Zuoren* 吳作人 (Beijing, 1988); *Wu Zuoren zuopinji* 吳作人作品集 [Collected works (*guohua* only) of Wu Zuoren], with essays by Ai Zhongxin 艾中信 and Qian Shaowu 錢紹武. (Shenyang, 1995); and *Han mo* 翰墨, no. 16 (1991.5), complete issue on Wu and Xiao. (*Photo on p. 124; portrait, p. 187.*)

Xi Dejin 席德進 (Shiy De Jin, 1923–81, b. Nanbuxian, Sichuan province). Oil and watercolor painter. 1941 entered Sichuan Provincial Academy of Art in Chengdu;

pupil of **Pang Xunqin.** 1943 studied in NAA Chongqing, where in 1945 began to study under **Lin Fengmian.** 1948 graduated from Hangzhou Academy, went to Taiwan. 1963 moved to Paris, where work was influenced by Bernard Buffet and later by Pop Art, Hard Edge, and Op Art. Returned to Taiwan as associate professor in Dept. of Fine Art, NTNU.

Xia Biquan 夏碧泉 (Ha Bik-chuen, b. 1925, Xinhuixian, Guangdong province). Sculptor, photographer, and printmaker. 1949 moved to Macao. 1957 settled in Hong Kong. Has exhibited widely in Asia, Australia, Europe, and US. 1974 became member of Hampshire International Graphics Society (US) and exhibited in the society's annual exhibition. Has won many awards in China, US, and Hong Kong.

Xia Feng 夏風 (b. 1914, native of Henan province). Wood engraver. 1930s and '40s active in Yan'an and liberated areas.

Xia Jun'na 夏俊娜 (b. 1971, Inner Mongolia). Painter. 1995 graduated from Studio 4, Oil Painting Dept. of CAFA. 1995 visited Japan on scholarship. 1996 exhibited expressionist/decorative figure groups at Shanghai Biennale.

Xia Peng. See **Yao Fu**

Xia Xiaowan 夏小萬 (b. 1959, Beijing). Oil painter. 1982 graduated from Oil Painting Dept. of CAFA. Member of post-1989 avant-garde movement. 1993 teaching in Central Academy of Drama, Beijing. His apocalyptic figure compositions featured in China's New Art, Post-1989 exhibition (Hong Kong, 1993).

Xia Yan. See **Xia Yang**

Xia Yang 夏陽 (Xia Yan, b. 1932, Nanjing). Oil painter. 1962 went to Paris. 1968 settled in US. Founded Ton Fan Group. Member of Gruppo Ta in Italy. Became photorealist. 1999 moved to Taiwan. 2002 settled in Shanghai.

Xia Yifu 夏一夫 (b. 1925, Shandong province). Painter. Studied painting in Yantai Normal School. 1947 passed qualifying exam for Hangzhou Academy, but did not enroll. After teaching two years, moved to Taiwan, where he did various jobs, including interior design. 1978 turned to painting full time. Known for his dense-textured landscapes. Solo exhibitions in Taiwan include National Museum of History (1996) and Taipei Fine Arts Museum (1997).

Xiao Ding. See **Ding Cong**

Xiao Feng 蕭峰 (b. 1932, Jiangxi province). Oil painter. 1943 joined CCP. 1954–60 studied oil painting in Leningrad, then taught in ZAFA. For some time director of oil painting studio in Shanghai. Since 1983 president and professor in ZAFA. Mother of **Xiao Lu**. Socialist realist.

Xiao Haichun 蕭海春 (b. 1944, Fengcheng, Jiangsu province). Jade carver and *guohua* painter. Trained in Shanghai Academy of Arts and Crafts as jade designer and carver. 1964 graduated. Later became largely self-taught painter. Vice-president of CAAC. Works in Shanghai.

Xiao Huixiang 蕭惠祥 (b. 1933, Changsha, Hunan province). Painter trained in CAFA. 1959 banished to Taiyuan; for a time sent for reeducation in the countryside. 1973–74 condemned as "bourgeois revisionist." 1979 rehabilitated; joined staff of CAAC; designed *The Spring of Science* wall decoration in ceramic tiles for Beijing Airport.

Xiao Junxian 蕭俊賢 (*zi* Zhiquan 屋泉, 1865–1949, native of Hengyang, Hunan province). Early 1900s taught *guohua* in Nanjing High Normal School. Later taught in Nanjing and Beijing. Academic artist, known as "the white Xiao" for his sparse use of ink.

Xiao Lihong 蕭麗虹 (Margaret Shiu, b. 1946, Hong Kong). Installation artist and ceramicist. BA University of California, Berkeley. Several solo exhibitions in Taipei, where she lives.

Xiao Lingzhuo 蕭凌卓 (Siao Ling-cho/Ling-tcho, native of Jiangsu province). Oil painter. Pupil of her father, Ling Wenyuan, and of **Qi Baishi**. 1930 obtained diploma in US. 1931–33 taught at NCU Nanjing. 1933 settled in Paris.

Xiao Lisheng 蕭力聲 (Siu Lap-sing, 1919–83, native of Chao'an, Guangdong province). *Guohua* painter, specializing in *luohan* and immortals. 1948 settled as art educator in Hong Kong. 1962 appointed lecturer in Fine Art Dept., Chinese University of Hong Kong, and tutor in Extramural Studies Dept.

Xiao Lu 蕭魯 (b. 1962, Hangzhou). Painter and installation artist. Daughter of **Xiao Feng**. Active in Hangzhou. 1989 her pistol shots into **Tang Song**'s controversial *Dialogue* installation brought about premature closing of China/Avant-Garde exhibition in Beijing. Since 1991 she and Tang Song have lived and worked in Sydney, Hangzhou, and Beijing.

Xiao Ping 蕭平 (b. 1942, Chongqing, Sichuan province, native of Yangzhou). *Guohua* painter and art scholar. 1963 graduated from Jiangsu Painting Academy, Nanjing,

where he is now master painter. Holds a number of teaching and administrative appointments in Nanjing. Since 1980 has participated in 48 exhibitions worldwide. See *Moyuan Xiao Ping shuhua ji* 墨緣蕭平書畫集 [*Moyuan*: Collected calligraphy and painting of Xiao Ping] (Nanjing, 2002).

Xiao Qin 蕭勤 (b. 1935, Shanghai, native of Zhongshan, Shandong province). Oil and ink painter. 1949 moved to Taiwan with his family. 1954 graduated from National Taiwan Teachers' College. From 1952 studied with **Li Zhongsheng.** 1956 moved to Madrid to study modern painting. 1957 cofounded Ton Fan modern art group. 1959 moved to Milan, where he joined Punto art movement in 1961. Later moved to New York. 1985 returned to Milan, finally settling in Taipei. Active member of international avant-garde movement. Abstract expressionist.

Xiao Shufang 蕭叔芳 (b. 1911, Zhongshanxi, Guangdong province). *Guohua* painter. Wife of **Wu Zuoren.** 1925 studied Chinese painting under Weng Shenzhi. 1926 studied Western painting in NAA Beijing. 1929 moved to Art Dept. of NCU Nanjing, where she studied under **Xu Beihong.** 1937–40 studied at Slade School of Art, London. During WWII in west China. 1947 part-time associate professor at NAA Beijing. After 1949 associate professor at CAFA. See Hong Kong Institute for Promotion of Chinese Culture, ed., *Paintings by Wu Zuoren, Xiao Shufang* (Hong Kong, 1988).

Xiao Sun 蕭愻 (*zi* Qianzhong 謙中, *hao* Longqiao 龍樵, 1883–1944, native of Huaining, Anhui province). *Guohua* painter. Student of **Jiang Yun,** for whom he was ghost painter. One of early members of Chinese Painting Research Society, founded in Beijing in 1920 by **Jin Cheng** and **Chen Hengke.** Later professor in NAA Beijing. His work was much influenced by Anhui *xieyi*-style painters of the Qing period, especially Shitao (1642–1707), Gong Xian (1599–1689) and Mei Qing (1623–79).

Xiao Zhangzheng 蕭長正 (Shiau Jon Jen, b. 1954, Chang-hua, Taiwan). Sculptor who works in wood, stone, bronze, and mixed media. Educated at NTNU. Lives and works in Taipei.

Xie Dongming 謝東明 (b. 1956, native of Hunan province). Oil painter. 1984 graduated from CAFA, became teacher in Studio 3. Has traveled and painted in upper Yellow River borderland region.

Xie Gongzhan. See **Xie Zhu**

Xie Haiyan 謝海燕 (1910–2001, native of Jieyang, Guangdong province). *Guohua* painter. 1927 entered art school in Guangzhou. 1928 studied Western painting in

Zhonghua Art University under Cheng Wangdao and **Chen Baoyi**, then in Japan. 1931 returned to China. 1934 professor at Shanghai Meizhuan. 1939 acting director of Shanghai Meizhuan when **Liu Haisu**, his close friend, was in Southeast Asia. During WWII in west China. 1944 taught in NAA Chongqing. 1945 deputy director of Shanghai College of Fine Arts. 1952 professor and head of Art Dept. in East China Art School. 1979 vice-president of Nanjing Academy.

Xie Hongjun 謝鴻均 (Shieh Hung Juin, b. 1961, Taiwan). Oil, watercolor, and mixed-media painter. BA, NTNU. MFA, Pratt Institute, Brooklyn, New York. PhD candidate New York University. She has held solo exhibitions in Islip Museum, Long Island, and in Taipei. 1990s living in New York.

Xie Jinglan 謝景蘭 (Lalan Ching-lan Hsieh, b. 1924, China). Painter, musician, choreographer, dancer, and poet. Studied in Hangzhou Academy. Continued her studies in Paris. Lives and works in Paris.

Xie Liqing 謝禮卿 (*zi* Gongrang 恭讓, *hao* Mengfu 孟甫, 1922–87, native of Qingyuan, Guangdong province). Painter. Trained in traditional medicine, he also learned traditional painting and calligraphy, which he studied with several masters. After WWII settled in Hong Kong, where he made his living teaching and producing calligraphy and paintings. 1990 retrospective of his work held in Hong Kong.

Xie Nanxing 謝南星 (b. 1970, Chongqing, Sichuan province). Avant-garde oil painter. 1993 graduated from Print Dept. of Sichuan AFA. 1999 MA. Later joined Art Dept. of Southwest Jiaotong University. Solo exhibits include Amsterdam 1998. Group exhibits include Forty-eighth Venice Biennale 1999 and Shanghai Biennale 2000.

Xie Qusheng 謝趣生 (1906–59, native of Sichuan province). Cartoonist. Active chiefly in Sichuan (Chengdu and Chongqing) in 1930s and '40s. Cartoons end in 1951.

Xie Ruijie 謝瑞階 (1902–?, native of Gongxian, Henan province). Painter and calligrapher. 1924 graduated from Western Art Dept. of Shanghai Meizhuan. Taught in Normal College in Kaifeng and Art Institute in Zhengzhou. 1956 joined CCP. In his thirties began to study *guohua*. Active in Henan. 1980 solo exhibition in Kaifeng. Noted for painting scenery of Yellow River.

Xie Xiaode 謝孝德 (b. 1940, Taoyuan, Taiwan). Oil painter. 1965 graduated from Art Dept. of NTNU. 1973–74 studied in Paris. Works in Taiwan.

Xie Xiaosi 謝孝思 (b. 1905, Guiyang, Guizhou province). *Guohua* painter and calligrapher. 1927 entered Art Dept. of NCU Nanjing. 1933 graduated, returned to teach

in Guiyang. 1946 went to Suzhou to teach painting, where he remained. 1983 joined delegation to Japan.

Xie Yuqian 謝玉謙 (Chia Yu Chian, b. 1936, Johore, Malaysia). Oil painter. Studied in Nanyang Academy, Singapore. 1959–61 studied at Ecole Nationale Supérieure des Beaux Arts in Paris. Returned to Malaysia for a few years, then settled in Paris.

Xie Zhiguang 謝之光 (1900–76, b. Yuyao, Zhejiang province). *Guohua* painter and graphic artist. Active in Suzhou and Shanghai, where he was member of Bees Society. 1920s and '30s played prominent part in commercial art world of Shanghai, producing magazine covers (especially for the pictorial *Liangyou*), line drawings for newspaper illustrations, calendars, etc. Also commercially successful *guohua* artist.

Xie Zhiliu 謝稚柳 (*hao* Zhuangmu sheng 壯暮生, Zhuangmu weng 壯暮翁, 1910–97, b. Changzhou, Jiangsu province). *Guohua* painter and connoisseur. Husband of **Chen Peiqiu.** 1937 went to Chongqing. Became close friend of **Zhang Daqian,** through whom he met **Xu Beihong.** 1942 visited Zhang in Dunhuang. Professor in Art Dept. of NCU Chongqing. After WWII in Shanghai. 1949 became adviser to Shanghai Museum and professor in NCU Nanjing. 1979 professor in Shanghai Academy. Scholarly versatile artist, master of variety of classical styles. 1983–90 led team commissioned by State Council to appraise over 70,000 works of Chinese painting and calligraphy from 207 institutions. Edited *Zhongguo gudai shuhua mulu* (Bibliography of ancient Chinese painting and calligraphy) and wrote works on Chinese painting. See Shanghai Museum, *Xie Zhiliu* 謝稚柳 [Xie Zhiliu] (Shanghai, 2002); *Han mo* 翰墨, no. 44 (1993.9).

Xie Zhu 謝壽 (*zi* Gongzhan 公展, 1885–1941, native of Dantu, Jiangsu province). *Guohua* painter of birds, insects, and flowers, especially chrysanthemums. Taught in several institutions in Nanjing and Shanghai.

Xie Ziwen 謝梓文 (b. 1916, Santai, Sichuan province). Wood engraver. Graduated from Printmaking Dept. of Sichuan AFA, then studied in Shanghai Academy. Became professor in Sichuan AFA, Chongqing.

Xin Dongwang 忻東旺 (b. 1963, native of Hebei province). Oil painter. 1986 graduated from Art Dept. of Jinzhong Teachers College, Shanxi province. 1994 completed his training in Oil Painting Dept. of CAFA. Associate professor in Oil Painting Dept. of Tianjin Academy.

Xin Haizhou 忻海洲 (b. 1966, Chengdu). Painter. 1989 graduated from Sichuan AFA, where he became a teacher. Member of post-1989 avant-garde movement. "Cynical realist."

Xing Baozhuang 邢寶莊 (Ying Pochong, b. 1940, native of Guangzhou province). 1980s and '90s active in Hong Kong. Figures in landscape, classical. Influenced by **Fu Baoshi** and Cantonese artists.

Xing Danwen 邢丹文 (b. 1967, Xi'an, Shaanxi province). Photographer. Undergraduate degree in painting, CAFA Beijing. 2000 MFA in photography and related media, School of Visual Arts, New York. Documented growing art movement in East Village artists' community. Exhibited at Yokohama Triennial 2001, Guangzhou Triennial 2002, Cantor Center for Visual Arts, Stanford University, 2005, and various photo festivals. Lives in Beijing.

Xing Fei 邢飛 (b. 1958, Beijing). Brush and ink, mixed-media, and installation artist. 1978–82 studied Chinese painting in CAFA. 1984 settled in New York, where she has done design work for major US companies in two and three dimensions, seeking to bring together elements of digital and fine art.

Xiong Bingming 熊秉明 (b. 1922, Nanjing). Sculptor and landscape painter. Studied philosophy in Southwest United University. 1947 to Paris, where he studied sculpture under Ossip Zadkine and others. Settled in Switzerland; later returned to Paris.

Xiong Hai 熊海 (Hung Hoi, b. 1957, Fujian province). Painter. 1978 moved to Hong Kong, where he studied *guohua* under **Yang Shanshen.** Noted for monumental landscapes in classic Northern Song style. 1996 solo exhibition in Hong Kong Museum of Art.

Xiyai. See **Zhang Xiyai**

Xu Anming 徐安明 (b. 1960, Beijing). Self-taught painter. Before 1991 produced series of realistic portraits. Thereafter his work became increasingly abstract, as featured, e.g., in China's New Art, Post-1989 exhibition (Hong Kong, 1993).

Xu Bangda 徐邦達 (b. 1911, native of Haiying, Zhejiang province). *Guohua* painter, connoisseur, and scholar in history of Chinese painting. Studied painting and connoisseurship in Shanghai under **Wu Hufan** and others. Joined research staff of Beijing Palace Museum, where he became a leading authority on history of Chinese painting.

Xu Beihong 徐悲鴻 (1895–1953, b. Yixingxian, Jiangsu province). Painter in both *guohua* and Western style. At seventeen, art teacher in primary and middle school in Yixing. 1914 went to Shanghai, was helped by **Gao Lun** and his brother, **Gao Weng.** Entered Zhendan University and studied French and drawing at Tushanwan Art School (Ziccawei) in Shanghai. 1917 spent six months in Japan. Appointed by Cai Yuanpei as tutor in Painting Methods Research Society of Beijing University. 1919, encouraged

and supported by Cai Yuanpei, went to Paris, studied in Ecole National Supérieure des Beaux Arts. 1921–23 in Berlin. 1925 visited and painted in Singapore, then returned to Shanghai. 1926–27 studied and traveled in Europe. 1927 returned to China; head of Art Dept. of Nanguo Art Institute. 1928 head of Art Dept. of NCU Nanjing. 1933–34 organized modern Chinese painting exhibitions in France, Italy, Germany, and Soviet Union. 1935 went to Guangxi to set up art academy. During WWII traveled twice to Southeast Asia to raise funds for war relief by holding exhibitions and selling paintings. 1940 invited by Rabindranath Tagore to visit and lecture at his Visva-Bharati University near Bolpur in West Bengal, India. 1941 exhibited in Penang, Ipoh, and Kuala Lumpur. 1942 returned to Chongqing; organized Chinese Art Research Institute at Panxi, Sichuan. 1936 president of NAA Beijing. 1949 attended world peace conference in Prague, president of CAFA, president of CAA. Strenuous opponent of Western modernism (expressed in his rivalry with **Liu Haisu**). Dedicated teacher who greatly influenced early development of orthodox oil painting. Made notable progress in combining Western realism with *guohua* techniques in, e.g., innumerable paintings of horses. See Song Guangsen 宋光森, ed., *Xu Beihong huaji* 徐悲鴻畫集 [Collected paintings of Xu Beihong], 6 vols. (Beijing, 1988); Hong Kong Urban Council, *Xu Beihong di yishu* 徐悲鴻的藝術 [The art of Xu Beihong] (Hong Kong, 1988); and *Han mo* 翰墨, no. 21 (1991.10). (*Photos on pp. 124, 187.*)

Xu Bing 徐冰 (b. 1955, Chongqing, Sichuan). Wood engraver, painter, and installation artist. Son of history professor at Beijing University. 1977 entered CAFA. 1987 MA. 1988 instructor in Print Dept. of CAFA. 1985 became active in New Wave. His *Tianshu* (A book from the sky), on which he had been working since 1986, exhibited in 1988 in National Art Gallery, Beijing. This highly controversial installation consisted of about 1,200 invented characters; subsequently traveled abroad, creating a sensation. Other major projects include *Ghosts Pounding the Wall* (1990), his satirical answer to Party critics who had condemned the "futility" of *Tianshu*; *Square Word Calligraphy* (1994–96); and *A Case Study in Transference* (1994). 1990 he moved to US, settling in New York. 2001 major exhibition curated by Britta Erickson, Word Play: Contemporary Art by Xu Bing (Arthur M. Sackler Gallery, Washington, D.C.), which included his new "landscripts." 1999 received prestigious MacArthur "genius" award. 2004 mounted exhibition, Tobacco in China, for presentation in Cardiff, Wales (and later in Shanghai), which won Artes Mundi award. See Britta Erickson, *Words without Meaning, Meaning without Words: The Art of Xu Bing* (Washington, D.C., 2001). Has participated in many group exhibitions, including Cantor Center for Visual Arts, Stanford University, 2005. (*Photo on p. 188.*)

Xu Cao 徐操 (*zi* Yan Sun 燕孫, 1898–1961, native of Shenxian, Hebei province). *Guohua* painter. Learned figure painting under **Yu Ming.** 1930s and '40s earned living

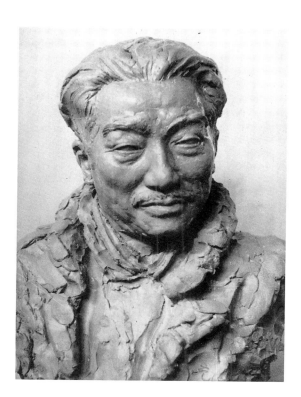

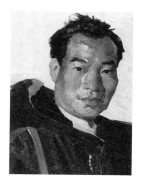

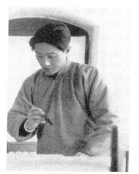

clockwise from left
Wu Hufan. Portrait bust by Zhang Chongren.
Wu Zuoren. Portrait (detail) by Valentin Maxsimov.
Xu Beihong.

 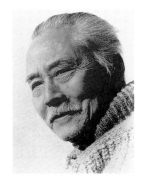

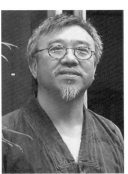

clockwise from top left

Xu Bing, 2001. Photo by Morna Livingston.
Yan Lei, 2004. Photo by Britta Erickson.
Ye Qianyu.
Yu Feng, 1983. Photo by Michael Sullivan.
Yu Hong, 2004. Photo by Britta Erickson.
Yu Peng, 2004. Photo by Britta Erickson.

as professional artist and art teacher. His many pupils included **Wang Shuhui** and **Pan Jiezi**. Vice-president of Beijing Chinese Painting Research Institute and deputy director of Beijing Chinese Painting Academy. Noted for his historical figures in landscape settings painted in *gongbi* technique.

Xu Dazhi 徐達之 (b. 1907, native of Meixian, Guangdong province). *Guohua* painter. Graduated from Guangzhou College of Fine Art. 1948 settled as artist and art teacher in Hong Kong, serving as tutor in the Extramural Studies Dept., University of Hong Kong.

Xu Jiaming 徐嘉明 (b. 1908, Shandong province). *Guohua* painter, traditional and modern schools. For sixteen years engaged in art education in Guangxi. Formerly editor of periodicals *Yinyue yu yishu* 音樂與藝術 and *Xiandai yishu* 現代藝術.

Xu Jianbai 徐堅白 (b. 1925, Hangzhou, Zhejiang province). Oil painter. 1946 graduated from NAA Chongqing. Went to Nanjing to teach in girls' middle school, then went to US to study at Art Institute of Chicago. June 1949 returned to China. In Guangzhou published a newspaper with **Guan Shanyue** and others. 1957 joined CCP. 1958 joined staff of Guangzhou Academy. Has exhibited in Guangzhou, Taiwan, and New York, where she settled in 1990.

Xu Jiang 許江 (b. 1955, Fuzhou, Fujian province). Painter. 1982 graduated from Oil Painting Dept. of ZAFA. 1988–89 studied in Hamburg. Returned to become dean of Oil Painting Dept. in China Institute of Fine Art, Hangzhou. Has exhibited widely in China, Hong Kong, Queensland, New York, and Hamburg. 2004 living in Hangzhou.

Xu Jianguo 徐建國 (b. 1951, Shanghai). Studied at Shanghai Academy of Drama. 1984 went to study in US. 1987 MFA Bard College. Artist in residence for New York Foundation of the Arts. Abstract expressionist.

Xu Jin 徐進 (b. 1958, Zhejiang province). Painter. Graduated from ZAFA. Member of New Space Group. Mid 1980s active in Beijing.

Xu Kuang 徐匡 (b. 1938, Changsha, Hunan province). Graphic artist and oil painter. Husband of **A Ge**. 1958 graduated from middle school attached to CAFA. 1957–58 labeled as Rightist. Engaged in graphic work in Chongqing branch of CAA, member of Chinese Graphic Artists Association, deputy director of Chongqing branch of CAA. Has won many prizes for his heroic prints of Tibetans and other minority people.

Xu Lei 徐累 (b. 1963, Nantong, Jiangsu province). Painter and writer on modern Chinese art and aesthetics. Husband of **Yu Hui**. 1963 began to study *guohua* in Nan-

jing Chinese Painting Academy. 1988–89 active in avant-garde movement. 1980–84 teacher in Nanjing Academy. Paints quiet, sombre interiors with houses, figures, chairs.

Xu Lele 徐樂樂 (b. 1955, Nanjing, Jiangsu province). 1976 graduated from Fine Arts Dept., Nanjing Academy. Currently professional painter at Jiangsu Chinese Painting Academy and member of Chinese Artists Association. 1987 silver prize at Wild Field International Illustrations for Children's Reading Materials Contest, sponsored by UNESCO Asian Culture Centre; first prize for paintings at First Children's Books Prize Award in China. See *Compendium of Chinese Painters of the Second Half of the Twentieth Century: New Literati Painting, Xu Lele* (Hebei, 1997).

Xu Linlu 許麟盧 (b. 1916, Bohai, Hebei province). *Guohua* painter and art expert. 1938 met **Li Yingjie** and through him **Qi Baishi;** becoming Qi's last student. 1950 established Heping Painting Shop in Beijing to sell leading artists' works on consignment. Shop later combined with Rongbaozhai Painting Studio. Paints landscapes in a dashing style.

Xu Mangyao 徐芒耀 (b. 1945, Shanghai). Painter. 1980 MA from ZAFA. From 1981 artist in residence and teacher at ZAFA. 1984–86 studied in Pierre Cardin studio, Paris. Professor and president of Art College of Shanghai Normal University. Began as realist oil painter; became hyperrealist and surrealist member of avant-garde.

Xu Minghua 徐明華 (b. 1932, Yixingxian, Jiangsu province). Oil painter. 1950 entered Art Dept. of Nanjing University. 1954 graduated from Nanjing Teachers College, joined faculty. 1955 to Potemkin Teacher's College, Moscow, then to Oil Painting Dept. of Repin AFA, Leningrad, where he studied under Aleshnikov. From 1960 professor in Nanjing Normal University. Socialist realist and impressionist landscape painter.

Xu Qinghui 徐慶慧 Oil painter. Trained in CAFA. Wife of **Wang Huaiqing.**

Xu Qixiong 徐啟雄 (b. 1934, Wenzhou, Zhejiang province). Painter. 1955 studied *guohua* in CAFA. 1956 returned to Wenzhou, where he joined staff of Wenzhou Art and Craft Research Institute. Illustrator and painter of pretty girls, including minorities, in *gongbi* style.

Xu Shiqi 許士騏 (1899–?, Anhui province). Painter, traditional (literary) school. 1930s studied in Paris and visited Germany. During WWII became professor at NCU Chongqing. After war returned to Shanghai.

Xu Shuxiu 徐術修 (b. 1927, Gusongxian, Sichuan province). Painter. Learned about art from his father's ceramic factory. First career in military police. 1947 started to study painting in Canton. 1950 settled in Taiwan. 1960s began experimenting with modern painting techniques. 1973 retired from PLA and became teacher, increasingly involved with painting and Daoist meditation.

Xu Shuzhi 徐庶之 (b. 1922, native of Guangshan, Henan). 1946 began to study painting with **Zhao Wangyun**. 1949 worked with Northwest Arts and Crafts Association in Xi'an. Did serial pictures for the pictorial *Xibei huabao*. 1953 went to work for Xinjiang Cultural Bureau.

Xu Tan 徐坦 (b. 1957, Wuhan, Hubei province). Installation artist. 1983 graduated from Guangzhou Academy; 1983–86 taught at Hubei AFA. 1986–89 postgraduate in Oil Painting Dept., Guangzhou Academy. 1989–97 taught in same department. Member of Big Tail Elephant Group. Exhibited at Inside Out: New Chinese Art (San Francisco and New York, 1998) and Venice Biennale (2003). Lives in Guangzhou.

Xu Weixin 徐唯辛 (b. 1958, Xinjiang province). Oil painter. 1981 graduated from Teachers Training Dept. of Xi'an AFA. 1987 graduated from graduate class in ZAFA. Taught in Guangzhou Academy. 2000 enrolled in doctoral program at Qinghua University Fine Art College.

Xu Wuyong 徐武勇 (b. 1920, Tainan, Taiwan). Painter. Studied medicine and art in Tokyo. Later returned to Taiwan, where he was a pioneer cubist.

Xu Xi 徐希 (b. 1940, Shaoxing, Zhejiang province). *Guohua* painter. Trained in ZAFA. Staff member of People's Art Publishing House. Noted chiefly for his landscapes in wet ink and color technique.

Xu Xiaoyan 徐曉燕 (b. 1960, native of Hebei province). Oil painter. 1982 she graduated from Fine Arts Dept. of Hebei Normal University. Associate professor in Fine Arts Dept. of Baoding Teachers Training College. Painter of desolate landscapes.

Xu Xingzhi 許幸之 (1904–91, b. Yangzhou, Jiangsu province). Oil painter. Studied in Shanghai. 1924 went to Tokyo, where he studied under Fujishima Takeji. On returning to China, joined Northern Expedition Army. After arrest and release by KMT, continued study in Japan. 1929 back to China. Taught Western painting in Zhonghua Art University. Joined League of Left-Wing Artists. 1934–35 art designer for Tianyi Film Studio. 1940 taught in LXAFA in Shenyang. 1942 professor of art in Zhongshan University. 1954 professor at CAFA, head of Art Theory Research Center. Dedicated promoter of Soviet socialist realism. Active in CCP cultural politics.

Xu Xinrong 許信容 (b. 1959, Nanjing, Jiangsu province). *Guohua* painter. 1985 graduated from Nanjing Academy; 2004 assistant professor there. Noted for his landscapes inspired by Northern Song models. See *Xu Xinrong yanjiu* 許信容研究 [A study of Xu Xinrong] (Shijiajiang, Hebei, 2002).

Xu Xuebi 許雪碧 (Pat Suet-bik Hui, b. 1943, Hong Kong). Painter and calligrapher. Studied philosophy at Hong Kong University, later art history. 1975–80 worked in silk-screen printing and fashion design. 1980 to Minneapolis. Established Hui Arts to print and exhibit contemporary Chinese art, especially work of Wang Wuxie, with whom she collaborated in painting and calligraphy.

Xu Yangcong 徐陽聰 (Onion Shyu, b. 1953, Taiwan). Sculptor. 1979 graduated from Sculpture Dept., NTNU.

Xu Yansun 徐燕蓀 (1898–1961, b. Beijing). *Guohua* painter. Active chiefly in Beijing. Figures (including opera scenes) in *gongbi* style. Member of Beijing Chinese Painting Academy.

Xu Yongqing 徐詠青 (1880–1953). Learned Western drawing at Tushanwan Art School (Ziccawei), Shanghai. Studied in Japan. In Shanghai, worked for newspapers and magazines, taught watercolor. Sometimes collaborated with **Zheng Mantuo**. 1933 moved to Hong Kong, where he had his studio in Wanchai. Made his reputation as painter of calendars.

Xu Zhiju 徐志鉅 (Joseph Chee Kui Tsui, b. 1937, Hong Kong). Oil painter. 1973 first solo exhibition in Hong Kong City Hall. 1975 founded and chaired INGROUP. Became art teacher in Extramural Studies Dept. of Chinese University of Hong Kong.

Xu Zhongmin 許忠敏 (b. 1961, Mianyang, Sichuan province). 1975–81 studied acting and stage design with Mianyang Sichuan Opera Troupe. 1983–87 studied printmaking at Sichuan AFA, Chongqing. 1992 moved to England. Has won many awards, including Guinness prize at Royal Academy Summer Exhibition, London (1997).

Xu Zhongou 徐中偶 (b. 1952, Chengdu, Sichuan province). Oil painter and printmaker. 1982 graduated from Sichuan AFA, Chongqing. Active from c. 1980 in Chengdu, where he teaches in School of Arts, Sichuan University, and in School of Visual Arts, Sichuan Normal University.

Xu Zixiong 徐子雄 (Chui Tze-hung, b. 1936, Hong Kong). *Guohua* and watercolor painter and photographer. Guest lecturer in Extramural Studies Dept., Hong Kong University, and Hong Kong Polytechnic. 1979 received Urban Council Fine Arts Award.

Xue Baoxia 薛保瑕 (b. 1956, Taizhong, Taiwan). Oil painter. 1975 graduated from Art Dept. of NTNU. 1983 MFA from Pratt Institute, Brooklyn. Works and exhibits in New York and in Taipei, where she is an art teacher.

Ya Ming 亞明 (original name Ye Ming 葉明, 1924–2002, native of Hefei, Anhui province). *Guohua* painter. 1941 studied painting in Huainan Art College, then painted posters and cartoons and made prints. 1953 started to practice *guohua*. Assigned to Nanjing. His close association with **Fu Baoshi** influenced his style of painting. 1956 vice-chairman of Jiangsu branch of CAA. 1958 vice-president of Jiangsu Chinese Painting Academy. 1966–72, with **Huang Yongyu, Huang Zhou,** and **Shi Lu,** sent to countryside to work as peasant. 1978 leader of Chinese painters group visiting Pakistan. 1980 visited Japan with **Sun Zongwei.** Chairman of Jiangsu branch of Nanjing Academy.

Yan Dehui 嚴德暉 (Yen Te-fai, Yen Töfei, b. 1915, Zhejiang province). Sculptor. Studied in Shanghai Meizhuan, where he taught sculpture in wood from 1936. 1937 commissioned to make monument to Sun Yat-sen for Jiangsu province. 1938 arrived in Paris to study under Henri Bauchard at Ecole Nationale Supérieure des Beaux Arts. 1940s exhibited in Spring and Autumn salons in Paris.

Yan Di 顏地 (1920–79, b. Rongchang, Shandong province). *Guohua* painter. Active in cultural affairs, chiefly in Beijing. Influenced by **Fu Baoshi** and **Li Keran.** Member of Beijing Chinese Painting Academy.

Yan Han 彥涵 (b. 1916, Donghaixian, Jiangsu province). Printmaker and graphic designer. 1935 entered Painting Dept. of Hangzhou Academy under **Lin Fengmian** and **Pan Tianshou.** 1938 studied in LXALA, Yan'an. 1943 taught and made prints there. 1946–48 taught art in North China University. 1949 taught in ZAFA. 1953 worked in CAA. 1957 labeled Rightist and expelled from CCP. 1961 taught in Beijing Teachers College. 1979 rehabilitated. 1980 professor at CAFA. In 1980s his work became more abstract.

Yan Jiyuan 宴濟元 (*zi* Ping 平, *hao* Laoji 老濟, Suzhen laoren 素貞老人, 1902–?, Neijiang, Sichuan province). *Guohua* painter. 1926 graduated from college in Chengdu. 1930 studied in Sino-French Institute in Shanghai. 1932 did some collaborative works with **He Xiangning.** 1933–40 studied in Tokyo University. Returned to Beijing, where he met **Zhang Daqian.** Went to Sichuan, held joint exhibition with Zhang Daqian in Chongqing. 1942 to Chengdu. After WWII continued painting chiefly in Sichuan. Known for his paintings of birds and flowers in meticulous *gongbi* style.

Yan Lei 顏磊 (b. 1965, Hebei province). Oil painter, performance and installation artist. Lives in Hong Kong and Beijing. 1991 graduated from Hangzhou Academy. 2002 won first prize, Contemporary Chinese Art Award; exhibited at Shanghai Bien-

nale, Kwangju Biennale (South Korea), São Paulo Biennale, Guangzhou Triennial. 2003 at Venice Biennale. 2005 at Cantor Center for Visual Arts, Stanford University. (*Photo on p. 188.*)

Yan Li 嚴力 (b. 1954, Beijing). Modern painter and poet. Chiefly self-taught. 1979 and 1980 exhibited twice with the Stars. 1984 one-artist show in gallery of People's Park, Shanghai. 1985 went to New York to study.

Yan Peiming 嚴培明 (b. 1960, Shanghai). Oil painter. Lives and works in Dijon, France, where his career began. Has exhibited widely in US. 2000 first exhibition in China at Shanghai Biennale. 2003 first exhibition in Europe at Venice Biennale.

Yan Ping 閆平 (b. 1956, native of Shandong province). Oil painter. 1983 BA from Shandong Art Academy; completed training in 1991 at CAFA. Became associate professor in Shandong AFA.

Yan Shaoxiang 宴少翔 (b. 1914, native of Lichengxian, Shandong province) *Guohua* painter. 1930 entered Art Dept. of Furen University in Beijing; student of **Pu Jin**. 1934 graduated; worked in Antiquities Dept. of Palace Museum. Stayed in Beijing during WWII. Member of Bees Society. Studied briefly under **Zhang Daqian**. 1956 joined staff of LXAFA in Shenyang. Thereafter worked and taught chiefly in Liaoning province. Specialized in ladies in gardens.

Yan Shuilong 顏水龍 (1903–97, b. Tainan, Taiwan). Oil painter. 1922–27 studied in Tokyo College of Art. 1929–32 in France. 1933–43 worked for Smoka Co. in Osaka. Thereafter worked in Taipei, where he took up handicrafts in addition to painting.

Yan Wenliang 顏文樑 (1893–1988, native of Suzhou). Oil painter. 1919 founded nationwide painting competition, which lasted for twenty years. In his early years, employed by Commercial Press doing copperplate etching and printing. 1922 founded Suzhou Art College. 1928–31 studied in Paris. Brought back large collection of plaster casts of sculpture and art books from Europe, which he used for teaching. They were destroyed by the Japanese. 1931–37 principal of Suzhou Academy. 1933–35 also taught in Art Dept. of NCU Nanjing. 1940–44 professor in Zhejiang University, Shanghai. 1952 professor and vice-president of Huadong AFA, formed by amalgamation of Suzhou Academy with Shanghai Meizhuan and Shandong University Art Dept. Influential teacher and practitioner of poetic-realist French-style landscape painting, strongly influenced by early impressionism. 1969 liberated from Cultural Revolution interrogation. Generous in helping young artists to develop their oil painting technique. See Lin Wenxia 林文霞, comp., *Yan Wenliang: Xiandai meishu-*

jia, hualun, zuopin, shengping 顏文樑現代美術家畫論作品生平 [Yan Wenliang, Contemporary artist: Writings on his art, works, and career] (Shanghai, 1982); and Huang Juesi 黃覺寺, ed., *Yan Wenliang* 顏文樑 [Yan Wenliang] (Hangzhou, 1982).

Yan Zhenduo 閆振鐸 (b. 1940, Jixian, Hebei province). Painter. 1963–67 studied in Oil Painting Dept. of CAFA under Zhang Qiuhai and **Wu Guanzhong**. Director of Beijing Oil Painting Research Institute. Solo exhibitions in San Francisco (1991) and Hong Kong (1992). In early 90s his work became increasingly abstract.

Yang Bailin 楊柏林 (Yang Bor-lin, b. Yunlin, Taiwan). Self-trained sculptor. In early years carved images for Buddhist temples. Later matured as abstract sculptor, chiefly in bronze. Works in Taiwan.

Yang Bor-lin. See **Yang Bailin**

Yang Chihong 楊熾宏 (b. 1947, Taiwan). Oil painter. 1980 settled in New York.

Yang Chunhua 楊春華 (b. 1953, Nanjing). Printmaker and ink painter. Daughter of pioneer printmakers Yang Han and Zhou Yiqing. Studied in Nanjing Academy. 1980 MA from CAFA. Since 1989 has taught in Nanjing Academy. Has participated in many group exhibitions. 2003–4 in exhibition of modern Chinese printmaking at British Museum, London. Noted for her prints of flowers, influenced by both folk prints and traditional painting.

Yang Feiyun 楊飛雲 (b. 1954, native of Baotou, Inner Mongolia). Oil painter. 1978 entered CAFA, encouraged by **Jin Shangyi**. After graduation became staff member there. Noted for his figures and portraits, especially those of his wife, Pengpeng.

Yang Fudong 楊福東 (b. 1971, Beijing). Video and photographic artist. 1998 graduated from Hangzhou Academy. 2004 working in Shanghai. 2002 exhibited in Paris and in Shanghai Biennale; 2003 Venice Biennale.

Yang Gang 楊剛 (b. 1946, Henan province). Painter. 1963 began studying at middle school affiliated with CAFA. 1973 went to work in Inner Mongolia. 1978 returned to Bejing for postgraduate study in CAFA. 1981 became professional painter working in Beijing Chinese Painting Academy. 1984–86 toured, lectured, and exhibited in US and Europe. Noted for his semiabstract figures, horses, and other subjects.

Yang Guanghua 楊光華 (b. 1940). *Guohua* painter. Teaches in Beijing Minorities Art Institute. Paints figures and landscapes in wet and splashed ink.

Yang Jiachang 楊嘉昌 (A Yang, n.d.) Wood engraver. Cofounder of woodcut movement in Shanghai. Early in WWII ran Wood Engraving Tool Cooperative Factory in west China with **Ye Fu.**

Yang Jianhou 楊建侯 (1910–93, native of Jiangsu province). Oil and *guohua* painter. Studied art and music privately in Shanghai. 1930 joined **Xu Beihong** in NCU. 1934 visited Beijing with **Pan Yuliang.** During WWII in Chongqing. Afterwards returned to Nanjing, where his teaching posts included Nanjing Normal University.

Yang Jiecang 楊詰蒼 (b. 1956, Foshan, Guangdong province). 1982 graduated from *Guohua* Dept. of Guangzhou Academy, where he taught from 1982 to 1989. 1989 studied art in Heidelberg and France. Settled in Paris. Member of avant-garde. Exhibited in Shanghai Biennale (1998), Kwangju Biennale and Paris (2002), Venice Biennale (2003), and Cantor Center for Visual Arts, Stanford University, (2005).

Yang Keyang 楊可揚 (1914–?, Suichang, Zhejiang province). Wood engraver. Active in 1940s.

Yang Liguang 楊立光 (1917–2000, Hubei province). Oil painter. After graduating from Wuhan Art School, became professor in Hubei AFA. Painted chiefly figure subjects, with solid, decisive style.

Yang Maolin 楊茂林 (b. 1953, Changhua, Taiwan). Satirical cartoonist. Graduated from Fine Art Dept. of Chinese Culture University, Taipei. Uses eclectic style to comment sardonically on history and political and social milieu of Taiwan. 1999 exhibited in forty-eighth Venice Biennale.

Yang Mingyi 楊明義 (b. 1943, native of Suzhou). *Guohua* and watercolor painter and printmaker. Active in Suzhou. Since 1984 has exhibited in England and Japan. Member of Suzhou Chinese Painting Academy. Noted for his southern landscapes in wet ink.

Yang Mingzhong 楊明忠 (b. 1957, Taiwan). Sculptor. Graduated from Dept. of Sculpture, National Taiwan Academy of Arts.

Yang Qiuren 楊秋人 (1907–83, b. Guilin, Guangxi province). Oil painter. 1928 entered Shanghai Meizhuan. Studied painting under **Chen Baoyi**. Associated with **Pang Xunqin** in Storm Society. During WWII returned to Guilin. 1949 member of Renjian Huahui in Hong Kong. After 1949 professor at Zhongnan Art College in Guangzhou. Vice-president of Guangzhou Academy. Formalist landscape painter somewhat influenced by postimpressionism.

Yang Sanlang 楊三郎 (original name Yang Zuo 佐 San Lang, 1908–95, b. Yonghe, Taipei, Taiwan). Oil painter. 1922 went to Japan. 1931 graduated from Kyoto College of Arts and Crafts. 1932–33 studied in Paris. 1934 returned to Taiwan. 1945 with a group of friend cofounded Taiyang Art Society. Prominent in development of Western-style oil painting in Taiwan, his style influenced by Jean-Baptiste Camille Corot. See Taiwan Museum of Art, ed., *Yang Sanlang huihua yishu zhi yanjiu* 楊三郎繪畫藝術之研究 [A study of the life and painting art of Yang Sanlang] (Taipei, 1997).

Yang Shanshen 楊善深 (1913–2004; native of Chiqixiang, Guangdong) *Guohua* painter. 1935–38 studied art at Domoto Art Institute, Japan. 1940 painted in Singapore with **Xu Beihong.** 1941 moved to Macao; organized Xieshe Art Society. 1949 settled in Hong Kong with **Gao Lun.** 1988 moved to Vancouver. Prominent member of Lingnan school. See National Museum of Singapore et al., *The Art of Yang Shanshen* (Singapore, 1989).

Yang Shaobin 楊少斌 (b. 1963, Tangshan, Hebei province). Painter and mixed-media artist. Noted for his satirical oil paintings and huge styrofoam images expressive of pain and suffering. 1999 exhibited in Venice Biennale. Several exhibitions in Berlin and elsewhere. Lives in Beijing.

Yang Shengrong 楊勝榮 (b. 1928, Hunan, of Tujia nationality). *Guohua* painter. 1949 joined PLA and produced propaganda art. 1963 entered Guangzhou Academy to study *guohua*, after which he was assigned to Lanzhou.

Yang Songlin 楊松林 (b. 1936, native of Nanjing). Graduated from Art Dept. of Shandong Normal College, then completed postgraduate study at CAFA Beijing. Professor in Shandong Provincial Art Academy.

Yang Taiyang 陽太陽 (b. 1909, native of Guilin, Guangxi province). *Guohua* and oil painter. 1928 studied in Shanghai Meizhuan. 1931 studied in **Chen Baoyi**'s studio in Shanghai. 1931 organized Storm Society with **Pang Xunqin** and **Ni Yide.** 1935–37, with Chen Baoyi's introduction, studied in Japan. 1941–44 in Guilin. 1949 joined Renjian Huahui in Hong Kong. 1959 headed Fine Art Dept. of Guangxi AFA. After 1981 visited Japan several times. His early work showed influence of postimpressionism. 1993 major retrospective in China National Art Gallery. 1995 exhibited in Taiwan.

Yang Xianrang 楊先讓 (b. 1930, Shandong). Printmaker. 1952 graduated from NAA, then associate professor and head of Dept. of New Year and Serial Pictures. Noted for his *shuiyin* and embossed prints.

Yang Xingsheng 楊興生 (b. 1938, Jiangxi). Oil painter. As a boy moved with his family to Taiwan. Graduated from NTNU Art Dept. 1967–69 studied in Missouri and New Mexico. Lives and works in Taipei. Founding member of Taipei Art Club. Abstract expressionist.

Yang Xiuzhuo 楊秀卓 (Ricky Sau Churk Yeung, b. 1952, Hong Kong). Painter and performance and installation artist. 1978–80 studied art and design part-time in Extramural Studies Dept., University of Hong Kong. Worked eighteen years as accountant. 1988 resigned his job to devote himself to art. 1994 graduated from University of Hong Kong. Has participated in various community art projects.

Yang Xixue 楊希雪 (Yeung Hai Shuet, b. 1936, Guangdong province). 1958–61 studied painting in Hong Kong. 1969 settled in Grimsby, England, as restaurateur and amateur artist. His huge painting of 5,339 carp (1998) secured him a place in *The Guinness Book of Records* for the world's longest painting.

Yang Xuemei 楊雪梅 (b. 1952, Taipei). Pastel and abstract painter. In 1980s she was on staff of National Palace Museum, Taipei.

Yang Yanping 楊燕屏 (b. 1934, Nanjing). Painter. 1958 graduated in architecture from Qinghua University. Wife of painter **Zeng Shanqing**. Member of Beijing Academy of Painting. 1986 awarded Culture and Educational Exchange with China fellowship; settled in Stony Brook, N.Y. Later moved to Port Jefferson. For several years collaborated with **Cao Dali**. Has exhibited widely in US, Japan, Europe, Taiwan, and Hong Kong. Noted chiefly for her lotus paintings, "pictorial calligraphy," and, more recently, her landscapes painted with rich color in Sino-Western technique. 1995 presented calendar in honor of Fiftieth Anniversary of United Nations. Exhibits chiefly at Michael Goedhuis Gallery, New York. See Shubo Li, *Yang Yanping* (Oslo, 2004).

Yang Yanwen 楊延文 (b. 1939, Shenxian, Hebei province). Oil painter and *guohua* landscape painter. 1963 graduated from CAFA, where he studied under **Wu Guanzhong** in Oil Painting Studio. Became professional painter in Beijing Painting Academy. His landscapes show both Western and Chinese influences.

Yang Yichong 楊鵁翀 (Yeung Yick-chung, *hao* Ciweng 次翁, Rongya 榕崖, Rongya Caolu 草蘆, Pochan 破禪, Yangchong 楊沖, Wusheng Shizhai 無聲詩齋, 1921–81, Jieyang, Guangdong province). Painter. 1949 settled in Hong Kong, where he studied under **Lü Shoukun**. Founding member and secretary of One Art Group and member of other art and photographic societies. 1982 retrospective exhibition at Hong Kong Arts Centre.

Yang Yingfeng 楊英風 (Yuyu Yang, 1926–97, b. Yilan, Taiwan). Sculptor. 1942–44 studied in Tokyo Academy of Arts, then in Furen University in Beijing, where he converted to Catholicism. 1963 returned to Taiwan. 1963–66 studied sculpture in Rome. 1968–76 **Zhu Ming** was his assistant. Noted for his laser sculpture and for his monumental work in stainless steel. Exhibited widely in Taiwan, New York, Singapore, Saudi Arabia, and elsewhere. 1993 awarded major national culture prize in Taiwan.

Yang Yiping 楊益平 (b. 1947, Beijing). Oil painter. 1960 graduated from Beijing Painting Academy. Veteran of PLA, which he joined in 1966 as member of Communist Youth League. 1970 worked as commercial artist in factories and government organizations. 1979–80 member of Stars. Independent artist, developing into photorealist.

Yang Yong 楊勇 (b. 1975, Neijiang, Sichuan province). Photographer. 1995 graduated from Oil Painting Dept., Sichuan AFA. Lives in Shenzhen. Exhibited at Shanghai Biennale (1999), Kwangju Biennial (2002), Venice Biennale (2003).

Yang, Yuyu. See **Yang Yingfeng**

Yang Zhiguang 楊之光 (b. 1930, Shanghai, native of Guangzhou). *Guohua* painter and book illustrator. Lingnan school. 1950 studied in CAFA under **Xu Beihong, Ye Qianyu,** and others. 1980s professor in Guangzhou Academy.

Yang Zhihong 楊熾宏 (b. 1947, Taoyuan, Taiwan). Oil and watercolor painter and printmaker. 1968 graduated from National Fine Art Academy, Taipei. 1976 went to study printmaking at Pratt Institute, New York; settled there. 1987 became in-house artist at Michael Smith Gallery, New York. 1989 won Outstanding Asian American Art Award.

Yang Zuo San Lang. See **Yang Sanlang**

Yang Zushu 楊祖述 (b. 1913, Jiangsu province). Oil painter. 1931 studied under **Yan Wenliang** in Suzhou Academy. 1940 studied under **Wu Zuoren** in CAFA Chongqing. Involved in creation of first animated film in China. Later worked in publishing firms and taught in Shanghai Drama Academy and in Shandong Normal College, Qufu. 1957 denounced as Rightist. Chiefly a landscape painter, he later settled in Singapore.

Yao, C. J. See **Yao Qingzhang**

Yao Fu 姚夫 (original name Xia Peng 夏朋, ?–1936). Wood engraver. After studying in Hangzhou Academy, she was active in left-wing woodcut movement. Member

of One Eight Art Society, MK Woodcut Research Society, and other radical groups. Married to **Hu Yichuan**. Died in prison.

Yao Gengyun 姚耕雲 (1931–88, Shanghai). *Guohua* painter. 1951 entered Huadong campus of CAFA. 1955 graduated and became teacher at CAFA Huadong. Later vice-director of *Guohua* Dept. of ZAFA.

Yao Hongzhao 姚宏照 (Thomas Yeo, b. 1936, Singapore). Painter of landscapes and abstractions. Graduated from Nanyang Academy, Singapore, where he studied under Lim Cheng-hoe and **Zhong Sibin**. 1960–64 studied at Chelsea School of Art and Hammersmith College of Art and Architecture, London. 1966 made brief visit to Singapore, then returned to London to teach in Islington Green School. 1968 returned to settle in Singapore. See T. K. Sabapathy, *Thomas Yeo: A Retropective* (Singapore, 1997).

Yao Hua 姚華 (*zi* Chongguang 重光, *hao* Mangfu 茫夫, 1876–1930, native of Guiyang, Guizhou). *Guohua* painter of landscape, flowers, religious images, and figures. Studied law and government in Japan. On his return became principal of Women's Normal College and professor in NAA Beijing. During WWII visited Dunhuang. One of "eight masters of the early Republic" in Beijing. Close friend of **Chen Hengke** and **Zhang Daqian**.

Yao Kui 姚奎 (b. 1936, Shanxi province). 1957–62 studied in CAAC. On graduation entered Architecture Research Institute, specializing in wall painting. 1964 did ceramic wall decoration for art gallery in Guilin. 1964–73 unable to work. Since then has been art editor for People's Art Press. Paints landscapes with houses and gardens.

Yao Qingzhang 姚慶章 (C. J. Yao, b. 1941, Taiwan). Oil, watercolor, and mixed-media artist, printmaker, and photorealist. BA NTNU. Many solo exhibitions in Taiwan, US, Hong Kong, and Beijing.

Yao Yuan 姚遠 (b. 1952, Ningbo, Zhejiang). Oil painter. Trained in Beijing. Specializes in borderland subjects.

Yao Zhonghua 姚鍾華 (b. 1939, Kunming, Yunnan). Oil painter. 1955 entered middle school attached to CAFA. Went on to undergraduate studies in oil painting under **Dong Xiwen**. 1960 graduated. Sent to Kunming, where he became vice-chairman of Yunnan Academy of Painting and president of Yunnan Oil Painting Society. Paints chiefly landscape and genre subjects of Yunnan.

Yau, Stephen. See **You Rongguang**

Ye Bohe 葉柏河 (Henry Yip Pak Ho, b. 1960, Guangdong province). Painter. 1988 began to study under **Yang Shanshen.** Later joined several art groups, painting chiefly landscapes of Hong Kong in Chinese ink, oils, or watercolor. 1990 his exhibition Memories of Hong Kong held in foyer of Hong Kong Cultural Centre.

Ye Fu 野夫 (original name Zheng Chengzhi 鄭誠之, 1902–73, native of Liqing, Zhejiang province). Wood engraver. Studied in Shanghai Meizhuan. Organized Wild Wind Painting Society. Joined Eighteen Art Society. Organized China Wood Engraving Tool Cooperative. 1936 organized Third National Traveling Woodcut Exhibition with **Li Hua.** Also ran successful correspondence course in wood engraving.

Ye Gongchuo 葉恭綽 (1881–1968, native of Panyu, Guangdong province). Amateur *guohua* painter, especially of bamboo. Calligrapher and government official, working for Railway Administration at end of Qing regime. 1920 professor in Jiaotong University. 1926 official and professor of National Art Exhibition. 1933 joined staff of Shanghai Museum. 1934 on committee for Exhibition of Chinese Art at Royal Academy of Arts, London. From 1942 lived in retirement in Shanghai.

Ye Huocheng 葉火城 (1908–93, b. Taizhong county, Taiwan). Studied watercolor painting under Ishikawa Kin'ichirō at Taipei Teachers' College. Taught art in Taiwan for rest of his career, winning special awards between 1946 and 1948 at Taiwan Fine Arts Exhibition. Chiefly a landscapist.

Ye Jianqing 葉劍青 (b. 1972, Zhejiang province). Oil painter. 1998–2001 studied in Wall Painting Dept. of CAFA. 2002 joined department as teacher. 2003 enrolled for doctorate degree in CAFA. 1999 solo exhibition, CAFA. Noted for his almost monochrome wintry Beijing landscapes.

Ye Meisong 葉美松 (Tchai or Thongchai Sonteperkswong, b. 1954, Yala, Thailand). Sent to Malaysia at age ten. 1973 to US; settled in Bay Area, California. Advanced studies in architecture at University of Michigan. Practiced architecture in New York for several years. Became full-time artist. Paints watercolor landscapes and large abstract works influenced by Hans Hofmann. Lives in New York.

Ye Qianyu 葉淺予 (1907–95, native of Tongluxian, Zhejiang province). Cartoonist and painter. 1920s studied for a while in San Francisco. Founding member of *Shanghai manhua* 上海漫畫, for which in late 1920s he designed lurid covers. 1927 published his popular comic series *Mr. Wang.* 1937 in charge of All-China Association of Cartoonists for National Salvation. During WWII invited by Psychological Warfare Dept. of US Army to draw cartoons and studied *guohua* in Sichuan with **Zhang Daqian;** converted from cartoonist to serious painter. 1946 visited India with dancer Dai Ailian.

After 1949 head of Chinese Painting Dept. of ZAFA. 1957 branded Rightist; 1969–75 imprisoned as "KMT spy"; not cleared until 1978. See Zhou Shaohua 周韶華 et al., *Ye Qianyu di yishu* 葉淺予的藝術 [The art of Ye Qianyu] (Hong Kong, 1992). (*Photo on p. 188.*)

Ye Yaming. See **Ya Ming**

Ye Yongqing 葉永青 (b. 1958, Kunming). Painter. 1982 graduated from Sichuan AFA, where he became lecturer and later professor in Education Dept. Active in avant-garde movement. Has shown his work, including oil paintings, collages, and mixed-media works. Many exhibitions in Beijing, Guangzhou, Hong Kong, Barcelona, and Bonn. 2004 living in Kunming.

Ye Yushan 葉毓山 (b. 1935, Deyangxian, Sichuan province). Sculptor. 1956 graduated from Sculpture Dept. of Sichuan AFA, Chongqing. Became teacher there. 1960 joined sculpture research class of CAFA. 1977 group leader for team that designed statue of Mao in Mao's Memorial Hall. 1978 deputy director of Sichuan AFA; 1983 director. Designed *Four Seasons* figures for Yangzi Bridge, Chongqing. 1986 created *Martyrs of Geleshan*, a powerful group in red granite in Chongqing Military Cemetery.

Ye Zhengchang 葉正昌 (b. 1909, Tongliangxian, Sichuan province). Oil painter. 1928 studied in Nanguo Institute under **Xu Beihong**. 1930 began teaching. 1946 professor at National Beijing Art Institute and secretary to Xu Beihong (principal). 1949 principal and professor in Sichuan AFA. 1993 head of Zhongqing Panqi Painting Academy. Paints in highly realistic style.

Ye Ziqi 葉子奇 (b. 1957, Hualian, Taiwan). Oil painter. Studied Western painting in Taipei. 1989 MFA, Brooklyn College. Has participated in exhibitions in Taipei, Hong Kong, and New York.

Ye Zuibai 葉醉白 (1909–99, native of Qingtian, Zhejiang province). *Guohua* painter, especially of horses. Moved to Hong Kong. Later settled in Taiwan.

Yen Te-fai. See **Yan Dehui**

Yen Töfei. See **Yan Dehui**

Yeo, Thomas. See **Yao Hongzhao**

Yeung Hai Shuet. See **Yang Xixue**

Yeung, Ricky Sau Churk. See **Yang Xiuzhuo**

Yeung Yick-chung. See Yang Yichong

Yi Dahan 易大厂 (1874–1941, b. Heshan, Guangdong province). *Guohua* painter, connoisseur, and collector. After passing *xiucai* examinations, he went to Shanghai. Attended French Jesuit Aurora Academy, then studied in Tokyo Normal College. Returning to China, he became involved in Shanghai in art teaching and publishing, founding Huanan Publishing Co. Remained in Shanghai during Japanese occupation. His rare landscapes show influence of Shitao (1642–1707) and Bada Shanren (1626–1705).

Yi Yueshi 易越石 (Yik Yuet Sek, b. 1912, Hunan province). Painter, calligrapher, and seal carver. 1949 settled in Hong Kong, where he specialized in *Shigu* (stone drum) style of seal script calligraphy. His landscapes are inspired by his frequent travels.

Yik Yuet Sek. See Yi Yueshi

Yin Guangzhong 尹光中 (b. 1944, Guiyang, Guizhou province). Oil painter, sculptor, and printmaker. 1980 first attracted attention with his work *The Great Wall* in second Stars Exhibition. Works in Guiyang Arts and Calligraphy Studio. Early 1980s fashioned one hundred pottery marks, *The Chinese Forerunners*, portraying ancient legendary characters. 1986 exhibited in New York and Vassar College.

Yin Xiaofeng 尹曉峰 (b. 1965, Chongqing, Sichuan province). Installation and performance artist. 1988 graduated in oil painting from Sichuan AFA, Chongqing. His work often expressive of imprisonment and suffocation.

Yin Xin 尹欣 (b. 1959, Kashgar, Xinjiang). Painter and printmaker. Graduated from Xi'an AFA and from Beijing University in printmaking. MA Royal Melbourne Institute of Technology, Australia. As figurative painter, best known for portraits of Cultural Revolution period. His work has been shown in the US, South America, the UK, France, Taiwan, and Russia. Since 1984 has lived in Paris.

Yin Xiuzhen 尹秀珍 (b. 1963, Beijing). Installation artist. Graduated from oil painting division of Fine Art Dept., Capital Normal University, Beijing. Lives in Beijing. Exhibited at Third Asia-Pacific Triennial of Contemporary Art (1999), Kwangju Biennale (2002), Second Fukuoka Triennial (2002), Cantor Center for Visual Arts, Stanford University (2005).

Yin Yi 尹毅 (b. 1954, Huantai, Shandong province). *Guohua* painter. 1979 graduated from Hangzhou Academy. Later became Director of Painting Dept. of Artistic Creation Research Center of Shandong province. General director of Shandong Contemporary Ink Painting Institute. Influential promoter of ink painting.

Ying Pochong. See Xing Baozhuang

Yip Pak Ho, Henry. See Ye Bohe

You Rongguang 游榮光 (Yao, Stephen, b. 1957, Hong Kong). Painter. Studied Chinese and Western media, including watercolor. Has held four solo exhibitions in Hong Kong and Taiwan. Teaches watercolor in First Institute of Art and Design, Hong Kong, and as visiting lecturer in Hong Kong Polytechnic.

You Shaozeng 尤紹曾 (Jackson Yu, 1911–99, b. Suzhou). Amateur painter and businessman. 1936 graduated from Shanghai University. 1963 opened one of first modern oil painting galleries in Hong Kong. Member of Circle Group. After some years practicing *guohua*, became an expressionist, influenced by German expressionism. Later returned to *guohua*, studying under **Peng Ximing**. Retired to Manila, where he died.

Yu Ben 余本 (1905–95, native of Taishan, Guangdong province). Oil painter. 1918 went to Canada with his uncle; worked in laundry and restaurant. 1928–29 studied oil painting in Winnipeg. 1929 transferred to Ontario Provincial College of Art. 1936 returned to Hong Kong. Opened Yu Ben Studio. Worked as professional painter. Joined Hong Kong Art Club. 1952 with Li Bing and **Chen Fushan** founded Hong Kong Art Society. 1956 settled in Guangzhou, where he became vice-president of Guangdong Painting Academy. 1980 visited Philippines as head of Chinese artists delegation. Major retrospectives in Guangzhou (1995) and Hong Kong (1996).

Yu Chen Chee, Elsie. See Yu Zhenci

Yu Chengyao 余承堯 (1898–1993, native of Yongchun, Fujian province). *Guohua* painter. General in KMT. Retired to Taiwan. Self-taught landscape painter. Developed highly individualistic style inspired by classical models, in which his bold use of color and technical mistakes reflect his independent personality. See Hanart TZ Gallery, *Yu Chengyao* (Hong Kong, 1997); and Shih Shou-ch'ien 石守謙, ed., *Yu Chengyao jiushi huigu* 余承堯九十回顧 [Yu Chengyao at ninety] (Taipei, 1988).

Yu Fei'an 于非闇 (*hao* Xianren 閒人, 1889–1959, b. Beijing, native of Penglai, Shandong province). *Guohua* painter of flowers and birds in *gongbi* technique. For some years after 1912 he was active as a reporter before turning exclusively to painting and calligraphy. After 1949 devoted most of his time to painting and teaching. Vice-chairman of Beijing Painting Research Society. Vice-director of Beijing Painting Academy. An eclectic and conservative artist noted for his calligraphy in *shoujin* (slender gold) style of Song emperor Huizong. Wrote books on use of color in Chi-

nese painting and on painting birds and flowers in *gongbi* technique. See *Han mo* 翰墨, no. 18 (1991.6).

Yu Feng 郁風 (b. 1916, native of Fuyang, Zhejiang). Oil painter. Niece of Yu Dafu, wife of critic and calligrapher **Huang Miaozi**. Studied oil painting under **Pan Yuliang** in NCU Nanjing. 1938–41 lived in Hong Kong. 1944 joined **Xu Beihong**'s Art Institute in Chongqing. 1950s and 1960s worked for CAA in Beijing where, for a time, she ran office and Exhibitions Dept. of CAA. Later taught in CAFA. 1989, under great political stress, left for Brisbane, Australia, with her husband. 1999 they returned to settle in Beijing. (*Photo on p. 188.*)

Yu Hong 喻紅 (b. 1966, Beijing). Oil painter and photographer. 1988 graduated from Oil Painting Dept. of CAFA, where she became a teacher. 1995 MA. 1996 completed her postgraduate studies in CAFA. Wife of **Liu Xiaodong**. Has participated in a number of avant-garde exhibitions in China and abroad, including 2004 Shanghai Biennale. 2003 solo exhibition at Halsey Gallery, Charleston, S.C., and at Goedhuis Contemporary. See Britta Erickson, *A Woman's Life: The Art of Yu Hong* (New York, 2003). Lives in Beijing. (*Photo on p. 188.*)

Yu Hui 喻慧 (b. 1960, Nanjing). Artist. Wife of **Xu Lei**. 1980–83 BA, Jiangsu Institute of Fine Arts, where she became a teacher. *Gongbi* bird and flower painter in manner of **Chen Zhifo**. Exhibits with her husband. See Tianjin Yangliuqing Painting Society, *Xin gongbi huaniao: Yu Hui* 新工筆畫鳥喻慧 [New *gongbi* bird and flower painting] (Tianjin, 1999).

Yu, Jackson. See **You Shaozeng**

Yu Jianhua 俞劍華 (1895–1979, native of Jinan, Shandong province). Painter, calligrapher, art historian, and critic. Student of **Chen Hengke**. Active chiefly in Beijing. Author of *Zhongguo huihua shi* (History of Chinese painting), 2 vols. (Beijing, 1937), and other works.

Yu Jifan 俞寄凡 (1892–1968, Wujin, Jiangsu province). Painter. Trained in Japan. 1926 active in Shanghai. Cofounder of Xinhua AFA, Shanghai. Member of Bees Society. Publications include *Jindai xiyang huihua* 近代西洋繪畫 [Modern Chinese painting] (Shanghai, 1924) and a short history of Western music (1939).

Yu Ming 俞明 (*zi* Jingren 鏡人, *hao* Difan 滌凡, 1884–1935, native of Wuxing, Jiangsu province). *Guohua* painter. Learned watercolor painting in his youth in Shanghai. Practiced as professional painter, chiefly of figures and portraits, after style of Chen Hongshou (1599–1652) and Ren Yi (1840–95), in Shanghai. Close friend of **Wu Changshuo**.

Yu Peng 于彭 (b. 1955, Taipei, Taiwan). *Guohua* painter, wood engraver, sculptor, and ceramicist. Studied under Chen Yigeng, Zhang Mingshuo, and Xu Funeng. 1980 first one-artist show in Taipei. 1981 visited Europe. 1985 established art and ceramic studio in Taipei. Has exhibited in Taipei and New York. 2000 exhibited at Shanghai Beinnale. (*Photo on p. 188.*)

Yu Rentian 余任天 (1908–84, native of Zhejiang province). *Guohua* painter, especially of landscapes. Friend of **Huang Binhong**. Active in Shanghai. Later in ZAFA.

Yu Shaofei 于少非 (b. 1959, Shandong province). Oil painter. Studied in Shandong Academy of Art and Central Chinese Opera and Drama Institute, where he became a lecturer. Specializes in highly finished figures of traditional opera.

Yu Shaosong 余紹宋 (1883–1949, b. Guangzhou, native of Longyu, Guangdong province). Painter and critic. After studying in Japan, returned to succession of high government posts. Later lived in Hangzhou. Amateur *guohua* landscape painter known chiefly for his valuable *Huafa yaolu* [Important texts on the art of painting] (Peiping, 1926; Shanghai, 1934) and for *Shuhua shulu jieti* [Compendium of works of calligraphy and painting listed in catalogues], 6 vols. (Beiping, 1931).

Yu Shichao 虞世超 (b. 1953, Shanghai). *Guohua* and oil painter. Studied ink painting under **Cheng Shifa** in Shanghai. Later concentrated on oils. 1989 settled in US.

Yu Wai Luen, Francis. See **Yu Weilian**

Yu Weilian 余偉聯 (Francis Yu, Yu Wai Luen, b. 1963, Hong Kong). Painter. BFA, York University, Hong Kong. MA, Royal College of Art, London. Lecturer in Art School of Hong Kong Arts Centre.

Yu Xiaofu 俞曉夫 (b. 1950, Changzhou, Jiangsu province). Painter. 1978 graduated from Fine Art Dept. of Shanghai Drama Institute. Became painter in Shanghai Academy of Painting and Sculpture, specializing in historical themes.

Yu Youhan 余友涵 (b. 1943, Shanghai). Painter. 1970 graduated from CAAC, where he became a teacher. A key figure in post-1989 political pop movement. Noted for his images of Mao Zedong depicted in various modern Western styles.

Yu Yuan 俞原 (*zi* Yushuang 語霜, 1874–1922, native of Guian, Zhejiang province). *Guohua* painter and poet. Active in Shanghai. Follower of Shitao (1642–1707). Committed suicide.

Yu Yunjie 俞雲階 (1917–92, native of Changzhao, Zhejiang province). Oil and *guohua* painter. 1941 graduated from NCU Art Dept., Chongqing, where he studied under **Xu Beihong, Fu Baoshi,** and **Huang Junbi.** After WWII continued to study painting in Beijing. 1956 studied under Konstantin Maksimov at CAFA. His painting of a woman doctor, *Days and Nights* (1981), exhibited in Paris Spring Salon.

Yu Zhenci 余振慈 (Elsie Chen Chee Yu, b. Shanghai, n.d.). Sculptor. 1964 graduated from Northcote College, Hong Kong. 1967 to London for her MA in Communications Design at Royal College of Art. 1969 won H. W. Sanderson Memorial Award. 1994 received PhD in economics at London University. 2000 received Singapore Council of Women's Organizations Award. Has received many other awards and many commissions for sculpture (chiefly in metal) in Singapore and London. Lives in Singapore.

Yu Zhixue 于志學 (b. 1935, Heilongjiang province). *Guohua* painter. Studied in Harbin College of Art, where he became a teacher. Lives in north China. Specializes in snow and ice landscapes.

Yu Zhizhen 俞致貞 (1915–95, Beijing, native of Shaoxing, Zhejiang province). *Guohua* painter. 1934 she studied under **Huang Binhong** and **Yu Fei'an.** 1937 copied famous paintings in Palace Museum. Stayed in occupied China during WWII. 1946 studied under **Zhang Daqian** in Chengdu. 1951 joined Chinese Painting Research Society. Later taught *guohua* in CAAC. Specialized in birds, flowers, and insects. 1959 did large painting of lotus flowers for Great Hall of the People.

Yuan Chin-taa. See **Yuan Jinta**

Yuan Dexing 袁德星 (*hao* Ch'u Ko, Chu Ge 楚戈, b. 1931, Xiangyunxian, Hunan province). *Guohua* painter, poet, and art critic. Joined KMT army during Civil War period (1948–49). 1949 went with army to Taiwan. 1957 first publication of his poems; assumed the name Chu Ge. Largely self-taught. 1967 graduated from night classes. Curator in bronze section of National Palace Museum, Taipei. 1969 first group exhibition. 1984 seriously ill with nasopharyngeal cancer. Since recovering in 1985, visited US, Korea, and Europe many times. See Hui-shu Lee and Peter C. Sturman, with contributions from Richard Barnhart, Liu Guanzhong, and Zheng Chouyu, *Chu Ko: The Soldier from Chu* (Taipei, 1991), with full list of his writings on art. (*Photo on p. 213.*)

Yuan Jinta 袁金塔 (Yuan Chin-taa, b. 1949, Zhanghua, Taiwan). *Guohua*, oil, and watercolor painter. 1975 graduated from NTNU Art Dept.; MFA, City University of New York. Instructor in NTNU. Expressionist.

Yuan Qinglu 袁慶祿 (b. 1953, Quzhou, Hebei province). Print artist. 1973 graduated from Tianjin Academy. 1978 studied at CAFA. Joined PLA. Later taught in Handan College of Education, Hebei province. His prints of Tibetan and other minority people continue Soviet-style realism and romanticism.

Yuan Shun 袁順 (b. 1961, Shanghai). Painter. Trained in Dept. of Fine Art of PLA Art Institute, Beijing. From 1986 teaching in Shanghai Academy. Late 1980s, leading member of Shanghai avant-garde.

Yuan Shuzhen 袁樞真 (b. 1911, native of Tiantai, Zhejiang province). Oil painter. Trained in Xinhua AFA, Shanghai, then studied oil painting in Japan and Paris. 1938 and '39 exhibited in Salon du Printemps and Salon des Indépendants. 1940 returned to China, taught in NAA Chongqing. 1949 went to Taiwan. Taught in NTNU. 1969 became head of NTNU Art Dept. Founding member of Taipei Art Club.

Yuan Songnian 袁松年 (*zi* Hewen 鶴文, 1895–1966, Panyu, Guangdong province). Painter. Graduated from St. John's University, Shanghai. Studied Chinese and Western painting. After 1949 was artist in Shanghai Painting Academy. After experimenting with Western techniques, reverted in his landscapes to purer *guohua* style.

Yuan Xiaocen 袁曉岑 (b. 1915, Guizhou province). Painter and sculptor. 1935 entered Yunnan University. 1938 held first solo exhibition in Kunming. 1941–42 noticed and encouraged by **Xu Beihong**. After 1949 spent many years in southwest working with minority people on land reform and executing "genre" sculpture. Competent and orthodox painter and sculptor.

Yuan Yunfu 袁運甫 (b. 1933, Nantong, Jiangsu province). Painter. Brother of **Yuan Yunsheng**. 1949 entered Hangzhou Academy, studying oil painting. 1952–54 postgraduate student at CAFA. 1956 joined staff of CAAC. 1958 branded Rightist. 1980–81 did large mural for Jianguo Hotel, Beijing. 1991 professor and dean of Special Arts Dept. of CAFA and vice-chairman of Mural Council of CAA. Leading member of Oil Painting Research Association.

Yuan Yunsheng 袁運生 (b. 1937, native of Nantong, Jiangsu province). Painter. Brother of **Yuan Yunfu**. 1955 studied in CAFA. Influenced by **Dong Xiwen**. 1960–62 sent to labor camp. 1962–67 artist in Workers' Cultural Palace in Changchun, then exiled to countryside. 1979 recalled to paint mural for Beijing Airport, *Water Festival, Song of Life* which, because it contained nudes, was later partly covered over by CCP authorities. 1980 took up teaching position at CAFA; did wall paintings for restaurant in Beijing Airport, his designs partly derived from **Ding Shaoguang**'s drawings of Dai people of

Xishuangbanna. 1981 visited Dunhuang. 1983 visiting artist in residence in several universities in US. Made large mural for Tufts University. From 1987 freelance artist in New York. 1996 returned to Beijing, became head of Studio 4 in CAFA. His later work became much more abstract and expressionistic.

Yuan Zhan 袁旃 (b. 1941, Chongqing, Sichuan province). *Guohua gongbi*-style painter and conservationist. 1962 BA, NTNU. 1964 attended graduate school in Pennsylvania State University. 1966 MA, University of Louvain, Belgium. 1968 doctoral studies at Institut Royaux du Patrimonie Artistique, Bruxelles, and in US. 1998 doing research at National Palace Museum, Taipei. She paints imaginary landscapes in bright colors inspired by Tang dynasty style. Well-trained in traditional *wenren* styles. Recent works bold, strong color forms, with stylistic reference to Tang "blue and green" painting and to styles of Dong Qichang (1555–1636) and Wang Yuanqi (1642–1715). Solo exhibitions in Taipei, in the Hanart TZ Gallery, Hong Kong (1998), and in He Xiangning Art Gallery, Shenzhen (2000).

Yue Minjun 岳敏君 (b. 1962, Daqing, Heilongjiang province). Painter, sculptor, mixed-media artist. 1968 moved with family to Beijing. 1979 worked as electrician in Tianjin. 1983 graduated from Hebei Normal University, Oil Painting Dept. 1992 living in artists' colony, Yuanmingyuan, Beijing. Later built his own studio in a village near Beijing. 2000 solo exhibition at China Contemporary, London. Many group exhibitions. Member of avant-garde movement of 1990s and later. Noted for his paintings and life-size painted styrofoam figures of a laughing man (himself), ambiguously expressive of genuine happiness, mockery, and despair. (*Photo on p. 213.*)

Yun Gee. See **Zhu Yuanzhi**

Yung Ho Chang. See **Zhang Yonghe**

Zao Wou-ki. See **Zhao Wuji**

Zeng Fanzhi 曾凡志 (b. 1964, Wuhan). Oil painter. 1991 graduated from Hubei AFA. Member of avant-garde movement of early 1990s. Full-time professional painter. Noted for his parody of the Last Supper, for his Mask Series, and for his intense hospital scenes with naked, staring figures, influenced by German Expressionism, shown, e.g., in China's New Art, Post-1989 exhibition (Hong Kong, 1993), and in Paris (2002). Lives in Beijing.

Zeng Hao 曾浩 (b. 1963, Kunming, native of Guangzhou, Guangdong province). Oil painter. 1989 graduated from Oil Painting Dept. of CAFA; became teacher in Guangzhou Academy. Exhibitions include First Biennial Art Exhibition (Guangzhou, 1992)

and exhibition of works of Fifteen Contemporary Chinese Artists (Germany, 1996). 2004 living as professional artist in Beijing.

Zeng Jingwen 曾景文 (Dong Kingman, b. 1911, Oakland, California). Western-style watercolor painter. 1916 moved with his family to Guangzhou. 1942 settled in New York.

Zeng Laide 曾來德 (b. 1955, Liannan *xian*, Sichuan province). Calligrapher. 1980 began to study calligraphy. 1985–86 worked for PLA in Lanzhou. Several volumes of his ink landscapes and calligraphy have been published. Works chiefly in Beijing.

Zeng Mi 曾宓 (b. 1935, Fuzhou, Fujian province). Ink painter. 1957–62 studied *guohua* in ZAFA. Became teacher. Condemned in Cultural Revolution; not rehabilitated till 1979. 1984 appointed professor in ZAFA. 1992 visited Europe. 1995–56 traveled extensively to Hong Kong, Singapore, London, Köln. 1998 in Chinese Ink Painting in the Xieyi Tradition exhibition in Malmö, Sweden. Retrospective in Meishuguan Gallery, Beijing. One of early experimenters in expressionist ink painting. See Alice King, ed., *Zeng Mi: A Contemporary Literati Expressionist* (Hong Kong, 1999). (*Photo on p. 213.*)

Zeng Ming 曾鳴 (b. 1911, Guangdong province). Painter. 1934, while studying in Japan, joined China Independent Art Society. 1934 returned to China; 1935 showed his surrealist paintings at society's first exhibitions in Guangzhou.

Zeng Shanqing 曾善慶 (b. 1932, Beijing). Oil and *guohua* painter. 1950 graduated from CAFA; became research student under **Xu Beihong**. Later taught in Qinghua University. After much suffering in Cultural Revolution, joined staff of CAFA. 1986 settled on Long Island, New York, with his wife, painter **Yang Yanping**. Noted for his oil paintings on revolutionary themes and expressionistic renderings of figures and horses. See Priscilla Liang Norton, ed., *Rhythms of Vitality: Zeng Shanqing* (Hong Kong and Singapore, 1997). Solo exhibitions include Michael Goedhuis, London (1999), and New York (2003 and 2004).

Zeng Wu 曾鳴 (n.d.). Painter and poet. Active in 1930s. Stayed in Japan for some time. 1934 founded China Independent Art Research Institute, Tokyo. Same year returned to China, founded Chinese Independent Art Society in Shanghai.

Zeng Xi 曾熙 (*zi* Nongran 農髯, *hao* Ziqi 子緝, Siyuan 俟園, 1861–1930, native of Hengyang, Hunan province). Painter and innovative calligrapher. 1903 earned his *jinshi* degree. Served Manchu court till Revolution of 1911, after which he became professional scholar-painter and teacher in Shanghai. Among his students was **Zhang Daqian**.

Zeng Xiaofeng 曾曉峰 (b. 1952, Kunming, Yunnan province). Printmaker. Trained in CAAC. Active in Yunnan in 1980s and '90s.

Zeng Yannian 曾延年 (*zi* Xiaogu 孝谷, ?–after 1921, Sichuan province). Oil painter. 1911 graduated from Tokyo Academy. Fellow student with **Li Shutong**. Returned to teach in Shanghai.

Zeng Yi 曾藝 (b. 1961, Inner Mongolia). Oil painter. 1985 graduated from Oil Painting Dept. of LXAFA, Shenyang. Became teacher and deputy director in Hohhot. Noted for his highly realistic scenes of peasant life in north China.

Zeng Youhe 曾幼荷 (Tseng Yu-ho, Betty Ecke, b. 1923, Beijing). Painter. Studied under and ghosted for **Pu Jin** and **Pu Quan** at Furen University, where she also studied epigraphy with Rong Geng and calligraphy with **Qi Gong**. 1945 married Gustav Ecke. 1946–48 lectured at Yale Language School, Beijing. 1948 left for Xiamen and Hong Kong. 1949 went to Honolulu. From 1951 she taught brush painting in Honolulu Academy of Arts. 1957 first visit to Europe; solo exhibition at Galerie d'Orsay, Paris. 1969 appointed associate professor, University of Hawaii, Manoa. 1972 PhD, Institute of Fine Arts, New York University. 1973 returned to University of Hawaii as professor. After rigorous training as *guohua* painter, she developed in Honolulu a modern style, using mixed media, that combines traditional and modern elements. She also wrote a number of articles on Chinese painting and calligraphy. See Melissa Jane Thompson, "Gathering Jade and Assembling Splendor: The Life and Art of Tseng Yuho" (PhD diss., University of Washington, 2001); and Hanart-TZ Gallery, ed., *Dsui Paintings by Tseng Yuho* (Hong Kong, 1992). (*Photo on p. 213.*)

Zeng Yu 曾堉 (b. 1930, Changshu, Jiangsu province). Painter and art scholar. After art training in London, he went to Taipei, where he worked as researcher at National Palace Museum, then took up appointment in Art Dept. of Chinese University in Hong Kong. He has translated several Western books into Chinese, including Michael Sullivan, *The Arts of China* (Taipei, 1985).

Zeng Yuwen 曾郁文 (b. 1940, Tainan, Taiwan). Oil painter. Graduated from National Institute of Fine Art. Collector of ethnic art, which influenced his style.

Zhan Jianjun 詹建俊 (b. 1931, Liaoning province). Oil painter. 1953 graduated from CAFA. 1964–65 contributed to History Painting Campaign at CAFA. 1980s taught in Studio 3, CAFA. Chairman of Oil Painting Committee, CAA. Specialized in narrative paintings influenced by Soviet socialist realism.

Zhan Shengyao 詹聖堯 (Chan Sheng-yao, Stephen Chan, b. 1958, Taipei). Painter. 1974–77 educated at Fu-hsing Art School, Taipei. 1992–94 in Art Dept., University of Kansas. Accompanied his wife, Tsai Hsing-li, traveling till 1996, when they immigrated to Vancouver. Noted for his large-scale abstract compositions inspired by Buddhist doctrine and for figurative paintings. His solo exhibition in Vancouver was subject of Hsing-li Emily Tsai 蔡杏莉, *Hongguan, weiguan, neiguan: Zhan Shengyao di yishu* 宏觀, 微觀, 內觀：詹聖堯的藝術 [Macrocosm, microcosm, introspection: Art of Chan Sheng-yao] (Taipei, 2003).

Zhan Wang 展望 (b. 1962, Beijing). Sculptor and installation artist. 1981 graduated from CAAC. 1988 graduated from Sculpture Dept. of CAA. 1990 sculpture *Ren xing dao* set up in National Physical Training Center. Took part in Guangzhou Young Sculptors exhibition. 1994 one-artist show in CAFA gallery. Also exhibited in Taiwan. 1995 member of sculpture research, CAFA. His many exhibitions include Shanghai Biennale (2000), where he showed rock forms in metal made by hammering sheets of stainless steel over natural Taihu rocks; Venice Open International Exhibition of Sculpture and Installations (2003); and Cantor Center for Visual Arts, Stanford University (2005). 2005 living in Beijing, where he teaches in Sculpture Dept. of CAFA.

Zhang Anzhi 張安治 (1911–91, b. Yangzhou, Jiangsu province). Painter, calligrapher, and art historian. 1928 entered Art Dept. of NCU Nanjing; studied under **Xu Beihong** and **Lü Fengzi**. 1931 graduated and taught drawing in Nanjing Academy. 1936 invited by Xu Beihong to organize Guilin AFA. 1940 head of art section, Provincial Art Gallery, Guangxi. 1944 associate researcher in Chinese Art Research Institute, Chongqing. 1947–48 in London on British Council scholarship. 1953 professor in Art Dept. of Beijing Normal College. 1956–64 head of Art Dept. of various art colleges in Beijing. Later professor in CAFA.

Zhang Bihan 張碧寒 (b. 1909). *Guohua* painter. Active in Hong Kong.

Zhang Bu 張步 (b. 1934, Fengrunxian, Hebei province). Decorative *guohua* painter. Started career as carpenter and electrician. 1958 studied under **Li Keran** at CAFA. 1979 exhibited with Li Keran and others of his students. 1980 solo exhibition in Tokyo. Member of Beijing Chinese Painting Academy.

Zhang Chaoyang 張朝陽 (b. 1945, Hubei province). Print artist. 1964 graduated from middle school attached to CAFA, then worked at state farm in Heilongjiang. Noted for his romantic female figures (often nude) in landscape settings.

Zhang Chongren 張充仁 (1907–98, b. Suzhou, native of Shanghai). Painter and sculptor. 1931–35 studied sculpture in Royal AFA, Brussels; traveled widely in Europe. 1935

clockwise from top left
Yuan Dexing (Ch'u Ko), 2004. Photo by Britta Erickson.
Yue Minjun, 2004. Photo by Britta Erickson.
Zeng Mi.
Zeng Youhe, 2003. Photo by Sally Y. Leung.

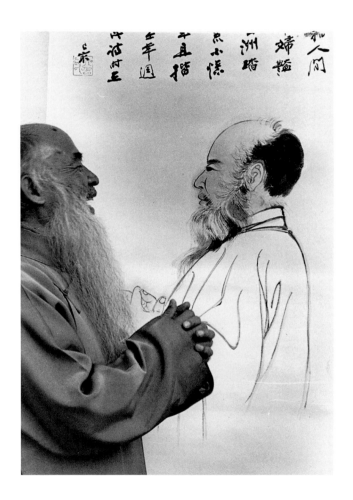

Zhang Daqian with self-portrait, 1967. Photo by Hank Kranzler.

returned to Shanghai; opened his own studio. 1938 professor in Architecture Dept. of Zhejiang University. 1958 professor in Sculpture Dept. in Shanghai College of Fine Art. 1965 worked for Shanghai Oil Painting Academy. 1981 study tour to Belgium.

Zhang Dai Chien. See **Zhang Daqian**

Zhang Daofan 張道藩 (1897–1968). Painter, playwright, and art bureaucrat. 1923–26 studied at Slade School of Art, London, and in Paris. Returning to China, became involved in KMT politics and art administration. 1938 initiated National Art World War of Resistance Society in Wuhan, and many patriotic artists joined. After WWII in Shanghai and Paris. 1949 moved to Taiwan.

Zhang Daqian 張大千 (Chang Dai Chien, original name Zhang Yuan 爰, 1899–1983, native of Neijiang, Sichuan province). *Guohua* painter, collector, connoisseur, and forger. 1917 went to Shanghai with his elder brother, **Zhang Shanzi**, then enrolled in commercial art school in Kyoto to study textile technology. There he was somewhat influenced by current trends in Japanese painting. 1919 returned to Shanghai, studied under **Zeng Xi**. Later studied calligraphy with **Li Ruiqing**. When briefly a monk (to avoid an arranged marriage), he changed his name to Daqian. Started to travel widely in China. 1929 executive member of National Art Exhibition. 1936 joined **Xu Beihong** as professor in NCU Nanjing. During WWII in west China. 1941–43 in Dunhuang, where with assistants he copied Buddhist wall paintings. 1943–46 in Chengdu. 1948–77 lived in Hong Kong, India, Argentina, Brazil, and Carmel, California. Finally settled in Taipei, where he built a house near the Palace Museum. In 1960s his art developed, partly under Western influence, from eclectic *guohua* traditionalism into a free expressionist style. His forgeries of works of the masters are greatly admired. His last and arguably finest work, the huge *Panorama of Mount Lu* (originally commissioned by a Chinese restaurateur friend, Li Haitian, in Yokohama), was almost finished at the time of his death. He was the subject of an important study by Fu Shen and Jan Stuart, *Challenging the Past: The Paintings of Chang Dai Chien* (Washington, D.C., 1991). See also Ye Qianyu 葉淺予, ed., *Zhang Daqian zuopin xuan* 張大千作品選 [Selected works of Zhang Daqian], 2d ed., (Tianjin, 1987); Mayching Kao, *The Mei Yun Tang Collection of Paintings b y Chang Dai-chien* (Hong Kong, 1993), with a translation by Yao Xinnong of Zhang Daqian's *Discourses on Chinese Art* (Hong Kong, 1961); and *Han mo* 翰墨, nos. 39 and 40 (1994.2,3). (*Photo on p. 214.*)

Zhang Dazhuang 張大壯 (1903–80, native of Hangzhou, Zhejiang province). *Guohua* painter. Self-taught when young. Protégé of the Shanghai collector and connoisseur Pang Liachen (Pang Yuanqi), in whose house he studied for over ten years. Member of Shanghai Chinese Painting Academy. Specialized in flowers, plants, and fruits.

Zhang Ding 張仃 (*hao* Tashan 它山, b. 1917, native of Heishanxian, Liaoning province). *Guohua* painter (*gongbi* style) and cartoonist. 1932 studied Chinese painting in Beijing Academy. 1936 went to Nanjing and published cartoons there. 1937 joined cartoon propaganda team. 1938 taught in LXALA in Yan'an. 1945 editor of *North China Pictorial* in Harbin. 1949 professor in CAFA. 1954 started to paint from life in *guohua* style; held influential exhibition with **Li Keran** and **Luo Ming.** 1956 founding member and later dean of CAAC. 1957 purged as Rightist, his style attacked as "formalism." Rehabilitated in 1978. 1979 in charge of decoration of Beijing Airport lounge, for which he created the large mural *Nezha Defeats the Dragon King.* 1980 president of CAA.

Zhang Dongfeng 張冬峰 (b. 1958, Guilin, Guangxi province). Oil painter. 1984 graduated from Guangxi AFA, where he later became professor. Participated in many group exhibitions in China. 2000 his landscapes in oils shown in Shanghai Biennale.

Zhang Gong 張弓 (b. 1959, Beijing). 1979 worked in artists' workshop of cultural center for workers in Xicheng district, Beijing. 1985 art director in college publishing house. 1990 studied at CAAC. Later became teacher there. Elaborate symbolic, finely detailed pictures with Mao as principal figure. 1997 presented pop images, nudes, surrealism, etc., in Quotation Marks exhibition, Singapore.

Zhang Guangyu 張光宇 (1904–64, native of Wuxi, Jiangsu province). Painter, illustrator, designer, and cartoonist. Twin brother of **Zhang Zhengyu.** Studied with **Zhang Yuguang** in Shanghai. 1928–29 designed lurid covers for *Shanghai Manhua* 上海漫畫. In 1930s influenced by Miguel Covarrubias. 1937 went to Hong Kong. Spent WWII in west China. 1945 produced famous anti-KMT cartoon series *Journey to the West.* 1946 joined Renjian Huahui in Hong Kong. 1949–63 head of Decorative Art Dept., CAFA. Chief artist for cartoon film based on original *Journey to the West.*

Zhang Guchu 張谷雛 (1890–1968, native of Shunde, Guangdong province). *Guohua* painter. Spent three years on Lushan, painting over a hundred views of the mountain. During WWII in Guilin and Chongqing. An expert on, and collector of, teapots, about which he wrote.

Zhang Gunian 張毅年 (1903–?, native of Wujin, Jiangsu province). *Guohua* painter. Studied as boy under his uncle **Feng Jiong.** As young man made many copies of paintings in collection of Pang Laichen and Li Pingshu. In west China during WWII. 1949 moved to Taiwan. 1939 did huge panorama of scenery of Taiwan for New York World's Fair.

Zhang Guolong 張國龍 (b. 1957, native of Liaoning province). Oil painter and mixed-media artist. 1928 graduated from LXAFA in Shenyang and stayed on to teach there.

1988 MA in oil painting, Xi'an AFA. 1991 went to Germany for advanced study in Mainz University.

Zhang Hanhong 張漢洪 (Cheung Han Hung, b. 1937, Guandong province). Watercolor painter. 1973 moved to Hong Kong, where he works as professional artist specializing in landscapes, portraits, and still lifes. Has exhibited in many shows in Hong Kong and Hangzhou.

Zhang Hong 張虹 (1890–1968, b. Shunde, Guangdong province). *Guohua* painter, collector, and dealer. Student of **Gao Lun** in Guangzhou. 1923 met **Huang Binhong.** Thereafter he worked in two styles: that of his teacher and that of Huang Binhong, with whom he had a long friendship. Taught in Shanghai and Hong Kong.

Zhang Hong 張弘 (b. 1931, Hefei, Anhui province). Primarily wood engraver. Active in Anhui.

Zhang Hong 張洪 (Arnold Chang, b. 1954, New York, native of Jiashan, Zhejiang). Painter and art historian. Studied *guohua* technique with **Wang Jiqian** and others. 1976 BA in Chinese language and East Asian studies from University of Colorado, Boulder. 1978 MA in Asian studies, University of California, Berkeley. 1980–82 cataloguer of Chinese painting at Sotheby's, New York. 1984–92 vice-president and director of Sotheby's Dept. of Chinese Painting. 1992–94 consultant. Later joined Kaikodō, New York. Author of *Painting in the People's Republic of China: The Politics of Style* (Boulder, Colo., 1980).

Zhang Hong 張虹 (b. 1957, Beijing). Oil painter. 1990 she graduated from Printmaking Dept. of CAFA.

Zhang Hongnian 張洪年 (b. 1947, Nanjing). Oil painter. 1966 graduated from middle school attached to CAFA. 1969 sent to rural area to work. 1985 enrolled for MFA at City College of New York.

Zhang Hongtu 張宏圖 (b. 1943, Gansu province). Painter. 1964–69 studied *guohua* and calligraphy, Buddhist art, and socialist realist art in CAFA. 1969–72 worked in countryside of Hebei province. 1973 designer for Beijing Jewellery Co. 1982 went to New York to study at Art Students League, where he transformed himself into a political pop–style artist, making satirical images of Mao Zedong and other symbolic protest works. Lives in New York, where he produces traditional Chinese compositions in the manner of Paul Cézanne, Vincent van Gogh, and Claude Monet. 2002 exhibited in Espace Cardin, Paris; 2005 exhibition at Cantor Center for Visual Arts, Stanford University; etc.

Zhang Huaijiang 張懷江 (1922–89, native of Yueqing, Zhejiang province). Printmaker. Professor in ZAFA.

Zhang Huan 張洹 (b. 1965, Anyang, Henan province). Performance and installation artist. 1988 BA, Henan University, Kaifeng. 1993 graduated from CAFA. Noted for controversial performances using the naked human body. Influential member of "East Village" colony of avant-garde artists outside Beijing, which was closed down by police in 1995. Exhibited in Whitney Biennale (2002) and Cantor Center for Visual Arts, Stanford University (2005). Lives in New York. (*Photo on p. 229.*)

Zhang Huaqing 張華清 (b. 1932, Feichengxian, Shandong province). Painter. 1945 joined Revolutionary Army led by CCP. 1952 graduated from Shandong University. 1956–62 studied in Repin AFA, Leningrad, returning to become professor and then dean of Fine Arts Dept. of Nanjing Academy. Soviet-style socialist realist.

Zhang Huayu 張華育 (b. 1932, Shandong province). Oil painter. 1952 graduated from Shandong University Art Dept. 1955 graduate degree from CAFA Oil Painting Dept. 1962 graduated from Repin AFA, Leningrad, with MA and title of Artist. After returning to China, taught in Nanjing Academy. Chairman of Jiangsu Artists Association and Jiangsu Oil Painting Association.

Zhang Jiahui 章家慧 (Beatrice Ts'o, b. 1914, Jiangsu province). Painter. Studied in Art Dept., University of Nanjing. 1937 settled in Hong Kong.

Zhang Jianjun 張建君 (b. 1955, Shanghai). Painter. Trained in Dept. of Theater Design, Shanghai Academy of Drama. 1978–89 lecturer and member of staff of Shanghai Art Museum. Member of Shanghai avant-garde. 1989 settled in US, where he became an environmental, conceptual, and installation artist. 2002 exhibited in Shanghai Biennale.

Zhang Jie 張杰 (b. 1924, native of Dinghai, Zhejiang province). Painter in watercolors. After graduating from an art school in Danyang, settled in Taiwan, where he founded Taiwan Watercolor Association. 1981 founding member of Taipei Art Club. Participated in many international exhibitions.

Zhang Jiemin 章杰民 (b. 1951, Shanghai). Sculptor and painter. Trained in Shanghai. 1987 studied in US.

Zhang Jingying 張菁英 (Chang Chien-ying, 1913–2003, b. Wuxi, Jiangsu province). Artist. Trained in Western art under **Xu Beihong** in Nanjing. 1947 sent on British

Council scholarship to UK, where she settled, becoming *guohua* painter and teacher of Chinese painting. Married to **Fei Chengwu.**

Zhang Jinlong 張錦隆 (Cheung Kam Long, b. 1939, Sichuan province). Painter. 1960s trained in Hong Kong. 1995–97 vice-chairman of Hong Kong Artists Society. His Chinese ink paintings show influence of watercolor technique.

Zhang Junshi 張君實 (b. 1912, native of Shunde, Guangdong province). *Guohua* painter. Lingnan school. Graduated from Dept. of Chinese Painting, Guangzhou Municipal College of Fine Art. 1950 settled in Hong Kong. Cofounder of Hong Kong Chung Kok Chinese Art Club. Studied painting under **Li Yanshan,** Li Yaoping, **Chen Zhifo,** and **Huang Junbi.**

Zhang Keduan 張克端 (b. 1960, Hohhot, Inner Mongolia). Sculptor. 1985 graduated from ZAFA. Associate professor at CAFA.

Zhang Kunyi 張坤儀 (1899–1967, native of Panyu, Guangdong province). *Guohua* painter. Adopted daughter and favorite student of **Gao Weng** and custodian of his memory after his death in 1933.

Zhang Leping 張樂平 (1910–92, Haiyanxian, Zhejiang province). Cartoonist. 1930s influenced by **Ye Qianyu,** did cartoons for *Shidai Manhua* 時代漫畫 and *Dulian Manhua* 獨立漫畫. During WWII joined Anti-Japanese Cartoon Propaganda Team. 1935 his cartoon series *San Mao* (Three hairs), about a poor street boy, first appeared in Shanghai. An enormous success, it was revived after WWII. 1952 joined Shanghai People's Art Publishing House as staff artist, and produced serial pictures and New Year paintings. From 1953 prominent in **Jiang Feng**'s reorganization of CAA.

Zhang Li 張利 (b. 1958, Beijing). Oil painter. 1983 graduated from PLA Institute of Art, where he remained as lecturer. Academic romantic who specializes in depicting minority cultures.

Zhang Linglin 張玲麟 (b. 1933, Xiangxiangxian, Hunan province). Painter. After successful career as movie actress in Hong Kong, she retired at height of her career in 1960s to take up painting. After working in Lingnan tradition, she developed her own styles, using both *shuimo* and Western watercolor techniques. Has held a number of exhibitions in East Asia and Europe.

Zhang Liying 張荔英 (Georgette Chendana, 1906–93, b. Paris, native of Wuxi, Jiangsu province). Oil painter. 1910 moved with her family to China. 1914–19 returned to

Paris. 1919–23 at school in New York. 1923–26 at Seminar High School in Shanghai. 1926–27 studied at Art Students League, New York. 1930–34 studied and practiced painting in Paris. 1930 exhibited with **Liu Kang** in Salon d'Automne. 1930 married Eugene Chen, Chinese foreign minister, in Paris. 1934–49 lived in Shanghai (where she was interned by the Japanese), Hong Kong, and Paris. Spent a period in Penang with her second husband. 1953 settled in Singapore, where she taught oil painting in Nanyang AFA until her retirement in 1981.

Zhang Minjie 張敏傑 (b. 1959, Tangshan Hebei province). Print artist. After graduation from CAFA, founded Masses Art Center at Qinghuangdao. Later became head of College of Visual Arts in ZAFA. 1994 his print *Dance in the Plain No. 2* won grand prize at Fifth Osaka Triennale.

Zhang Peili 張培力 (b. 1957, Hangzhou, Zhejiang province). Painter and conceptual, installation and video artist. 1985 MS from Oil Painting Dept. of ZAFA. 1985 organized New Space Group in Zhejiang. Founding member of Pond Society. Became teacher in Hangzhou Institute of Technology, where he was responsible for series of art events, happenings, and installations. Member of post-1989 avant-garde movement. Exhibted multi-media installations dealing with language, communication, and the absurd in Shanghai Biennale (2000), Venice Biennale (2003), and elsewhere around the world. Director of New Media Art Center of the Hangzhou Academy.

Zhang Peiyi 張佩義 (b. 1939, Taigu, Shanxi province). Graphic artist. 1960 graduated from Beijing Art Institute. 1986 teacher in Graphic Arts Dept. of CAFA. From 1980 has practiced and taught *shuiyin* color printing.

Zhang Ping 長平 (b. 1934, native of Xinxiang, Henan province). *Guohua* landscape painter. 1961 graduated from CAFA. Student of **Li Keran** and **Qian Songyan.**

Zhang Renzhi 張仁芝 (b. 1935, native of Jixian, Hebei province). *Guohua* painter. Graduated from CAFA. Member of Beijing Chinese Painting Academy.

Zhang Shangpu 章尚璞 (Constance Chang, b. 1928, Nantong, Jiangsu province). Painter and actress. 1938–36 studied art in ZAFA. 1936 began her interest in performing arts; moved to Shanghai, where she became movie actress. In west China during WWII. 1948–67 actress and painting student in Hong Kong, studying under **Zhao Shao'ang, Lü Shoukun,** and others. 1974 moved to San Francisco, where she became known as Constance Chang. Many solo exhibitions in China and US, including Asian Art Museum, San Francisco.

Zhang Shanzi 張善孖 (1895–1943, native of Neijiang, Sichuan province). *Guohua* painter. Elder brother of **Zhang Daqian**, whom he took with him to Japan in 1917. During WWII went on fund-raising visit to US. Died shortly after his return to China. Specialized in tigers.

Zhang Shaoshi 張韶石 (Cheung Shiu-shek, 1914–91, native of Panyu, Shandong province). Flower painter. Studied painting under his uncle, Zhang Xunzhu. 1939 moved to Hong Kong. During WWII in Macao and Vietnam. After war settled in Hong Kong to teach painting. Particularly noted for his peonies.

Zhang Shipei 張石培 (native of Guangdong province). *Guohua* painter. After schooling in Guangzhou Academy Middle School and five years in training college, went to live in a Pearl River village. His landscapes of riverside villages in South China show influence of **Zhang Bu** and **Li Keran**.

Zhang Shoucheng 張守成 (b. 1918, Shanghai). *Guohua* painter. Studied in Shanghai under **Wu Hufan**. From 1956 member of Shanghai Chinese Painting Academy. 1982 settled in US.

Zhang Shuqi 張書祈 (1899–1974, native of Pujiang, Zhejiang province). *Guohua* painter, especially of cranes, flowers, and birds. Student of **Liu Haisu** in Shanghai Meizhuan. 1924–40 taught at NCU Nanjing. 1937 moved with NCU to Chongqing. 1941–46 taught and lectured in US. 1946 returned to Nanjing to resume teaching at NCU Nanjing. Later moved to California, where he died. His paintings of birds and flowers in bright colors were popular in US.

Zhang Songhe 張松鶴 (b. 1912, native of Guangdong province). Sculptor. 1930 studying painting in Guangzhou Art Museum. Studied Western painting in Guangzhou Academy. 1934 graduated in sculpture. 1937 went to Shanghai. 1938 joined CCP, returned to Guangdong, worked with anti-Japanese resistance. 1946 to north China. After Liberation worked in monumental sculpture projects in Beijing, including Martyrs' Memorial in Tiananmen (1952–58). Member of many official culture bodies.

Zhang Songnan 張頌南 (b. 1942, Shanghai). Modern painter. 1964 graduated from CAFA. 1964–78 worked in district propaganda unit. 1978 enrolled as postgraduate student in CAFA. After graduating, joined staff in Wall Painting Dept. 1982 went to study in Europe.

Zhang Tielin 張鐵林 (b. 1957, Tangshan, Hebei province). Amateur artist and professional actor. Trained in Beaconsfield Film School, UK.

Zhang Wanchuan 張萬傳 (b. 1909, Taipei). Oil painter. Studied under Ishikawa Kin'ichirō and at Kawabata Institute in Tokyo. 1938 taught in Xiamen AFA. Later returned to Taipei; taught oil painting in National Taiwan Fine Art Institute. Since 1975 has visited Europe and US many times.

Zhang Wang 張望 (b. 1916, native of Guangzhou). Wood engraver. 1931 one of organizers of MK Woodcut Research Society in Shanghai. 1934 graduated from Shanghai Meizhuan. Active in woodcut movement in Shanghai. During WWII engaged in propaganda work and teaching. 1938 went to Yan'an. From 1942 taught in LXALA. After 1949 taught at LXAFA in Shenyang.

Zhang Wanli 張萬里 (b. Xinjiang province). Graphic artist. 1984 graduated from Xi'an AFA. Noted for her serial pictures and book illustrations.

Zhang Wanxin 張萬新 (Wanxin Zhang, b. 1961, Changchun, Jilin province). Painter, sculptor, and ceramicist. 1978–80 studied in Jilin College of Art. 1983 BA in sculpture from LXAFA in Shenyang. 1992 went to study in US. 1996 MFA in sculpture, Academy of Art University, San Francisco. Since 1985 has held seven solo exhibitions in US. Lives and works in San Francisco.

Zhang Wei 張偉 (b. 1952, Beijing). Oil painter. Denied access to CAFA owing to his "capitalist" background. During Cultural Revolution worked as garbage collector. Since 1979 stage designer with Beijing Kunqu Opera. 1981 joined Nameless Art Society. Developed abstract style influenced by Jackson Pollock. 1982 his work was exhibited in New York and at Vassar College. 1986 settled in US.

Zhang Wenxin 張文新 (b. 1928, Tianjin). Oil painter and sculptor. 1948 studied art in North China University. 1949–51 studied physics in Beijing University. After graduating, briefly attended Konstantin Maksimov's class in CAFA; worked in Beijing Municipal Company of Fine Arts. Subsequently became professional painter in Beijing Academy of Painting. Realist.

Zhang Wenyuan 張文元 (b. 1910, Jiangsu province). *Guohua* painter and cartoonist. Studied in Shanghai. Active as cartoonist and in anti-Japanese propaganda during WWII. Later developed as conservative landscape painter.

Zhang Xian 張弦 (1901–36). Oil painter. Studied in Paris. On his return, taught in Shanghai Meizhuan. Joined Storm Society, established in 1931 by **Ni Yide, Pang Xunqin,** and others. Much admired by his friends and students, but very poor. Lack of help from **Liu Haisu** contributed to his early death.

Zhang Xiaofan 張小凡 (b. 1950, Zhejiang province). Oil painter. 1980 graduated from Painting Dept. of Tianjin Academy.

Zhang Xiaogang 張曉剛 (b. 1958, Kunming, Yunnan province). Painter. 1982 graduated from Oil Painting Dept. of Sichuan AFA, where he later taught. Symbolist-surrealist and member of avant-garde movement, influenced by Pablo Picasso and Salvador Dali. Founding member of Discovery Community for Western Art. Noted for his paintings of family groups, which look like retouched photographs. 2004 living as professional artist in Beijing. 2004 participated in Shanghai Biennale.

Zhang Xiaoming 章曉明 (b. 1957, native of Zhejiang province). Oil painter. 1984 graduated from Oil Painting Dept. of CAFA and stayed on as teacher. 1988–91 in France on French government scholarship. Returned to China to become associate professor and dean of Oil Painting Dept. in ZAFA.

Zhang Xiaoxia 張小夏 (b. 1957, Nanjing). Painter. Largely self-taught. In early career painted in traditional *guohua* style. 1986 studied in Brussels AFA, where he was influenced by Joseph Beuys. Member of avant-garde movement.

Zhang Xinyu 張新予 (b. 1932). Printmaker. 1958 graduated from Graphic Arts Dept. of ZAFA. Since 1960 in charge of graphics at Jiangsu Provincial Art Hall. Active in Jiangsu in 1980s and '90s. Sometimes collaborated with **Zhu Qinbao**.

Zhang Xiyai 章西厓 (Ch'ang Hsi-ya, *hao* Xiya, b. 1916/17, native of Hangzhou). Wood engraver and graphic artist. Noted for elegant stylized woodcuts showing influence of Western engravers, including Eric Gill. In deep trouble in Cultural Revolution (because, e.g., he owned a typewriter); Red Guard thought he was a spy. In prison a long time.

Zhang Yangxi 張漾兮 (1912–64, b. Chengdu, Sichuan province). Wood engraver and cartoonist. Studied in Chengdu. 1939 joined National Anti-Japanese Association of Wood Engravers. During WWII active in Chengdu. 1948–49 in Hong Kong. Later chairman of Graphic Arts Dept. of ZAFA.

Zhang Yayan 張雅燕 (Lucia Cheung, b. 1950, Macao). Painter. 1965 she moved to Hong Kong. 1969 graduated from Lingnan College. Paints landscapes in mixed Sino-Western style marked by fine drawing. Since 1984 has held solo exhibitions in Macao, Hong Kong, and Guangzhou.

Zhang Yi 張義 (Cheung Yee, b. 1936, Guangzhou). Sculptor. 1958 graduated from Fine Art Dept. of NTNU; moved to Hong Kong. 1964 became professional sculptor. From

1970 he became leading sculptor in many media. Early work inspired by Paul Klee and primitive art. Later influenced by archaic Chinese bronzes, jades, and stone reliefs.

Zhang Yixiong 張義熊 (b. 1914, Jiayi, Taiwan). Oil painter. 1938–40 studied in Tokyo. Taught at Taipei Normal College. Later worked in Japan and Paris before returning to Taipei.

Zhang Yonghe 張永和 (Yung Ho Chang, b. 1956, Beijing). Architect and installation artist. 1978 studying at Nanjing Institute of Technology. 1981 went to study in US. 1984 BA in environmental design, Ball State University, Indiana. 1986 MA in architecture, University of California, Berkeley. 1993 established Atelier Feichang Architectural Workshop with Lijia Lu (Lu Lijia 魯力佳). 1996 returned to China. Exhibitions include Kwangju Biennale (1997); Cities on the Move, Vienna and London (1997); Shanghai Biennale (2000).

Zhang Yongjian 張永見 (b. 1958, Shandong province). Sculptor. 1980 graduated from Art Dept. of Shandong Jining Normal College. 1990s working in sculptural division of Jining Municipal Public Works Dept. Abstract works using a variety of materials featured in China's New Art, Post-1989 exhibition (Hong Kong, 1993).

Zhang Youxian 張友憲 (b. 1945, Nanjing). *Guohua* painter. 1982 graduated from Nanjing Academy. 2004 vice-director and assistant professor at Nanjing Academy. Noted for his figures in landscapes and illustrations to historical novels and poetry. A number of books and postcard sets of his work have been published, including *Zhang Youxian huaji* [Collected paintings of Zhang Youxian] (Nanjing, 2001).

Zhang Yu 張羽 (b. 1959, Tianjin). Experimental ink painter. 1979–88 graduated from Tianjin Arts and Crafts College. Exhibitions include Moscow Modern Art Museum (1992) and Shanghai Biennale (1998). 2004 associate professor and dean of Artistic Design Dept., Tianjin Traffic Vocational College. 2004 solo exhibition, Michael Goedhuis Gallery, New York.

Zhang Yuan. See **Zhang Daqian**

Zhang Yuguang 張聿光 (1884–1968, native of Shaoxing, Zhejiang province). Painter (*guohua* and Western style) and cartoonist. 1912 cofounder of Shanghai Meizhuan with **Liu Haisu** and others. 1916 organized his own studio in Shanghai. 1921 studied in France. 1924 in Japan. 1926 head of Xinhua AFA, Shanghai. During WWII went to southwest China. 1945 returned to Shanghai.

Zhang Zhaoxiang 張兆祥 (1874–1922, native of Tianjin). *Guohua* painter. Active in Beijing. Painted birds and flowers in rich, thick colors. Published book of letter paper with flower designs, *Baihua jianpu* [Hundred flowers letter paper].

Zhang Zhenduo 張振鐸 (b. 1908, Pujiang, Zhejiang province). *Guohua* painter. 1927 graduated from Art Education Dept. of Hangzhou Academy. Taught in high schools in various places. During WWII in Sichuan. After Liberation taught in Wuhan.

Zhang Zhenggang 張正鋼 (b. 1953, native of Zhejiang province). Oil painter. Graduated 1987 from Fine Art Dept. of PLA Art Academy. Late 1980s and early '90s Active in Beijing. Later moved to Shanghai, where he became "Class A" painter in Shanghai Academy of Painting and Sculpture. His later work shows strong influence of Italian Renaissance painting and of the work of Balthus.

Zhang Zhengyu 張正宇 (1904–76, native of Wuxi, Jiangsu province). Cartoonist, decorative painter, and stage designer. Twin brother of **Zhang Guangyu**. Active in Shanghai before WWII. Later taught in CAFA.

Zhang Zhiyou 張志有 (b. 1941, Hebei province). Printmaker. Graduated from CAFA. Established first independent printmaking studio in Zhouxian, south of Beijing. Noted for his series of lithographs of Zhou Enlai's years in Paris (1920–24).

Zhang Zhunli. See **Mao Lizi**

Zhang Zizheng 張自正 (b. 1918, Guangdong province). Oil painter. 1940s studied oil painting under **Liu Haisu** in Shanghai Meizhuan. 1945–48 studied painting in Lyon, France. 1959 exhibition in Singapore. 1990 exhibition in Hong Kong.

Zhang Zuoliang 張作良 (b. 1927, Shandong province). Woodcut artist. 1944 joined Revolution. 1950 went to Korea. 1952 with art Dept. of *Liberation Army Pictorial*. 1958 went to Heilongjiang and began to do graphics. Since 1975 in Tianjin.

Zhang Zuying 張祖英 (*hao* Lu'an 魯庵, Wangyun Caotang 望雲草堂, b. 1940, native of Shanghai). Oil painter. 1963 graduated from Stage Design Dept. of Shanghai Drama Academy and completed his training at CAFA. 1992 solo exhibition in San Francisco Art Center at the Presidio. Paints portraits and landscapes.

Zhao Bandi 趙半狄 (b. 1966, Beijing). Mixed-media artist. 1988 BA in oil painting, CAFA. Lives and works in Beijing. From 1999 abandoned oil painting for computer-enhanced satirical photographic images.

Zhao Baokang 趙葆康 (b. 1953, Shanghai). Painter. 1978 graduated from Theatre Design Dept., Shanghai Academy of Drama. 1978–85 director of stage design at Wuhan Army District Theater. 1986–95 lecturer in College of Fine Arts, Shanghai University. Since 1995 professional abstract artist. Lives and works in Sydney.

Zhao Chunxiang 趙春翔 (Chao Ch'un-hsiang, 1913–91, b. Henan province). Painter. Studied under **Lin Fengmian** and **Pan Tianshou** in Hangzhou Academy. 1949 went to Taiwan. 1951–55 associated professor in NTNU. 1956 to Spain for travel and study, then settled in New York as abstract expressionist. 1990 retired to Sichuan, returned to painting in Chinese ink. See Alice King, Chuang Shen, Roger Goepper, et al., *Chao Chung*[sic]-*hsiang* (Hong Kong, 1992). 2004 major retrospective in Shanghai Museum of Art.

Zhao Dajun 趙大鈞 (b. 1938, native of Shandong province). Oil painter. 1962 graduated from Oil Painting Dept. of LXAFA in Shenyang. Became professor and dean there. Vice-president of Liaoning branch of Chinese Oil Painting Society.

Zhao Gang 趙剛 (b. 1961, Beijing). Painter. 1979–81 member of Stars. 1973–78 mainly worked on his own, with some guidance from a teacher at CAFA. 1978–79 studied mural painting at CAFA. 1983 went to study particularly mural painting in Holland on art scholarship; held solo exhibition in Maastricht. 1984 at Vassar College in US. 1986 exhibited in Chinese Avant-Garde show in New York and Vassar College. Publisher of *ART Asia Pacific*. Lives in New York.

Zhao Haitian 趙海天 (Chao Hai Tien, b. 1945). Painter. She studied in New Asia College under **Ding Yanyong** and **Wang Jiyuan**. Went abroad to study modern art. 1969 BFA at Cooper Union, New York. 1988 given award for excellence in painting at International Art Competition, Gallery 54, Soho, New York. Has held solo exhibitions in Hong Kong and Shanghai.

Zhao Heqin 趙鶴琴 (1894–1971, native of Jinxian, Zhejiang province). *Guohua* painter, calligrapher, and seal carver. Settled in Hong Kong, where he was lecturer in Fine Art Dept., New Asia College of Chinese University of Hong Kong.

Zhao Jietang 趙戒堂 (1904–77, native of Jiangdu, Jiangsu province). *Guohua* painter. Graduated in law in Shanghai. 1948 settled in Hong Kong, where he was lecturer in Baptist College.

Zhao Ke 趙可 (b. 1907, native of Xinhui, Guangdong province). *Guohua* painter. Studied arts and crafts in Japan. Joined resistance forces during WWII. After a time teaching in Guangzhou, settled in Hong Kong, where he became chairman and supervising director of Hong Kong Chung Kok Chinese Art Club.

Zhao Mei 晁楣 (b. 1931, native of Shandong province). Woodcut artist. 1949 joined PLA. 1958 went to Heilongjiang. Influential member of Beidahuang (Northern Wilderness) school of wood engravers who in 1950s and early '60s produced lyrical, somewhat idealized, prints of northern landscape and farms that were widely exhibited.

Zhao Mengzhu 趙夢朱 (1892–1984, b. Xiongxian, Hebei province). *Guohua* painter. Long career in north China as academic painter of landscapes, birds, and flowers.

Zhao Nengzhi 趙能智 (b. 1968, Nanchong, Sichuan province). Oil painter. 1990 graduated from Sichuan AFA, Chongqing. Awarded prize for his oil painting. Settled and works in Chengdu. Noted chiefly for his portraits in close-up.

Zhao Shao'ang 趙少昂 (*zi* Shuyi 叔儀, 1905–98, Panyu, Guangdong province). *Guohua* painter. 1920 studied with **Gao Weng**. 1927 taught in Fushan Municipal School of Art. 1929 established his Lingnan Art Studio in Guangzhou. 1937 head of Chinese painting in Guangzhou Municipal Art College. During WWII in Guilin and Chongqing. 1948 professor in Art Dept. of Guangzhou University. Same year settled in Hong Kong and engaged in painting and teaching. Became very influential, with many students. Prominent member of Lingnan school. See Terese Tse Bartholomew, Mayching Kao, and Sokam Ng Lee, *Masterworks by Chao Shao-an [sic]* (San Francisco, 1997).

Zhao Shou 趙獸 (b. 1912, Wuzhou, Guangxi province). Surrealist painter. 1927 studied art in Guangzhou. 1933 went to Japan, became involved in surrealist movement. 1934 with **Li Dongpin** cofounded Chinese Independent Art Association in Japan. 1935 association held its first exhibition in Guangzhou. Also painted enigmatic symbolist works.

Zhao Shuru 趙叔孺 (*zi* Xianchen 献忱, *hao* Ernu Laoren 二弩老人, 1874–1945, native of Zhejiang province). Collector, painter, and seal engraver. Government official in Fujian. Later active in Shanghai. Taught many students, some of whom became well established as painters and calligraphers in Hong Kong and Taiwan. Wrote a painting manual, *Huapu*.

Zhao Wangyun 趙望雲 (1906–77, native of Sulu, Hebei province). Painter in both *guohua* and Western styles. As an orphan, apprenticed to fur trade. Protégé of General Feng Yuxiang in Xi'an. 1925 studied painting in Beijing. 1932 moved to Shanghai. During WWII in west China. 1948 jailed by KMT for left-wing sympathies. After 1949 active in Xi'an. 1949 chairman of Federation of Chinese Arts, Xi'an branch. 1965 visited Egypt.

Zhao Wuji 趙無極 (Zao Wou-ki, b. 1921, Beijing). Painter. His father was banker and amateur artist. 1935 entered Hangzhou Academy at age fourteen; studied under **Lin Fengmian**. Went with NAA to west China during WWII. 1941 appointed instructor in drawing in NAA Chongqing. 1946–48 in Shanghai, where he held his first solo exhibition. 1948 left for France, settling in Paris, studying in Académie de la Grande Chaumière, and laying ground for wide circle of friends in the art world. 1950–57 under contract to Pierre Loeb and supported by critic Henri Michaux. Thereafter worked independently. 1958 visited Hong Kong; met and subsequently married his second wife, Chan May Kan (d. 1972). 1977 married Françoise Marquet. 1972 visit to China helped secure release of his teacher, Lin Fengmian. 1982 returned again to China to paint panels for I. M. Pei's Fragrant Hills Hotel outside Beijing. 1985 taught classes in Hangzhou Academy. Has had successful career as abstract expressionist painter, consistent in style. 1985 made officer of French Legion of Honor; 1993 promoted to commander of that order. Has held a number of solo exhibitions worldwide, including major retrospectives in Shanghai (1998) and Paris (2003). Among many studies of this important artist, see particularly Shanghai Art Museum and Association Française d'Action Artistique, *Zhao Wuji huihua liushinian huigu* 趙無極繪畫六十年回顧 [Zao Wuji: Sixty years of painting] (Shanghai, 1998). (*Photo on p. 229.*)

Zhao Xiuhuan 趙秀換 (b. 1946, Beijing, native of Renqiu, Hebei province). Painter. Studied in high school affiliated with CAFA. 1969–72, during Cultural Revolution, she was assigned to Hebei province. 1973 member of Beijing Academy of Painting. Noted for decorative landscape and flower compositions. 1989 went to New Mexico, then settled in California.

Zhao Yannian 趙延年 (b. 1924, native of Huzhou, Zhejiang province). Printmaker. 1938 entered Woodcut Dept. of Shanghai Meizhuan; studied woodcut and cartooning. During WWII active in woodcut movement in Guangdong. 1946 to Shanghai, where he continued woodcut activities and became staff artist in Shanghai People's Art Press. Noted for his portraits of Lu Xun and for his illustrations of Lu Xun's *Story of Ah Q* and other works. Has received many honors and distinctions.

Zhao Yixiong 趙以雄 (b. 1934, Beijing). Oil painter. 1960 graduated from Oil Painting Dept. of CAFA, then worked in Beijing Fine Art Center before joining Beijing Academy of Painting. 1975 recorded his journey along the Silk Road in a series of paintings.

Zhao Youping 趙友萍 (b. 1932, Beijing). Painter. 1953 she graduated in oil painting under Konstantin Maksimov from CAFA. 1983–86 did advanced study in Belgium. Returned to China to became professor in CAFA. Her work shows influence of Russian artists Isaac Levitan, Vasily Surikov, and Prastov.

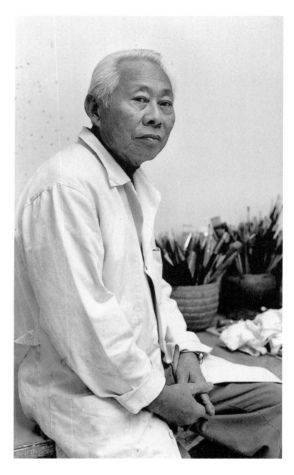

clockwise from top left
Zhang Huan.
Zhao Wuji. Photo by J. F. Bonhomme.
Zhou Tiehai.

clockwise from top left
Zhu Dequn, 1995. Photo © Jeff Hargrove.
Zhu Qizhan, 1998. Photo by Leon Wender.
Zhuang Zhe, 1999.

Zhao Yunyu 趙蘊玉 (1915–2003, Sichuan province). *Guohua* painter and calligrapher. Studied painting and taught school. 1945 went to Chengdu, where he studied with **Zhang Daqian.** From 1952 active chiefly in Sichuan Provincial Museum, Chongqing, authenticating and reproducing ancient paintings and calligraphy. Versatile artist. 1975 his calligraphy was exhibited in Japan.

Zhao Zongzao 趙宗藻 (b. 1931, native of Jiangyinxian, Jiangsu province). Printmaker. From 1947 educated in Suzhou Art College and Art Dept. of Nanjing University. 1952 art teacher in Zhejiang Jinhua Teachers' College. After 1955 taught in Graphic Arts Dept. of East China Division of CAFA. Professor and head of Graphic Arts Dept. of ZAFA.

Zheng Chang 鄭昶 (*zi* Wuchang 午昌, *hao* Ruogang 弱龕, 1894–1952, native of Chengxian, Zhejiang province). *Guohua* painter and art historian. Director of Art Dept. of China Book Bureau, Shanghai. Participated in Bee Society and other painting societies. Later professor in Shanghai Academy. 1991 major exhibition in Hangzhou. Active in publishing and author of several books on Chinese painting and fine arts.

Zheng Chengzhi. See **Ye Fu**

Zheng Hong 鄭紅 (b. 1949, Beijing). *Guohua* painter and calligrapher. 1981 graduated from CAAC, where he became a teacher. 1987 moved to UK to study art theory in Leeds and Manchester Universities. Since 1993 teaching and doing research in Durham. His landscapes show the influence of Shitao 石濤 (1642–1707), on whose *Huayulu* 話語錄 Zheng wrote an essay. Chiefly a wildlife painter.

Zheng Jiazhen 鄭家鎮 (Cheng Kar-chun, b. 1918, native of Hainan Island). 1929 studied in Nanjing Middle School; later in Guangzhou and Hong Kong. In 1930s did Sino-Japanese comic strips. 1945 art editor in Hong Kong. 1958 published *Manhua shijie* (Comic world). In later years devoted himself to painting landscapes, figures, and flowers.

Zheng Jin 鄭錦 (1883–1953, native of Guangzhou, Guangdong province). Painter. Son of Cantonese merchant living in Japan. Studied in Kyoto and Tokyo, developing as a Westernized "Sino-Japanese" painter. 1920–25 taught in Beijing, lecturing in modern Western art. Later joined Liang Shuming's rural reconstruction program, ceased to paint, and spent his last thirty years in Macao.

Zheng Ke 鄭可 (1906–87, b. Xinhui, Guangdong province). Sculptor and medalist. 1924–34 trained and worked in Paris. Returned to teach in Guangzhou Municipal School of Art. 1950 he went to Beijing. 1953 began to teach in CAFA. 1956 appointed professor.

Zheng Manqing 鄭曼青 (1905–79, after fiftieth birthday changed name to Manran 曼髯). *Guohua* painter. 1925 first one-artist show in Beijing. Ministry of Education sent him to Japan to study. 1931 took part in *guohua* exhibition in Tokyo with **Zhang Daqian** and others. 1964 settled in New York.

Zheng Manran. See **Zhang Manqing**

Zheng Mantuo 鄭曼陀 (1885–1961, native of Shexian, Anhui province). Calendar and graphic artist. Active in Shanghai. Collaborated with **Gao Lun,** who did landscape parts. 1915 invented "rub and paint" method by applying color over a surface covered with carbon powder.

Zheng Ming 鄭明 (Cheng Ming, b. 1949, Hong Kong). Calligrapher and ink painter. 1973 graduated from Fine Art Dept. of NTNU. 1977 won Hong Kong Urban Council Fine Arts Award in calligraphy. 1999 established Great Talent Painting Center and taught part-time at Chinese University of Hong Kong. Author of five books on Chinese art technique and theory.

Zheng Naiguang 鄭乃珖 (*hao* Shatipufu 沙堤璞夫, Bishouweng 壁壽翁, b. 1911, native of Fuzhou, Fujian province). *Guohua* painter, specializing in birds and flowers. Orphaned son of poor family, educated in mission school and taught by local artist. Studied under **Liu Haisu** in Shanghai. Later taught in Xi'an AFA and served as principal of Fuzhou Painting Academy. See Huang Disi 黃迪杞, ed., *Zheng Naiguang huaji* 鄭乃珖畫集 [Collected paintings of Zheng Naiguang] (Fuzhou, 1990).

Zheng Shanxi 鄭善禧 (Cheng Shan-hsi, b. 1932, Shima, Longchixian, Fujian province). Modern *guohua* painter. Went to Taiwan as a boy. 1960 graduated from National Taiwan Normal College, where he later taught. 1981 founding member of Taipei Art Club. 1983 visited India and Nepal, where he made many lively genre paintings.

Zheng Shengtian 鄭勝天 (b. 1938, Luoshanxian, Henan province). Painter. 1958 graduated from Oil Painting Dept. of ZAFA and joined faculty. 1961–62 did advanced study in studio of **Dong Xiwen** in CAFA. 1981–83 sent by Ministry of Culture for further study in University of Minnesota. 1986–87 taught in San Diego State University, California. Returned to be associate professor in Oil Painting Dept. of ZAFA and active in exchange program sending young artists to study in Europe and North America. Late 1990s director of Art Beatus Gallery, Vancouver, British Columbia. 2000 research curator in Villa Stuck Museum, Munich. From 2003 board member of Vancouver International Centre for Contemporary Asian Art and managing editor of art journal *Yishu: Journal of Contemporary Chinese Art* (Taipei). 2004 one of curators of Shanghai Biennale.

Zheng Weiguo 鄭維國 (Cheng Wei-kwok, b. 1920, native of Bao'an, Guangdong province). 1943 graduated from National Zhongshan University with doctorate in agriculture. 1949 settled in Hong Kong, where he was principal of two schools. 1960s one of Hong Kong *guohua* experimentalists. 1966, inspired by **Lü Shoukun**, he studied painting in Dept. of Extramural Studies, University of Hong Kong and in Chinese University of Hong Kong. 1970 cofounded One Art Group.

Zheng Xiaoxu 鄭孝胥 (1860–1938, native of Fujian province). Amateur *guohua* painter. Became first prime minister of Japanese puppet state Manchukuo.

Zheng Xu 鄭旭 (b. 1959, Lancang, Yunnan province). Printmaker. Active in Yunnan province in 1980s and '90s.

Zheng Yi 鄭藝 (b. 1961, native of Heilongjiang province). Oil painter. 1985 graduated from Oil Painting Dept. of LXAFA in Shenyang. Vice-president of Harbin Art Academy, vice-president of Heilongjiang Provincial Oil Painting Society. Paints peasant life of northeast.

Zheng Yuebo 鄭月波 (Cheng Yueh-po, b. 1916, Tongwan, Guangdong province). Painter. Grew up in Malaysia. 1928 entered Hangzhou Academy. On graduating, taught in several colleges in China and Hong Kong. Later moved to US, establishing gallery of Chinese art in Carmel, California. Specialized in animals, fishes, and birds.

Zheng Zaidong 鄭在東 (Cheng Tsai-tung, b. 1953, Taipei). Self-taught sculptor and oil painter, especially of figures influenced by surrealism and German expressionism. Works in Taipei and Beijing. 1997 solo exhibition, Wanderings in Taiwan, in Taipei.

Zhong Biao 鐘飆 (b. 1968, Chongqing, Sichuan province). Oil painter. 1987 graduated from middle school attached to Sichuan AFA. 1991 graduated from Oil Painting Dept. of Sichuan AFA. 1991 became lecturer there. Paints highly detailed, somewhat satirical figure groups.

Zhong Dafu 鍾大富 (Chung Tai Fu, b. 1956). Sculptor and printmaker. 1981 graduated from Fine Arts Dept. of Chinese University of Hong Kong. Later studied printmaking in Japan. His works, chiefly landscapes and man in nature, employ a variety of techniques, including relief, intaglio and etching, and gold and silver leaf.

Zhong Genglüe 鍾耕略 (Kang L. Chung, b. 1947, Guangzhou). Painter. Studied art at Guangzhou Academy. During Cultural Revolution went to Hong Kong. 1980 became permanent resident of US. For many years represented by Staempfli Gallery, New

York. Trained in *guohua*. Panoramic landscapes and cloudscapes in semi-Western style, some in pastels.

Zhong Han 鍾涵 (b. 1929, Pingxiangxian, Jiangxi province). Painter. 1946 entered Qinghua University to study architecture. 1948 joined CCP. 1955 entered CAFA. Assigned to work in CAFA after graduation. 1960–63 attended oil painting seminar conducted by **Luo Gongliu** in CAFA. Socialist realist specializing in narrative painting.

Zhong Sibin 鍾泗濱 (Cheong Soo Pieng, 1917–83, b. Xiamen, Fujian province). Painter. Trained in Xinhua AFA in Shanghai and Xiamen AFA. 1946 settled in Singapore. Traveled widely in Southeast Asia and taught in Nanyang AFA, Singapore. 1952 went on painting tour of Bali with **Liu Kang, Chen Zhongrui**, and **Chen Wenxi**. 1962 visited London, where he held one-artist show at Frost & Reed Gallery, Bond Street. In late years worked also in batik and metal. He was for some years the leader of Singapore school of artists, their work refreshingly free from the influence of Paul Gauguin.

Zhong Zhengshan 鍾正山 (Chung Chen-sun, b. 1935, Malaysia). *Guohua* painter. 1955 graduated from Nanyang AFA, Singapore. 1967 became head of Malaysian College of Arts. Vice-president of Council of Fine Arts Education in Asia-Pacific region and acting president of Chinese Culture Association of Malaysia.

Zhong Zhenxiong 鍾振雄 (b. 1939, Taiwan). Painter, modern semi-abstract school. Studied under **Li Zhongsheng.** Founded the monthly *Avant-Garde*. Exhibits with Ton Fan Group and Modern Empire Arts Association. Writes on art in newspapers and magazines.

Zhong Zhiren 鍾志仁 (Wilson Chung, b. 1945, Hong Kong). Trained in Hong Kong in both Chinese and Western painting. 2002 chairman of Hong Kong Sketching Society and active in Hong Kong Fringe Club City Festival.

Zhou Bichu 周碧初 (1903–95, b. Pinghexian, Fujian province). Oil painter. 1922 began studying in Xiamen University and Xiamen AFA. 1925–30 in Paris studying in Académie Julien. Returned to teach in Xiamen AFA, Shanghai Meizhuan, and Xinhua AFA. 1931–34 member of Storm Society. 1949 went to Hong Kong. 1951 to Indonesia. 1959 returned to China. Settled in Shanghai.

Zhou Changjiang 周長江 (b. 1950, Shanghai, native of Jiangsu province). Oil painter. 1978 graduated from Fine Art Dept. of Shanghai Drama Academy. Director of Art Committee for Shanghai Academy of Painting and Sculpture. Noted for his fictional *Family Tree* (1997).

Zhou Chunya 周春芽 (b. 1955, Chengdu, Sichuan province). Painter. 1982 graduated from Oil Painting Dept. of Sichuan AFA. 1993 artist in residence at Chengdu Institute of Art, where his work showed influence of Georges Rouault, Vincent van Gogh, and Frank Brangwyn. 1987 traveled to Germany for advanced study. Earlier works focused on Tibetan landscape. Later influenced by expressionism and surrealism. Active in post-1989 avant-garde movement. 1996 exhibited at Shanghai Biennale. 2004 living as professional artist in Chengdu.

Zhou Duo 周多 (1905–?). Oil painter. Active 1920s to '40s. Studied in Japan. Worked in Shanghai, where he was member of Storm Society. Stopped painting after WWII and vanished from art world. Died in Taiwan.

Zhou Gongli 周公理 (Chou Kung-lei, 1901–90, native of Guangdong province). *Guohua* and Western-style painter. Graduated from Shanghai University of Arts, where he studied oil painting from a Russian teacher, figure painting from **Li Tiefu**, and *guohua* from **Wu Changshuo**. Lectured for a time in Dept. of Fine Art, Bangkok University, Thailand. Noted for his landscapes and nudes.

Zhou Gui 周圭 (*zi* Fangbai 方白, b. 1906, Nanwei, Jiangsu province). Painter and sculptor. 1930–33 studied in Paris under Louis Roger and J. P. Laurens. 1933–35 in Brussels, where he studied under Alfred Bastien, and in Italy. 1937 returned to China. Later taught in Suzhou, Wuchang, Chongqing, and Hangzhou Academy. Exhibited with his wife, Lu Zhuanwen.

Zhou Huaimin 周懷民 (*hao* Zhou Ren 周仁, 1907–97, native of Wuxing, Jiangsu province). *Guohua* painter. 1926 studied landscape painting in Beijing Painting Research Society. Later taught in Beijing. Member of Beijing Academy of Painting. After Liberation worked on a number of collaborative paintings with other artists.

Zhou Jianfu 周建夫 (b. 1937, native of Shanxi province). Wood engraver. 1962 graduated from CAFA, where he became teacher in Graphic Arts Dept. Noted for his powerful *shuiyin* prints and woodcuts of Shanxi peasant life.

Zhou Jianxu 周建旭 (Chiu Tenghiok, 1903–72, b. Xiamen, Fujian province). Western-style painter. Attended Anglo-American Collage in Tianjin. 1929 arrived in US to study history and archaeology at Harvard. Left to study art for two years at School of the Museum of Fine Arts, Boston. 1923 went to study at Ecole Nationale Supérieure des Beaux Arts in Paris. 1925 went to Royal Academy of Arts, London, to study under Sir George Clausen. 1926 won Cheswick Prize for landscape painting. 1929 won gold medal at Royal Academy. 1930 graduated. 1930–32 in Beijing. Later worked in

Spain, the south of France, and Morocco. 1938 settled in US, where he had a successful career. Friend of Georgia O'Keefe in Texas.

Zhou Jingxin 周京新 (b. 1959, Nanjing). *Guohua* painter. 1984 graduated from Nanjing Academy. 1989 MA, Nanjing Academy. 2004 professor and vice-director. Subject of a number of publications, including *Zhou Jingxin di yishu shijie shuimo diaosu* [Zhou Jingxin's art world: Ink painting and sculpture] (Nanjing, 1999).

Zhou Jirong 周吉榮 (b. 1962, Xinan, Guizhou province). Printmaker. 1981 graduated from Guizhou Provincial Art School. 1987 graduated from Printmaking Dept. of CAFA. 1996 artist in residence, CAFA Studio, Royal Academy of Fine Arts, Madrid, Spain. Became deputy director and associate professor in Printmaking Dept. of CAFA. Solo exhibitions in Spain and at Red Gate Gallery, Beijing.

Zhou Jun 周俊 (b. 1955, Shanghai). *Guohua* painter. BA in fine art, Shanghai Normal University. MA in *guohua*, CAFA. 1982–87 taught art at Shanghai Normal University. 1987 curator at Shanghai Museum. 2000 professor in Dept. of Fine Art, Beijing Normal University. 1989 worked in France, US, and China. 2004 living in Nijmegen, Holland. See Sandra Borstlap, ed., *Zhou Jun: Chinese Watercolour and Ink Paintings* (Leeuwarden, 2004).

Zhou Ling 周菱 (b. 1941, Tianjin or Hefei, Anhui province). Painter. 1960 studied in Central Nationalities Institute. After graduation married her teacher, **Liu Bingjiang**, and for that was banished to Yunnan for eight years. From 1983 taught in Central Nationalities Institute. 1980–82 she and her husband created huge mural painting, *Creativity Reaping Happiness*, in restaurant of Beijing Hotel.

Zhou Lingzhao 周令釗 (b. 1919, Pingjiangxian, Hunan province). *Guohua* painter. 1935 graduated from Wuchang Normal College, went to Shanghai. Active in woodcut movement in west China during WWII. 1949 recruited by **Xu Beihong** to teach in CAFA.

Zhou Luyun 周綠雲 (Irene Chou, b. 1924, Shanghai). Painter. 1945 graduated from St. John's University, Shanghai. Worked four years as reporter. 1949 she moved to Hong Kong. Studied under **Zhao Shao'ang** and **Lü Shoukun**. Became teacher in Dept. of Extramural Studies, Hong Kong University. Leading figure in Hong Kong art scene. Has held many exhibitions in Hong Kong and overseas. 1970 exhibited at Royal Academy of Arts, London. 1991 went to Brisbane, Australia.

Zhou Ren. See **Zhou Huaimin**

Zhou Shaohua 周韶華 (b. 1929, Rongcheng, Shandong province). Former army general and amateur *guohua* painter. Active in Hebei. 1966 in military prison. 1978 president of reopened Hubei AFA. 1986 professor in Huazhong Normal University. 1987 visited West Berlin. 1993 awarded Hubei Literary and Artistic Star. 1995 one-artist show at CAFA Gallery, Beijing. 1996 exhibitions in Taipei Pacific Cultural Foundation and in Nagoya, Japan. 1998–99 showed semiabstract expressionist landscapes in Vision 2000 exhibition (Lübeck and Stuttgart, Germany). See *Zhou Shaohua huaji* 周韶華畫集 [Collected paintings of Zhou Shaohua] (Wuhan, 2005).

Zhou Shenghua 周勝華 (1949–2000, b. Shuangcheng, Heilongjiang province). Printmaker. 1968 learned printmaking on state farm in Heihe. Graduated from Harbin Normal University. 1983–84 studied in CAFA. Became professional artist in Heilongjiang. Has won several prizes, including gold medal for one of his forest landscape prints in Tenth National Chinese Print Exhibition.

Zhou Shicong 周世聰 (Chow Sai-chung, b. 1914, native of Zijin, Guangdong province). *Guohua* painter, especially of flowers and bamboo, and calligrapher. In 1990s principal of International College of Fine Art, Hong Kong.

Zhou Shixin 周士心 (Johnson Chow, b. 1923, Suzhou, Zhejiang province). *Guohua* painter. 1944 graduated from Suzhou Academy, returned to Suzhou. 1949 moved with his family to Hong Kong, where he was active in commercial design and, increasingly, as teacher of *guohua* techniques in several institutions. His wife, Lu Xinru, is also a painter. See Hing-yu L. Chow, *Johnson Chow's Paintings*, with an essay by Kai-yü Hsü (Taipei, 1981).

Zhou Shufen 周淑芬 (Josephine Suk-fan Chow, b. 1965, Hong Kong). Painter. Since 1985 has been involved in children's art education in Hong Kong. 1989 with **Chen Yusheng** founded Cultural Corner Art Academy to teach children art. Paints semiabstract works in oils and acrylics.

Zhou Sicong 周思聰 (1939–96, native of Ninghexian, Hebei province). *Guohua* painter. 1955 studied in middle school attached to CAFA. 1958–63 studied Chinese painting in CAFA under **Jiang Zhaohe, Ye Qianyu, Li Keran,** and **Li Yingjie** and had private lessons in figure painting from Jiang Zhaohe. 1963 member of Beijing Academy of Painting. 1980 vice-president of Beijing branch of CAA and committee member of Beijing Political Bureau. Specialized in figure painting and genre scenes.

Zhou Tiehai 周鐵海 (b. 1966, Shanghai). Conceptual artist. Lives in Shanghai. Attended Fine Art School, Shanghai University. Part of early performance art group, "M"

Art Body. 1998 first prize, Contemporary Chinese Art Award. Exhibited at Venice Biennale (1999), Guangzhou Triennial (2002), Kwangju Biennial, South Korea (2002), Cantor Center for Visual Arts, Stanford University (2005). (*Photo on p. 229.*)

Zhou Xi. See **Jiang Feng**

Zhou Xiang 周湘 (1871–1942). Oil painter, progressive Qing official. Studied under Jesuits in Tushanwan Art School (Ziccawei), Shanghai. 1912 set up Oil Painting School chiefly for teaching scenery and backdrop painting, where **Chen Baoyi** and **Liu Haisu** were among his pupils, and established a correspondence school for *guohua* in Shanghai. He aged rapidly, dying before he had completed his portrait of **Li Shutong.**

Zhou Xianglin 周向林 (b. 1955, Wuhan, Hubei province). Oil painter. 1983 graduated from Oil Painting Dept. of Hubei AFA. 1991 MFA from CAFA. 1991 at exhibition of Chinese Oil Painting in Hong Kong, his *Kaifeng, Nov. 12, 1969*, in memory of Premier Liu Shaoqi, won silver medal.

Zhou Xiqin 周西芹 (Chou Su-ch'in, b. 1945, Sichuan province). Painter and wood engraver. 1962–64 studied in CAFA. Joined staff of Natural History Museum, Beijing. Later worked in Los Angeles and Melbourne. Specializes in plants and animals.

Zhou Xixin 周西心 (Chow Su-sing, b. 1923, Suzhou). *Guohua* painter. Graduated from Suzhou Academy. Taught for ten years in Hong Kong. 1971 settled in Los Angeles. 1980 moved to Vancouver. Has written extensively on history, aesthetics, and technique of Chinese painting.

Zhou Yifeng 周一峰 (1890–1982, native of Panyu, Guangdong province). *Guohua* painter, Lingnan school. In Guangzhou studied under Gao Weng. Later settled in Hong Kong as professional artist.

Zhou Yuanting 周元亭 (b. 1904, Beijing). *Guohua* painter. 1920 studied painting, worked, and exhibited in Beijing, Tianjin, and Shanghai. Teacher in Beijing Academy of Painting. Noted for his landscapes.

Zhou Zhentai 周真太 (C. T. Chow, ?–1936, native of Changshu, Zhejiang province). Oil painter, active in 1930s. Studied in Japan. 1930 formed Taimeng Art Society with **Pang Xunqin.** Member of Independent Artists Group in Shanghai.

Zhou Zhiyu 周至禹 (b. Hebei province). Printmaker. Pursued advanced study at CAFA. 1984 opened first independent printmaking studio in Zhuoxian, south of Beijing.

Zhu Chonglun 祝崇倫 (b. 1955, Shenyang, Liaoning province). Oil painter. 1989 graduated from Fine Art Dept. of Shenyang College of Education. 1991 awarded gold medal for his *Summer* in Four Seasons exhibition.

Zhu Chuzhu 朱楚珠 (Nancy Chu Woo, b. 1941, Guangdong province). Painter. Moved to Hong Kong with her parents. 1963 BA in Fine Arts from Cornell University. 1964 MA from Columbia University. 1973 returned to Hong Kong, where she studied Chinese art under **Yang Shanshen** and taught part time in Dept. of Fine Arts, University of Hong Kong and Chinese University of Hong Kong. Noted for her nude studies (especially back views) in Western media.

Zhu Dacheng 朱達誠 (Chu Tat Shing, b. 1942). Sculptor. Graduated from Sculpture Dept. of CAFA. 1984 settled in Hong Kong. Member of Hong Kong Association of Sculptors. On board of directors of Hong Kong Artists Association. Has taught in Extramural Studies Depts., University of Hong Kong and Chinese University of Hong Kong. Director of Cutian Art Studio.

Zhu Danian 祝大年 (b. 1915, Hangzhou). Painter and decorative artist. Trained in Hangzhou Academy. 1933–37 studied art and ceramic technology in Tokyo. 1979 designed *The Song of the Forest* in ceramic tile for Beijing International Airport.

Zhu Daoping 朱道平 (b. 1949, native of Huangyan, Zhejiang province). *Guohua* painter. 1977 graduated from Nanjing Academy. Became vice-president of Nanjing Academy of Painting and Calligraphy. Paints southern landscapes in free literati style. 2004 director of Nanjing Painting and Calligraphy Academy, chairman of Nanjing Artists Association, etc. See *Jiangsu dangdai guohua youxiu zuopin zhanhuaji: Zhu Daoping* 江蘇當代國畫優秀作品展畫集－朱道平 [A selection of fine works by contemporary painters: Zhu Daoping] (Nanjing, 2002).

Zhu Dequn 朱德群 (Chu Teh-chun, b. 1920, Xiaoxian, Jiangsu province). Painter. 1936 entered NAA Hangzhou. Went with NAA to west China during WWII. Enrolled in NCU art school in Chongqing. 1947–49 taught in NCU Nanjing, then went to Taiwan, where he was professor in NTNU. 1955 left for France. Studied at Académie de la Grande Chaumière, Paris. 1956 awarded silver medal at Salon du Printemps. Became independent and increasingly successful abstract expressionist. Since 1983 has paid a number of return visits to PRC and Taiwan. 1997 elected member of Institute of the Académie des Beaux Arts, Painting Section. See Pierre Cabanne, *Chu Teh-chun* (Paris, 1993). (*Photo on p. 230.*)

Zhu Dongsan 諸東三 (*hao* Xizhai 希齋, b. 1902, Anjixian, Zhejiang province). *Guohua* painter, calligrapher, and seal carver. Aged nineteen studied under **Wu Changshuo**. 1922

went to Shanghai, where he enrolled in Shanghai Meizhuan. After 1930 taught in Xinhua AFA, Shanghai. 1946 became professor in ZAFA. 1980 joined Zhejiang Art Institute.

Zhu Hanxin 朱漢新 (Chu Hon-sun, b. 1950, Guangdong province). Sculptor. 1975 graduated from Fine Arts Dept., Chinese University of Hong Kong. 1976–80 studied in Carrara, Italy. Works in Hong Kong.

Zhu Hui 朱慧 (b. 1959). Tapestry designer and soft-sculpture maker. Pupil of Marin Varbanov in ZAFA. Active in Hangzhou in mid 1980s.

Zhu Jiahua 朱嘉樺 (Chu Chiahua, b. 1960, Taipei). Installation artist. 1982 graduated from National Taiwan Academy of Arts. 1990 studied at Academia di Belle Arti, Milan. "Aesthetic materialist" working with ready-made objects.

Zhu Jinshi 朱金石 (b. 1954, Beijing). Amateur painter. Active in Beijing. 1979 and 1980 exhibited with Stars. Later settled in US. 1986 showed works in Avant-Garde Exhibition, New York and Vassar College.

Zhu Lesan 諸樂三 (*hao* Xizhai 希齋, 1902–84, native of Zhejiang province). *Guohua* painter, calligrapher, and seal engraver. Pupil of **Wu Changshuo.** Before WWII taught in Xinhua AFA, Shanghai. After 1949 professor in Nanjing Academy and later in ZAFA.

Zhu Ming 朱銘 (Ju Ming, b. 1938, Miaolixian, Taiwan). Sculptor. Apprenticed to woodcarver Li Jinchuan. Became independent carver of religious images. 1960 began to study modern sculpture. 1968–76 assisted **Yang Yingfeng.** 1974 took up *taijijuan* (*t'ai chi chuan*). 1976 became independent sculptor working in stone, bronze, wood, cast styrofoam, etc., often taking his themes from *taijijuan*. By late 1980s had an international reputation, with many public commissions in East Asia, Europe, and US. In addition to *taiji* pieces, he is well known for Living World series of figures, hacked out of wood and gaily colored, and for figures in styrofoam. His sculpture garden near Kao-hsiung displays a wide range of his work. June–July 2004 major retrospective in Singapore. September 2005 exhibition and symposium in his honor in Taipei. See *Renjian* 人間 [The living world], vol. 3 of *Zhu Ming diaoke* 朱銘雕刻 [Zhu Ming's sculpture], 3 vols. (Taipei, 1989–91); and Singapore Art Museum and iPreciation, ed., *Ju Ming* (Singapore, 2004).

Zhu Minggang 朱鳴岡 (n.d.). Wood engraver. Studied in Xinhua AFA, Shanghai. Started producing woodcuts early in WWII.

Zhu Naizheng 朱乃正 (b. 1935, Haiyan, Zhejiang). Oil painter. 1953 entered CAFA. After graduation assigned to work in Qinghai. 1980 transferred back to CAFA, where

he became professor and vice-president. 1972 selected with other young painters—e.g., **Jin Shangyi, Chen Yifei,** and Tang Xiaohe 唐小禾 (b. 1941)—to "correct" (technically) works submitted by amateurs and workers to official Cultural Revolution exhibition in Beijing.

Zhu Peijun 朱佩君 (b. 1920, Sichuan province). *Guohua* painter, chiefly of birds and flowers. Self-taught. Active in Sichuan art politics. Friend of Jiang Qing (Madame Mao) and persecutor of **Chen Zizhuang.**

Zhu Qinbao 朱琴葆 (n.d.). Printmaker. Active in Jiangsu province in 1980s and '90s.

Zhu Qizhan 朱屺瞻 (*hao* Qizai 起载, Erzhanlaomin 二瞻老民, 1892–1996, b. Taicang-xian, Jiangsu province). Oil and *guohua* painter. 1912 began to study oil painting in Shanghai Meizhuan. 1922 and 1930 studied in Japan, where he studied Western art under Lin Tonghua 林同華 and came under the influence of Paul Cézanne, Henri Matisse, and Vincent van Gogh. 1932 exhibited war paintings in oils after Japanese attack in Shanghai. Later turned to Chinese painting. Taught in Shanghai Meizhuan and headed painting research group at Xinhua AFA. Also taught for many years at Hangzhou Academy. Before 1949 he was well off, as he owned a soy sauce factory. 1982 teaching in Shanghai Chinese Painting Academy. 1983 professor in East China Normal University in Shanghai. Continued painting vigorously into extreme old age. See Leo K. K. Wong and Christina Chu, *Encounters with Zhu Qizhan,* 2 vols. (Hong Kong, 1994); A. J. Wender, *Zhu Qizhan: At the Height of Inspiration* (New York, 1994), and *Unafraid of the Autumn Wind: Retrospective Exhibition of Paintings by Zhu Qizhan (1892–1996)* (New York, 1999); and Feng Qiyong 馮其庸 and Yin Guanghua 尹光華, eds., *Zhu Qizhan nianpu* 朱屺瞻年譜 [Biographical chronology of Zhu Qizhan] (Shanghai, 1985). (*Photo on p. 230.*)

Zhu Wei 朱偉 (b. 1966, Beijing). Painter, sculptor, and installation artist. 1974–75 studied art in Beijing Children's Palace. 1982 joined PLA. 1989 graduated from PLA Art Academy. 1993 graduated from Beijing Film Academy and became independent artist. Produces satirical works in various media associated with political pop. For commentary on contemporary Chinese urban life, see *Zhu Wei: The Story of Beijing* (Hong Kong and Singapore, 1994). Lives in Beijing.

Zhu Weibai 朱為白 (b. 1929, Nanjing). Painter. Member of Ton Fan Group in Italy.

Zhu Xinghua 朱興華 (Chu Hing-wah, b. 1935, Guangdong province). 1960–65 trained in psychiatric nursing at Maudsley Hospital, London. 1968–92 served in Castle Peak Psychiatric Hospital, Hong Kong. 1974 completed certificate course in art and design in Extramural Studies Dept. of University of Hong Kong. Joined Visual Arts Society,

which he chaired from 1983 to 1986. 1992 retired to New Territories to become full-time artist, painting dreamlike pictures of people and streets of Hong Kong. 1989 given Urban Council Fine Arts Award. 1989 named Painter of the Year by Hong Kong Artists' Guild Association. 1994 received scholarship from Asian Cultural Council for art research in New York.

Zhu Xinjian 朱新建 (b. 1953, Nanjing). 1980 graduated from Nanjing Academy, where he then taught. Also employed by Shanghai Art Movie Studio. 2004 practices as professional artist, specializing in humorous and erotic figure subjects. See *Zhu Xinjian di yishu shijie: Shuimo diaosu* 朱新建的藝術世界: 水墨雕塑 [Zhu Xinjian's art world: Ink painting and sculpture] (n.p., 1999).

Zhu Yiyong 朱毅勇 (b. 1957, Chongqing, Sichuan province). Oil painter. Graduated from Printmaking Dept. of Sichuan AFA, Chongqing, where he became then taught. Realist.

Zhu Yuanzhi 朱沅沚 (Yun Gee, 1906–63, b. Guangzhou). Painter. 1921 went with family to San Francisco. 1925 started to study painting. 1927 and 1936 in Paris, where he exhibited with Marie Laurençin, Michel Soutine, Amedeo Modigliani, and others. 1940 in New York, where he created huge painting celebrating China's resistance to Japan. Died in New York after mental breakdown. His work shows various influences from modern European art.

Zhuang Hui 莊輝 (b. 1963, Yumen, Gansu province). Independent artist. Lives and works in Beijing. Has traveled widely and exhibited in France, Germany, and Italy.

Zhuang Pu 莊普 (Tsung Pu, b. 1947, Shanghai). Painter and installation artist. 1982 graduated from Escuela Superior de Bellas Artes de San Fernando, Madrid. Minimalist. Works in Taipei.

Zhuang Shihe 莊世和 (b. 1923, Tainan, Taiwan). Oil painter. 1938 entered Kawabata Painting Academy, Tokyo. After eight years in Japan studying cubism and abstract art, returned to Taiwan. Took up teaching career in Taipei and elsewhere. 1989 retired to southern Taiwan, where he worked as a farmer.

Zhuang Zhe 莊喆 (b. 1934, Beijing). Painter. 1948 moved to Taiwan. 1958 graduated from Art Dept. of Taiwan Provincial Normal University. 1960s member of Fifth Moon Group. Head of Dept. of Art and Architecture at Donghai University, Taizhong. 1969 turned to oil painting. Later on staff of National Palace Museum, Taipei. 1973 emigrated to US. Settled in Ann Arbor, Michigan; later in New York. Abstract expressionist. (*Photo on p. 230.*)

Zhuo Hejun 卓鶴君 (b. 1947, Hangzhou, Zheijiang province). *Guohua* landscape painter. Pupil of **Lu Yanshao.** Professor in ZAFA. 1990 visited US and UK.

Zhuo Yourui 卓有瑞 (Y. J. Cho, b. 1950, Taipei) Oil and watercolor painter. 1973 BFA, NTNU. 1977 MA, State University of New York, Albany. Has held solo exhibitions in Taiwan, Hong Kong, and USA. Lives and works in New York. Hyperrealist.

Zong Qixiang 宗其香 (b. 1917, Jiangsu province). Painter, traditional and modern schools. Studied in NCU. 1946 became teacher in NAA Beijing. After 1949 joined PLA and made many pictures of revolutionary struggle. Labeled "black artist" in Cultural Revolution. 1977 rehabilitated. Painted many large murals in tourist hotels and airports.

Zou Lin 鄒琳 (Chau Lam, b. 1942, Guangdong province). Painter. 1979 arrived in Hong Kong. 1979–93 worked as designer. 1993 became professional artist, producing paintings, sketches, and charcoal drawings. See Chau Lam, *Rhythmic Soul: The Portrait Paintings of Chau Lam* (Hong Kong, 1999).

Zou Ya 鄒雅 (1916–74, native of Jiangsu province). Wood engraver. Active in Shanghai. 1938 went to LXALA in Yan'an. After 1949 took up *guohua*, influenced by **Huang Binhong** and **Li Keran.** Member of Beijing Academy of Painting. Noted for his powerful woodcuts of workers and the sufferings of miners. 1974 was living in Shanxi when he died in a mining accident. 1980 memorial exhibition of his woodcuts held in National Art Gallery, Beijing. See Jiang Feng 江丰 and Shao Yu 邵宇, eds., *Zou Ya huaji* 鄒雅畫集 [Collected paintings of Zou Ya] (Beijing, 1982).

bibliography

Monographs on individual artists are cited under the artist concerned.

Chinese and Japanese Sources

Art Bureau of the Ministry of Culture of the PRC 中華人民共和國文化部藝術局, ed. *Zhongguo meishu wushinian, 1942–1992* 中國美術五十年 1942–1992 [Fifty years of Chinese art, 1942–1992]. Hangzhou, 1992.

Art Department of the Ministry of Culture of the PRC 中華人民共和國文化部藝術司, Chinese Oil Painting Society 中國油畫學會, and National Art Gallery 中國美術館. *20 shiji Zhongguo youhuazhan zuopin ji* 20 世紀中國油畫展作品集 [Collection of works from the exhibition of twentieth-century oil painting]. Nanning, 2000.

Art Department of the Ministry of Culture of the PRC 中華人民共和國文化部藝術司, Chinese Oil Painting Society 中國油畫學會, and Wen Lipeng 聞立鵬, eds. *Ershi shiji Zhongguo youhua* 二十世紀中國油畫 [Chinese oil painting in the twentieth century]. 6 Vols. Beijing, 2001.

Beijing Academy of Chinese Painting 北京畫院. *Beijing Huayuan Zhongguohua xuanji* 北京畫院中國畫選集 [A selection of Chinese paintings in the Beijing Academy of Chinese Painting]. Beijing, 1982.

Beijing Language Institute 北京語言學院. *Zhongguo yishujia cidian* 中國藝術家辭典 [Dictionary of Chinese artists]. 5 vols. Changsha, 1981.

Cha Liangyong 查良鏞 and Ma Lin 馬臨. Prefaces to *Dangdai Zhongguo huihua* 當代中國繪畫 [Contemporary Chinese painting]. Hong Kong, 1986.

Chen Yutang 陳玉堂, ed. *Zhongguo jinxiandai renwu minghao dazidian* 中國近現代人物名號大字典 [Biographical dictionary of prominent Chinese of recent times]. Shanghai, 1993. Supplement, 2001.

China Art Gallery 中國美術館, ed. *Zhongguo meishu nianjian 1949–1984* 中國美術年鑒 1949–1984 [Yearbook of Chinese art, 1949–1984]. Beijing, 1993.

Guo Xiang 郭翔, ed. *Shijie Huaren meishu mingjia nianjian* 世界華人美術名家年鑒 [Yearbook of famous Chinese artists of the World]. Hefei and Hong Kong, 1997.

Hu Guojun 戶國俊, ed. *Dangdai shuhua zhuankejia cidian* 當代書畫篆刻家辭典 [Present-day calligraphers, painters, and seal carvers]. 2 vols. Beijing, 1994.

Huang Miaozi 黃苗子, ed. *Xiandai Zhongguohua jicui* 現代中國畫集粹 [A selection of contemporary Chinese paintings]. Beijing, 1981.

Lang Shaojun 郎紹君. *Zhongguo dangdai jingwu* 中國當代靜物 [Chinese modern still lifes]. Zhengzhou, 1999.

Li Chao 李超. *Shanghai youhua shi* 上海油畫史 [A history of oil painting in Shanghai]. Shanghai, 1995.

Li Jian'er 李建兒. *Guangdong xiandai huaren zhuan* 廣東現代畫人傳 [Biographies of modern Guangdong painters]. Guangzhou, 1941.

Liaoning Fine Art Publishing House 遼寧美術出版社. *Zhongguo dangdai yishujia: Liu Guosong, Ding Shaoguang, Song Yugui, Xu Xi, Shi Hu* 中國當代藝術家: 劉國松, 丁紹光, 宋雨桂, 徐希, 石虎 [Modern Chinese artists: Liu Guosong, Ding Shaoguang, Song Yugui, Xu Xi, Shi Hu]. Shenyang, 1998.

Lin Jiantong 林健同 and Lin Jikai 林紀凱. *Dangdai Zhongguo huaren minglu* 當代中國畫人名錄 [Biographies of present-day Chinese artists]. Hong Kong, 1971.

Lu Danlin 陸丹林. *Zhongguo xiandai yishujia xiang zhuan* 中國現代藝術家像傳 [Biographical sketches of modern Chinese artists]. Hong Kong, 1978.

Lu Hong 魯虹, ed. *Zhongguo dangdai meishu tujian 1979–99* 中國當代美術圖鑒 1979–99 [Pictorial survey of Chinese modern art: Ink painting, 1979–99]. Wuhan, 2001.

Ni Wendong 倪文東, ed. *Ershishiji Zhongguo shuhuajia* 二十世紀中國書畫家 [Twentieth-century Chinese calligraphers and painters]. 2 vols. Xi'an, 2002.

Pan Gongkai 潘公愷, ed. *Shiji Zhuanxin: Zhongguo meishu xueyuan qishi zhounian jinian* 世紀傳薪：中國美術學院七十周年紀念 [The flames of art: The seventieth anniversary of the founding of the Chinese Academy of Art]. Hangzhou, 1998.

Shanghai Art Museum. *96 Shanghai Meishu Shuangnianzhan* 96 上海美術雙年展 [Exhibition of the 1996 Shanghai Biennale]. Shanghai, 1996.

———. *98 Shanghai Meishu Shuangnianzhan* 98 上海美術雙年展 [Exhibition of the 1998 Shanghai Biennale]. Shanghai, 1998.

———. *2000 Shanghai Meishu Shuangnianzhan* 2000 上海美術雙年展 [Exhibition of the 2000 Shanghai Biennale]. Shanghai, 2000.

Shui Tianzhong 水天中, ed. *Meishu Pipingjia Niandu Timingzhan: Youhua* 美術批評家年度提名展：油畫 [The annual exhibition of works of the artists nominated by art critics: Oil painting]. Beijing, 1994.

Tao Yongbai 陶永白, ed. *Zhongguo youhua erbaibashi nian* 中國油畫二百八十年 [Two hundred and eighty years of Chinese oil painting]. Shanghai, 1988.

Tsuruta Takeyoshi 鶴田武良. "Index to Chinese Painters of the Last Hundred Years." *Bijutsu kenkyū* 美術研究 (Tokyo) (May and July 1974, Jan. 1976, and Sept. 1978).

———. *Kindai Chūgoku kaiga* 近代中國會畫 [Modern Chinese painting]. Tokyo, 1974.

Uchiyama Kakichi 內山嘉吉. "Chūgoku manga to watashi" 中國版畫卜私 [Chinese woodblock prints and I]. In *Chūgoku mokuhan gaten* [Exhibition of Chinese woodblock prints]. *Nihon Bijutsukan*. Tokyo, 1975.

Wang Chaojian 王朝間, Zhang Ding 張仃, and Wu Guanzhong 吳冠中, eds. *Zhongguo*

minghuajia quanji 中國明畫家全集 [Collected works of famous Chinese painters]. 25 vols. Shijiazhuang, 2000.

Xie Wenyong 謝文勇. *Guangdong huaren lu* 廣東畫人錄 [Records of Guangdong painters]. Guangzhou, 1985.

Yan Juanying 顏娟英, ed. *Taiwan jindai meishu dashi nianbiao* 台灣近代美術大事年表 [Chronological table of major events in modern Taiwanese art]. Taipei, 1998.

Yishu yaolan 藝術搖籃 [The cradle of art: Sixty years of the Zhejiang Academy of Fine Arts]. Hangzhou, 1988.

Yu Jianhua 俞劍華, ed. *Zhongguo meishujia renming zidian* 中國美術家人名辭典 [Biographical dictionary of Chinese artists]. Shanghai, 1981.

Zhang Fucheng 張復乘. *Zhongguo dangdai youhua* 中國當代油畫 [Contemporary Chinese oil painting]. 2 vols. Zhengzhou, 1997.

Zhu Boxiong 朱白雄 and Chen Ruilin 陳瑞林. *Zhongguo Xihua wushinian 1898–1949* 中國西畫五十年 1898–1949 [Fifty years of Western painting in China, 1898–1949]. Beijing, 1989.

Zou Ya 鄒雅 and Li Pingfan 李平凡. *Jiefang qu muke* 解放區木刻 [Woodcuts of the Liberation era]. Beijing, 1992.

Sources in Western Languages

Andrews, Julia F. *Painters and Politics in the People's Republic of China*. Berkeley, 1994.

Andrews, Julia F., and Kuiyi Shen. *A Century in Crisis: Modernity and Tradition in the Art of Twentieth-Century China*. New York, 1998.

Boorman, Howard, ed. *Biographical Dictionary of Republican China*. 4 vols. New York, 1967.

Chang, Tsong-zung, et al. *China's New Art, Post-1989, with a Retrospective from 1979–1989*. Hong Kong, 1993.

———, et al., eds. *The First Annual Exhibition of Chinese Oil Painting*. Hong Kong, 1992.

China Oil Painting Gallery et al. *The First Academic Exhibition of Chinese Contemporary Art, 96–97*. Beijing and Hong Kong, 1996.

Chinese Woodcutters' Association. *Woodcuts of Wartime China, 1937–1945*. Shanghai, 1946.

Chu, Christina, ed. *Artists and Art in Contemporary Chinese Paintings*. Hong Kong, 1989.

Clarke, David. *Art and Place: Essays on Art from a Hong Kong Perspective*. Hong Kong, 1996.

Cohen, Joan Lebold. *The New Chinese Painting, 1949–1986*. New York, 1987.

Contemporary Chinese Oil Painting. Shijiazhuang, 1991.

Croizier, Ralph. *Art and Revolution in Modern China: The Lingnan (Cantonese) School of Painting, 1906–1951*. Berkeley, 1988.

Ellsworth, Robert Hatfield, with James C. Y. Watt et al. *Later Chinese Painting and Calligraphy, 1800–1950*. 3 vols. New York, 1987.

Erickson, Britta. *Words without Meaning, Meaning without Words: The Art of Xu Bing.* Washington, D.C., 2001.

Farrer, Anne, ed. *Chinese Printmaking Today: Woodblock Printing in China, 1980–2000.* London, 2004.

Gao Minglu, ed. *Inside Out: New Chinese Art.* New York, 1998.

Hall, Robert, and Edwin Miller. *Lo Shan Tang, Contemporary Chinese Paintings.* London, 1988.

Hearn, Maxwell K., and Judith G. Smith, ed. *Chinese Art: Modern Expressions.* New York, 2001.

Hong Kong Museum of Art. *Hong Kong Artists: Collection of the Hong Kong Museum of Art.* Vols. 1 and 2. Hong Kong, 1995 and 2000.

———. *Tradition and Innovation: Twentieth Century Chinese Art.* Hong Kong, 1995.

Hu Shih, Kinn-wei Shaw, Lin Yutang, and Alan Priest. *An Exhibition of Modern Chinese Paintings.* New York, 1943.

Kao, Mayching. "China's Response to the West in Art, 1898–1937." PhD diss., Stanford University, 1972.

———, ed. *Twentieth Century Chinese Painting.* Oxford, 1988.

Kuo, Jason C. "After the Empire: Chinese Painters of the Post-war Generation in Taiwan." In *Modernity in Asian Art*, edited by John Clark. Sydney, 1993.

———. *Art and Cultural Politics in Postwar Taiwan.* Seattle, 2000.

———. "Painting, Decolonisation, and Cultural Politics in Post-war Taiwan." *Ars Orientalis* 25 (1995): 73–84.

Laing, Ellen. *Index to Reproductions of Paintings by Twentieth-Century Chinese Artists.* Eugene, Oregon, 1984.

———. *The Winking Owl: Art in the People's Republic of China.* Berkeley, 1988.

Li Chu-tsing. "Trends in Modern Chinese Painting: The C. A. Drenowatz Collection." *Artibus Asiae*, supplement 36 (1979).

Li, Chu-tsing, and Thomas Lawton. *The New Chinese Landscape: Six Contemporary Chinese Artists.* New York, 1966.

Lim, Lucy, ed. *Six Contemporary Chinese Women Artists.* San Francisco, 1991.

Liu, Charles, ed. *Artists of Taiwan.* Taipei, 1994.

Minick, Scott, and Jiao Ping. *Chinese Graphic Design in the Twentieth Century.* London, 1990.

Moss, Hugh. *The Experience of Art: Twentieth Century Chinese Paintings from the Shuisongshi Shanfang Collection.* Hong Kong, 1983.

Murray, Graeme, et al. *Reckoning with the Past: Contemporary Chinese Painting.* Edinburgh, 1996.

Priest, Alan, ed., with contributions by Wellington Koo and Lin Yutang. *Contemporary Chinese Paintings.* New York, 1948.

Rogers, Howard, Kaiyuen Ng, and Lang Shaojun. *Spring in Jiangnan: Works of Fifteen Contemporary Nanjing Painters.* New York, 2004.

Schioni, Manfred, et al., ed. *History of Chinese Oil Painting: From Realism to Post-Modernism.* Brussels, 1995.

Sullivan, Michael. *Art and Artists of Twentieth-Century China.* Berkeley, 1996.

————. *Chinese Art in the Twentieth Century*. London, 1959.

————. *The Meeting of Eastern and Western Art*. 1973; Berkeley, 1986.

————. *Modern Chinese Art: The Khoan and Michael Sullivan Collection*. Ashmolean Museum, Oxford, 2001.

Sullivan, Michael, and Paul Serfaty. *Wang Keping*. Hong Kong, 2001.

Toyka[-Fuong], Ursula. *Contemporary Chinese Ink Art: Fission–Metamorphosis*. Bonn, 2003.

————, ed. *Vision 2000: Chinesische Gemälde und Skulpturen der Gegenwart* [Vision 2000: Contemporary Chinese painting and sculpture]. Lübeck 1998, Stuttgart, 1999.

Tsang, Gerald, ed. *Hong Kong Artists: Collection of the Hong Kong Museum of Art*. Vol. 1. Hong Kong, 1995.

Urban Council, Hong Kong, and Hong Kong Arts Festival Society. *Twentieth Century Chinese Painting*. Hong Kong, 1984.

Vainker, Shelagh. *Chinese Painting in the Ashmolean Museum*. Oxford, 2000.

Wu Hung, with Wang Huangsheng and Feng Boyi. *Reinterpretation: A Decade of Experimental Chinese Art—The First Guangzhou Triennial*. Guangzhou, 2002.

Xiu, Huajing Maske. "Shanghai, Paris: Chinese Painters in France and China, 1919–1937." DPhil thesis, Oxford University, 2000.

SPONSORING EDITOR
DEBORAH KIRSHMAN

ASSISTANT ACQUISITIONS EDITOR
SIGI NACSON

PROJECT EDITOR
SUE HEINEMANN

EDITORIAL ASSISTANT
ANNE SMITH

COPYEDITOR
AMY KLATZKIN

DESIGNER
JESSICA GRUNWALD

PRODUCTION COORDINATOR
JOHN CRONIN

TEXT
9/11 ALDUS ROMAN

DISPLAY
AGENCY BOLD

COMPOSITOR
INTEGRATED COMPOSITION SYSTEMS

PRINTER AND BINDER
THOMSON-SHORE, INC.